JEWELS FROM IMPERIAL ST. PETERSBURG

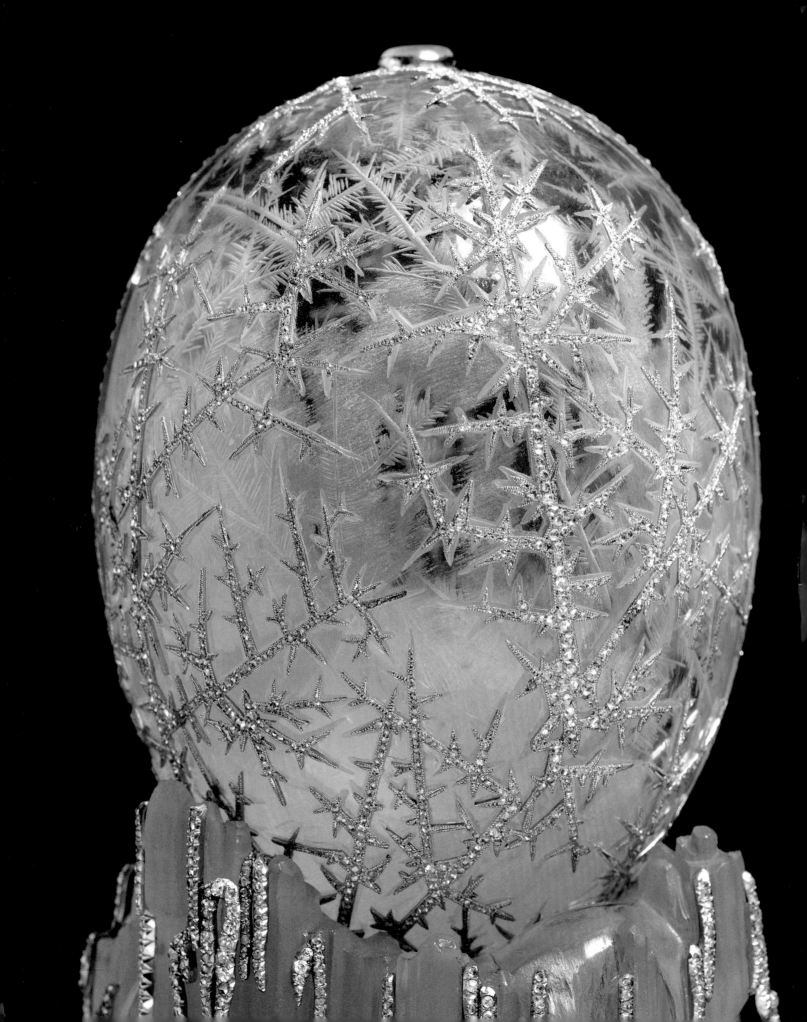

JEWELS
FROM IMPERIAL ST. PETERSBURG

ULLA TILLANDER-GODENHIELM

LIKI ROSSII
ST. PETERSBURG

UNICORN PRESS LTD.
LONDON

In memory of L-P. G.

Published by
LIKI ROSSII
17/8 Pirogova Lane,
St. Petersburg, 190000 Russia
www.liki-rossii.ru

Distributed by
UNICORN PRESS LTD.
66 Charlotte Street,
London, W1T 4QE, UK
www.unicornpress.org

ISBN: 978-5-87417-457-6 (Liki Rossii)
ISBN: 978-1-910065-15-0 (Unicorn Press Ltd.)

Layout by Maria Appelberg
Cover design by Timothy F. Boettger
Printed in China for XY Books Ltd, London 2014

Preceding page
The Winter Egg
Fabergé, workshop of Albert Holmström, St. Petersburg, 1913
Designed by Alma Pihl
Platinum, gold, rock crystal, diamonds, moonstone, demantoid garnets, Siberian nephrite
Collection of Sheikh Saoud Al-Thani
Photo: Courtesy of Wartski, London

TABLE OF CONTENTS

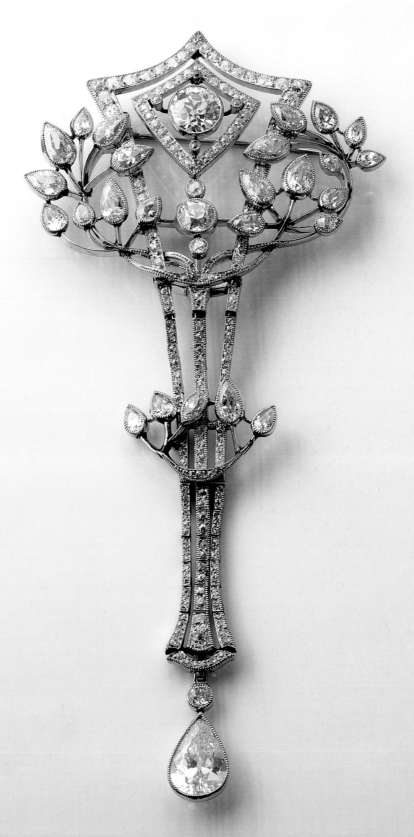

Pendant brooch
Vladimir Gordon, St. Petersburg, c.1910
Platinum, diamonds
Private collection
Photo: Katja Hagelstam

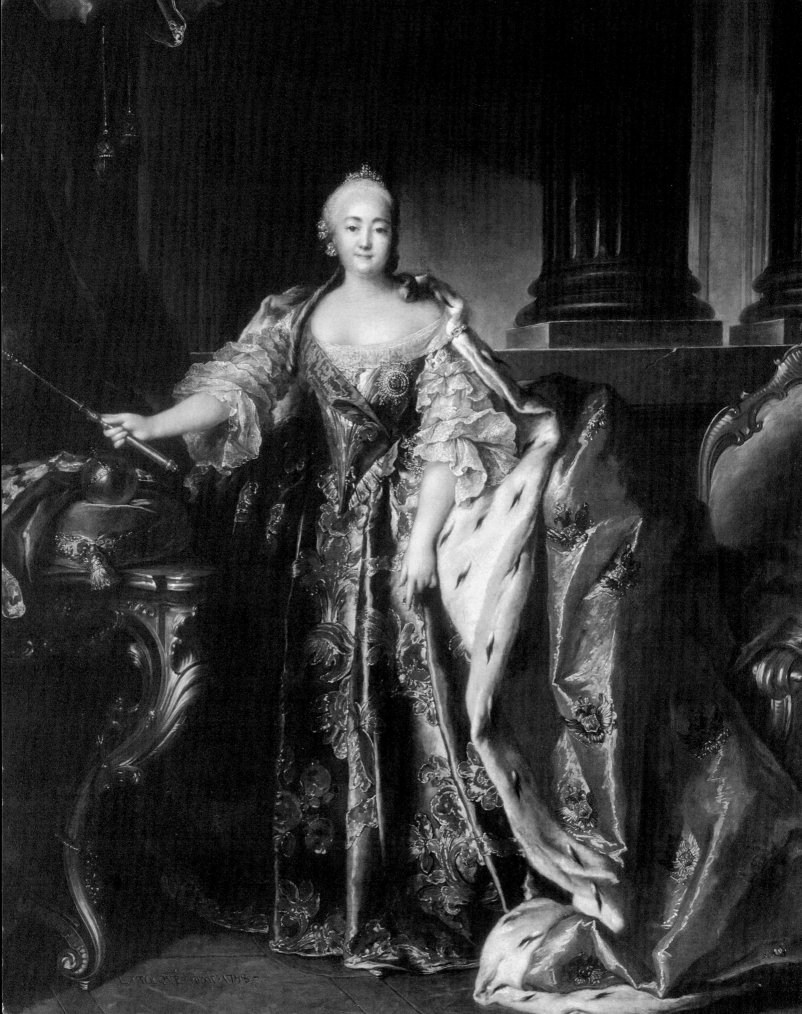

AVANT-PROPOS

The present book offers chance glimpses into the multifaceted world of imperial Russia; gem-like vignettes of people's lives as seen through their jewels, with a special focus on individuals from the Grand Duchy of Finland.

Being born into a St. Petersburg goldsmith's family, now in its fifth generation, jewels have been an important part of my life. My first encounter with these precious things took place in my father's office. For a brief moment, he turned his back on the desk at which he was working with parcels of rubies, sapphires, and emeralds, and during this unguarded instant—so the story goes—I swallowed a few of his finest Burma rubies and Kashmir sapphires, believing these colorful little objects to be candies. The dramatic incident took a happy turn the following day when the costly stones were recouped, having passed through my tummy. The saga of my great-grandfather and grandfather is included in the book, and I take great pride in seeing their names alongside those of St. Petersburg's legendary jewelers.

My professional role as a jeweler, lecturer, organizer of exhibitions, and author has given me the unique opportunity of handling an abundance of jewels produced in imperial St. Petersburg now in private collections in Finland. What fascinates me most about these exquisite pieces is the fact that they have been passed down through many generations in the same families, all of whom in some way have been linked to the great metropolis on the Neva River. Each piece, therefore, has an interesting story to tell.

Finland's one hundred years as a grand duchy of the Russian Empire (1809–1917) gave thousands of its native sons and daughters ample reason for visiting and even moving to St. Petersburg—to learn a craft or occupation; to be educated in one of the elite schools or institutions; to serve in the military, the civil service, or at court; or to engage in a business enterprise. It is only natural that, as a Finn myself, I would take a particular interest in the life stories—some joyous, some heartbreaking—of these individuals, and it gives me great pleasure to be able to share them with you in the following pages.

Elisaveta and Yurii Shelaev, owners of the publishing house Liki Rossii in St. Petersburg, invited me to write this book. They were wholeheartedly seconded by their colleagues Galina Korneva and Tatiana Cheboksarova, authors and specialists in the history of St. Petersburg and the Romanov dynasty, who took it upon themselves to translate the manuscript into Rus-

Empress Elizabeth Petrovna
Louis Tocqué, 1758
The State Hermitage Museum, St. Petersburg

9

sian. They have shared many of their own remarkable discoveries from the treasure troves of the St. Petersburg archives, not to mention having introduced me to their enormous network of scholarly collaborators. I will forever cherish the friendship, guidance, and enthusiasm of my "St. Petersburg sisters."

My dear friend and colleague in Waterloo, Canada, Timothy F. Boettger, has been a key person to the success of the scheme, both as the picture editor and as the researcher and translator (from French and Russian to English) of a myriad of fascinating details which make up this text. His passion for genealogy and the history of the Russian Empire—including the art of its goldsmiths—has made him an invaluable sounding board throughout this creative process.

The indefatigable Maria Appelberg has been responsible for the graphic work, and my long-time collaborator Katja Hagelstam has beautifully photographed most of the jewels from private collections in Finland. The continuous support of this wonderful team has been vital to me in the course of writing this tome.

I have furthermore had the unfailing assistance of many colleagues and friends near and far. First and foremost I want to mention the great generosity of the State Hermitage. A large number of the illustrations for the book have come from the collections of this, the most impressive of museums. My special thanks go to its jewelry specialists Olga Kostiuk, Marina Lopato, and Lilia Kuznetsova. Valentin Skurlov, with his encyclopedic knowledge of St. Petersburg jewelers, has also been of great assistance. Warm thanks as well go to Geoffrey Munn, Katherine Purcell, and Kieran McCarthy of Wartski, London; the Schaffer family of A La Vieille Russie, New York; Dorothy and Artie McFerrin, Humble, Texas; Harry Woolf, London; Christian Bolin, Stockholm, Alexander von Solodkoff, Hemmelmark, Germany; Emmanuel Ducamp, Paris; Alexis Tiesenhausen, Barbro Schauman, and Mark Moehrke of Christie's; Darin Bloomquist of Sotheby's; Christel McCanless, Huntsville, Alabama; Annemiek Wintraecken, Venray, Holland; and Daniel Brière, Montreal. The names of countless others in the world of imperial jewelry in Russia, North America, and Europe can be found throughout the text, along with those of the collectors, antiquarians, auction houses, museums, and specialists who have contributed picture material and documentation. Many of the photographs have been generously sponsored by the Finnish Nobility Association, Helsinki.

Ollas, Pernå, August 2012
ULLA TILLANDER-GODENHIELM

ORTHOGRAPHY AND DATES

Russian names have been transliterated with the primary aim of being accessible to a general readership. A modified version of the Library of Congress system has been employed.

Names of foreign origin have been given in their original language, as opposed to transliterating them from the Russian form; for example, von Kraemer, rather than Kremer (Кремер). Given names appear in their Russian form—for example, Georgii and Ekaterina, rather than George and Catherine—the only exception being monarchs and their consorts, for whom English equivalents have been used.

Dates in the text are cited according to both the Julian calendar, used in imperial Russia, and the Gregorian calendar, used in the Grand Duchy of Finland. The former was twelve days behind the latter in the nineteenth century and thirteen days in the twentieth. The abbreviations *o.s. (old style) and n.s. (new style) have also been used for clarification when necessary.*

Diamond flowers
Probably Louis David Duval, St. Petersburg, 1780s
Gold, silver, diamonds
Collection of Mr. and Mrs. James M. Vaughn, Jr.
Courtesy of the Houston Museum of Natural Science

Small diamond flowers in various shapes were used as trimmings during the latter part of the eighteenth century. They were either pinned or sewn onto ladies' garments on grand occasions. The nine flowers in the photograph, originally part of the Russian crown jewels, were sold by the Soviet People's Commissariat of Finance at Christie's, London, on March 16, 1927. Altogether, one hundred and ten diamond flowers of the same type were offered at this auction. Fersman describes them as being of three kinds: flowers in full bloom, half-opened, and closed buds. He says that "these three motifs resemble in workmanship some of the pieces of the famous jeweler Duval, who in 1780 was working on diamond jewels of this particular type. Both the design and the character of these pieces allow us to attribute them to this great artist." (Fersman 1925, part III, no. 106, plate LVIII, and no. 216) The flowers have subsequently been adapted as brooches.

Four Empresses

EARLY HISTORY

Sprig of flowers
Unknown maker, late 1770s
Silver, diamonds
The State Hermitage Museum, St. Petersburg

Shortly after the foundation of St. Petersburg in 1703, the first gold- and silversmiths found their way there, setting up workshops in what was still an enormous building site. Peter the Great's new city on the banks of the Neva River grew rapidly. It was proclaimed the Russian capital barely nine years after the first cornerstones had been laid and became the center of court life and the administration.

Most of the St. Petersburg craftsmen during Peter's reign are unknown. They came from various parts of Western Europe, mainly the German principalities, Courland, Livonia, and the Nordic countries. Some of them were prisoners captured by the Russian armies during the Great Nordic War (1700–21), which was fought between Sweden and Russia.

A fair number of gold- and silversmiths from the ancient Kremlin Armory were ordered by the sovereign to move to the new city. There is hardly any information about these masters, but their craftsmanship and skills were legendary from as far back as the sixteenth century.

Peter was an admirer of the Dutch Palladian style and German baroque, and their influence was apparent both in the early architecture and the arts and crafts of his new city. His personal interest was surely one reason why the gold- and silversmiths, who from the very beginning worked along Western lines, got off to a flying start.

But the heyday was yet to come. Between 1725 and 1796, the Russian Empire was ruled by women: Catherine I, Anna Ioannovna, Elizabeth Petrovna, and Catherine II. It therefore comes as no surprise that the art of the goldsmith flourished under this long period of feminine influence.

Little is known about the personal taste of Peter the Great's widow, Catherine I, who ascended the throne for the short period of two years (1725–27), but she did continue Peter's ambition to westernize Russia.

Empress Anna Ioannovna, daughter of Ioann (Ivan) V and niece of Peter I, ruled for ten years (1730–40). She took a great interest in the goldsmith's art, commissioning services and objets d'art in precious metals, as well as sumptuous jewelry, mostly, however, from abroad.

Snuffbox
Jérémie Pauzié, 1740s
Gold, silver, sapphires, diamond, quartz
The State Hermitage Museum, St. Petersburg

Snuffbox
Unknown maker, St. Petersburg, 1750s
Gold, amethyst quartz, enamel
The State Hermitage Museum, St. Petersburg

THE GUILD SYSTEM

In pre-industrial cities, free independent master craftsmen—masons, carpenters, gold- and silversmiths, for example—formed associations, called guilds, based on their trade. In 1714, the foreign goldsmiths of St. Petersburg joined to create a fraternity modeled after the long-established traditions of Europe. As the mother tongue of the majority of the newcomers was German, that language became the official one of the foreign guild. A few years later their Russian counterparts formed their own union. Initially these guilds were unofficial, but were subsequently ratified by the sovereign in 1721 and were maintained until the middle of the nineteenth century. Foreign craftsmen remained in the majority until this time, their number augmented by a continuous flow of new arrivals from almost all corners of Europe. There was a large influx from Finland, which in 1809 had become a grand duchy of the Russian Empire. By the 1870s, one-fourth of all gold- and silversmiths in St. Petersburg were Finnish-born.[1]

Elements of the system (mainly education) continued well into the early twentieth century, long after all restrictions on the pursuit of trades had been abolished. The main goal of the guilds was to oversee the interests of their respective craft, to shape labor and production, and to supervise the training of new generations of craftsmen. They had a governing body consisting of an alderman (a respected master craftsman elected from within the guild), his depu-

ties (typically two master craftsmen), and the members' assembly. Instruction followed a prescribed pattern. An adept (aged ten to eleven) was accepted as an apprentice to a master craftsman. The youngster lived in his household while learning the initial skills of the trade. After six or seven years, and upon producing a qualifying piece of work, judged by a committee within the guild, he was officially granted the title of journeyman and now free to work for other masters in order to gain experience. Journeymen voyages (wanderings) were usual in Western Europe. They were a way of learning new methods, techniques, and the latest styles. As St. Petersburg offered endless possibilities locally, wanderings were therefore unusual for those who resided there. After several years of experience, a journeyman could apply for the right to become a master craftsman. To obtain this rank, he had to produce a master piece, which once again was judged by members of the guild.

The St. Petersburg goldsmiths' guild included, in addition to goldsmiths, silversmiths, who produced objects in that metal; jewelers, who made adornments set with precious stones (алмаз мастер); and finally luxury-goods masters, who produced elaborate objets d'art such as snuffboxes, bonbonnières, and pillboxes, as well as other fancy jeweled items in precious metals (*Galanteriemeister / галантерейный мастер*).

Snuffbox with a medallion
Jean Pierre Ador, 1770s
Gold, silver, diamonds, enamel miniature
The State Hermitage Museum, St. Petersburg

Snuffbox glorifying Empress Catherine II
Johann Gottlieb Scharff, 1776
Gold, silver, diamonds, sapphires
The State Hermitage Museum, St. Petersburg

Snuffbox with a rosette
Jean Pierre Ador, 1782
Gold, silver, diamonds, guilloché enamel
The State Hermitage Museum, St. Petersburg

The reign of Empress Elizabeth Petrovna (1741–62), daughter of Peter I, was characterized by the rococo style in its opulent Russian incarnation. Colored gems were the fashion of the moment, in contrast to the transparent diamonds and white pearls favored in the previous reign. The empress was, like her predecessor, a great lover of jewelry, which she wore in abundance at lavish balls and festivities arranged in her palaces at Tsarskoe Selo and Peterhof. Exquisite examples of her personal jewels have been preserved and are today at the Diamond Fund in Moscow. Precious metals, until this time brought to Russia in the form of bars and coins from abroad, had been discovered in Siberia. Deposits of gold and silver were soon being mined in Ekaterinburg, resulting in an increased and flourishing production of jewelry within Russia.

The art of the St. Petersburg goldsmiths reached its zenith during the reign of Catherine II (1762–96). Hers was the age of gem-encrusted snuffboxes and jewelry in the neoclassic style. Catherine understood perfectly the effect a majestic court, opulent jewels, and stately costumes could produce. She took great pleasure in adornments that manifested her rank as empress and the power of her empire. She was one of the greatest collectors of all time in both scale and quality. Dressed in gala attire, she was truly impressive—her corsage covered in jewels, her skirts strewn with diamond flowers, and her hair decorated with a glittering aigrette.

The foremost jewelers of the empresses came to Russia from abroad. Among them were Gravereaux and Dunckel, court jewelers of Empress Anna Ioannovna; Bernardi, Pauzié, and Pfisterer, favored by Empress Elizabeth Petrovna; and Bouddé, Ador, and Duval, purveyors to Catherine II.

Brooch / Aigrette
Unknown maker, c.1750
Gold, silver, diamonds, emeralds, rubies, sapphires
Courtesy of Christie's

The brooch was purchased by the jeweler S. J. Phillips for £180 at the sale of the Russian state jewels held at Christie's, London, on March 16, 1927. See Fersman 1925, no. 190, plate XCIV, who describes it as an "aigrette in the form of an eagle" and "an elegant example of goldsmith's work."

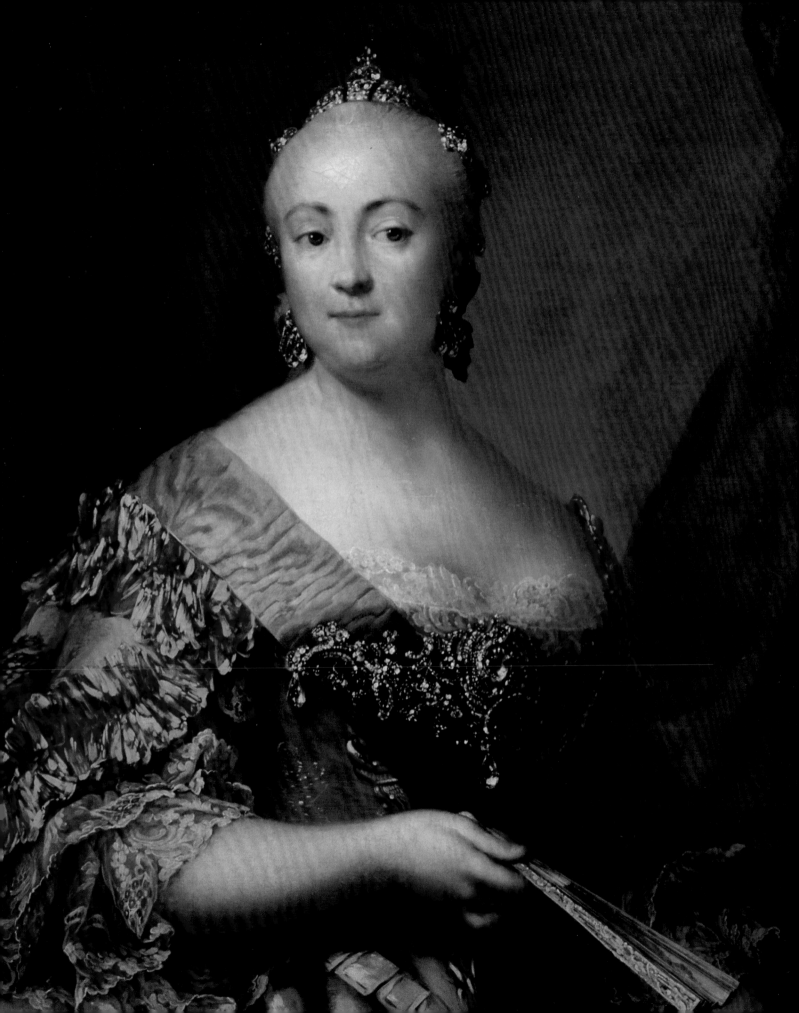

Elizabeth Petrovna
Vigilius Erichsen, 1757
The State Museum-Preserve "Tsarskoe Selo"

The empress wears the light blue sash of the Order of St. Andrew and a magnificent devant de corsage with a large central brilliant-cut diamond and three pear-shaped diamonds pendants. These impressive pieces, worn to emphasize a generous décolletage, were fashionable in the mid eighteenth century. (They were revived in reduced size during the first decade of the twentieth century.) A small diamond crown, flanked by a pair of diamond ornaments and an aigrette, and a pair of girandole earrings complete her elegant parure.

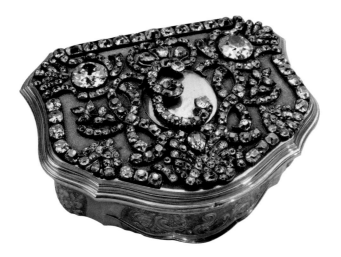

Snuffbox with a diamond monogram
of Empress Elizabeth Petrovna
Jérémie Pauzié, 1750s
Gold, silver, diamonds
The State Hermitage Museum, St. Petersburg

Jérémie Pauzié, a native of Geneva, introduced the French rococo style to Russia, working in close proximity with his patroness. The most exquisite jewels, snuffboxes, and trinkets were created in his workshop. Pauzié explored an entire palette of colors and did not shy away from combining costly precious gems, such as rubies, sapphires, emeralds, spinels, and peridots, with simple decorative stones, such as garnet and agate or even glass. Pauzié was the quintessential St. Petersburg goldsmith: a craftsman from the West, influenced by the court of Versailles, creating jewelry that had distinct characteristics of the environment in which he was working and the personal taste of his august benefactress. The same can be said about the Italian-born Bernardi, who during the 1750s became Pauzié's competitor, and Louis David Duval, with whom he collaborated.

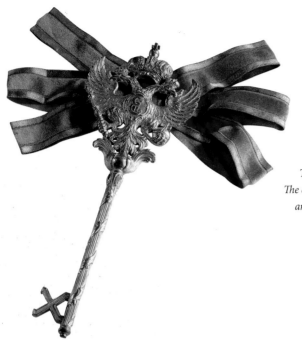

Chamberlain key from the reign of Catherine II
Unknown maker, St. Petersburg, 1762–96
Gilded metal
Courtesy of Christie's

Chère Cousine
Gustav III Visits Catherine the Great

King Gustav III of Sweden visited St. Petersburg for an entire month in the summer of 1777, from June 16 to July 16. His sojourn is well documented in contemporary reports, diaries, and correspondence, and makes fascinating reading. The trip was, as one would expect, full of colorful episodes and events.[2]

The visit came about on the king's initiative. His motives were political; he hoped for a renewed understanding and an alliance with his colossal neighbor to the east. But he was well aware that the empress would not have received him under a political agenda, so Gustav cunningly concealed his intentions under the guise of family affection, a wish to become personally acquainted with his *chère cousine* (Catherine's mother, Johanna Elisabeth of Holstein-Gottorp, was the sister of King Adolf Fredrik of Sweden, Gustav's father). Catherine was hesitant to invite her cousin to St. Petersburg—she did not view him as a trustworthy player on the political stage of the day—but could not very well reject his proposition.

Long before the empress's invitation arrived in Stockholm, the king commenced his preparations for the journey. He commissioned a staggering number of presentation gifts from Paris and took a great deal of time selecting his wardrobe for the occasion. He knew that the Russian court was the most sumptuous in Europe and that the empress had a fondness for diamonds. The Kingdom of Sweden at the time had a rather modest collection of crown jewels. As the king under no circumstances wished to meet Catherine and her court in the role of a poor country cousin, he convinced his mother, the dowager queen, to lend him the contents of her jewel box. He also obtained diamond jewelry on loan from one of his

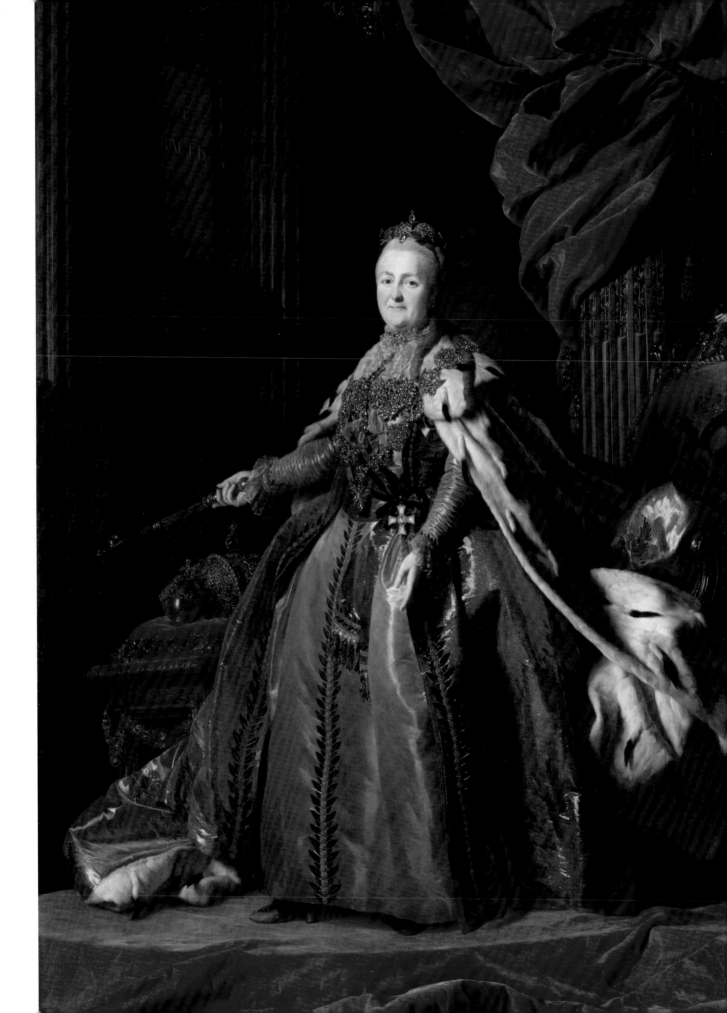

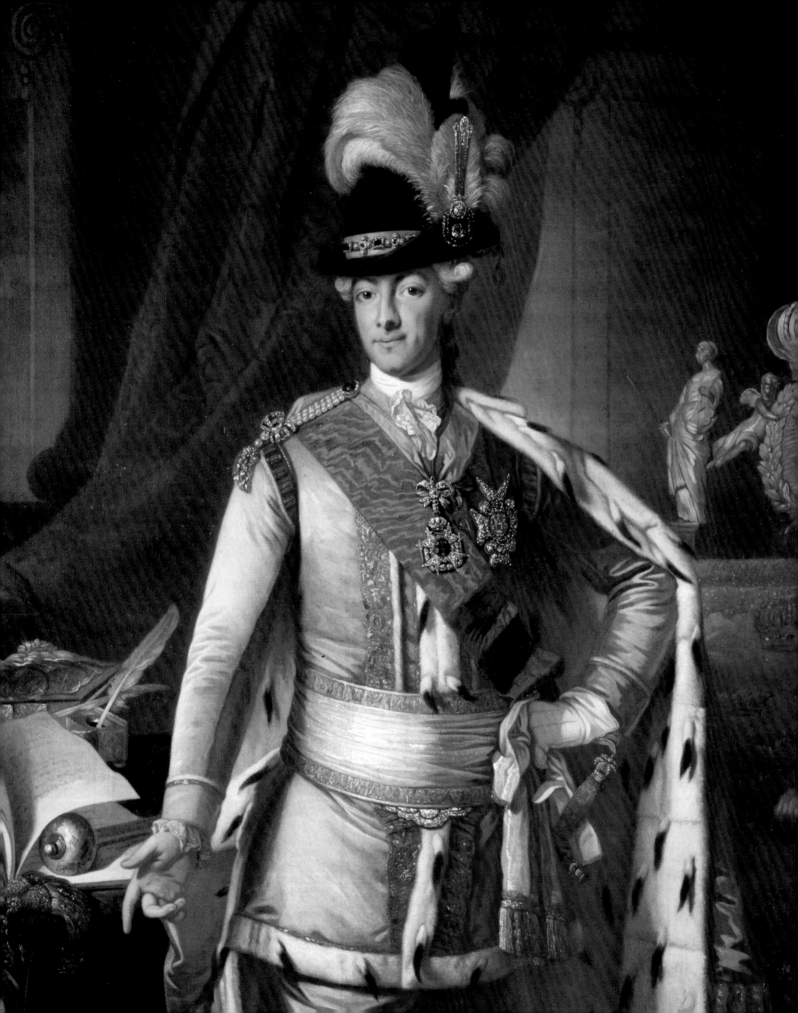

The king can be seen in the ceremonial attire that he wore for many years on important political occasions. It is made of purple silk in the same cut as the Swedish national costume and is decorated with gold lace and ermine. On his left breast he wears the lesser star of the Royal Order of the Seraphim in diamonds, Sweden's highest order; and around his neck, the Royal Order of the Sword surmounted with a diamond bow. On his shoulder is a magnificent epaulette composed of a large sapphire surrounded with diamonds, three strands of pearls, a diamond and sapphire bow, and a diamond tassel. He sports a tall diamond aigrette on his hat, the band of which is ornamented with diamonds and sapphires. Peeking out from under the wide white silk sash is the diamond clasp of the belt attached to the sword worn by the king at his coronation in 1772. The portrait was commissioned in two identical versions. One, painted in 1778, was a gift to the Polish king Stanislas Poniatowski, to be hung in his portrait gallery of contemporary rulers in the royal castle in Warsaw. The other, painted in 1779, was the king's gift to the Prince of Anhalt-Bernburg. According to Lena Rangström, the king possibly wished to impress the empress by presenting his portrait to two persons close to her: Poniatowski, her former favorite, and Anhalt-Bernburg, an important commander of her armies

Ring with the cipher of Catherine II
Unknown maker, 1770s–80s
Gold, silver, chrysoprase, diamonds, enamel
The State Hermitage Museum, St. Petersburg

Stockholm suppliers, the jeweler J. Pehr Suther. The king's preparations were all carried out under the utmost secrecy as there was strong opposition to any association with the Russians in political circles both at home and in France, Sweden's foremost ally. When the news of the trip finally became public, there was an immense outcry in Paris and Stockholm, but the king brushed all protests aside and took off on his escapade.

On June 16, 1777, the squadron of royal Swedish war ships anchored off Kronstadt. The king had insisted that his stay in St. Petersburg be private and unofficial, hence he was received as the Count of Gotland. Gustav was convinced that his personal charm would enrapture the empress. But he was wrong; she was not at all impressed by him. She was aware, however, that politically he still must be reckoned with, and therefore received him with utmost politeness. That in turn awoke his fervor. He totally succumbed to her charismatic personality and reported home to Stockholm that the visit was a great success and the two of them were getting along splendidly.

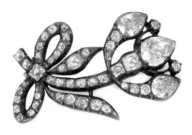

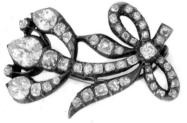

Diamond flowers
Probably by Louis David Duval, St. Petersburg, 1780s
Gold, silver, diamonds
Courtesy of the McFerrin Collection, Texas

From the Russian crown jewels (see page 12).

Brooch
Unknown maker, c.1776
Gold, silver, emerald, diamonds
Courtesy of Christie's

This emerald and diamond brooch was given by Catherine II to her daughter-in-law, Maria Feodorovna, on the occasion of her marriage in 1776 to Grand Duke Pavel Petrovich (future Paul I). It was inherited by their daughter Grand Duchess Maria Pavlovna.

Pendant
Unknown maker, central Europe, late 16th century
Gold, enamel, tourmaline
The Diamond Fund of the Russian Federation, Moscow
Photo: Nikolai Nikolaevich Rakhmanov

The pendant, originally thought to be a ruby, is a 226-carat tumbled tourmaline in the shape of a raspberry. It was possibly booty brought to Sweden during the Thirty Years War and may well have originated from the Kunstkammer of Emperor Rudolf II in Prague. The pendant was named the State Ruby (Riksrubinen) in Sweden. During his visit to St. Petersburg in 1777, King Gustav III presented the jewel to Empress Catherine the Great.

As the trip was not an official one, the king had time to enjoy places of special interest in the "Palmyra of the North." His itinerary brings the admirable side of this Swedish monarch to light. He was a well-educated person, a patron of the arts, and himself proficient in many art forms. In between the many rendezvous with the empress, her gala dinners and fancy balls, Gustav enjoyed the brilliance of the opera and the theaters of the city. He paid visits to the imperial academies of Arts and Sciences, inspected the elite regiments and military institutions, among them the Corps of Pages, and was enchanted by the educational methods for young girls of the nobility at the Smol'nyi Institute. He was received at the Mint, the Mining Institute, the Kunstkamera, and also called on the Swedish court painter Alexander Roslin in his atelier. The artist was working for portraits of the empress, which the august visitor had a chance to admire. The king also made his way to the studios of Falconet, where the monument of Peter the Great was being completed. A visit to the imperial tapestry and porcelain manufactories, in the company of Prince Potemkin, was next on the list. The glazed Chinese-style tile stove he received is today in one of the salons at Drottningholm Castle. He also made several social calls. Prince Grigorii Orlov welcomed him at the palace of Gatchina. It was still under construction, with eight hundred souls at work. An evening with Countess Ekaterina Andreevna Chernysheva was also on the program. The two of them were acquainted from her husband's diplomatic missions in Western Europe.[3]

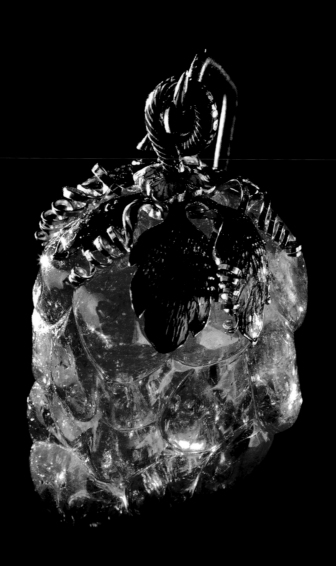

Gustav III realized shortly after his arrival in St Petersburg that the gifts he had prepared for his hostess and her close circle were much too modest and altogether too few. He had brought with him jeweled objects commissioned in Paris valued at 25,000 *riksdaler* (the Swedish currency at the time). The lavish gifts with which he was showered on almost a daily basis naturally needed to be reciprocated. Something drastic had to be done. The St. Petersburg court jeweler Herbst was summoned to the king's apartments at Peterhof. He brought along his stock of merchandise from which Gustav chose additional items: costly watches, snuffboxes, rings, and gold chains. Five thousand gold rubles were allocated for gratuities to the army of imperial servants attached to his service.

But an even greater predicament was in store. On the fifteenth anniversary of her ascension to the throne, Catherine arranged an opulent gala dinner at Peterhof. The king was the empress's honored guest. The party took a brief promenade in the palace gardens after the meal. Catherine was magnificently dressed in gold brocade, jewels, and her diamond chains of the Order of St. Andrew. She leaned on a majestic walking stick, its handle set with a large diamond solitaire and a braid composed of pearls terminating in a pair of tassels set with 450 diamonds. Everybody gazed at it with admiration, including the king. The empress asked her guest what he thought of it. He obviously expressed his delight at being shown such an exquisite object. With an elegant gesture, the empress said it was his to keep.

Reciprocating such a costly gift became a true dilemma for King Gustav. He did not have many days to arrange for something worthy in return. But an idea came to him. He had noticed that the ruby on top of the Russian imperial crown was small and insignificant. Among the Swedish crown jewels there was a large tumbled ruby pendant weighing 226 carats,

the so-called State or Caesar's Ruby. This, in the king's estimation, would be an admirable addition to the Russian regalia. He made arrangements for the stone to be brought to St. Petersburg post haste, knowing full well that he was committing a breach of Swedish law. Not even the sovereign had the right to remove the crown jewels without the consent of the government.

His gifts were to be presented to his hosts on the eve of his departure. Grand Duke Pavel Petrovich was given a costly diamond ring with Gustav's portrait; his wife, a jeweled writing tablet, a so-called souvenir.[4] In proffering his gift to the empress, the king rose from his seat and addressed his *chère cousine* and handed her a jeweled "souvenir" with his portrait. He had written a gallant ode to her on one of the ivory plaques inside. Then he spoke to her about the magnificent State Ruby of the Swedish crown jewels, praised its beauty, and asked the empress if she would like to see it. With a theatrical gesture he fished the jewel from his pocket and placed it in her hand, saying it was hers. She was at first surprised, but soon recovered her presence of mind and accepted the gift.

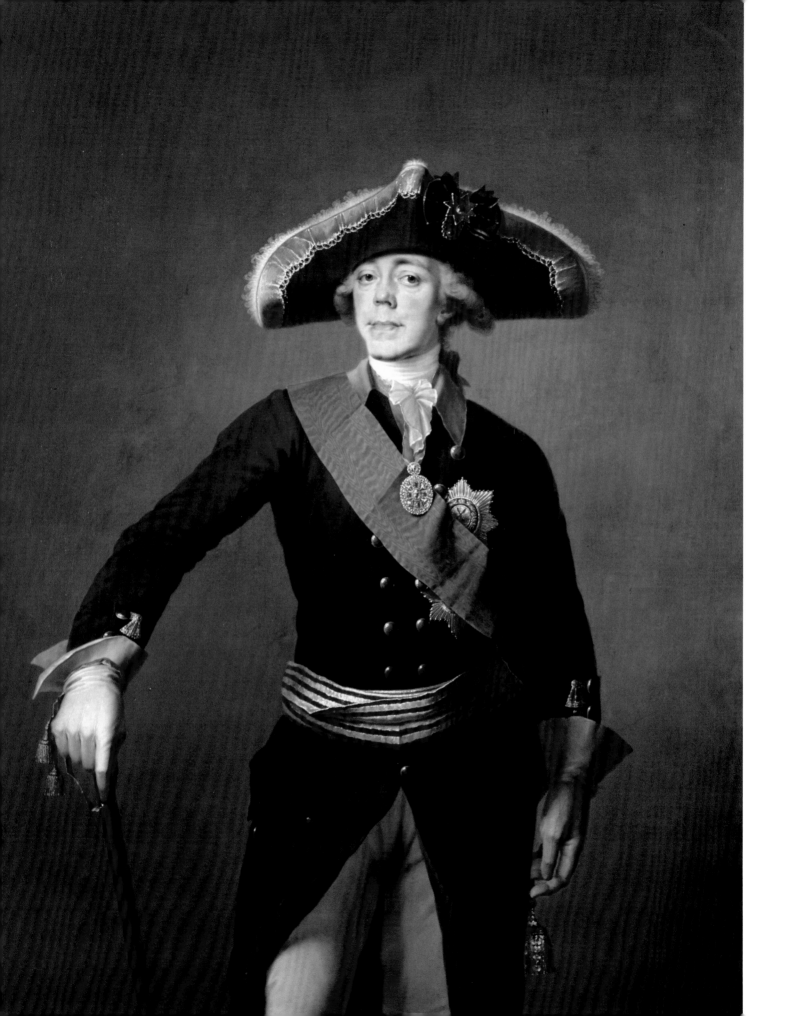

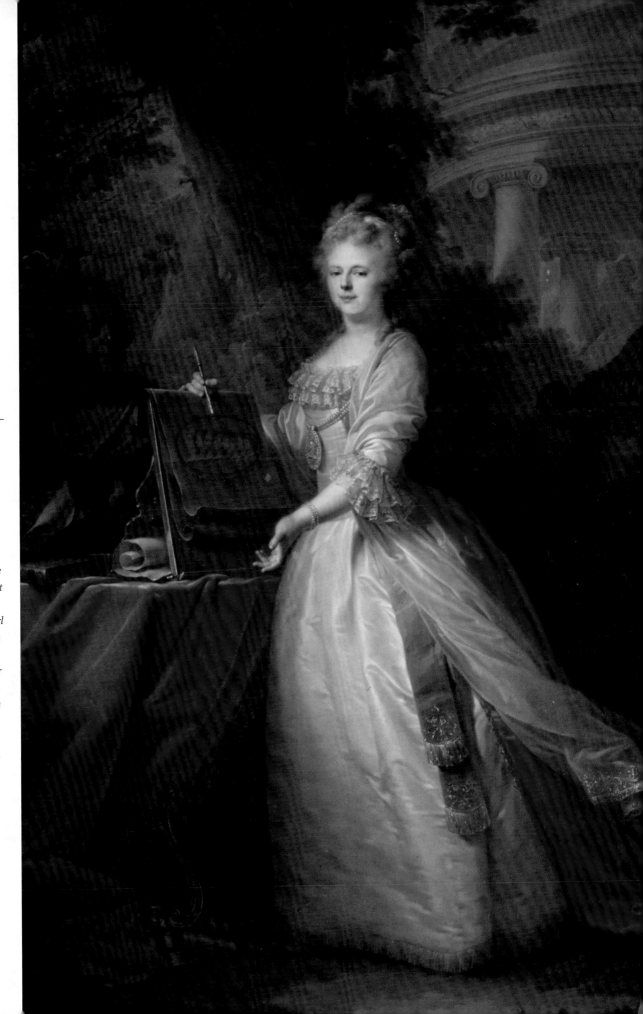

Emperor Paul I
Stepan Semenovich Shchukin,
1797
The State Hermitage Museum,
St. Petersburg

The emperor wears the general's
uniform of the Life-Guards Preo-
brazhenskii Regiment, the blue
sash of the Order of
St. Andrew and the diamond
badge of the Order of St. Anne
around his neck.

Empress Maria Feodorovna
Johann Baptist Lampi the Elder,
1795
The State Museum-Preserve
"Pavlovsk"

The portrait was painted a year
before Maria Feodorovna became
empress of Russia. She had a great
interest in glyptic art and took
lessons in cameo cutting from Carl
Leberecht (1749–1827), who was
an engraver of medals at the
St. Petersburg Mint and a teacher
at the Imperial Academy of Arts.
The agate cameo that hangs from
her necklace was carved by her.
It depicts her mother-in-law,
Catherine the Great, as Minerva.
A drawing for a cameo of the
imperial children that she
was about to execute appears
on the stand.

From Neoclassicism to the Empire Style

PAUL I

1796–1801

The reign of Emperor Paul I coincided with a transition period in the arts and crafts. The neoclassicism of the Louis XVI era gradually gave way to the Empire style, which also made its presence known in the art of the goldsmiths. Emperor Paul I, the son of Catherine the Great, ascended the throne after his mother's death in 1796. His reign was short, only four and a half years. Like his father, his life ended abruptly in conspiracy. If Paul himself did not get a chance to rule the empire, he nevertheless served it well by providing two subsequent able monarchs, his sons Alexander I and Nicholas I.

Paul's second wife was Princess Sophie Dorothee Auguste Louise of Württemberg (1759–1828), who was given the name Maria Feodorovna upon conversion to the Orthodox faith.[5] While still grand duke and grand duchess, Paul and Maria made a grand tour of Europe from 1781 to 1782. In order to underscore the privacy of the trip, and to be free from the strict rules of etiquette that governed official trips and state visits of members of ruling houses, the couple travelled under the name of comte et comtesse du Nord (Count and Countess of the North). Both were interested in history,

Ring with the monogram of Grand Duke
Pavel Petrovich (future Paul I)
Unknown maker, St. Petersburg, 1790s
Gold, silver, diamonds, hair
The State Hermitage Museum, St. Petersburg

The ring is from the personal effects of Empress Maria Feodorovna, consort of Paul I.

geography, literature, and the arts. They were fluent in German and French, and Paul had a good knowledge of Latin.

They traveled to Kiev, then through Poland to Vienna, thereafter to Italy, with stops in Trieste and Venice en route to Naples. They climbed Vesuvius and saw the excavations in Pompeii and Herculaneum in the company of the English envoy Sir William Hamilton, who in his private life was a connoisseur, amateur archaeologist, and an active spokesman for the excavations. From Naples the visitors journeyed to the eternal city and made a courtesy call at the Vatican. The Villa d'Este in Tivoli was also on the program, thereafter Frascati with its famous Renaissance and baroque villas. The trip continued to Livorno, Pisa, Florence, Parma, and Milan. The imperial couple visited Lyon and Dijon en route to Paris and Versailles. They enjoyed the sights of Paris for nearly thirty days and then proceeded to Chantilly, Orleans, Tours, Angers, Nantes, Le Mans, Rouen, Amiens, and Lille. Thence they made their way to Ghent, Brussels, Spa, Düsseldorf, and Frankfurt. The parents of the grand duchess received the young couple at their summer palace, Étupes, in the vicinity of Montbéliard. After a month-long stay with the family came a visit to Besançon, Lausanne, Bern, Basel, and Karlsruhe. The route home took them through Brno, Krakow, and Riga. A total of 190 days were spent travelling.

At every stop they met with important artists and artisans, as well as with members of the cultural elite. The valuable contacts that were made during this trip came to be of great importance, not only for the imperial couple themselves, but for St. Petersburg as a whole. The latest Western-European artistic trends found their way to the Russian capital as a direct result of this voyage. Substantial and important commissions and acquisitions of art and antiques were made wherever they stopped. Much of these were used in the decoration of their new palace of Pavlovsk on the outskirts of St. Petersburg.

Purchases of jewels on this trip are not recorded, but the couple no doubt familiarized themselves with the latest trends. The jewelry made by their favorite goldsmiths, the Duval brothers, for the trousseaus of their daughters bear witness to their European tastes. Furthermore, Maria Feodorovna herself had displayed a keen interest in glyptic art and successfully tried her hand at cameo cutting. No doubt the antiquities she had seen and collected during her grand tour served as inspiration.

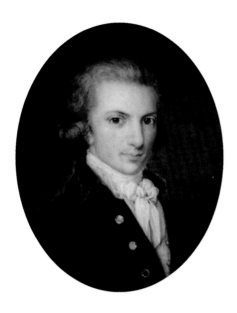 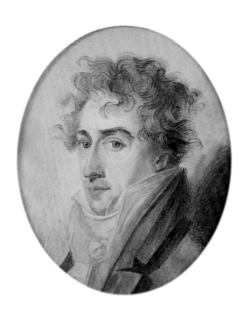

Jacob David Duval
Gerhard von Kügelgen, 1799
Courtesy of Christie's

Jean François André Duval
Domenico Bossi, 1806
Boris Wilnitsky Fine Arts, Vienna

THE DUVAL FAMILY OF JEWELERS AND THE DOWRIES OF THE YOUNG GRAND DUCHESSES

The Duval family had held a special position among St. Petersburg's jewelers since the reign of Empress Elizabeth Petrovna. The workshops of the family were founded in 1754 by Louis David Duval, born in Geneva in 1727. As a young man he had worked in commerce in London, together with his brothers, but decided to try his luck in St. Petersburg, where he moved in 1745. His business contacts both in England and Switzerland helped him to establish himself in the Russian capital. A decade later, he was a successful dealer in precious stones and luxury objects and soon expanded his activity to creating jewelry and objets d'art. He became a partner of Empress Elizabeth Petrovna's favorite jeweler, Jérémie Pauzié, who also heralded from Geneva. This association opened doors at the imperial court. When Pauzié left St. Petersburg in 1764, Duval's preeminence became indisputable, and Catherine II appointed him her personal jeweler. He worked for her for two decades, producing much of the splendid jewelry for which his sovereign was so widely admired.

Louis David's two sons Jacob David (born in Moscow in 1768) and Jean François André (born in St. Petersburg in 1776) both trained as goldsmiths. Although only twenty years old at his father's death in 1788, Jacob David was poised to take over the family business. He called the workshop Duval & fils in honor of his father.[6] His younger brother joined the firm some ten years later, and in 1793, the two of them were working under the name Duval frères.

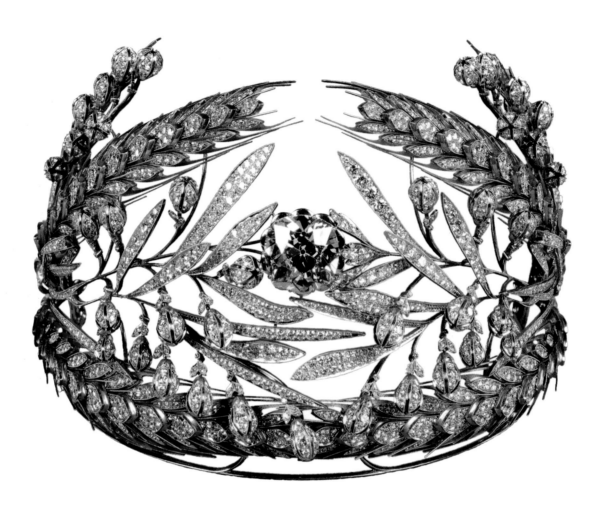

"Russian Field" Tiara
Viktor Nikolaev and Gennadii Aleksakhin, Moscow, 1980
Platinum, gold, silver, diamonds
The Diamond Fund of the Russian Federation, Moscow
Photo: Nikolai Nikolaevich Rakhmanov

This tiara is a copy of the one made by Duval for Empress Maria Feodorovna and sold by the Soviet Government in 1929.

Jacob David, like his father, also won the personal confidence of the empress and was appointed her personal jeweler. At her death in 1796, Paul I continued to use his services and gave him the additional honor of "crown jeweler with the rank of civil colonel."[7] Having worked for fifteen years in the business, Jacob David left St. Petersburg for Geneva, the home of his ancestors, apparently "at the wish of his father."[8] The year was 1803. He continued his professional life as a deputy of the Conseil Représentatif (D.C.R.) from 1814 to 1841, and for fourteen years was a member of the Chambre des comptes and the Société Économique. He married Bonne Alexandre, of Metz, in 1790, and had four children, none of whom became jewelers.[9] Jacob David died in Geneva in 1844.

The younger son of Louis David Duval, Jean François André, became head of the firm at the departure of his older brother in 1803. In 1817, at the age of forty-one, he also left St. Petersburg for Geneva, where, like his brother, he became a deputy of the Conseil Représentatif from 1818 to 1842. He was a talented amateur painter and a collector of art. He married the daughter of the artist Wolfgang Adam Töpffer in 1821. He and his wife Ninette had eight children, but again, none became jewelers. Jean François André died in Geneva in 1854.

The departure of the two Duval brothers from St. Petersburg did not end their collaboration with the Russian imperial court; they continued their work from Switzerland. Whether they ever revisited the Russian capital is not known, but they continued to receive important commissions from the Cabinet of His Imperial Majesty throughout the reign of Alexander I and into that of Nicholas I. The last orders noted in archival documents are from 1837.[10] It is not known whether the Duval brothers set up a new workshop in Geneva or if they handled these commissions with the help of independent craftsmen.

It is difficult to estimate the extent of Duval's production during their impressive career in St. Petersburg. Fine examples of their work have survived in the State Hermitage Museum in St. Petersburg, the Diamond Fund in the Moscow, royal collections of Europe, and private hands in the United States. Only a few pieces are signed or documented in archival sources. Much is identified as theirs through style and technique.

An important part of Duval's work between the years 1799 and 1816 consisted of producing jewels for the dowries of the five daughters of Paul I. Two of them, Aleksandra (1783–1801) and Elena (1784–1803), were married in 1799. Their father was still alive at the time, and it goes without saying that he commissioned his court jeweler to create the pieces to be included in their *corbeilles de mariage*. The lists made for both grand

Pendant of Empress Maria Feodorovna
Duval frères, St. Petersburg, 1790s
Gold, glass, hair, foil, enamel
The State Hermitage Museum, St. Petersburg

The small pendant is inscribed on the reverse "Souvenir de ma chère fille Alex Paul." As Alexandra was the first of her daughters to marry abroad, this sentimental piece expresses her mother's feelings.

Sprig of lilies of Grand Duchess Aleksandra Pavlovna
Duval, 1790s
Silver, gold, pearls, diamonds, chrysolites, glass
State Hermitage Museum, St. Petersburg

The lily is number 15 on the list of jewels she received when she married in 1799.

duchesses have survived and serve as an important record of jewelry fashions at the turn of the eighteenth century.

The dowry of a Romanov bride was a matter decided upon by her father (or her oldest brother if her father be deceased), whereas the practical details were handled by the Cabinet of His Imperial Majesty. The value of the jewelry in the trousseau of Paul I's daughters was a staggering 600,000 rubles, a sum of money not readily available even for an emperor of Russia. Empress Maria Feodorovna, being a practical woman, is known to have initiated a new system with regard to the planning and financing of the dowries for the younger daughters of the family so that the funds did not have to be raised at a moment's notice. Her idea to put aside a sum of 30,000 rubles per year for this purpose was accepted and thereafter employed for all brides in the Romanov family.[11]

In 1799, Paul I arranged the marriage of his oldest daughter, Aleksandra, to Archduke Joseph of Austria, a younger brother of Emperor Franz II. He was palatine (governor) of Hungary. The nuptials took place in St. Petersburg in October of that same year. Aleksandra was only sixteen at the time. She had previously been engaged to King Gustav IV of Sweden, but her Orthodox faith became a problem for the Swedes and the engagement was annulled.

Aleksandra was not happy in her marriage. The young bride bore an astonishing likeness to her maternal aunt, Duchess Elisabeth of Württemberg, the first wife of Emperor Franz II. Empress Maria Theresia, his second wife, was most likely resentful towards the young newcomer for this simple reason. The empress was both envious of her beauty and of her magnificent jewels, which outshone her own. Aleksandra was therefore not allowed to wear hers at official functions.

A year after her wedding, Aleksandra gave birth to a stillborn daughter, and herself died shortly after. Her dowry, including her jewelry, was returned to the Cabinet of His Imperial Majesty in St. Petersburg. Many of the pieces were later included in the trousseaus of her youngers sisters Maria, Ekaterina, and Anna.

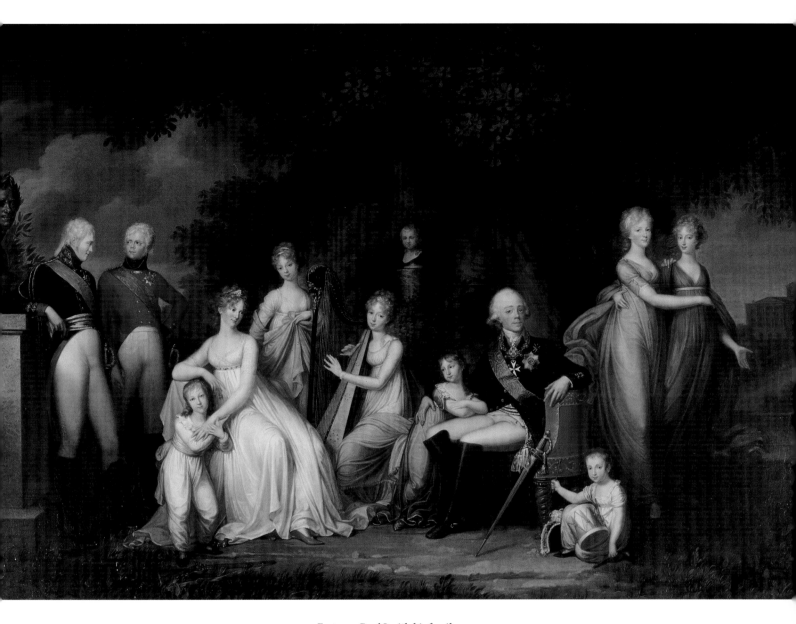

Emperor Paul I with his family
Gerhard von Kügelgen, 1800
The State Museum-Preserve "Pavlovsk"

From left to right: Aleksandr Pavlovich (1777–1825), future Emperor Alexander I; Konstantin Pavlovich (1779–1831), future viceroy of Poland; Nikolai Pavlovich (1796–1855), future Emperor Nicholas I; Empress Maria Feodorovna (1759–1828); Maria Pavlovna (1786–1859), future Grand Duchess of Saxe-Weimar-Eisenach; Ekaterina Pavlovna (1788–1819), future Queen of Württemberg; Anna Pavlovna (1795–1865), future Queen of the Netherlands; Emperor Paul I; Mikhail Pavlovich (1798–1849), future inspector general of the Engineers; Aleksandra Pavlovna (1783–1801), future Archduchess of Austria; and Elena Pavlovna (1784–1803), future Hereditary Grand Duchess of Mecklenburg-Schwerin. The bust in the middle of the painting depicts Grand Duchess Ol'ga Pavlovna (1792–1795).

Next page: The list of jewelry in Grand Duchess Aleksandra Pavlovna's dowry, which is in the Russian State Historical Archive in St. Petersburg, has kindly been communicated by Galina Korneva and Tatiana Cheboksarova. It has been translated from the Russian by Timothy F. Boettger.[12]

List of the jewels of Grand Duchess Aleksandra Pavlovna

Register.

Jewelry belonging to Her Imperial Highness the late Sovereign Grand Duchess Aleksandra Pavlovna Arch Duchess of Austria.

	No.		Value. Rubles	
1	1.	Star in brilliants of the Order of St. Catherine.	4500.	Used in 1803 in the dowry of Her Highness Grand Duchess Maria Pavlovna.
	2.	Epaulette in brilliants.	4500.	Used in 1809 in the dowry of Her Highness Grand Duchess Ekaterina Pavlovna.
	3.	Medallion with the portrait of Empress Catherine the Second and encrusted with brilliants.	2,200.	y.
2	4.	Rivière of 31 brilliants. There remain 14 brilliants valued at 14,391 rubles.	48,000.	Used in 1803 in the dowry of Her Highness Grand Duchess Maria Pavlovna. 17 brilliants valued at 33,609 rubles.
3	5.	639 brilliants in collets. There remain 352 brilliants in collets, at 17,786 rubles 25 kop.	43,000.	Used in 1803 in the dowry of Her Highness Grand Duchess Maria Pavlovna 100 brilliants at 9000 rubles, and in 1809 used in the *esclavage* made as gift for Her Highness Grand Duchess Ekaterina Pavlovna on the day of Her marriage 187 brilliants at 16213 rubles 75 kop.
	6.	Pair of clasps for bracelets in brilliants.	6500.	y.
	7.	Watch in brilliants with the cipher of Empress Catherine the Second made of small rubies.	7000.	
	8.	Pair of earrings in brilliants with pendeloques.[13]	37000.	y.
	9.	Pair of earrings of a lesser size.	4400.	y.
4	10.	Large agraffe.	24000.	Used in 1803 in the dowry of Her Highness Grand Duchess Maria Pavlovna.
	11.	*Esclavage* with pendeloques and small chains of large rose-cut diamonds and brilliants, and at the end thereof a diamond of Eastern faceting in the form of a pendeloque.[14]	38000.	y.
5	12.	Bouquet in brilliants with pendeloques of which two pendeloques are deficient	21000.	Used in 1803 in the dowry of Her Highness Grand Duchess Maria Pavlovna.
6	13.	Sprig consisting of 3 branches joined at the base by a knot with 12 diamond pears of Eastern faceting and 9 brilliant pendeloques encrusted with small brilliants.[15] There remain 17,280 rubles.	18000.	Used in 1804 to encrust a comb made as a gift for Her Highness Grand Duchess Maria Pavlovna on Her name day at 720 rubles.
	14.	Agraffe in brilliants for a belt.	20000.	Used in 1809 in the dowry of Her Highness Grand Duchess Ekaterina Pavlovna.

	15.	Lily flower with brilliants and rubies.	3600.	Used in 1809 in the dowry of Her aforementioned Highness.	
	16.	Seven flowers in brilliants.	11,600.		
7	17.	Gold fan with brilliants.	3700.	Used in 1803 in the dowry of Her Highness Grand Duchess Maria Pavlovna.	3.
	18.	Cross consisting of six brilliants.	300.		
	19.	Small medallion with the portrait of Empress Catherine the Second.	600.	*y.*	
	20.	Watch with green enamel set with small rubies and brilliants, of which the enamel and hands are damaged and a few stones are deficient.	200.		
	21.	Turquoise ring in the shape of a heart, encrusted with brilliants.	500.		
	22.	Wheel of the Order of St. Catherine.[16]	2600.	Deposited in the apartment of Her Highness Grand Duchess Anna Pavlovna in the month of February 1816.[17]	
	23.	Parure with emeralds and with brilliants. having: An *esclavage*. A pair of earrings A pair of bracelets. Three flowers One aigrette. A belt agraffe. A ring with a round emerald in the form of a basket. A collet with an emerald.	38000. 36200[18]	*y*	
	24.	Parure with red telesia and with brilliants. having: An *esclavage*. A pair of earrings. A pair of bracelets. A bandeau. Three flowers. A belt composed of rubies. A belt agraffe composed of 2 oval medallions made of papier-mâché cameos.[19]	43,000.	Presented in the month of January 1806 to Her Highness Grand Duchess Anna Pavlovna.	4.
	25.	Parure of filigree work with papier-mâché and brilliants. having: A large *esclavage*. A bandeau. A belt agraffe with small chains. A pair of earrings. One necklace. Two bows. A pair of large bracelets. A pair of bracelets of lesser size.	8000.		

	26.	Parure of filigree work with aquamarines and with brilliants. having: One necklace. A pair of earrings. A pair of bracelets. A bandeau. One belt composed of 5 pieces. [illegible annotation]	16,000. 8800		
8	27.	Parure with amethysts and with brilliants. having: A necklace. A pair of earrings. Two flowers. One aigrette. There remain 2 flowers, at 1800 rubles.	10,000.	Used in 1803 in the dowry of Her Highness Grand Duchess Maria Pavlovna: Rubles A necklace at 2400. A pair of earrings at 1700. An aigrette at <u>4100.</u> Rubles 8,200.	5.
	28.	Parure of filigree work with amethysts and with brilliants. having: A necklace. A pair of earrings. A pair of bracelets. A one-piece belt with two small chains and a buckle. A bandeau. A large chain with two other small end chains.[20]	17000.		
9	29.	Parure of pearls. having: [illegible annotation] 544 large pearls. [illegible annotation] 2249 seed pearls. Two strings, one esclavage, and a pair of bracelets having 493 pearls. Pair of earrings with 2 large pear-shaped pearls and with brilliants. [illegible annotation]	58,000.	Used in 1803 in the dowry of Her Highness Grand Duchess Maria Pavlovna 236 grains on a string valued at 30,000 rubles. 1816 in the month of February deposited in the apartment of Her Highness Grand Duchess Anna Pavlovna at 18200 rubles. These earrings valued at 9800 rubles were presented in 1802 to Her Highness Grand Duchess Maria Pavlovna.	
	30.	Parure with blue telesia and with brilliants. having: A large *esclavage*. A necklace. A pair of earrings. A pair of bracelets. One sprig. A diadem.	66000.	Presented to Her Highness Grand Duchess Ekaterina Pavlovna on Her name day 24 November 1806.	
	31.	Belt agraffe with 2 large labradorites.	200.		
	32.	Gold fan.	800.		6.
	33.	Pair of labradorite earrings with brilliants.	800.		
	34.	Ring with a small turquoise encrusted with brilliants.	50.		

No.	Description	Rubles	Annotation
35.	Breloque in the shape of a small egg set with rose-cut diamonds, the enamel of which is damaged.[21]	50.	
36.	Small ring with the cipher of Their Imperial Majesties.	70.	
37.	Gold vase with red enamel, set with rose-cut diamonds, the enamel of which is damaged.	150.	
38.	Necklace consisting of ten large and twenty-seven small antique cameos.[22]	12000.	*y.*
39.	Sprig in brilliants. [illegible five-line annotation]	28000. 25612	Broken up in 1804 and the brilliants removed and used: 1) in an esclavage and in a comb made for Her Highness Grand Duchess Maria Pavlovna at 25612 rubles, 2) in 1809 in the dowry of Her Highness Grand Duchess Ekaterina Pavlovna at 888 rubles, and kept out for design work 1500 rubles.[23]
40.	Three gold medals.	380.	
41.	Gold medallion set with small brilliants, with the hair of the Sovereign Emperor Alexander Pavlovich.	300.	

Total	Rubles 600,000
Of the other pieces used for Their Imperial Highnesses the Grand Duchesses at	Rubles 346,642 kop. 75.
After which remain	Rubles. 253,357. kop. 25.

In addition to this:

Seven gold crosses	Rubles. 56.	
Three gold watches and two chains	600.	
Two aquamarine cane handles	100.	
Three brilliants totaling $4^{23}/_{32}$ carats	300.	
One triangular rose-cut diamond totaling 3⅝ carats.	200.	
Seventeen amethysts.	250.	
Pieces of gold, at	150.	Rubles 1656

All pieces remaining, at	Rubles. 255,013. kop. 25.

Filigree and cameo parure of Grand Duchess Aleksandra Pavlovna
Duval frères, St. Petersburg, 1799
Gold, silver, diamonds, papier-mâché, glass
The State Hermitage Museum, St. Petersburg

The parure is number 25 on the list of jewels she received when married in 1799.

__Ring of Grand Duchess Aleksandra Pavlovna__
Duval, 1796
Gold, turquoise, diamonds
The State Hermitage Museum, St. Petersburg

The ring is number 21 on the list of jewels she received when married in 1799.

The magnificent precious stones and pearls came from the stock of the Cabinet of His Imperial Majesty. It is interesting to note that most of the jewels were especially designed and made for the young bride; in other words, very few pieces were heirlooms from previous reigns. The importance of the bride's grandmother Catherine the Great is emphasized by the pieces bearing her miniature portrait. The empress is known to have cared very dearly for her many grandchildren.

Among the extant jewels of Grand Duchess Aleksandra Pavlovna made by Duval frères is a parure of gold filigree work with diamonds and papier-mâché cameos, number 25 on the list. It consists of an *esclavage*, a bandeau, a belt agraffe, a pair of earrings, a necklace, two bows, and two pairs of bracelets. The cameos were made by Empress Maria Feodorovna herself, who undoubtedly wished to give her oldest daughter a personal memento.

A modest piece, more or less a souvenir, has been preserved from the personal jewel box of Empress Maria Feodorovna: a rectangular gold pendant decorated with a dainty bouquet made from a lock of her daughter Aleksandra's blond hair. This delightful piece was also made in the Duval workshops in the 1790s. It sheds light on the tastes of the day to a higher degree than the state jewelry that the imperial ladies wore at official functions.

A pink topaz and diamond parure, now in the royal collection of Sweden, is one of the most exquisite examples of Duval's work (see pages 44–45). It was commissioned by Dowager Empress Maria Feodorovna from Jean François André Duval and completed by him on September 13, 1811. The papers in the dowager empress's personal chancellery contain the following passage, "September 13, 1811…An assortment in Topazes and Brilliants."[24] A diary entry she wrote on September 27 at Pavlovsk reads, "I'm leaving my beautiful Ferma on 27 September almost immediately after receiving the joyous news that my dear, kind Maria delivered a second granddaughter, for which I genuinely thank the Creator. God save my good children and grandchildren, bless them, make them happy, especially Aleksandr, and allow me to return here with all the children happy and

The Order of St. Catherine
Unknown maker, 1780s
Gold, silver, diamonds, rubies, enamel
Photo: Nikolai Nikolaevich Rakhmanov

On the left is the diamond and ruby half-wheel hat ornament of the ceremonial costume of the order. It symbolizes the spiked breaking wheel upon which the legendary fourth-century St. Catherine of Alexandria was condemned to be tortured by Emperor Maxentius. See numbers 1 and 22 on the list of jewels received by Grand Duchess Aleksandra Pavlovna; numbers 3, 4, and 6 on the list of Grand Duchess Elena Pavlovna; and numbers 1 and 2 on the list of Grand Duchess Anna Pavlovna.

healthy."[25]

Grand Duchess Maria Pavlovna was married to Hereditary Grand Duke Karl Friedrich of Saxe-Weimar-Eisenach, and the happy young mother received her gift shortly after having given birth to her second daughter Augusta Louisa Katherina. The pink topaz was for the Russians a symbol of "happy days spent together." This sentimental gift reminded the young grand duchess of her childhood in beloved Mother Russia. It was certainly an appropriate choice for the birth of a new member of the family.

The set consists of a necklace, a corsage ornament, and a *fermoir* made in gold. The settings for the topazes and the diamonds are made of silver, which was the only "white" metal in use at the time. The seventeen topazes had been brought to Russia from Brazil. It is a story in itself as to how the overseas gem trade was pursued. Russia, although rich in minerals and metals, had yet to discover its wealth in precious stones.

The topazes used by Duval in this set are not uniform in color or cut, but this diversity only adds to its overall interest. It was typical in St. Petersburg for gemstones not to be dogmatically calibrated. The central drop-shaped topaz of the necklace is fashioned as a briolette, with small facets across the entire surface of the stone. The total weight of the diamonds is approximately one hundred carats. They are fashioned in various shapes, the majority being brilliant cut. Minute rose-cut diamonds encircle each topaz—a typical St. Petersburg feature—enhancing the color of the topazes and lending an extra air of elegance. In the girandole-style corsage ornament (originally having three pendant drops, two of which in modern times have been reworked as earrings) is an element of the Empire style: the large triangular diamond with branches of laurel in diamonds on either side, reminiscent of Roman chaplets.

Another exquisite set, similarly set with pink topazes and diamonds, has survived. See pages 28–29. It consists of a necklace and a pair of earrings and was also commissioned from the jeweler Jean François André Duval. It was completed in 1818, in time for a trip in November that same year which Dowager Empress Maria Feodorovna took to Weimar once again to visit with her daughter Maria. She brought the parure as a gift for her then

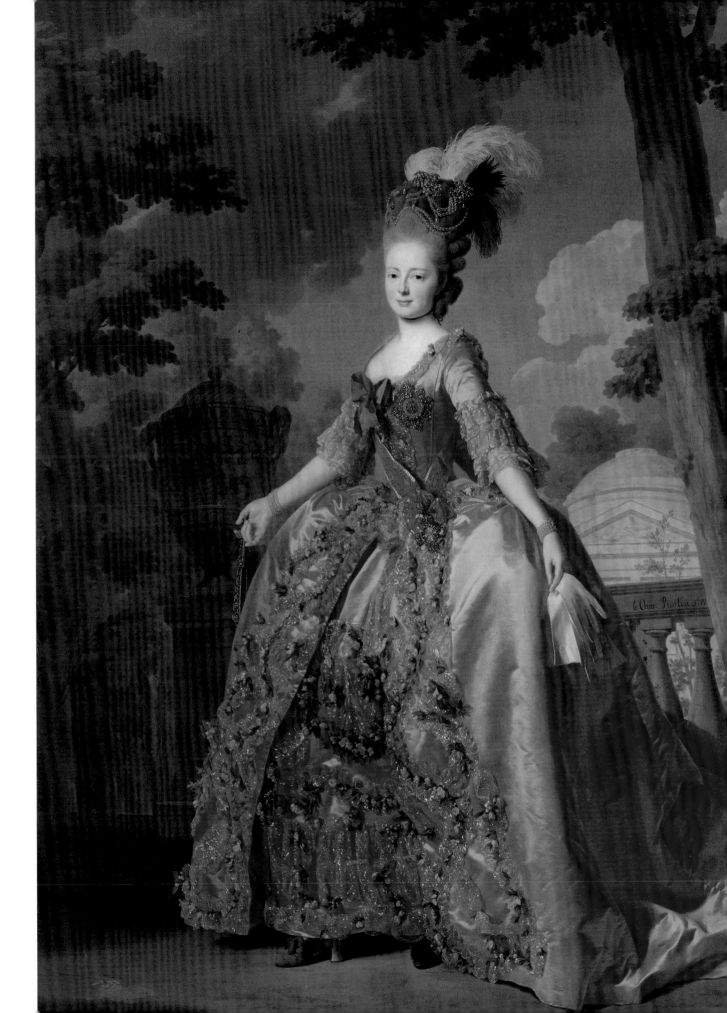

le Chev. Roslin 1777

Parure of Grand Duchess Maria Pavlovna
Duval frères, St. Petersburg, 1811
Gold, silver, pink topazes, diamonds
Courtesy of the Bernadotte Foundation, Stockholm

The set was a gift by Dowager Empress Maria Feodorovna to her daughter Maria on the occasion of the birth of her second daughter, Augusta. It was inherited by Augusta (1811–1890), later Queen of Prussia and Empress of Germany. She passed it on to her daughter Luise (1838–1923), Grand Duchess of Baden, who in her turn bequeathed it to her daughter Viktoria (1866–1929), Queen of Sweden.

seven-year-old granddaughter Augusta.[26] It no doubt became a symbol of the happy days the child spent with her grandmother. The entry at the State Historical Archives in St. Petersburg states that the price of the suite came to 1,600 rubles.

A complete list of the jewels Grand Duchess Maria Pavlovna received as part of her dowry has not survived, but scanty information on what she brought to Weimar following her marriage in 1804 can be gleaned from the list of her older sister Aleksandra. Numbers 1, 4, 5, 10, 12, 13, 17, 27, 29, and 39, which had been returned to St. Petersburg after Aleksandra's death, were restored and included in Maria's trousseau. She received 17 brilliant-cut diamonds valued at 33,609 rubles from the diamond rivière (4), 100 brilliant-cut diamonds in collets (5), and the necklace valued at 2,400 rubles, the earrings valued at 1,700 rubles, and the aigrette valued at 4,100 rubles from the amethyst and diamond parure (27).

Grand Duchess Elena (1784–1803) was the second daughter of Paul I and Maria Feodorovna. She was married in St. Petersburg in 1799 to Hereditary Grand Duke Friedrich Ludwig of Mecklenburg-Schwerin (1778–1819), eldest son of Grand Duke Friedrich Franz I. The union was a happy one. Two of her great-granddaughters, Princess Elisabeth of Saxe-Altenburg and Marie of Mecklenburg-Schwerin, married Russian grand dukes, the former Grand Duke Konstantin Konstantinovich and the latter Grand Duke Vladimir Aleksandrovich.

The dowry of Grand Duchess Ekaterina Pavlovna (1788–1819), who in 1809 married Duke Georg of Oldenburg, has not been traced, but details of her jewelry can be found in the archival documents of her oldest sister Aleksandra. Numbers 5, 14, 15, 30, and 39, were passed on to her. Among others, she received 187 diamonds in collets (5) valued at 16,213 rubles and 75 kopecks.

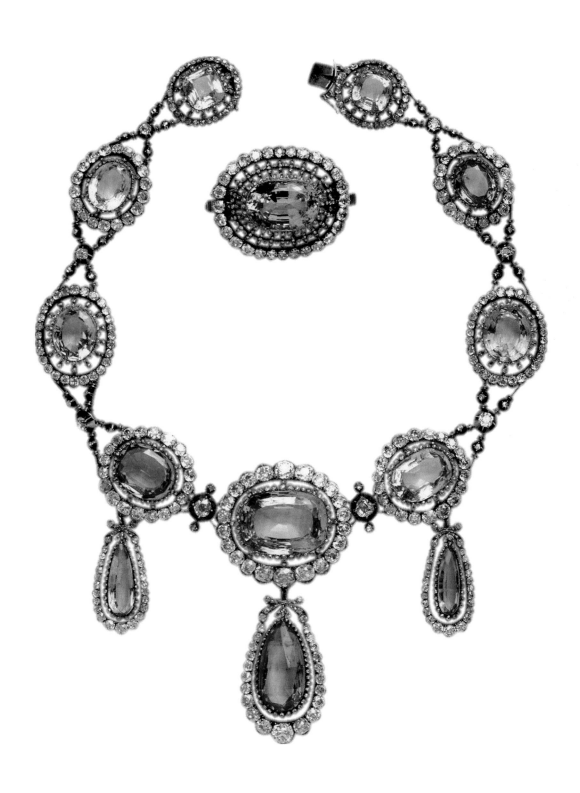

List of the personal belongings of
H.I.H. Grand Duchess Elena Pavlovna, 1799

The list of jewels received by Grand Duchess Elena Pavlovna (pages 27–33 of the trousseau) has survived in the archive in the Lande-shauptarchiv Schwerin and has kindly been communicated by Alexander von Solodkoff.[27]
It has been translated from the French by Timothy F. Boettger.

Jewels	Pieces	Jewels	Pieces
1. Medallion with the portrait of His Majesty the Emperor	1	Aigrette "*en Sultanne*"	1
2. Bracelets for the upper arm	1 pair	Bandeau	1
3. Order of St. Catherine in brilliants	1	Belt Buckle	1
4. Star of the same Order	1	Large Flowers	2
5. Epaulette in brilliants	1	24. Parure in Emeralds and Brilliants	
6. Wheel of the Order of St. Catherine	1	Large *Esclavage*	1
7. Rivière of large brilliants	1	Necklace	1
8. Brilliants mounted in collets	407	Earrings	1 pair
9. Earrings in brilliants	1 pair	Bracelets	1 – –
10. A heart of a large brilliant pendeloque	1	Belt Buckle	1
11. Bracelet clasps in brilliants	1 pair	Aigrette "*en Sultanne*"	1
12. Watch and chain in brilliants	1	Flowers	3
13. Medallion with the portrait of Her late Majesty the Empress	1	25. Parure in Opals and Brilliants	
14. The same, smaller	1	A Necklace and earrings, Bandeau, and a *Fermoir*	4
15. Large bouquet in brilliants	1	26. Parure in Rubies and Brilliants	
16. Flowers in brilliants	4	Necklace	1
17. Leaves in brilliants suitable for forming a garland	20	Earrings	1 pair
18. Agraffe in brilliants	1	Cherry branch in the form of a garland	1
19. Aigrette	1	Bracelets	1 pair
20. Rivière in brilliants	1	Flowers	4
21. Ears of wheat	6	27. Parure in Amethysts and Brilliants	
22. *Esclavage* in brilliants	1	Necklace	1
23. Parure in Sapphires and Brilliants		Earrings	1 pair
Large *Esclavage*	1	Large flowers	3
Bracelets	1 pair	A bandeau	1
Earrings	1 – –	Bracelet clasp	1
		A large Agraffe	1

46

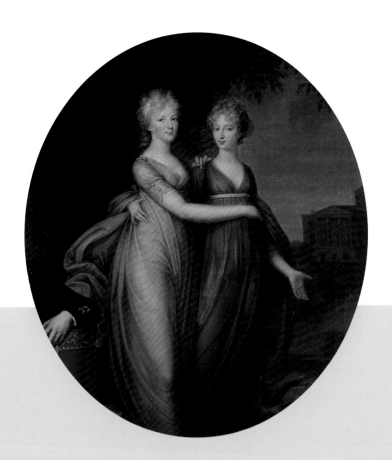

Grand Duchesses
Aleksandra and Elena
Detail of the painting on page 35.

Jewels	Pieces
28. Parure in Pearls	
Agraffe having 157 large pearls and 149 small and two pendeloques	1
String having 27 large & 26 small pearls	1
Bracelets having 128 large et 120 small pearls, the clasps in brilliants	1 pair
Earrings in pearls and brilliants	1
Pearls	324
Seed pearls	2248
Strings of Pearls having large Pearls	4
29. Parure in Aquamarines and Brilliants mounted in Filigree Work	
A large chain	1
Necklace	1
Earrings	1 pair
Bandeau	1
Bracelets for the upper arm	1 pair
30. Ring with a Solitaire	1
31. Ditto with a Sapphire surrounded with brilliants	1
32. Ring with a Ruby spinel surrounded with brilliants	1

Jewels	Pieces
33. Ring with an Amethyst surrounded with brilliants	1
34. Ring with a small turquoise surrounded with brilliants	1
35. Ring with the Cipher P M in small diamonds	1
36. Similar Ring	1
37. Ring of hair with the Cipher O P in diamonds	1
38. Ring with a yellow Aquamarine, surrounded with brilliants	1
39. Shoe Knots in diamonds	2
40. An enamelled egg decorated with small diamonds	1

signed:

Count Rumiantsev

Count Kochubei

Count Rostopchin

St. Petersburg

this 22 of July 1799

Grand Duchess Anna Pavlovna
G. Walter, c.1805
The State Museum-Preserve "Gatchina"

List of the personal belongings of
H.I.H. Grand Duchess Anna Pavlovna, 1816

The dowry of the youngest daughter of Paul I, Grand Duchess Anna Pavlovna (1795–1865), who in 1816 married
Prince Willem of Orange, later king of the Netherlands, has been preserved in the archives of the Royal Household of the Netherlands.
The list has generously been provided by Paul Rem, curator at Het Loo Palace, Apeldoorn, the Netherlands.[28]
It has been translated from the French by Timothy F. Boettger.

Jewels

1. The Cross and the badge of the Order of St. Catherine, in diamonds
2. The Wheel, belonging to this Order.
3. The Epaulette in diamonds.
4. A rivière, of thirty large diamonds
5. 816 tassels in diamonds of different sizes
6. a bouquet, in diamonds
7. a chain in diamonds
8. a pair of earrings in diamonds
9. a Tiara in diamonds.
10. a comb in diamonds.
11. a fringe in diamonds
12. a galloon in a Greek design, in diamonds
13. a branch in diamonds.
14. Tiara of eight ears of wheat in diamonds.
15. Suite in diamonds and rubies.
 a bandeau.
 a branch with 31 rubies
 a comb with 31 rubies
 a pair of earrings with
 eight rubies.
 a chain with 32 rubies
 a *fermoir* with a cube-shaped ruby.
 80 tassels of rubies.
 180 pieces, each with 3 rubies.
16. Suite in diamonds and sapphires.
 a Bandeau with 7 sapphires
 a chain with 13 sapphires
 a Necklace with 3 sapphires

Jewels

a pair of bracelets, each
bracelet with a sapphire
a pair of earrings with
4 sapphires.

17. Suite in diamonds and emeralds.
 a Bandeau with 20 emeralds.
 a chain with 40 emeralds
 The center of a bandeau with 3 Emeralds
 a comb with 34 emeralds
 a pair of earrings with
 8 emeralds.
18. Suite in diamonds and amethysts.
 a *fermoir* with a large amethyst.
 a Necklace with eight amethysts
 a pair of bracelets with 12 Amethysts.
 a pair of earrings with
 4 amethysts.
19. Suite in diamonds and natural pearls.
 a Fringe with 21 pearls.
 a pair of earrings with
 6 pearls.
 a branch with 15 pearls.
 a string with 38 pearls.
 a string with 125 pearls.
 181 large pearls.
 302 medium-size pearls.
 541 average-size pearls
 74 of different sizes.

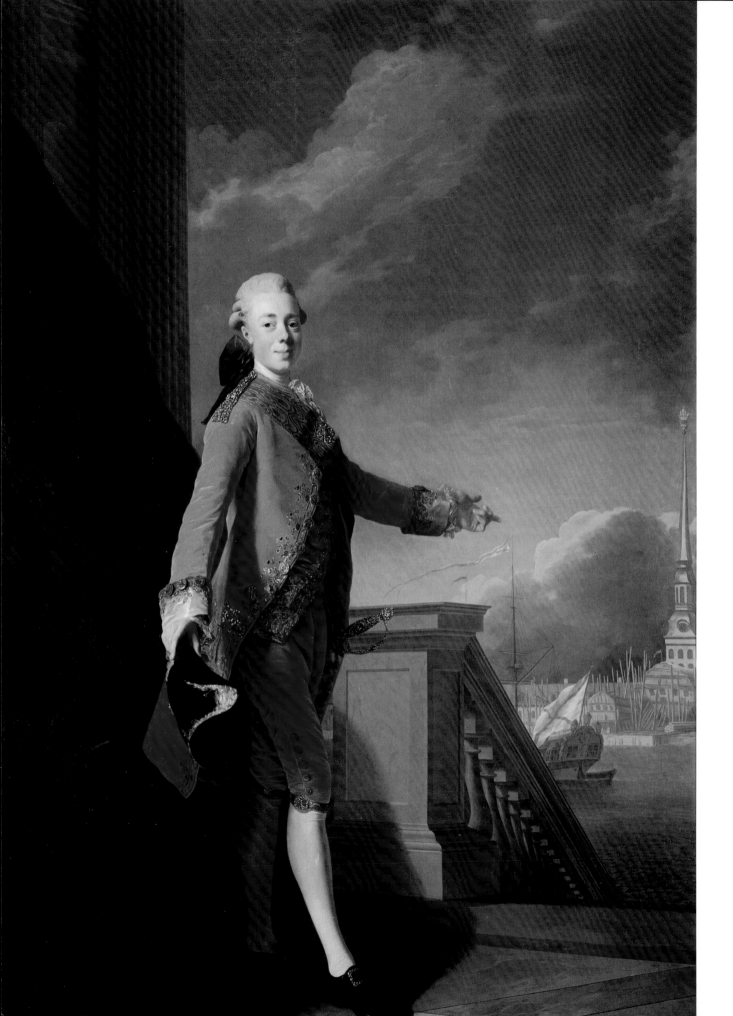

AN IMPERIAL CHRISTENING GIFT

In 1796, Emperor Paul I consented to become godfather to Nadezhda Iva-novna Kutaisova, youngest daughter of his favorite Count Ivan Pavlovich Kutaisov (1759–1834).[29] The christening gift, a jeweled *fermoir*, has sur-vived and is now in the family of the child's great-great-great granddaugh-ter. Not only the fact that a gift presented over two hundred years ago has been preserved, but the unique history of this family makes a wonderful story well worth the telling.

The life and career of baby Nadezhda's father is an example of unique upward mobility of which there are only rare examples in the Russian Em-pire. Ivan Pavlovich Kutaisov, of humble origin, was born in the Ottoman Empire, in the town of Kütahya, and came to Russia at the age of fifteen as a prisoner of war.

The story begins at the fortress of Bender, on the Dniester River, which the Russian armies took from the Turks in 1770. The boy, whose original name is unknown, made his way to the enemy camp either by mistake or induced by the inherent curiosity of a youngster. The soldiers took a lik-ing to the lad, who became the "mascot" of the camp and soon earned his living cutting hair and trimming beards. At the end of the war, in 1774, he was brought to St. Petersburg. Empress Catherine the Great, informed

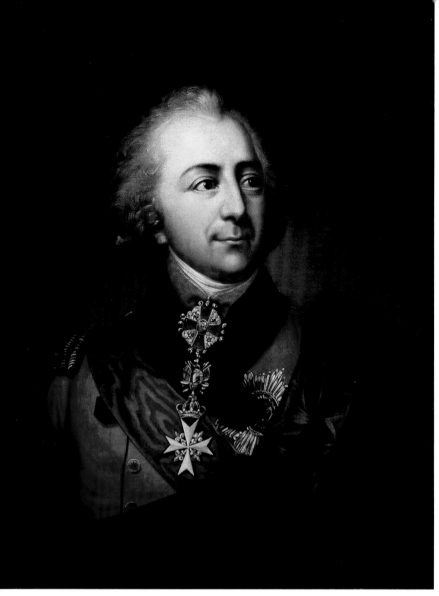

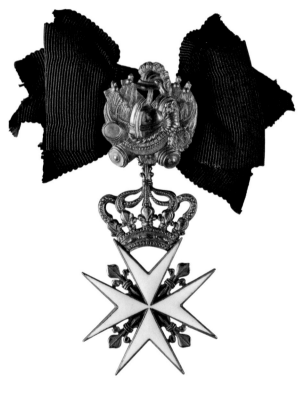

Count Ivan Pavlovich Kutaisov
Unknown artist, c.1800
The State Hermitage Museum, St. Petersburg

Count Kutaisov wears the star and sash of the Order
of St. Andrew; and around his neck, the Order of
St. Anne with diamonds and the grand cross of the
Order of St. John of Jerusalem (Malta).

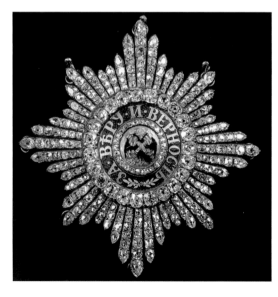

Above:
The Grand Cross of the Order
of St. John of Jerusalem (Malta)

Left:
The Star of the Order of St. Andrew
with diamonds

of this extraordinary young prisoner of war, decided to present him as a gift to her son, Pavel Petrovich. The heir to the throne was at the time a twenty-year-old man, who the previous year had entered into an arranged marriage with Princess Wilhelmina (Natalia Alekseevna) of Hesse-Darmstadt. She died in childbirth in 1776. The tsesarevich, in need of a true confidant, became deeply attached to the young Turk, who was five years his junior. He was given the Russian name Ivan Pavlovich. Initially he served as barber to his master, but was gradually showered with favors, gifts, and titles. His first appointment was that of valet de chambre (*kamer-diner*). In 1796, at Paul's ascension to the throne, he became an usher of the chamber (*kamer-fur'er*), and shortly thereafter, master of the wardrobe (*garderobmeister*). In 1798, Ivan Pavlovich was appointed head master of the wardrobe (*ober-garderobmeister*) of the fourth class and simultaneously received the Order of St. Anne first class with diamonds. The following year, he was created a baron of the Russian Empire and received the court title of master of the hunt (*egermeister*). These honors were soon followed by the title of count of the Russian Empire and the Order of Aleksandr Nevskii. In 1800, Count Kutaisov was appointed grand master of the horse (*ober-shtal'meister*) and received the grand cross of the Order of St. John of Jerusalem, the title of state secretary, and finally the Order of St. Andrew with diamonds, Russia's most prestigious knighthood. This mercurial rise of an uneducated barber—four years from the lowest rank to the very highest—created shock and dismay in the leading circles of the empire. For the average Russian statesman it took an entire lifetime of service to reach the top.

The career of Count Kutaisov came to an abrupt end at the death in 1801 of his emperor. Despite his fall from favor, the family had continued success. By his wife, Anna Petrovna Rezvaia (1760–1842), the daughter of a wealthy St. Petersburg merchant, he had six children. The sons had prosperous careers and the daughters made good marriages. The oldest boy, Count Pavel Ivanovich (1780–1840), rose to become an actual privy counselor, grand master of the court, and a member of the Council of the Empire. Next in line was Major General Count Aleksandr Ivanovich (1784–1812). He fought with valor in the Napoleonic Wars, giving his life at Borodino. His name appears in Leo Tolstoy's *War and Peace*. Countess Maria Ivanovna (1787–1870) was married to Actual State Counselor Count Vladimir Fedorovich Vasil'ev. The youngest child, Countess Nadezhda Ivanovna (1796–1868), was a maid of honor and married Actual Privy Counselor Prince Aleksandr Fedorovich Golitsyn. She wrote her reminiscences of the Polish uprising of 1830–31.[30] Two other children, a son Nikolai and a daughter Sofia, died young.

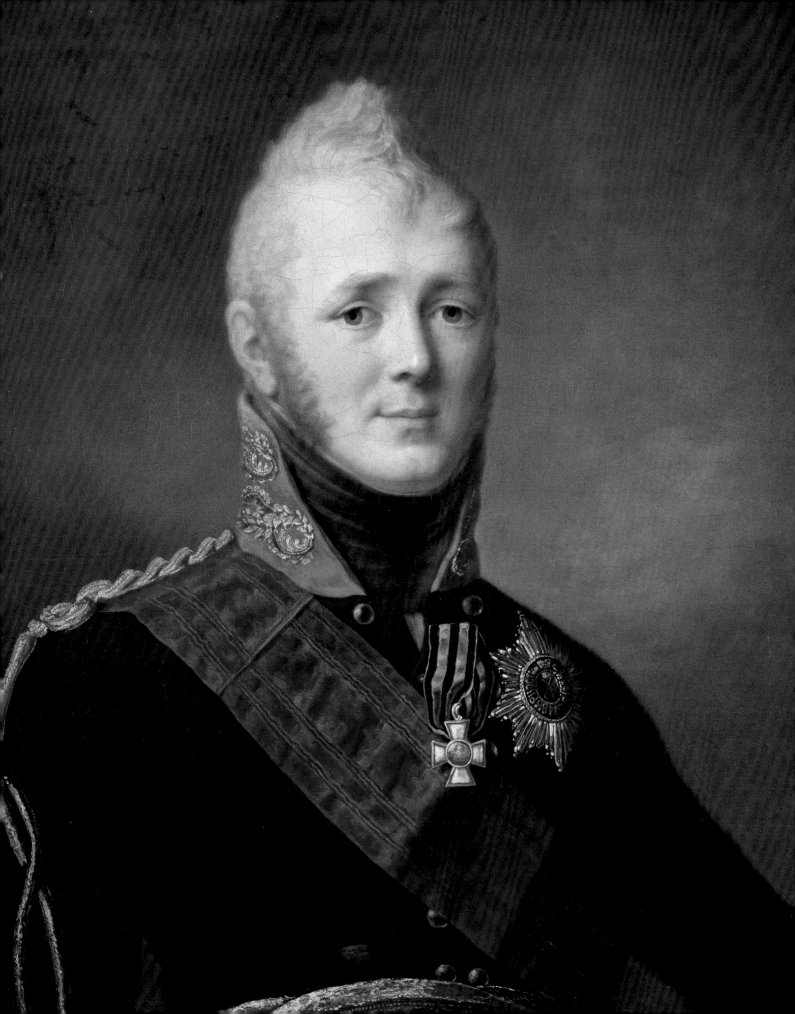

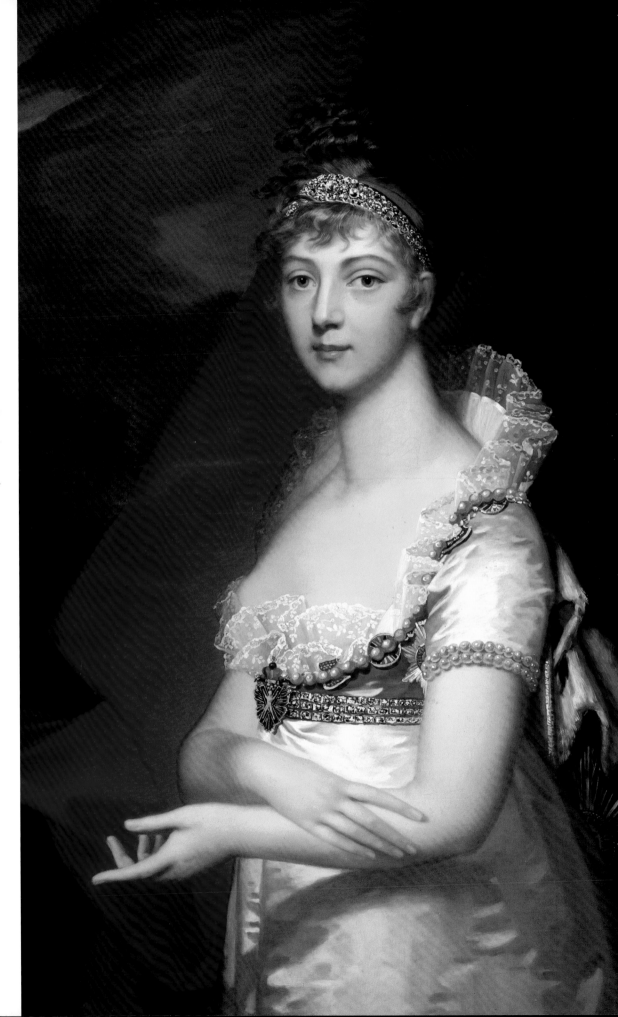

Emperor Alexander I
*Unknown artist
(formerly attributed to Stepan Semenovich Shchukin), c.1806
The State Russian Museum,
St. Petersburg*

The emperor, in the uniform of the Preobrazhensky Guards Infantry Regiment, wears the Order of St. Andrew and the St. George fourth class, which he received in 1805 shortly after the Battle of Austerlitz against Napoleon. The Duma (chapter of the order) offered him the first class of the order, but he declined in favor of the fourth.

Empress Elizabeth Alekseevna
*Jean Laurent Mosnier, 1807
The State Russian Museum,
St. Petersburg*

The empress wears a diamond bandeau and belt, strings of pearls along her décolletage and sleeves, and the chain and star of the Order of St. Andrew.

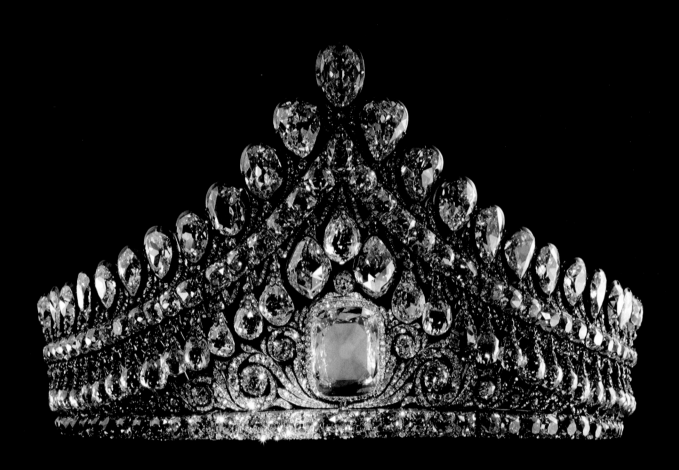

The Empire Style

ALEXANDER I

1801–1825

The Empire style of Napoleonic France made its way to St. Petersburg and dominated the arts in Russia during the reign of Alexander I. With the assistance of his corps of architects, designers, and jewelers, Napoleon, for his coronation in 1804, had orchestrated an entire framework of magnificent attributes to glorify his new status as emperor. These included the regalia and sumptuous jeweled ornaments. He crowned himself with a gold wreath, the Roman symbol of a great victor. For the ladies of the court, he commissioned stunning tiaras from the court jeweler Nitot. The designs were likewise inspired by ancient Greek and Roman models. New was the opulent use of precious stones, as well as sets of jewelry, or parures, which comprised a whole array of adornments—a necklace, a pair of bracelets, earrings, a belt buckle, one or several brooches, rings, hairpins, often with the addition of a bandeau and/or a decorative comb.

It is in a way a paradox that Napoleon's Empire style so strongly influenced Russia, given that she recently had triumphed over his armies in the Great Patriotic War. But trends created in Paris, the center of European fashion since the court of Versailles, were not easily ignored. Happily, politics and the arts are antipoles. Alexander I himself admired the arts and crafts of France, and in addition, was a friend of Napoleon's former consort, Empress Josephine, one of the era's style icons.

The St. Petersburg jewelers, like their colleagues in Paris, took their inspiration and models from ancient Rome. Jewelry for both men and women became monumental at this time. Pearl and gold necklaces with gem-set fermoirs were the fashion of the day. Hair ornaments—tiaras, bandeaux, combs—often worn in combination, adorned elegant coiffures, and magnificent belts and buckles accentuated high waistlines. Petersburg pieces of the time were essentially geometrical—square, rectangular, elliptical, or circular—and, more importantly, became colorful after a long period during which transparent stones predominated. Yellow gold was combined with a vivid array of Russian gemstones: emeralds, aquamarines, topazes, spinels, amethysts, citrines, and garnets, not to mention colorful paste stones.

Tiara of Empress Maria Feodorovna
Jacob David Duval, St. Petersburg, c.1800
Gold, silver, diamonds
The State Historical-Cultural Museum-Preserve
"The Moscow Kremlin"
Photo: Nikolai Nikolaevich Rakhmanov

The large pink diamond in the center, purchased by Emperor Paul I for his consort Empress Maria Feodorovna, weighs 13.35 carats. It is of a faint rosy hue and of remarkable purity, as described by Fersman in Russia's Treasures of Diamonds and Precious Stones. Typical of Russian jewelry of the nineteenth century is the frame of minute rose-cut diamonds encircling it. The pear-shaped diamonds in the top row are of Brazilian origin and exceptionally white in color. A row of brilliant-cut diamonds divides them from the briolettes mounted en tremblant.

Hortense de Beauharnais, Queen of Holland
L. Thomasset, 1812
Courtesy of Sotheby's

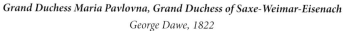

Hortense was the daughter of Empress Josephine by her first husband, Alexandre de Beauharnais. She married Napoleon's brother Louis Bonaparte and became queen of Holland. She wears the tiara of ancient cameos and pearls made by Nitot et Fils in 1812, which she has further enhanced by placing parallel strings of pearls through her hair. It is currently in the collection of the royal family of Sweden and has become their wedding tiara, having been most recently worn by Crown Princess Victoria when she married in June 2010.

Grand Duchess Maria Pavlovna, Grand Duchess of Saxe-Weimar-Eisenach
George Dawe, 1822
The State Hermitage Museum, St. Petersburg

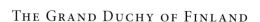

The grand duchess wears a diamond and ruby parure consisting of a tiara, earrings, and double necklace. Matching suites of jewelry such as this—which might also include bracelets, brooches, and combs—were typical of the Empire period.

THE GRAND DUCHY OF FINLAND

The war of 1808–9 between Russia and Sweden ended with Finland being ceded to the former. Finland, which for six hundred years had been a part of the Kingdom of Sweden, as of 1809 became a grand duchy of the Russian Empire. From this time onward, many Finns held important posts in Russia. They served the emperor on many levels in the military, at court, and in the civil service, and their sons and daughters were educated in the elite schools of St. Petersburg. The Russian sovereigns visited the grand duchy on numerous occasions, thus strengthening the bonds with their new subjects. It goes without saying that the influence of St. Petersburg's magnificent architecture, as well as its arts and crafts, soon made its way there. In 1812, the small coastal town of Helsinki (Helsingfors) became the capital city, and its center was redesigned in the Russian Empire style, as were the

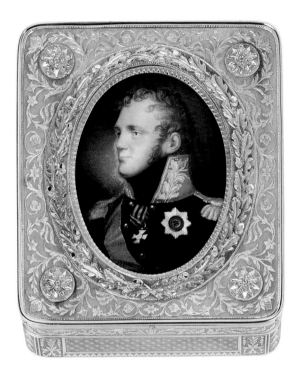

estates and residences of the new cadre of officers and civil servants. Objects in silver and gold, as well as jewelry, also followed this new esthetic.

The growing metropolis of St. Petersburg, home to the imperial court and many of Russia's wealthiest noble and merchant families, provided endless possibilities for craftsmen in the luxury trades. Hundreds of young boys from the grand duchy found their way to the Russian capital, many of whom sought apprenticeship with local gold- and silversmiths. These youngsters were most often sons of poor farmhands or craftsmen in search of a better life. Many of them succeeded, and in due course themselves became skilled professionals and masters.

Members of the four estates—nobility, clergy, bourgeoisie, and peasantry[31]—were invited to the first Diet of the fledgling grand duchy. They witnessed a glorious spectacle centered on the emperor of All the Russias and his entourage. The small town of Porvoo, on very short notice, succeeded admirably in its arrangements for this grand occasion. The entire population was engaged in the preparations. An imposing triumphal arch decorated with flowers, foliage, and the crowned cipher of the emperor welcomed the august guest at the gates of the town. Accommodations and rooms for dining and the grand ball to be held in the presence of His Majesty had to be found and fitted out, not to mention suitable chambers for the meetings of the four estates. A plethora of imperial awards, titles, and gifts were bestowed at the end of the Diet.

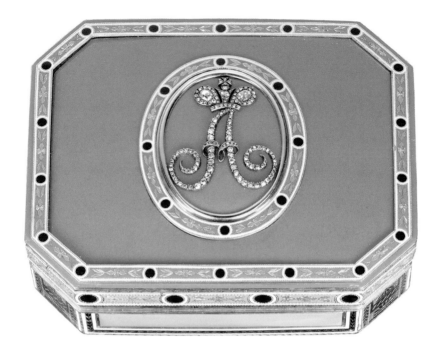

Presentation snuffbox with the cipher of Alexander I
Pierre Etienne Theremin, c.1801
Gold, enamel, diamonds
Courtesy of Sotheby's

The shape of snuffbox is typical for the Empire period—rectangular with cut corners—and has an austere décor of light blue opaque enamel with foliate borders dotted with geometric shapes in dark blue enamel.

Presentation ring with the cipher of Alexander I
Unknown maker, c.1810
Gold, silver, guilloché enamel, diamonds
The State Hermitage Museum, St. Petersburg

The ring was formerly in the collection of Grand Duke Aleksii Aleksandrovich, younger brother of Alexander III. It was an imperial presentation gift bestowed on worthy subjects of the empire in ranks three and four of the Table of Ranks, such as lieutenant generals, major generals, privy counselors, and actual state counselors.

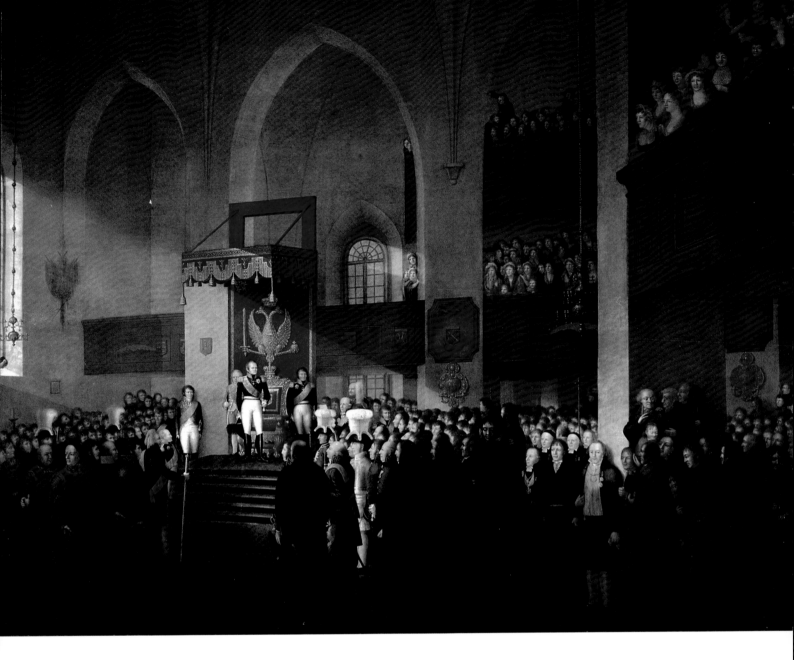

The Diet of Porvoo (Borgå) opening ceremony
Emanuel Thelning, 1812
The Borgå Diocese chapter, Porvoo
Photo: Studio Lindell

The ceremony of the four estates of the Grand Duchy of Finland swearing allegiance to the Russian emperor took place in the medieval cathedral in the center of the small town of Porvoo on March 29, 1809. Alexander I stands in front of the throne under the baldachin. On his left is the Russian minister of war, Count Aleksei Andreevich Arakcheev, and next to him, the minister of foreign affairs, Count Nikolai Petrovich Rumiantsev. On the left below the stairs, holding the marshal's staff, stands Baron Robert Wilhelm De Geer, who presided over the Diet. Just above him, on the second stair, is Governor General Magnus Sprengtporten. The wives and daughters of the men who took part in the ceremonies watched from the balcony.

Maid-of-honor cipher from the reign of Alexander I
Unknown maker, 1801–25
Gold, silver, diamonds
Private collection
Courtesy of Wartski, London

The initials E and M stand for Empress Elizabeth Alekseevna, consort of Alexander I, and Dowager Empress Maria Feodorovna, his mother.

Maid of honor from the reign of Alexander I wearing the EM cipher
Unknown artist, early 19th century
The State Museum-Preserve "Pavlovsk"

The unidentified lady wears a fashionable parure consisting of a necklace, earrings, a pair of bracelets, and a belt buckle set with antique cameos.

THE 12,000-RUBLE MYSTERY

During the opening ceremonies of the Diet, which lasted two days, the emperor was given accommodations in the town of Porvoo, but a week later, on his return from Turku (Åbo), he chose to stay at Möllershof, the estate of Governor Carl Adolf Möllersvärd, in nearby Mäntsälä.[32] His Majesty and his entourage enjoyed dinner with the Möllersvärd family, and later in the evening, an impromptu ball was arranged in the pillared salon. A stable hand who played the fiddle was called to the house to entertain the august visitors. Several times during the evening, the emperor led the dance with Ulrika, the youngest daughter of the house, and according to family lore, the next morning, when he bade farewell to his hosts, hastily drew the blushing young girl behind a door and kissed her.[33]

There is a longstanding oral tradition among the good inhabitants of Porvoo as to how and why Governor Möllersvärd came to have the honor of hosting the emperor at his house. The reason for his change of plans is said to have been an episode that took place at the Diet ball: The ballroom was filled to capacity, the young girls understandably being the most excited of the group. It is said that eighteen-year-old Ulrika Möllersvärd inadvertently dropped her fan on the floor in front of the emperor, who chivalrously picked it up. He thereafter honored the embarrassed young lady with many dances during the course of the evening.[34]

A few weeks after the visit, a courier from St. Petersburg brought the governor's family a thank-you note with a diamond ring for the host, a jeweled *fermoir* for the hostess; a gem-set comb for the elder daughter, Maria Lovisa; and a magnificent topaz and diamond *fermoir* in the Empire style—the costliest of the four gifts—for Ulrika. When she celebrated her twentieth birthday in 1811, she was named a maid of honor (*freilina*) of the empresses, one of the first six from the grand duchy to receive this great honor.[35]

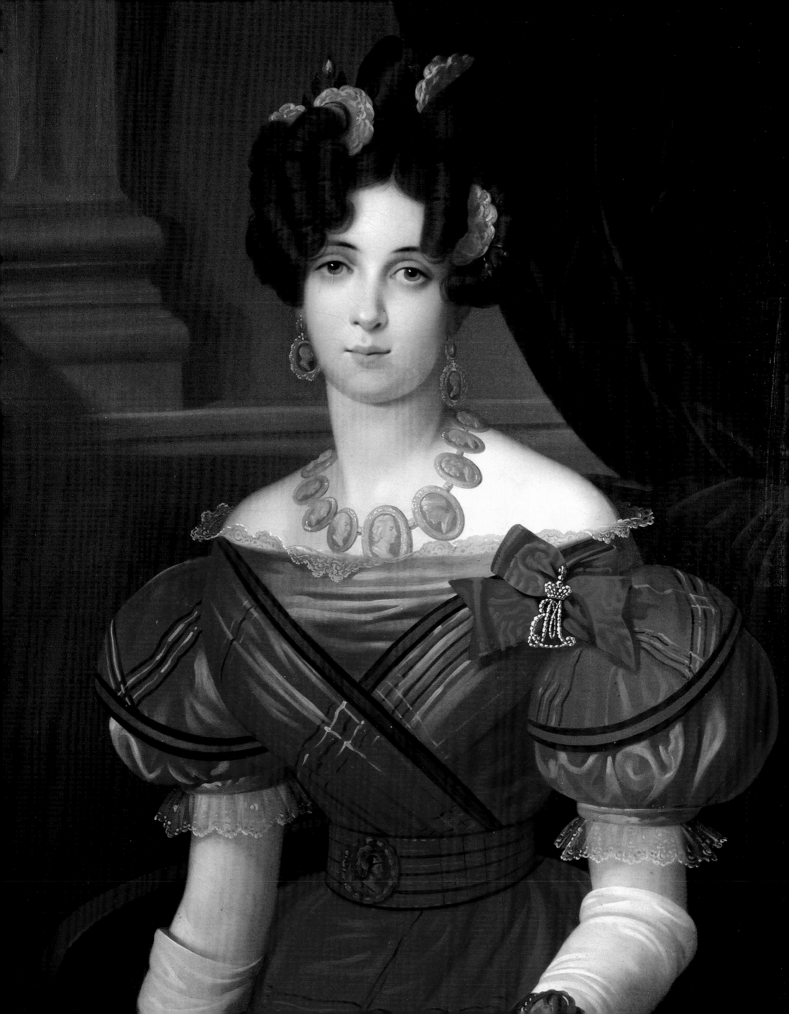

Fermoir presented to Ulrika Möllersvärd by Alexander I
Unknown maker, c.1809
Gold, silver, pink topaz, diamonds
Courtesy of the descendants of Ulrika Möllersvärd's niece

The maids of honor were given a diamond cipher made up of the empresses' initials E and M suspended from the light blue ribbon of the Order of St. Andrew. It was worn on the left shoulder. The appointment was important for these young ladies, especially when it came time to marry. A maid of honor who had entrée to the festivities at the Winter Palace and had been introduced to Their Majesties had added appeal in the eyes of a prospective husband.

It has been widely speculated that there was a romance between Alexander I and the eighteen-year-old Ulrika Möllersvärd. The emperor, at the time a handsome thirty-two-year-old man known to have a roving eye, made the young girl fall head over heels in love. For the emperor, the episode in Porvoo was no doubt momentary, but as far as the young girl was concerned, it came to mark her entire life.

In addition to her appointment as maid of honor, Ulrika Möllersvärd received a gift of 12,000 rubles from the emperor. She refers to it as "pin money" (*den'gi na bulavki / karmannye den'gi*) in official documents. Pin money of 12,000 rubles from the sovereign to the daughter of a comparatively

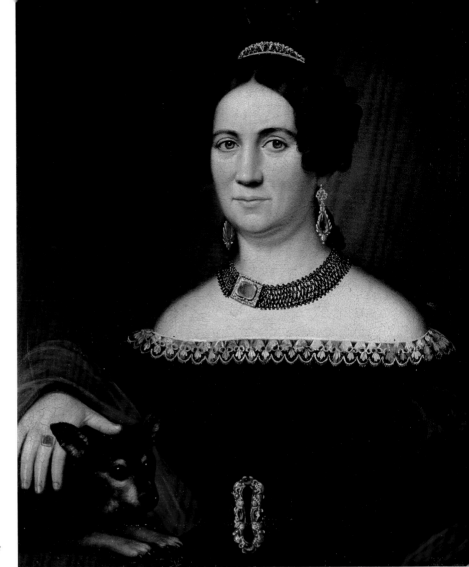

Ulrika Ottiliana Möllersvärd

Johan Erik Lindh, 1835

The National Museum of Finland

Ulrika "Ulla" Möllersvärd wears her fermoir with five strings of black glass pearls. In her hair is a small tiara set with red paste stones. Her earrings and belt buckle are typical of the 1830s. The portrait, black glass pearls, and tiara are now in the collections of The National Museum of Finland.

Ulrika Möllersvärd's fan

Porvoo Museum, Finland

Photo: Jan Lindroth

Sire,

C'est avec les Sentimens de respect et de reconnoissance que moi et mes deux Filles avons Reçues les marques de la Générosité de Votre Majesté Impériale, Permettés

Sire, de vous offrir nos très humble remercimens et de vous prier, de les recevoir avec la bonté que vous Caractérise—

—Je Suis avec le plus profond respect—

Sire

de Votre Majesté

la plus Soumise
Servante
Charlotte Möllersvärd.

Le 6.e Avrill 1809

uninfluential man, a young girl who had not even served at court, was exceptional. The annual salary for a highly ranked official of the empire was not even close to this amount. Research has not yielded any information on gifts of this nature, especially as these appointments were more or less honorific.[36] Had such a large sum of money been presented to all maids of honor, it would have represented a substantial expenditure of the state budget given that there were on average fifty to sixty at any given time during the reign of Alexander I, and their rapid rate of matrimony necessitated new appointments on a constant basis.

Two years after her appointment, Ulrika Möllersvärd was thrust into marriage. Her husband was Major General Odert Reinhold von Essen.[37] The union, however, remained unconsummated as the young bride, assisted by her brothers, fled her spouse on their wedding night. The bride was not to blame as the groom was an old and unattractive man, twice a widower, and thirty-six years her senior.

The pin money would have remained a secret had Ulrika Möllersvärd not reclaimed it in the court proceedings of their divorce.[38] It was ultimately restored to her, and consequently she was able to purchase a large house in the center of Porvoo, where she remained for the rest of her life. She never remarried, living a quiet life in the small town surrounded by a circle of friends and the families of her two brothers. She passed on her treasured topaz and diamond *fermoir* to her niece, who in turn ensured that the heirloom remained in the family. And so it has until this day.

The National Archives of Finland has a series of interesting documents that shed light on the first appointments of maids of honor from the grand duchy.[39] They also provide proof that the romance discussed above was merely a passing fancy for the emperor. At the end of March 1811, State Secretary for Finnish Affairs, Mikhail Mikhailovich Speranskii, sent Prince Aleksandr Nikolaevich Golitsyn a list of sixteen candidates for the honor of *freilina*. It had been compiled by the governor general of Finland, Magnus Sprengtporten. Early in April, Prince Golitsyn wrote back with a copy of the emperor's ukase with appointments for six of the sixteen young girls from the list. The emperor had put checkmarks next to the following names: Tengström, De Geer, Tandefelt, Carnall, Cronstedt, and Möllersvärd. No given names for the girls were mentioned. For Baron Tandefelt and Möllersvärd a problem arose. The former had no daughters of his own, so in a letter to the emperor, he proposed one of his nieces. Governor Möllersvärd was in more of a predicament. He had two daughters. Should he follow established procedure and accept the appointment in favor of his elder daughter? She, however, was hunchbacked and unattractive, whereas his younger daughter had all the qualities suitable for a maid of honor. Möllersvärd therefore hastened to write the emperor, saying that his younger daughter Ulrika, "par sa figure, sa taille et ses qualités d'ésprit" (by virtue of her countenance, her height, and her wit and learning), was more suitable for the position than his elder daughter. The emperor consented to the wishes of both Baron Tandefelt and Governor Möllersvärd, thus settling the matter without further discussions.

Fermoir presented by Alexander I
to Hedvig Beata Sederholm
Unknown maker, c.1812
Gold, silver, diamonds
Courtesy of the descendants of the recipient
Photo: Per Åke Persson

Emperor Alexander I having lunch
at Haapalankangas
Bolms, 1826

During his tour of Finland in 1819, the emperor with his suite had lunch in a simple stable in Haapalank-angas. The walls were lined with fragrant birch branches. One of the delicacies on the table is the jar of arctic raspberry preserves which the local vicar's wife, Hedvig Wallenius, presented to the emperor. From right to left: Emperor Alexander I, Prince Petr Mikhailovich Volkonskii, aide-de-camp-general, Captain Sebastian Gripenberg, Sir James Wylie, physician in ordinary to H.I.M., and Sub-lieutenant Karl-Mauritz A. Martinau, attached to the Quartermaster Section of His Majesty's Suite.

THE EMPEROR'S TOURS OF THE GRAND DUCHY

Shortly after the peace treaty of 1809, lively contacts between Russia and the new grand duchy developed at all levels of society. Alexander I visited Finland four times, twice in 1809. The first time, as mentioned above, was when he received the oath of allegiance of the four estates and attended the Diet ball in Porvoo. The second time was in connection with the closing ceremonies of the Diet. A third trip took place in August 1812, when he met with Sweden's crown prince Karl Johan, with whom he signed a treaty of alliance. On his return to St. Petersburg, the emperor stopped over at the estate of Mustio (Svartå), where he agreed to another treaty of alliance, this one of a very different nature. He gave his consent to the marriage of nineteen-year-old Hedvig Beata Sederholm to her cousin Gustaf Adolf Sederholm. The emperor presented the bride-to-be with a *fermoir* in the neoclassical style. Intended to be worn as a clasp in a necklace, it is designed in a style popular in the late eighteenth century, reminiscent of a rococo flower. This model remained in favour in St. Petersburg until the late Empire.

Brooch presented to Hedvig Wallenius by Alexander I
Unknown maker, c.1819
Gold, silver, amethyst, diamonds
Courtesy of the descendants of the recipient
Portrait courtesy of Tjusterby manor, Pernaja (Pernå), Finland
Photo: Katja Hagelstam

In the portrait painted c.1830 by Johan Erik Lindh, Mrs. Wallenius wears the brooch she received from Alexander I. It is not signed or marked, but its quality and design indicate that it was made by one of the important St. Petersburg jewelers of the time.

In 1819, Alexander I made a nearly four-week tour of the country, partly to inspect the various regions of the newly conquered land, partly to secure the popularity of the new regime among the population. It was widely written about by contemporaries and later authors. These descriptions are both interesting and entertaining. The young Finnish staff captain Sebastian Gripenberg, from a well-known aristocratic family, accompanied the emperor on the voyage from the Nissilä guest house to Kajaani (Kajana), being in charge of the practical arrangements. He published an illustrated description of the tour in 1828. To meet with the emperor and to be part of this adventurous imperial progress was a great event in the twenty-three-year-old staff captain's life.

The author Sara Wacklin, who from her youth collected reminiscences of the imperial visits, gives a lively description of Alexander I's stopover in the coastal town of Oulu (Uleåborg) in western Finland. The historian Emil Fredrik Nervander published accounts of all the emperor's trips to

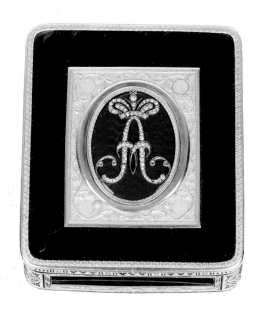

Snuffbox with the cipher of Emperor Alexander I
Unknown maker, c.1805
Gold, diamonds, tortoiseshell, guilloché enamel
Courtesy of Sotheby's

the country. He gives detailed information on the gifts and awards through which the emperor showed his gratitude towards his hosts and hostesses. These include fifteen diamond rings, six jeweled *fermoirs*, two diamond belt buckles, one diamond bishop's cross, one pair of diamond earrings, three gold snuffboxes, one jeweled comb, five gold watches, and three gold medals.

On August 25, 1819, the vicar of Tohmajärvi parish, Petrus Wallenius, received Alexander I and his entourage and arranged for lodging for the night. The vicar's wife, Hedvig Helena,[40] who did her utmost to show the sovereign the best of her cuisine and hospitality, became the happy recipient of a jeweled brooch in gratitude for her efforts. A gift often inspires a person to reciprocate. The vicar's wife, therefore, offered the emperor a jar of her finest arctic raspberry preserves. These berries were, and still are, extremely rare and considered a great delicacy in the northern countries. Later, as the august visitors paused in Haapalankangas to enjoy lunch, captain Gripenberg reports:

The Emperor had, during his trip through Karelia, received the gift of a jar of jam, which He much appreciated. When His Majesty had served Himself with the preserves and Prince Volkonskii also had taken some, His Majesty took the jar in His Own hands, put it in front of me, and with the captivating smile which was so typical of him said, "Gripenberg, you have to taste the jam, it is delicious, but don't take too much, I want to hold on it so that it lasts long; it is a gift from the vicar's wife in Tohmajärvi."

The emperor and his suite continued their tour northwards through the dense forests of the uninhabited regions of the grand duchy to the town of Kuopio, and from there to Iisalmi towards Kajaani. They reached Iisalmi via winding and primitive gravel roads in a horse-drawn carriage, but after that, the journey had to be continued by boat. Two sloops, manned with twenty-four sailors and a captain by the name of Junnelius, were engaged for this leg of the journey. At first all went according to plan as the two boats were rowed downstream along the river Vuolijoki. However, when they reached lake Oulunjärvi, the sails had hardly been hoisted when a storm unexpectedly came upon them.

In spite of all the skills Captain Junnelius demonstrated, he was unable to stop the sloop from taking on water. The storm was incredibly fierce, the waves so high that when the sloop was in between two of them, we did

not see anything else except the dark grey skies and the splashing spray. Two sailors were incessantly engaged in bailing out the masses of water that washed into the boat, and which, without any pardon, drenched both His Majesty as well as the rest of us. During this adventurous journey, His Majesty showed absolute tranquility, but was nevertheless more serious than normal. A few times His Majesty asked Captain Junnelius in English whether we were in danger, but the captain assured His Majesty that there was no peril to speak of. He, however, was put into a state of great embarrassment as the fierce waves suddenly broke off the helm. An inevitable disaster would have been the result had not Mr. Junnelius been prepared for such a calamity in having a reserve rudder, which he, with his utmost presence of mind, immediately and unnoticed succeeded in inserting in place of the broken rudder. After some two hours in the eye of the storm, we reached calmer waters at Paltamo vicarage, next to which the entrance to Kajaani harbor is situated. Junnelius received a costly "brilliant ring" as a memento of the adventurous journey, and each sailor was given a substantial "gratuity of money."

One of a pair of earrings presented to
Anna Sofia Turdin by Alexander I
Unknown maker, c.1819
Gold, diamonds
Courtesy of the descendants
Photo: Katja Hagelstam

Fermoir presented to Mrs. Holmsten by Alexander I
Unknown maker, c.1819
Turquoise, diamonds
Courtesy of the descendants of the Holmsten family
Photo: Katja Hagelstam

After Kajaani came Oulu, and thereafter Tornio (Torneå). The imperial suite made an early start from the latter on September 1 in order to take the road south to Kemi. Attempts to procure breakfast in these primitive surroundings during the early hours of the morning had proved fruitless, until Providence sent a Russian peddler to the rescue. The good man handed the emperor a large, newly baked salmon and rice piroshky, which he enjoyed with good appetite. The peddler's generosity was not left unreciprocated. On his return to St. Petersburg, the emperor sent his benefactor a gold snuffbox.

In Uusikaarlepyy (Nykarleby), the emperor stayed in the house of a wealthy merchant by the name of Johan Turdin. In gratitude for the comfortable accommodations and good dinner and breakfast, Mr. Turdin was granted the title of commercial counselor. The lady of the house, Anna Sofia, who was said to be "one of the most presentable merchant wives of her time, accustomed to entertaining guests since 1808," received a large gold and diamond brooch and a pair of gold and diamond earrings from the emperor. The brooch was inherited by her eldest granddaughter, Baroness Augusta von Rosenkampff, who had an ear for music. She sold the piece in order to purchase a grand piano. The younger granddaughter, Aline, married to Bishop H. Råbergh, inherited the earrings.

There is an amusing anecdote regarding the emperor's visit with the Turdin family. When the emperor inspected his bedroom, he explained, as he had done in all the previous homes in which he had stayed, that he was unable to sleep on down mattresses and duvets and would prefer to have a mattress filled with straw. His wish was naturally fulfilled.

On September 9, at close to ten in the evening, the emperor and his suite arrived in Hämeenlinna (Tavastehus). Accommodation this time had been arranged for in the governor's residence. The governor's wife, Baroness Gustava Sofia Hjärne, née Rosenborg, was in her turn presented with a gold *fermoir* set with a red hessonite garnet and an abundance of diamonds. The governor, Baron Gustaf Hjärne, had been in charge of the gunpowder stores at Suomenlinna (Sveaborg) during the recent war. It was rumored at the time that Captain (later Major) Hjärne had rendered himself guilty of miscalculating the amount of gunpowder at the fortress, the defense of which was of major importance for the outcome of the conflict. Hjärne gave his commander pessimistic reports, thereby spreading disillusionment among the officers and men at the fortress. These miscalculations, so it was said, also influenced the commandant, Vice-Admiral Carl Olof Cronstedt. Whether a deficiency of gunpowder was the reason for the hasty capitulation of the fortress continues to be debated to this day.

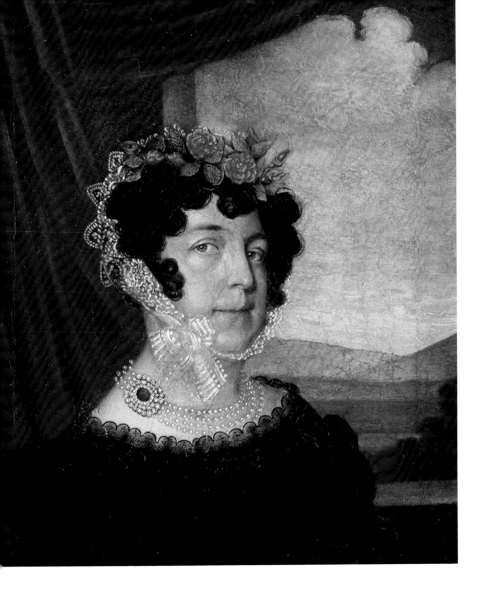

There were also rumors that Baroness Hjärne was a victim of the "psychological warfare" to which the members of the officers' families at the fortress were subjected. Evil tongues said that she was one of the "merry wives" of Suomenlinna, flattered by the courtship of the gallant and dashing enemy officers stationed at nearby Helsinki (Helsingfors). But Sara Wacklin, who for a few years worked as a governess in the Hjärne family, had nothing but good to say about the baroness. She described her former employer as an educated, intelligent lady who took great pleasure in entertaining her circle of likewise erudite friends.

Gifts from the emperor's earlier trips to the grand duchy have likewise survived. The monarch passed through the small town of Loviisa (Lovisa) a total of seven times. Once, possibly twice, he visited the family of Commercial Counselor Johan Holmsten, the wealthiest merchant in town. The historian Nervander wrote about one of these visits:

Amiable and charming as always, and fond of children, He [the emperor] took the small son of the family into his arms and kissed him on the mouth. He greeted the lady of the house and the adolescent daughters with a kiss on their hand. He presented Mrs. Holmsten with a jeweled belt buckle set with a topaz and diamonds and a *fermoir* with a large turquoise encircled by small East Indian diamonds set in silver.

Nervander went on to state that "the jeweled belt buckle was sold in the 1840s to the jeweler Möllenborg in Stockholm." He furthermore mentioned that the Holmsten family, most probably the commercial counselor himself, was presented with a diamond ring set with twenty-nine "white Cape diamonds fashioned in a singular way and therefore desirable for jewelers." The value of the ring was a point of interest among the descendants. Holmsten's children, or possibly his grandchildren, decided to have the ring appraised. It was first shown to a local goldsmith, but he did not understand the value of the "singularly fashioned Cape diamonds" and therefore grossly undervalued it. In a subsequent trip to Venice, the descendants decided to take the emperor's gift along to show it to a more cosmopolitan jeweler. The estimate this time was high, but it still did not satisfy the owners. The trip continued to Switzerland, and in Vevey— the beautiful town which Jean-Jacques Rousseau chose as the scene for his novel *La nouvelle Héloïse*—the diamond ring was valued by the jeweler Bloch. This connoisseur finally appreciated the finesse of the unique stones and set a very high value. Whether Bloch became the new owner of the ring was not reported. The cut of the diamonds also remains a mystery.

A Snuffbox Filled with Gold Ruble Coins

There are fine examples of presentation snuffboxes from the early nineteenth century preserved in Finnish collections. One of most interesting is the gift to the young lieutenant Volmar Johan Schildt (1780–1830) in 1808. Shortly before the outbreak of the war between Russia and Sweden, Lieutenant Schildt was stationed as chief of a small border-guard contingent at Ahvenkoski (Abborfors), which at the time was right at the frontier between the Russian Empire and the Kingdom of Sweden. Emperor Alexander I happened to be there at that very moment inspecting his own troops and inadvertently found himself with his entourage on the Swedish side.

Snuffbox presented to Volmar Johan Schildt by Alexander I
Gottfried Wichmann, St. Petersburg, c.1808
Gold, enamel, pastoral landscape with grazing horses
Courtesy of the descendants of Volmar Schildt
Photo: Katja Hagelstam

Spotting the Russian emperor on the wrong side of the border left Lieutenant Schildt at a total loss as to what to do; how to behave in front of the sovereign of a foreign empire. His good upbringing and innate politeness took over and he hastily commanded his men to stand at attention and to show the emperor military honors. Alexander I gave the modest troop of soldiers a friendly smile and quickly retreated across the border. When word of the incident reached the commandant of the garrison of the nearby town of Loviisa, the young lieutenant was strongly reprimanded, "Lieutenant Schildt, you would be wise to escape immediately to Russia! When the General Staff in Stockholm hears of this, you will either be severely punished or dismissed!" But before the report on the incident had reached Stockholm, there was a dispatch from the king of Sweden with a message stating that the Russian emperor should be accorded all possible honors should he be seen at the border. A few days after the incident, an imperial courier brought our hero a gold box filled to the brim with gold rubles.

Baron Gustaf Mauritz Armfelt as the Alcibiades of the North
Adolf Ulric Wertmüller, 1784
Private collection

Baron (later Count) Armfelt was a favorite of Gustav III and later an advisor of Alexander I on affairs concerning the newly established Grand Duchy of Finland. He was called "Baron Beautiful" or "Fair Apollo."

COUNT GUSTAF MAURITZ ARMFELT

Baron (later Count) Gustaf Mauritz Armfelt (1757–1814) was one of the most remarkable characters to have been born in Finland. He was in turn the favorite of two sovereigns, King Gustav III of Sweden and Emperor Alexander I of Russia. He spent his event-filled life between the royal courts of Stockholm, Paris, Naples, Vienna, and St. Petersburg. He fought on battlefields in his homeland against the Russians, in Norway against the Danes, and on the European continent in the wars against Napoleon. He met and became closely allied to a number of well-known European statesmen, and had many amorous affairs with some of the most beautiful women of the day.

That being said, he was by no means an adventurer. He spent his formative years seriously studying the arts and science. He was passionately interested in literature, opera, and the theater, and like his contemporaries, was also fascinated by the art and architecture of the ancient world and the Renaissance. He held many important offices, including that of *maître de plaisir* (master of the revels) of the royal court, was elected to the Swedish Academy, and was named head of the New Royal Dramatic Theater in Stockholm. He furthermore used his knowledge of architecture for the many building projects in which he participated, both official and private, and late in life planned and designed his beautiful estate of Åminne in Halikko, Finland.

In 1783, at the age of twenty-six, as senior gentleman of the chamber (överstekammarjunkare), he accompanied Gustav III to Italy. The original reason for this extended trip, which lasted almost a year, was to reestablish Sweden's position in the political life of Europe, a role it had lost a century earlier. However, its importance lay not in politics, but in the arts. The king and his closest companion became fascinated with the ancient arts and architecture they saw in Pompeii and at the Greek temple site of Paestum. The classical ideals of Antiquity revolutionized the arts and architecture in Sweden.

Following the death of Gustav III in 1792, the regent, the king's younger brother Karl, who was staunchly anti-Gustavian, sent Armfelt as ambassador to Naples to be rid of him. He wrote to Catherine II from there, urging her to militarily intervene in Swedish affairs to bring about a change in government in favor of the Gustavians. The plot was discovered and Karl sent a Swedish warship to Naples to apprehend him. Armfelt managed to escape and fled to Russia, but back in Sweden, he was condemned to death as a traitor in absentia and his property was confiscated. When Gustav IV

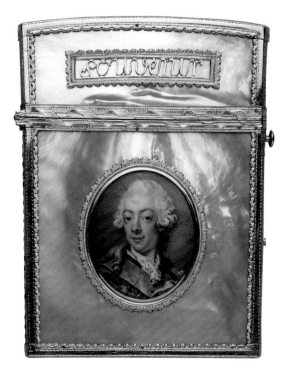

Writing tablet / "souvenir"
Unknown maker, France, 1780s
Miniature by Johan Georg Henrichsen, Stockholm
Gold, mother of pearl, enamel
The National Museum of Finland

The writing tablet was a gift from King Gustav III to Count Gustav Mauritz Armfelt. It contains ivory plaques on which the owner could make notes. Gustav III presented similar "souvenirs" to Tsesarevna Maria Feodorovna and Catherine the Great when visiting St. Petersburg in 1777. On the gift to the latter, the king wrote a gallant ode. See page 25.

Adolf attained his majority, Armfelt returned to Sweden, and in 1802 was named ambassador to Vienna. He was subsequently appointed commander-in-chief of the Swedish forces in Pomerania (1805–7), then of the Norwegian frontier. When Napoleon's former general Jean-Baptiste Bernadotte was chosen as crown prince of Sweden, Armfelt decided to return to Finland, which had recently been ceded to Russia following the Finnish War. He visited the Russian minister in Stockholm and swore an oath of allegiance to Alexander I. He was expelled from Sweden in 1811, at which time he entered Russian service and was appointed chairman of the Committee for Finnish Affairs. The following year, Alexander I appointed him general of the infantry, member of the Council of the Empire, chancellor of the University of Turku (Kungliga Akademien),[41] and made him a count of the Grand Duchy of Finland. He served as governor general of Finland for a brief period in 1813. His last years were spent between St. Petersburg, his home in Tsarskoe Selo, and his estate Åminne.

Gustaf Mauritz Armfelt married in 1785 Countess Hedvig Ulrika De la Gardie (1761–1832), a maid of honor of the queen of Sweden. In 1799, Countess Armfelt was appointed lady of honor (*statsfru*) of the queen and grand mistress of the court (överhovmästarinna) of the royal children. She received the honorific title of *riksrådinna* (literally state counselor's wife) in 1803. In Russia, she was given the equivalent title of lady of honor (*statsdama*) in 1811, then in 1814, received the Order of St. Catherine smaller cross. Countess Armfelt bore her husband eight children. Their son Gustav Fredrik, born in 1788, godson of the king and queen of Sweden and the heir to the throne of Denmark, died as an infant, as did the twins born at the end of the same year. Their other son Alexander (1794–1876) held the highest posts in the Grand Duchy of Finland and was generously awarded for his merits.

Princess Katharina Friederike Wilhelmine Benigna of Courland (1781–1839), Duchess of Sagan, was one of Gustaf Mauritz Armfelt's many paramours. Armfelt had previously been the lover of Wilhelmine's mother, Anna Dorothea, Duchess of Courland. When it was discovered that Wilhelmine was pregnant with his child, Armfelt, who was married and therefore unable to wed her himself, brokered a hasty alliance with an aristocratic and understanding French émigré Prince Jules Armand Louis de Rohan-Guéméné. The couple was discreetly married in 1800, and as Wilhelmine's term neared, she was sent off to Hamburg where she secretly gave birth to a daughter, Adelaide Gustava Aspasia, called Vava, on January 13, 1801. There was no attempt to pass off the child as a premature Rohan. As was customary at the time, Wilhelmine was named her godmother (so that

she might later settle a large estate upon her), and Vava was whisked off to Finland to live with Armfelt's relatives. Because of the midwife's clumsy ministrations, Wilhelmine was not able to have any more children. Although she later took in several foster daughters, she longed to have her beloved Vava back. In 1814, she entreated her then lover, Prince Metternich, to intercede on her behalf with Emperor Alexander I, but all attempts to regain custody came to naught. After two more failed marriages—to Prince Vasilii Sergeevich Trubetskoi and Count Carl Rudolf von der Schulenburg—Wilhelmine moved to Vienna to live quietly with her sisters. Vava, who passed away in 1881, married twice, firstly (1825) her cousin, Count Magnus Reinhold Armfelt, and secondly (1846), Johan August von Essen. Her parents had signed the following letter for her to open on her fifteenth birthday:

> Know, dearly beloved child, that you are the testimony of the truest love that joins the hearts of the undersigned. They have taken care of your fortune and if they have not been able to guide your education according to their desire, their wishes and their blessings will serve as a shield for you in the life you will live. We both sign this act with our own hands, placing thereon our seals, and our hearts pressed one against the other are an eternal pledge to you of our love for you...
> [Signed] Gustav Baron d'Armfelt
> [and] Cathérine Frédérique Wilhelmina Benigna,
> Princess of Courland,
> Duchess of Sagan—
> Sagan, 19 October, 1801[42]

Princess Wilhelmine of Courland, Duchess of Sagan
Joseph Grassi, 1799
Private collection
Courtesy of the National Museum of Finland

Emperor Nicholas I
George Dawe, 1821
The State Hermitage, St. Petersburg

The portrait was painted before he came to the throne. The grand duke wears the uniform of the Life-Guards Horse Pioneer Squadron.

Empress Alexandra Feodorovna with her children Aleksandr and Maria
George Dawe, 1820
The State Russian Museum, St. Petersburg

The portrait was painted before she came to the throne.

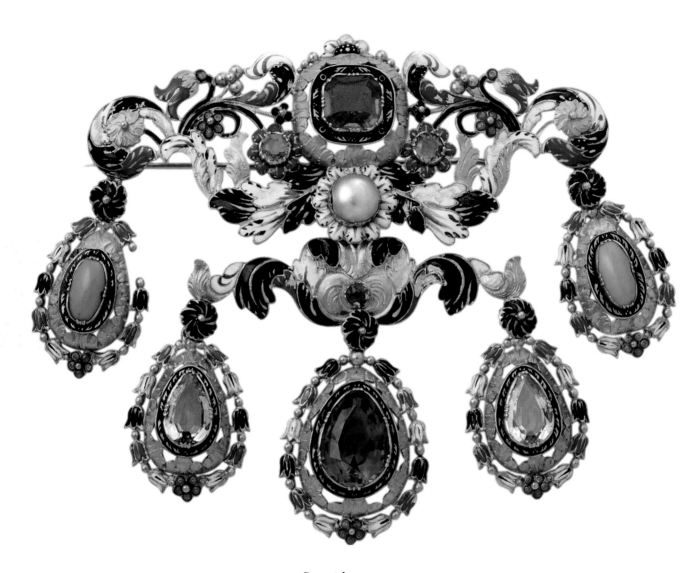

Devant de corsage
Unknown maker, St. Petersburg, c.1840
Gold, quartz, paste gems, enamel
Private collection
Photo: Katja Hagelstam

This piece is a perfect example of emerging historicism in jewelry. Its decorative motifs and enameling are in the Renaissance style.
The pear-shaped pendants, or girandoles, were a ubiquitous fashion of the seventeenth and eighteenth centuries. The original owner
was Charlotta Lovisa Thesleff (1804–1846).

The Emergence of Historicism

NICHOLAS I

1825–1855

The monumental aspect and strict geometric forms of the previous decades were gradually transformed in the art of gold- and silversmiths during the reign of Nicholas I, becoming lighter and more fluid. Known as Biedermeier[43] in the Germanic states, including the Kingdom of Prussia, the empress's country of birth, in Russia it was simply known as the "Empire style of Nicholas I." Styles of preceding centuries were also revived one after the other at this time, neo-rococo being the first.[44] Gold in various colors was now combined in one and the same jewel. The palette was diverse and consisted of almost every nuance, from pink to red and from yellow to green and grey. The reddish hues were produced by alloying it with copper, and green gold was the result of an admixture of silver. A miniature rose was a favorite ornament of the rococo and it appeared in virtually all late Empire jewels and objects made of precious metals. This era also witnessed the revival of Renaissance and classical motifs from ancient Greece and Pompeii.

The Romantic movement in painting and literature had begun during the reign of Alexander I and continued during that of his successor and younger brother. This was the golden age of Russian literature, with Aleksandr Pushkin, Vasilii Zhukovskii, and Mikhail Lermontov as its foremost representatives. Myths and legends and historical deeds of gallantry abounded. Alongside this infatuation for the Middle Ages and the Orient arose a nostalgic longing for a more natural environment and untouched nature. Contemporary poets, artists, and composers were inspired by all of these themes. Jewelers borrowed their motifs from Gothic architecture and their colors from Byzantine art. Arabian ornaments found their way into jewelry. Design in the age of Romanticism was also heavily influenced by sentimentalism; jewels frequently had secret compartments hiding a lock of hair or a miniature portrait of a lover, a burning heart, an inscription with a monogram, perhaps an anagram or a rebus.

An interest in the forms and motifs of indigenous art likewise took root at this time. On the initiative of the emperor, the artist, architect, and historian Fedor Grigor'evich Solntsev,[45] in the early 1830s, began researching and documenting the treasure trove of arts and crafts in the vast collections

Bracelet with a miniature portrait of Nicholas I
Johann Christian Barbé, St. Petersburg, 1832
Miniature signed Winberg
(for Ivan Andreevich Winberg)
Gold, silver, diamonds, turquoises, seed pearls
Courtesy of Christie's

The bracelet was commissioned by Nicholas I, who presented it to his sister Maria Pavlovna in 1832. The total cost was 7,760 rubles (RGIA fond 468, opis' 5, delo 27).

Sofia Petrovna Svechina
François Joseph Kinsoen, 1816
Courtesy of Sotheby's

Sofia Petrovna Svechina, née Soimonova (1782–1857),
is depicted in a romantic costume inspired by the national
movement. She wears an elaborately decorated kokoshnik,
Byzantine-style earrings, and a rosary.

of churches, monasteries, and palaces throughout Russia. Particular attention was given to the ancient regalia, presentation arms, decorative objects in precious materials, luxurious textiles, and ceremonial costumes housed in the Kremlin Armory. The precisely rendered drawings and watercolors made by Solntsev were published with detailed descriptions in a six-volume edition entitled *Drevnosti Rossiiskago gosudarstva* (Antiquities of the Russian state).

In the 1860s, Viktor Ivanovich Butovskii, one of the leading figures at the Stroganov Institute in Moscow, compiled an extensive inventory of ornaments from ancient manuscripts, sacred objects, textiles, and regional

costumes. Butovskii's students took part in gathering the material for the publication, which was entitled *Istoriia russkago ornamenta s X po XVI stoletie po drevnim rukopisiam* (The history of Russian ornamentation from the tenth to the sixteenth centuries taken from old manuscripts). These publications created a visual esthetic that provided inspiration for generations of artists to come and contributed to a revival of the "old Russian style." The passion for Russian national motifs persisted throughout the rest of the century, culminating in the tercentenary celebrations of the Romanov dynasty in 1913.

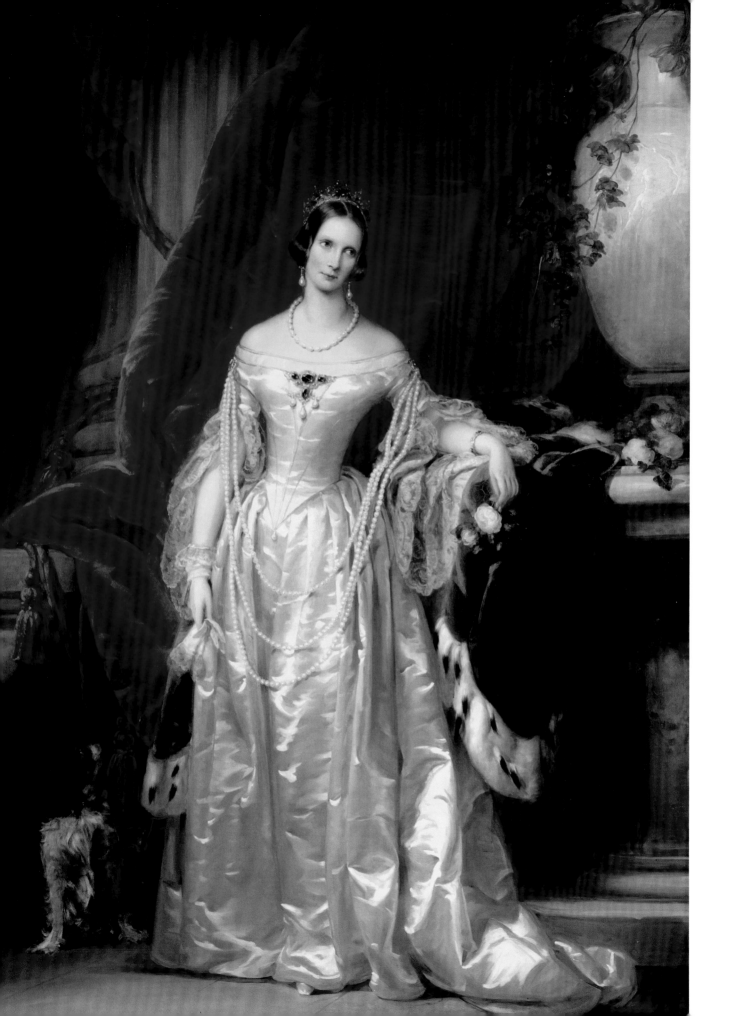

The empress wears three extraordinarily long strands of pearls reaching from her shoulders almost down to her knees; a devant de corsage with sapphires, diamonds, and large pearl drops; a sapphire and diamond tiara; a splendid necklace of South Sea pearls; and large pear-shaped pearls in her ears. The artist has surrounded her sitter with a sumptuous ermine-trimmed blue velvet mantle, and at her side, the symbol of loyalty and devotion, a favorite dog, presumably a setter, gazes worshipfully at his mistress.

THE EMPRESS'S JEWELRY CHESTS

Dr. Martin Mandt, the German-born physician in ordinary of Empress Alexandra Feodorovna from 1837 and of Emperor Nicholas I from 1840, has left us this interesting description of the empress's jewels in his reminiscences:[46]

I was escorted into the empress's bedchamber.

When I entered the room, the beautiful august lady was standing next to a small round table with a *pietra dura* top, her lips curled into a faint smile signaling agony, her eyes and facial expression showing traces of emotion. Her face was pale, an obvious sign of her illness. She had barely finished dressing. Her dress was surprisingly modest, but becoming and as always in good taste. She wore white silk stockings and shoes made of brown atlas silk. The glance and facial expression of the noble-born lady—in fact her entire disposition—moved me deeply. Looking at me for a moment in a sorrowful but friendly way, she said with the sonorous voice that was hers, "Poor Mandt, what a stroke of bad luck for you! The emperor has decided that from this moment on you will be my physician…"

The room is almost square in shape and lofty as a big drawing room. Light flows into the room through the crystal clear mirror-glass windows overlooking the Admiralty…On the right-hand side of the room, next to a small door, stands the enormous imperial double bed. It is decorated with bronze ornaments but has no draperies. At the head of the large bed stands a narrow camp bed of iron. This is where the emperor himself sleeps when he stays the night in this room. His bed is fitted with a simple hair mattress, a leather pillow filled with some shredded material, a white linen sheet, and a plain blanket. A worn but nevertheless quite attractive Turkish

shawl serves as the bedspread. Heavy silk drapery separates the beds from the rest of the room. The drapery, hung at a man's height, allows light and fresh air to pass over it. The room itself is furnished with armchairs upholstered with soft cushions. The dark blue papered walls are sparsely hung with costly paintings. But what actually lend luxury to this room are five or six large chests placed along the walls. Their meticulously secured lids are made of thick glass. Through the glass one can clearly see the entire contents, even objects the size of minute pin heads.

In these chests the empress of Russia keeps her jewelry. The one next to her bed holds countless large diamonds, one into which the miniature portrait of the emperor is set. There are about one hundred separate diamonds, placed right next to each other, the smallest the size of a hazelnut. The purpose of these glittering diamonds is to adorn the empress's dress, her hair, or her neck. Who would even venture to calculate the value of the contents of this casket?

Observing the contents of the next chest, the eye of the beholder is blinded by a collection of minute, almost invisible pearls, the value of which must be very high. From all directions of the world the most alluring and rarest treasures of the seas have been placed at the feet of the beautiful empress. In the next chest, one can see opals, rubies, emeralds, sapphires, and turquoises. Of each precious stone a special parure has been created consisting of a tiara, earrings, necklace, brooch, and bracelet. The most beautiful and costly gemstone of the set is always placed in the center of the necklace, its purpose being to glitter at the bosom of the first lady of the empire. Looking at the sapphire and emerald parures of the empress, one wonders how such surprisingly large precious stones can possibly exist.

There is only one precious stone that surpasses the empress's diamonds in magnificence. It is the diamond in the imperial crown [sic], which a member of the Lazarev family sold to the sovereign of Russia, having brought it from the Orient in an ingenious way. Lazarev smuggled the gemstone across the border hidden in a wound he had cut into his imposing hip with his razor…[47]

But I beg for your patience—I still have not mentioned the favorite pastime of the empress, her love of bracelets. Her bracelets represent the same to the empress as a diary to us ordinary people. She owns altogether some five hundred bracelets, which are not appreciated for their intrinsic value, but for the personal memories attached to them. The very first note in this extraordinary memorandum consists of a very simple, narrow gold bangle, the value of which is but very low. The august lady received this piece as a child from the old Duke of Mecklenburg-Strelitz, a member of her family.

Bedroom of Empress Alexandra Feodorovna in the Winter Palace
Eduard Hau, 1859
The State Hermitage Museum, St. Petersburg

A chest with a glass top can be seen behind the large standing mirror on the left.
Its pair is directly opposite.

The empress varies her mode of dressing with the help of her bracelets. She is often seen contemplating in front of her five jewel chests, most probably imagining herself back in time while leafing through the pages of her tightly written diaries.

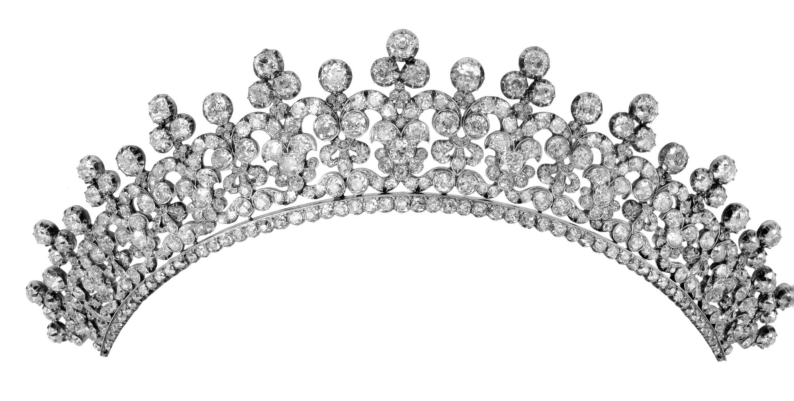

Tiara

Unknown maker, St. Petersburg, c. 1846
Gold, silver, diamonds
Private collection
Photo: Per-Åke Persson

The tiara was part of the trousseau of Princess Elena
"Hélène" af Nordin, née Shcherbatova.

THE ENVOY AND THE PRINCESS

Gustaf af Nordin (1799–1867), son of the bishop of Härnösand Carl Gustaf Nordin, was Swedish envoy extraordinary and minister plenipotentiary to the Russian court from 1845 to 1856. He had earlier served as attaché at the legations in Washington, D.C., Paris, Rome, and St. Petersburg. While in St. Petersburg in the early 1830s, he had noticed an eight-year-old princess who later was to become his wife.

Upon his return to the court of Emperor Nicholas I in 1845, now as envoy, Gustaf af Nordin not only made himself known as an able diplomat, but also as a gallant and generous host of dinners and balls in the grand style, to which he invited the crème de la crème of Russian society. Nordin was, despite of his "advanced" age (he was forty-six), still unmarried.

Petersburg society was all too quick to notice that Nordin—known to be a ladies' man—had totally lost his heart to the nineteen-year-old Princess Elena "Hélène" Sergeevna Shcherbatova (1827–1855), daughter of Prince Sergei Grigor'evich Shcherbatov and Princess Anna Mikhailovna Khilkova. The wedding was celebrated less than a year later, on August 9, 1846.

Princess Elena "Hélène" af Nordin,
née Shcherbatova
Ivan Kuz'mich Makarov, c.1850
Private collection

Gustaf af Nordin
Unknown artist, c.1845
Private collection

Olga af Nordin
Ivan Kuz'mich Makarov, c.1847
Private collection

Olga Anna Margareta af Nordin (1847–1895),
daughter of Gustaf af Nordin and Princess Shcher-
batova, married Count Carl Gustaf Conrad Eric
Lewenhaupt in 1869.

The Swedish legation now had a hostess, which no doubt made life both easier and more pleasant for the envoy. A daughter was born the following year. Her first name was Olga, but according to Swedish custom, the child received two additional Christian names: Anna (in honor of her maternal grandmother) and Margareta (in honor of a paternal aunt.)

Hélène died prematurely of tuberculosis, which she had tried to cure by taking frequent trips to the south of Europe. She was barely twenty-nine and little Olga only eight. Nordin left his post in St. Petersburg in 1856 at his own request. He must have been heartbroken and therefore left Russia, settling in his native Sweden with his daughter.

At the age of twenty-two, in 1869, Olga af Nordin married Count Carl Lewenhaupt (1834–1908), owner of Aske manor in Uppland. Their son, Count Gustaf, nicknamed "Askegreven," wrote his reminiscences, entitled *Askegreven berättar vidare* (The Askecount continues his stories), in which he relates the family's memories of his grandmother. The book has been used as a source for this text.

Jewelry chest of Princess Shcherbatova
Martin Guillaume Biennais, Paris, c.1805
Mahogany, silver
Private collection
Photo: Per-Åke Persson

The chest was a gift by Napoleon Bonaparte to Alexander I (whose monogram appears on the lid) during one of the Russian emperor's visits to Paris. It was later presented by Empress Elizabeth Alekseevna to Princess Anna Mikhailovna Shcherbatova, née Khilkova, who was an exceptional beauty in her youth. According to family tradition, Emperor Alexander I courted her and presented her with many jewels, none of which have survived. The inlays in silver are typical of the Empire style—griffons, sphinxes, palmettes, lotus flowers, and stars.

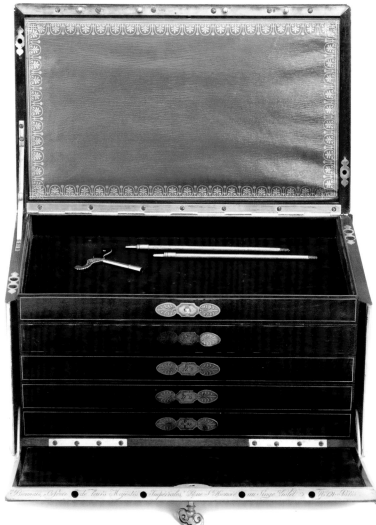

Interior of the jewelry chest

The interior of the chest was remodeled in 1846 and fitted with velvet-lined trays to hold the trousseau of Princess Elena "Hélène" Sergeevna Shcherbatova, daughter of the aforementioned. It has an ingenious device in the base that enables it to be secured to the floor, locking all the drawers at the same time.

In another book entitled *Juveler och Juveldyrkare* (Jewels and lovers of jewels), by the Swedish author Knut Bonde,[48] there is a charming personal account in the chapter entitled "Jewel-poor Sweden" of how the Bonde children from a young age learned to appreciate magnificent jewels:

The Swedish envoy to St. Petersburg Gustaf af Nordin in 1846 married the Russian princess Helena Scherbatov. She brought with her a dowry consisting of absolutely divine jewels, which were inherited by her daughter Olga, married to Count Carl Lewenhaupt, the well-known Askecount's father. He was the brother of my paternal grandmother. The Lewenhaupts had two rooms in the Bonde palace at their disposal every time they came to Stockholm from their manor Aske. Each time Aunt Olga was invited to court, it was the custom in our family to get together to admire her jewels.

Once, when visiting grandmother, I was also able to admire the greatest part of Aunt Olga's jewels…One evening—I was a boy of twelve or thirteen—grandmother sent for me and my brother Magnus. She had something to show us. Curious as we were, we scampered across the yards up to grannie…We came into her corner parlor, and on the large drawing-room table stood the jewel case. It contained part of the Scherbatov jewels. Grannie gave us permission to open the case and to empty its contents onto the table.

The most costly of the jewels were a collection of large diamonds, the one in the middle was at least as big as a twenty-five öre coin in my opinion, but one usually is mistaken about the size of glittering gemstones. Grannie pointed out the smallest diamonds near the clasp and told us that a jeweler from Paris had been here in order to buy just one of these stones as it was known in the world of European jewelers on account of its superb quality. There was also a necklace with three strands of large pearls, but I thought that the gold clasp set with half pearls was not worthy of the necklace. I found the host of gold hairpins peculiar. On each of them there was, mounted on a spiral, a clover leaf consisting of three large diamonds. There were furthermore massive round diamond brooches and large turquoises set with diamonds.

Grand-maman told us that the treasure trove (of Aunt Olga) also consisted of a large Russian tiara, a *kakoschnik* [sic] set with diamonds, but that it was at the bank or perhaps left at home in Aske. It was not the custom in those days to keep one's jewels in a bank safe. And then there was a pair of heavy drop earrings, which Auntie Olga hardly ever wore. There were many more Scherbatov jewels, but what forever stuck in my mind was the rivière.

Two brooches
Unknown makers, St. Petersburg, c.1846
Gold, turquoises, diamonds
Private collection
Photo: Per-Åke Persson

Pendant
Unknown maker, St. Petersburg, c.1855
Gold, enamel
Private collection
Photo: Per-Åke Persson

The pendant was possibly a mourning jewel made at the death of Princess Shcherbatova in 1855.

List of the Trousseau of P^{ss} Hélène Scherbatoff
28 July 1846.

The list contains 34 pages: Linge (linen) de 1. à 4. / Lingeries (lingerie) de 4. à 7. / Rubans (ribbons) 8 / Fichus, Echarpes (fichus and scarves) 9. / Robe de Noce (wedding dress) 10. / Manteau de Cour (court dress) 11. / Robes Parées (ball dresses) 12. / (13 blank) / ——— de Soirées (evening dresses) 14. / ——— Montantes (afternoon dresses) 15. / ——— [de] Chambre (negligees) 16. / Mantilles (mantillas) 17. / Manteaux (coats) 18. / Fourrures (furs) 19. / Coiffures (headdresses) 20. / Bonnets (bonnets) 21. / Fleurs (flowers) 22. / Chaussures (shoes) 23. / Mobilier (furniture) 24. / (25 blank) / Argenterie (silverware) 26. / (27 blank) / Ecrin (jewel casket) 28. / Bijoux Divers (miscellaneous jewels) 29. / (30 blank) / Brinborions (bibelots) 31. / (32 blank) / Equipages (carriages) 33. / Objets Divers d'Usage (miscellaneous objects) 34.

LIST OF THE JEWELRY IN THE TROUSSEAU OF PRINCESS SHCHERBATOVA[49]

[Page] 28

Jewel Casket In a Box offered to Emperor Alexander by Emperor Napoléon

Containing

A Comb in Diamonds Forming a diadem.

15 Ears of wheat en Diamonds.

4 Pins in Diamonds.

A Rivière of 38 Collets.

Earrings in Diamonds.

Small Clasp, Pin.

Clasp in Diamonds with blue stones.

Three strings, One Hundred and Ten Oriental pearls, and small clasp mounted in Gold, with three pearls.

Demi-Toilette Sets in Amethysts, mounted in Gold.

Comb forming a Diadem

Necklace

Earrings

Brooch

Two Bracelets

[Page] 29

Miscellaneous Jewelry

A Bracelet, Serpent

Pavéd with Turquoises

A ——— in Gold, with a Talisman brought from Constantinople in carnelian.

ditto in Gold, with a Heart-shaped Turquoise.

A Brooch, Turquoise mounted in Enamel and Roses.

The family says that the fifteen ears of wheat could be put together to form a tiara as well as be worn separately, pinned to a dress. They were sold by Gustaf af Nordin to finance his purchase of Forsbacka estate outside of Gävle, Sweden.

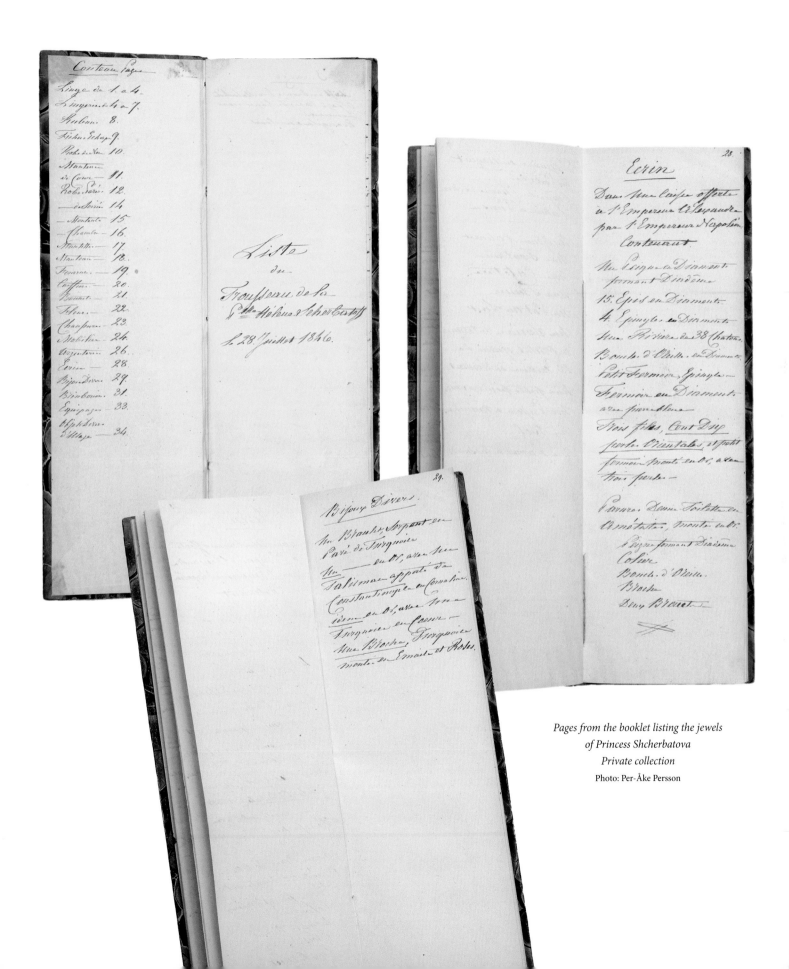

Pages from the booklet listing the jewels
of Princess Shcherbatova
Private collection
Photo: Per-Åke Persson

Princess Zinaida Ivanovna Iusupova
Christina Robertson, 1840s
The State Hermitage Museum, St. Petersburg

*Princess Iusupova, née Naryshkina (1809–1893),
can be seen wearing a gold sautoir, a classic devant
de corsage with a large red cabochon stone (possibly
an almandine garnet), and pearl drops. Four modest
bracelets set with pearls and precious stones adorn
her wrists—these were the latest fashion of the day.*

Princess Zinaida Ivanovna Iusupova

Prince Feliks Iusupov gives the following detailed account of his grand-mother in his memoirs *Lost Splendour*:

When a child, I had the rare good fortune of knowing one of my great-grandmothers, Zenaïde Ivanovna, Princess Youssoupoff, Comtesse de Chauveau by a second marriage. I was only ten when she died, but she still remains deeply impressed upon my memory.

She was one of the most beautiful women of her generation. She had led a very gay life and had had numerous love affairs, among them a romantic attachment for a young revolutionary whom she followed to Finland where he was interned in the Sveaborg Fortress. She bought a house on a hill facing the prison in order to be able to gaze at her beloved's window from her room.

When her son married, she gave the young couple her house on the Moïka Canal in St. Petersburg and went to live in Liteinaïa Street in a smaller replica of the Moïka residence.

When I was sorting her papers long after her death, I discovered, among a mass of correspondence with the greatest names of her day, a series of letters from the Emperor Nicholas I, which left no doubt as to the nature of their relations. In one of these letters the Tsar offered her The Hermitage, a pavilion in the park of Tsarskoïe-Selo and invited her to spend the summer there, in order to be nearer him. A draft of her reply was pinned to his letter. Princess Youssoupoff thanked the Tsar for his charming attention, but refused his gift, saying that she was used to living in her own houses, and the number of her estates was amply sufficient for her needs. However, she bought a piece of land adjoining the Imperial Palace and built a pavilion on it which was an exact copy of the one offered by the Tsar. Both the Emperor and his wife frequently visited her there.

Two or three years later, having quarreled with the Tsar, she went abroad. She settled down in Paris and bought a house in the Parc des Princes. All Paris of the Second Empire flocked there. Napoleon III took a great fancy to her, but his advances met with no response. At one of the balls given at the Tuileries, a handsome young Frenchman of modest extraction was introduced to her. His name was Chauveau. She was greatly taken by the good looking young man, married him, bought him the Château de Kériolet, in Brittany, and obtained for him the title of Count, and for herself that of Marquise de Serre. The Count de Chauveau died soon after their marriage, bequeathing the Château de Kériolet to his mistress. The Countess, furiously angry, bought the château from her rival at an exorbitant

The mansion, named 'Rauhaniemi' (peninsula of serenity), on the seashore overlooking the fortress of Sveaborg, was built in 1842 after designs by the architect A. F. Granstedt. Helsinki, capital of the grand duchy, was at the time a fashionable getaway for the Russian aristocracy. Princess Iusupova is known to have spent several enjoyable summers there from 1841 to 1850.

price and gave it to the state on condition that it should be turned into a museum.

We used to visit my great-grandmother in Paris every year. She lived alone with a companion in her house in the Parc des Princes. We used to stay in a pavilion connected to her house by a subterranean passage, and never called on her except in the evening. I can see her now, enthroned majestically in a huge armchair, the back of which was decorated with three coronets, the emblems of her triple rank of princess, marchioness and countess. In spite of her extreme old age, she was still beautiful and had retained an imposing appearance and aristocratic bearing. Always very carefully made up and perfumed, she wore a red wig and an impressive number of pearl necklaces.

She was strangely mean about some little things. For instance, she invariably offered us mouldy chocolates, which she kept in a box made of rock crystal studded with precious stones. I was the only one who would eat them, and I really believe this was the reason why I was her favourite. On seeing me accept what everyone else refused, Granny would caress me affectionately, saying: 'I like this child.'

She was a hundred years old when she died in Paris, in 1897. She left my mother all her jewels, my brother the house in Parc des Princes, and to me her houses in St. Petersburg and Moscow.

In 1925, when I was a refugee in Paris, I read in a Russian newspaper that the Bolsheviks, while searching our house at St. Petersburg, had discovered a secret door in my great-grandmother's bedroom; this door led to a room in which was a coffin containing the skeleton of a man. I pondered over this mysterious discovery for a long time. Could the skeleton have been that of the young revolutionary she had loved? Had she hidden him in her home, after helping him to escape? I recollected that years before, while going through my great-grandmother's papers in this very room, I had felt strangely ill at ease and even asked my manservant to stay with me so that I should not be alone.

BRILLIANT MATCHES

Of the many well-connected young ladies of the Grand Duchy of Finland, only two made truly brilliant matches in the Russian Empire. They were the Stjernvall sisters Aurora (1808–1902) and Emilie (1811–1846). They were born into a close-knit Swedish-speaking Finnish noble family. Their father was Lieutenant Colonel Carl Johan Stjernvall, governor of Vyborg. He died in 1815, and the following year his young widow, née Eva Gustafva von Willebrand, remarried State Counselor Carl Johan Walleen, who became a good husband and stepfather to the four Stjernvall children, doing his utmost to create a successful life for his family.

In December 1825, a group of Russian officers from the most distinguished families tried to stage a coup d'état. Their plan was to wipe out the autocracy and replace it either with a constitutional monarchy or a republic. The mutiny was put down in no time at all and the officers harshly punished. Five of the Decembrists—as they were called—were sentenced to death, one hundred and sixteen men were sent to labor camps in Siberia, and twelve were degraded and deported to distant garrisons. In the latter group was twenty-eight-year-old Count Vladimir Alekseevich Musin-Pushkin (1798–1854).

The small provincial town of Helsinki at first glance must have seemed the end of the world for a former captain in the elite Izmailovskii Regiment. However, he was soon to have reason to revise his initial impression. Being a member of an illustrious Russian family, with a winning personality, he became the center of interest in the social circles of the grand duchy. He formed friendships with young men who had a similar outlook on life and became a frequent guest at Governor General Arsenii Andreevich Zakrevskii's table; but more importantly, he fell in love. The object of

Countess Emilie Musina-Pushkina
Unknown artist, 1844
National Gallery, Central Art Archive, Helsinki
Photo: Janne Mäkinen

his affection was sixteen-year-old Emilie Stjernvall, a petite and delightful girl with a roguish twinkle in her blue eyes.

Musin-Pushkin proposed to Emilie in 1827. He asked her stepfather for her hand, and his request was met with an affirmative answer. Consent within his own family was more difficultly obtained. A young girl with no title and no dowry to speak of (compared to Russian standards) was seen as far from appropriate. The groom-to-be traveled to Moscow and was finally successful in convincing his mother to give her blessing. The engagement was announced in March of 1828. The news created a storm of surprise and became the talk of the season in both St. Petersburg and the grand duchy. The wedding was celebrated in May of that same year in Vyborg, where Musin-Pushkin's regiment had been transferred. That autumn he was sent to remote Caucasia. His young wife was pregnant and not able to join him. Her new home became the Musin-Pushkin residence in Moscow, under the wings of her mother-in-law and her husband's siblings. He was eventually pardoned for his involvement with the Decembrist uprising and returned home to take care of his estates and growing family.

Sublieutenant Aleksandr Alekseevich Mukhanov came to Helsinki in 1824 as adjutant of the Polish-born governor general Count Arsenii Andreevich Zakrevskii. Young Mukhanov was a member of a prominent Russian aristocratic family, the son of Senator Aleksei Il'ich Muhanov and Princess Varvara Nikolaevna Trubetskaia. He was highly educated, had literary interests, and was socially talented. In Helsinki, he became friends with the poet Evgenii Abramovich Baratynskii, who had been dismissed from the Corps of Pages for some offence and transferred to an infantry regiment in the grand duchy as punishment. The two young men both fell in love with sixteen-year-old Aurora Stjernvall, who had just come out. The former charmed the young girl, while Baratynskii declared his love for her in beautiful poems.

On May 12, 1830, the Helsinki newspapers announced, "His Imperial Majesty in his benevolence has...appointed Mademoiselle Aurora Stjernvall, daughter of the deceased governor of Vyborg, Carl Johan Stjernvall, maid of honor of Her Imperial Majesty the Empress." She was introduced to the monarch in Helsinki in August 1830, was presented at court two years later, and the following summer, when the imperial couple visited the grand duchy, was invited to be part of the empress's personal entourage.

Another two years passed. They had been difficult ones for Aurora; her heart had been broken when her fiancé, Aleksandr Mukhanov, unexpectedly passed away in September 1834, more or less on the eve of their wedding day. It was a great consolation when, in December 1835, Aurora

Alexandra Stjernvall
Unknown artist, c.1833
Courtesy of the Emil Cedercreutz Museum, Harjavalta, Finland

Alexandra "Alina" Stjernvall (1812–1850) was the daughter of Carl Johan Stjernvall and Eva Gustafva von Willebrand and younger sister of Aurora and Emilie. She was appointed a maid of honor of Empress Alexandra Feodorovna in 1833. In 1839, she married José Maurício Correia Henriques, 1st Baron (1842), 1st Viscount (1854), and 1st Count (1871) de Seisal, the Portuguese envoy in Paris.

Grand Duchesses Ol'ga and Maria Nikolaevna
Carl Timoléon von Neff, 1838
The State Russian Museum, St.Petersburg

was appointed maid of honor of the suite. At the start of the new year, she came to the Winter Palace to commence her service to the empress and her daughters. Although she was only there for six months, she won the sympathy and high regard of the monarch, the empress, and the imperial children.

Queen Olga of Württemberg, daughter of Nicholas I, mentions Aurora in her reminiscences. When she began her service to the empress, the then fourteen-year-old Grand Duchess Ol'ga Nikolaevna was disconsolate; she had recently lost her beloved governess.

> I therefore intently allied myself with Aurora Stjernvall, who at the time had been appointed maid of honor…she was a rare beauty both in body and soul, and her beauty was reflected in her features. When she spoke about the forests, hills, and lakes of her homeland, her eyes shone. The look in her eyes, her posture radiated pride and integrity, she was a genuine Scandinavian. Pavel Demidov, a rich uncongenial nabob, asked for her hand. She declined his proposal twice, but he did not give up. Not until Maman spoke in favor of matrimony did she agree. "Think of how much good you can do" settled the matter. On her wedding day, she gave me a tear from the depth of her heart. It was a small black enameled heart set with a diamond; I have preserved it carefully.[50]

Aurora was at this time (1836) twenty-eight, and there was a good chance she would remain a spinster. The empress was concerned about her future and found a suitable fiancé in Pavel Demidov. Aurora still mourned her lost love. Demidov was old and far from attractive in her opinion, and his health left much to be desired.

Aurora's service with the empress ended in November 1836. She consented to marriage with Actual State Counselor, Master of the Hunt Pavel Nikolaevich Demidov, one of the wealthiest men in the Russian Empire. Together with his brother Anatolii—Count and later Prince of San Donato, who was married to Princess Mathilde Bonaparte, niece of Emperor Napoleon—he was the heir to vast mining interests in the Ural Mountains. The bride received exceptional morning gifts: four strands of magnificent South Sea pearls as well as the legendary Sancy diamond. Ingrid Qvarnström gives us a description based on Aurora's correspondence with her relatives: "The pearl necklaces and the fabulous jewel *le Sancy* lay inside a magnificent casket artistically made of all the decorative minerals found in the Demidov Ural mines."[51] These wedding gifts became a sensation in the salons of St. Petersburg and Paris.

Pavel Nikolaevich Demidov as a young man
Jean-Baptiste Singry, 1817
Courtesy of Christie's

Aurora Karlovna Demidova, née Stjernvall
Karl Brüllow, c.1836
Courtesy of Sotheby's

The newly married Mme Demidova is depicted with very little jewelry—a simple bangle bracelet and a gold ring—possibly to enhance her natural beauty.
Her turban was much in vogue at the time.
The portrait, of which at least one copy was made, originally hung in one of the Demidov residences in Ekaterinburg, where the head office of the family's mining concerns was located.

THE SANCY DIAMOND

The Sancy diamond (also known as the Grand Sancy to distinguish from the Beau Sancy), weighing 55.23 carats, has a long and rather convoluted history, and much of what has been written about it over the past two centuries is pure fiction. Pavel Nikolaevich Demidov inherited the gem from his father and presented it to his bride Aurora Stjernvall as a morning gift in 1836.

The Sancy was part of the French crown jewels during the eighteenth century. It was set into the apex of the crown worn by Louis XV at his coronation, and Queen Marie Leszczyńska often wore it as a pendant in a necklace. Diamond jewelry at the time was worn on a wide ribbon of silk or velvet, usually black. In addition to setting off the stones, it served the practical

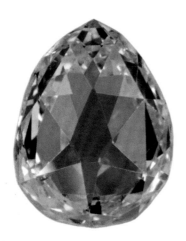

The Sancy diamond

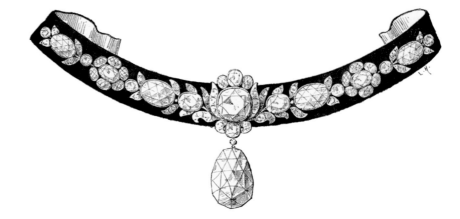

Drawing of a necklace with the Sancy diamond as worn by Queen Marie Leszczyńska

function of protecting the wearer's skin. Silver, the only known "white" precious metal then in use for setting diamonds, tarnishes and marks the skin.

The Sancy was purchased in January 1828 by Aurora Stjernvall's future father-in-law, Nikolai Nikitich Demidov, who lived in grand style in his palace at San Donato outside Florence and entertained lavishly. "His guests were struck with amazement visiting his salons...Large showcases were filled to the brim with precious objects and jewels, among them the legendary Sancy, the seventh largest of all the known diamonds in the world. There were in addition magnificent pearls, rubies, emeralds, and sapphires, which enchanted the ladies who saw them."[52]

Pavel Nikolaevich passed away in 1840. Aurora and her only child, Pavel Pavlovich, born in 1839, became heirs of an enormous fortune. As a widow, she divided her time between St. Petersburg, Helsinki, and the capitals of Europe. Her jewelry was entrusted to the Paris jeweler Jules Fossin. He (along with Menière and Bapst) was court jeweler to King Louis Philippe. Fossin created a new setting for the Sancy in 1841. It was inspired by the necklace once worn by Queen Marie Leszczyńska. The description of it has survived in his archives: "a collier in silver enameled in sapphire blue and encircled by diamond-set ribbon ornamentation." The Sancy was suspended centrally below a gold bow richly set with diamonds. The blue enameled necklace corresponded to the silk or velvet ribbon of the Queen's necklace.[53] Aurora Demidova wore her diamond in this rococo setting for five years. Fossin was once again commissioned to rework the jewel in 1846. It was the year Aurora married for a second time, to Captain (later Colonel) Andrei Nikolaevich Karamzin, son of the famous historian and au-

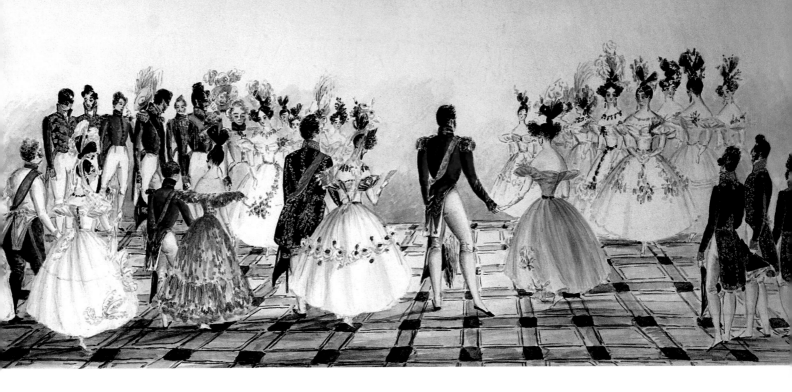

*Court ball in the Winter Palace
during the reign of Nicholas I*
August Mannerheim, 1830s
*Courtesy of Baron Mikael Aminoff, Rilax Manor,
Finland*
Photo: Douglas Sivén

thor Nikolai Mikhailovich Karamzin and his wife Ekaterina Andreevna Kolyvanova. The Sancy was now suspended from a rivière consisting of large brilliant-cut diamonds; a simple yet striking design.[54] Ingrid Qvarnström, quoting from the letters written between 1848 and 1849 by Aurora Karamzina to her sister Aline, provides us with personal glimpses into the most exclusive Parisian salons of the time:

> Last night the Austrian ambassador arranged a ball. It was magnificent for Paris, but cannot possibly be compared to one arranged in St. Petersburg. The guests were dancing in two ballrooms. Generally speaking, the dresses of the ladies were beautiful, but not exceptional—I, on the other hand wore a dress of corn-colored moiré, the most beautiful color I have ever seen in this style, with a frill of Brussels lace suspended on both sides with two bouquets of garnet red velvet carnations and at my waist a similar bouquet mixed in with diamonds, or more exactly, a bouquet of diamonds into which I had put carnations, a garland of similar flowers in my hair, and earrings, and around my neck a necklace with the Sancy suspended as a pendant. My toilette was indeed, I dare say it myself, beautiful and totally tasteful. Princess Kochubei wore a profusion of jewels, a complete parure of rubies and diamonds around her neck, in her hair, and on her dress and so on and so on...
>
> You cannot even imagine the wonderful effect my Sancy and my pearls have here in Paris, it is almost ridiculous. I have even heard that there are ladies who have arranged an invitation for themselves to the houses where I am a frequent guest only to catch a glance of my pearls;

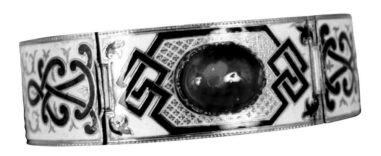

Bracelet decorated with arabesques
Unknown maker, St. Petersburg, 1846
Gold, almandine garnet, enamel
Courtesy of the descendants of Natalia Heiroth
Photo: Katja Hagelstam

The bracelet, with the crowned initials of Empress Alexandra Feodor-ovna, is engraved "Palerme, le 4 juin 1846." It was a gift to Natalia L'vovna Beketova (later Heiroth) from the empress.

Heart-shaped pendant with the crowned cipher of Emperor Nicholas I
Unknown maker, St. Petersburg, 1852
Gold, almandine garnet, diamonds
Courtesy of the descendants
Photo: Katja Hagelstam

The pendant was given by Emperor Nicholas I to his goddaughter Olga Heiroth.

it is not really very flattering for me, because I am myself eclipsed by my jewelry. And André assured me last night at the ball that he always knew my whereabouts because of the crowd of people that gathered around me and followed me around, and all of this due to my Sancy. I myself also heard wherever I moved loud whispers: Look there is the Sancy! Look at the Sancy![55]

Aurora Karamzina decided to sell the costliest of her jewels in 1865 to pay the gambling debts her son had incurred. The Sancy was purchased by the court jeweler Garrard in London, who in turn sold it to Sir Jamsetjee Jejeebhoy, 2nd baronet (1811–1877). The famous diamond was displayed at the 1867 Universal Exposition in Paris by Bapst, Napoleon III's court jeweler, at which time it valued at one million francs. It was in the collection of William Waldorf Astor (1848–1919), later Viscount Astor, the American-British financier and statesman, by 1906, the year in which he presented it as a wedding present, set in a tiara, to his daughter-in-law, née Nancy Witcher Langhorne (1879–1964).[56] Today the magnificent diamond is back in France and can be admired in Galerie d'Apollon at the Louvre, where it is exhibited next to other famous French crown jewels.

GIFTS TO FRIENDS AND GODCHILDREN

A number of imperial gifts of jewelry have survived from the reign of Nicholas I in the former grand duchy of Finland Among them there are pieces that can be classified as "personal mementos." One example is a gold bracelet with a red cabochon almandine garnet and decorated with Moorish-style arabesques in opaque enamel. It was a gift to Natalia L'vovna Beketova,[57] a maid of the chamber (*mladshaia kamer-iungfera*) of Empress Alexandra Feodorovna.[58] The staff of the empress's private chambers came into close contact with their august mistress. The nature of their daily tasks made them indispensable—they organized her wardrobe and saw to it that every detail of it was in good order. They communicated with the couturiers and modistes, took care of cleaning and minor repairs, and primarily assisted the empress with the ensembles she was to wear during the course of the day. It goes without saying that these were women with a knowledge of etiquette and fashion, and one or two of them accompanied the empress on all her trips within Russia and abroad. In 1846, the empress's physician in ordinary prescribed a longer sojourn in a warm climate for his patient, whose health had become alarmingly frail. Palermo in Sicily was chosen as the destination. Natalia L'vovna was part of the imperial retinue on this trip and received the bracelet in commemoration of it.[59] It is engraved with the empress's crowned initials AF with the text "Palerme, le 4 juin 1846." The piece itself is typical of the era and the Romantic movement in that it combines elements of various cultures. In this it symbolizes the city of Palermo itself, where ancient Greece and Rome met with the cultural influences of the Normans and Arabians.

Three years after the visit to Palermo, Natalia L'vovna married Colonel (later Major General) Alexander (Aleksandr Fedorovich) Heiroth. Their daughter Olga writes in her reminiscences:

The Empress was present when my mother was dressed for the wedding ceremony in the Winter Palace and herself attached her gift of diamond earrings on my mother's ears. These jewels have survived…The Empress gave my mother her entire trousseau: silver, linen, and evening gowns; the Emperor in his turn gave the bride and groom the gift of a small property and 25,000 rubles so that my parents could build themselves a house…Simultaneously the Emperor appointed my father superintendent of all the imperial palaces in Peterhof…On the morning of the day I was born, the Emperor passed by our house. His Majesty had his aide-de-camp inquire about the "health" of my mother. He was informed that Madame had been "taken ill" during the night. At around noon the Emperor once more had his aide inquire, and finally a third time, in the evening, at which time he was informed of my arrival. He then declared his august wish to become my godfather. At my christening ceremony, my mother received a diamond brooch from the emperor.[60]

The Heiroths had a total of five children. Their daughter Olga, born in 1852, was, as mentioned, the goddaughter of the emperor. Olga's younger sister Lydia, born in 1856, was the goddaughter of Empress Alexandra Feodorovna.[61]

Every summer, when the empress lived in Peterhof, the child was brought to Her Majesty on a complimentary visit. I remember that on one of these visits, the empress, when she had taken my little sister into her arms, asked her, "How old are you?" To this my sister Lydia replied bravely and fearlessly, "I am four years old."

Information on the empress's christening gift to Lydia has not survived. However, one further gift by the emperor to Olga is known—a gold pendant set with a large heart-shaped almandine garnet. Its only décor consists of the engraved crowned initial N set with diamonds. It is interesting that both mother and daughter received gifts of jewelry set with almandines. The beautiful gemstone possibly had some importance to both the donor and the recipients. Was it the deep red color and shimmer that fascinated them, or the knowledge that this stone has been important since ancient times and was one of the first precious stones used by mankind in jewelry? It was already a popular stone in ancient Egypt, but even more so in ancient Greece. Virtually all fine gold jewelry was set with almandines during Hellenistic times.

GUSTAF EHRSTRÖM

Eric Gustaf Ehrström (1791–1835), vicar of the Lutheran Church of St. Catherine in St. Petersburg, had an extraordinary life. He was born in East Bothnia, Finland, son of the chaplain Anders Ehrström and his wife Anna Maria Reinius. The clergyman had a large family, ten children in all, of whom two died young. The parents considered it important to give their sons an academic education. Gustaf was enrolled at Åbo Akademi, the Swedish university in Turku, where he, at the age of twenty-one, received a grant to study Russian at the university of Moscow. This was during the disastrous year of 1812, when Napoleon with his armies marched towards Moscow and the city was set on fire by its inhabitants in order to stop the enemy. The Muscovites fled the burning city, and Gustaf Ehrström was among them. His reminiscences from Moscow and the escape are preserved in his highly interesting diaries.[62]

When back in his homeland after the war, Ehrström continued his studies at the university. He earned his doctorate in 1815 and was appointed professor of Russian language and literature at his alma mater. He was the author of an important textbook on the Russian language, for which he received the Order of St. Vladimir third class and a diamond ring with the cipher of Emperor Alexander I (for a similar ring see page 60).[63]

But a university professor's salary was modest in those days, and Ehrström, unable to support his growing family, began to study theology and was ordained clergyman. He was appointed vicar of the Lutheran church of St. Catherine in St. Petersburg in 1827. The church and the home of the

vicar was an important meeting place for the many Swedes and Swedish-speaking Finns who lived and worked in the Russian capital. It was a lively center of social, cultural, and intellectual activity; a haven for those newcomers who did not have any sort of social network or family to support them.

Gustaf Ehrström's first wife was Ulrika Lovisa Ahlstedt, a socially active person, highly committed to helping people in need. She was presented with a costly diamond and aquamarine *fermoir* during an official visit of Emperor Nicholas I to the Church of St. Catherine in gratitude for her valuable services. She tragically died in 1831. The life of a widower is not easy, especially for a person with a great deal of responsibility, not to mention seven motherless children. A year after the passing of his wife, Ehrström found a new love. His letters to her from the time of their engagement have survived and detail this fledgling romance.

At home in St. Petersburg, 15 (27) March, 1832.
Here I am in my home surrounded by my little ones, writing to you my heart's beloved. I miss you in all and everything. My heart is overflowing. Alas, I would have so much to tell you, enough for an entire book. Only you are able to spread days of happiness in my life.

The recipient of the letter was Fredrika Schulman, the twenty-five-year-old daughter of a colonel in the small provincial town of Porvoo (Borgå) in the Grand Duchy of Finland, where she had grown up sheltered from the outside world.[64] They were a mismatched couple, but *amor vincit omnia*, and Fredrika and Gustaf were married in September 1832 at Gammelgård, the bride's home. We know very little of how she fared as stepmother to seven small children, but an educated guess is that her task was not an easy one. The couple's matrimonial bliss was short lived. Both Fredrika and Gustaf took ill three years after the wedding. He passed away in 1835; she, a year later. The seven children were cared for by family members.

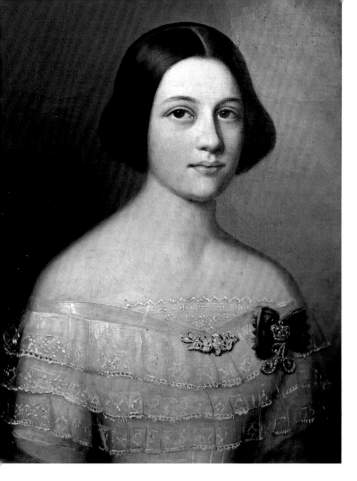

The fermoir could either be used as a clasp in a pearl necklace with four or five strands or as a brooch. A small slip of paper inside the original box reads (translated from Swedish), "This fermoir belonged to a pearl necklace which Alexander II presented to the Governor's wife Jenny Thesleff, née Thesleff, (because he was) enraptured by her beauty."

Eugénie "Jenny" Thesleff wears the diamond cipher of Empress Alexandra Feodorovna on the light blue ribbon of the Order of St. Andrew.

LADIES OF THE IMPERIAL COURT

A whole new group of Finnish young ladies were appointed maids of honor (*freiliny*) of Empress Alexandra Feodorovna. They were daughters of important men who had served the empire in high positions within the grand duchy.[65]

The insignia of the maids of honor consisted of the crowned initial(s) of the empress(es) in diamonds. It was worn on the left shoulder suspended from the light blue ribbon of the Order of St. Andrew. Originally introduced by Catherine II, the design was revised at the very beginning of each new reign or at the death of a dowager empress. When Nicholas I ascended the throne in 1825, the cipher consisted of the initials MEA—that of his mother, Dowager Empress Maria Feodorovna, his sister-in-law, Dowager Empress Elizabeth Alekseevna, and his wife, Alexandra Feodorovna. His sister-in-law died shortly afterwards, in 1826, and his mother passed away in 1828. Between the years 1828 and 1855, the cipher consisted of the initial A for Empress Alexandra Feodorovna.

The cipher was worn whenever court dress was prescribed, such as court balls, religious holidays, imperial anniversaries, weddings, baptisms, and funerals. A maid of honor, in spite of having retired from active service, was free to wear her insignia in private life at festive occasions.

Adelaide Armfelt (1825–1871) was the daughter of Lieutenant General Count Gustav Magnus Armfelt and Louise Cuthbert-Brooke. She married Major Jakob Erik Göran Gripenwaldt in 1849.

The cipher was presented to Countess Adelaide Armfelt in 1846.

Eugénie "Jenny" Thesleff was appointed maid of honor of the empress in 1842. She was born in Helsinki in 1827, daughter of General of the Infantry Alexander Amatus Thesleff and Johanna Maria Helsingius. Her father held the post of governor general from 1833 to 1847, standing in for Prince Aleksandr Sergeevich Menshikov, who was sent on other missions by the emperor during those years.[66] Thesleff was, in other words, the highest ranking official in the grand duchy, in addition to being the commander of the Russian troops stationed in Finland. The Thesleff family lived in the governor general's palace in Helsinki and entertained on a level commensurate with their rank. There are notes with regard to the governor general's daughter Eugénie in the family's reminiscences.[67] Jacob K. Grot, professor of Russian and director of the Russian library at the Imperial Alexander University in Helsinki, mentions her in a letter to his friend P. A. Pletnev in St. Petersburg, "The maid of honor Eugénie Thesleff and Mademoiselle Olga Armfelt are both delightful and will surely become the foremost beauties of Helsingfors. I, however, prefer Mademoiselle Thesleff—her face expresses so much goodness." In another letter he says, "As far as beauty is concerned, Mademoiselle Thesleff is superior to any of the others, but she still is more or less a child." [68]

Eugénie married her first cousin Colonel Alexander Adam Thesleff in 1845. The young family settled at his estate Kavantholm near the city of Viipuri. There still are objects commemorating an imperial visit in the home of their descendants: a jeweled *fermoir* and a fine teapot. When the future Alexander II called on the Thesleff family, he was served tea from this silver pot. After the visit it was named the "emperor's pot." The *fermoir* was a gift to Eugénie from the tsesarevich, and it was originally part of a necklace consisting of several strands of pearls. According to family tradition, the future emperor, during a ball at the Winter Palace, remarked to Colonel Thesleff, "Your young wife is beautiful, but she doesn't wear any jewelry."

Eugénie Thesleff's life did not pass beneath the bronze chandeliers of the Winter Palace, however. She was widowed early in life, after only eleven years of marriage, and had to raise her five children on her own under very strained circumstances. Having managed the family estate with strength and energy, it had a flourishing economy when handed over to the next generation. She also founded a Sunday school at Kavantholm for the village children, which gradually developed into the first primary school in the region.

SERVING SEVEN SOVEREIGNS
THE COURT JEWELERS BOLIN

Tiara

Bolin & Jahn, St. Petersburg, 1841
Gold, silver, pearls, diamonds
Reprinted from A.E. Fersman, Russia's Treasure of Diamonds and Precious Stones (Moscow 1925)

The tiara was made for Empress Alexandra Feodorovna, consort of Nicholas I. It became part of the crown jewels after her death and was worn at official functions by subsequent empresses.

The history of the court jewelers Bolin can be traced back to the 1790s, the last decade of the long reign of Catherine the Great. They are the sole representatives of their craft able to boast having continuously served seven Russian sovereigns. And the present generation in Stockholm with great pride serves as court jewelers to the Swedish royal family.

Saxon-born Andreas Römpler (?–1829), in his new homeland known as Andrei Grigor'evich, was the founder of the firm. He started out as a diamond merchant in St. Petersburg, but soon became a jeweler to the imperial court. He earned the confidence of the court officials early in his career and in 1823 was appointed appraiser of the Cabinet of His Imperial Majesty, the office in charge of commissioning objects in precious materials as imperial gifts and awards.[69] Vast quantities and a great variety were handled by the cabinet: exquisite gem-set snuffboxes, diamond orders and decorations, and all manner of precious jewelry. They were presented to Russian dignitaries, loyal state servitors, foreign statesmen and diplomats, or were gifts of a more private nature intended for family members and foreign royalty.

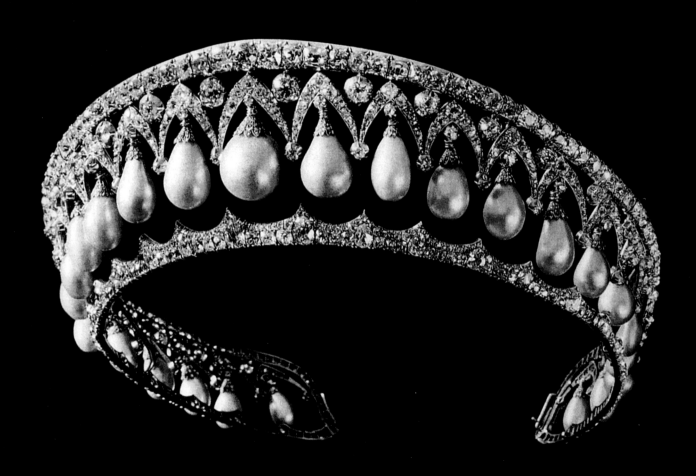

Carl Edvard Bolin
Unknown artist, 1830s
The State Hermitage Museum, St. Petersburg

The appraisers were official supervisors of court commissions, and it goes without saying that only an experienced craftsman could judge if an object met the requisite standards of quality and decide if the price of it was correct. To be an appraiser of the Cabinet of His Imperial Majesty was truly an honor for a goldsmith.

In 1812, Römpler engaged a young master goldsmith from his native Saxony, Gottlieb Ernst Jahn, to head the production of his firm. Jahn had apprenticed in St. Petersburg for Christoph Friedrich von Mertz and had become a journeyman (1802) and master (1812) under his auspices. The young master not only became his employer's close assistant, but also his son-in-law. His marriage to Sofia Römpler gradually earned Jahn a partnership in the family business. When his father-in-law died in 1829, Jahn became head of the company, supported by his mother-in-law Anna Geraselina Römpler. A widow who chose to continue a family business had the right to retain all the official benefits received by her husband. This also paved the way for her son-in-law to be appointed an appraiser of the Cabinet of His Imperial Majesty.

THE NEXT GENERATION

The next generation of the firm came from Sweden. Carl Edvard Bolin found his way to St. Petersburg in the hope of "striking gold." He was the son of a Swedish merchant and sea captain, Jonas Wilhelm Bolin, who made a living for himself, his wife, and their large family of twelve children in international trade. But Captain Bolin was not born under a lucky star; he was shipwrecked in the rough waters of the English Channel. Along with all his assets, he and one of his sons were swallowed up by the sea, leaving the large family destitute. Many of the children had happily reached the age of majority. Carl Edvard was twenty-six at his father's death. He was a born businessman and had therefore trained as a bookkeeper. His ambition was to become a rich man and therefore saw his future in the flourishing and rapidly growing metropolis of St. Petersburg. Arriving there in 1833, he found employment with Römpler & Jahn, and shortly afterwards, his future wife in the home of his employer. History was thus repeated; Carl Bolin (in Russia Karl Ivanovich) married Ernestine Catharina, the youngest daughter of Andreas Römpler. Through his marriage he became the brother-in-law of his boss and a co-owner of the family business.

Carl Bolin was amazingly talented and a fast learner. During their first years, the brothers-in-law had a clear division of tasks. Gottlieb Jahn, being

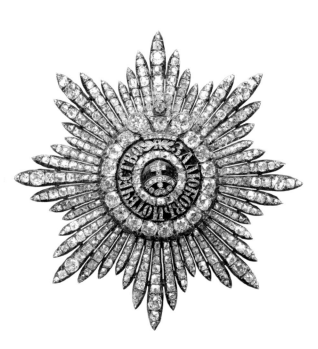

Star of the Order of St. Catherine
Unknown maker, 1850s
Gold, silver, diamonds, enamel

Bolin was one of the important makers of diamond insignia of the Russian orders.

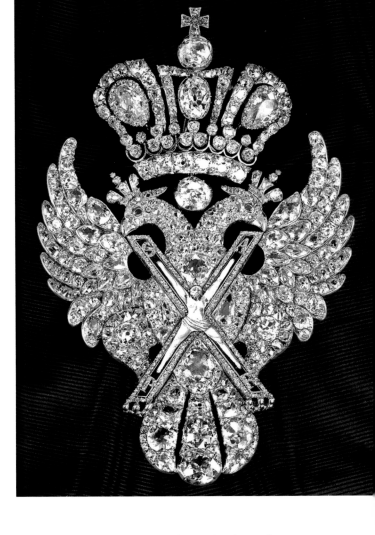

Badge of the Order of St. Andrew
Unknown maker, c.1800
Gold, silver, diamonds, rubies, enamel
Courtesy of Sotheby's

This badge was originally presented to Duke Georg of Oldenburg (1784–1812) in 1809.

a trained jeweler, headed the production, whereas Carl Bolin saw to the business side of things. However, in short order, Bolin decided to learn the secrets of the craft, and within a few years he had become a master in his own right. A new sign—Jahn & Bolin—was put above the door. The business developed into one of the foremost enterprises of St. Petersburg in the years to come, specializing solely in the creation and production of costly jewelry. This was a totally new concept among Russian goldsmiths, who until this time, in order to be successful, produced a whole array of merchandise. They became the jewelers of choice of the elite, as well as making personal pieces for the imperial family. No doubt superior craftsmanship combined with a true talent for business was the key to their success.

Gottlieb Jahn died in 1836, making Carl Bolin head of the business. The names on the shop sign were reversed, thereafter reading Bolin & Jahn. Sofia Jahn, née Römpler, remained an active member of the firm, thus retaining her widow's right to the benefits of her deceased husband. When in 1839 Emperor Nicholas I appointed Bolin crown jeweler, the same honor was bestowed on Sofia. The nomination was a personal one to the head or heads of a renowned business with several decades of service to the court. It required citizenship, and Carl did not hesitate to become a true Russian.

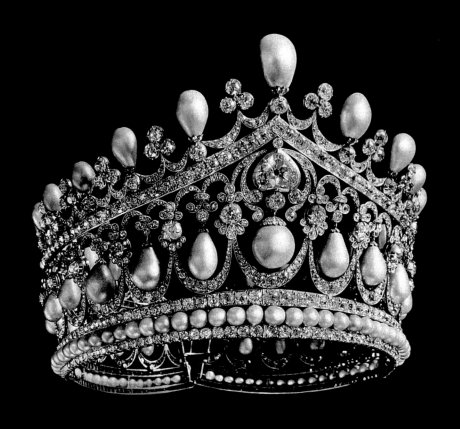

Empress Alexandra Feodorovna
Boissonnas et Eggler, 1906

The empress is photographed in full court dress for the opening ceremony of the first Duma. In addition to the tiara shown on the left, she also wears an array of exquisite pearl and diamond jewelry: a devant de corsage, a necklace, and a collier de chien from her private jewel box (possibly also made by Bolin), as well as her favorite pearl earrings. The small jeweled bracelets and the stunning diamond ring are also from the empress's personal collection. Her gem-set fan in carved mother of pearl with scenes from the coronation and St. Petersburg is described and illustrated by Fersman (no. 200, table XCVII, photo 228). To complete the full court dress, the empress wears her imposing diamond collar of the Order of St. Andrew and the sash, diamond badge, and star of the Order of St. Catherine.

Facing page, above:
Tiara
Römpler & Jahn, St. Petersburg, early 1830s
Gold, silver, pearls, diamonds
Reprinted from A.E. Fersman, Russia's Treasure of Diamonds and Precious Stones (Moscow, 1925). For details on the tiara, see note 73.

Facing page, below:
Tiara
C.E. Bolin, St. Petersburg, 1896
Gold, silver, emeralds, diamonds

Reprinted from A.E. Fersman, Russia's Treasure of Diamonds and Precious Stones, 1925, 3:29, plate LXXII
The tiara can be seen in the portrait of Empress Alexandra Feodorovna that opens the chapter on Nicholas II. It is designed in the Louis XVI style and set with the finest Columbian emeralds, the largest of which is a pyramid-shaped cabochon of approximately 23 carats, plus four rectangular and six round cabochons. The 880 diamonds weigh approximately 225 carats. Fersman and his team of authors (among them Agathon Karlovich Fabergé) were evidently not in favor of the design of this piece as their text reads, "This diadem, set with beautiful stones, is heavy and has sharp lines." It was part of a parure, probably a gift of close relatives of the empress, in connection with the coronation in 1896.

Brooch
C.E. Bolin, St. Petersburg, c.1910
Gold, silver, star sapphire, diamonds
Private collection
Courtesy of Christian Bolin, Stockholm

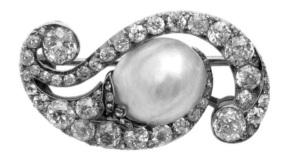

Brooch
C.E. Bolin, workshop of Robert Schwan, St. Petersburg, c.1896
Gold, silver, pearl, diamonds
Private collection
Courtesy of Christian Bolin, Stockholm
Photo: Per-Åke Persson

The title brought the firm even more success than before. Bolin employed up to fifty craftsmen in the early 1850s. They worked for the firm in several independent workshops, each headed by a master goldsmith, who stamped his production with his personal master's mark. The retail store was located on the Nevskii prospekt 71–73, on the corner of Griaznaia ulitsa.

In 1841, Bolin received an imperial commission to make a tiara in the shape of the traditional Russian headdress, the *kokoshnik*, for Empress Alexandra Feodorovna.[70] The tiara became part of the crown jewels after her death and was worn at official occasions by consecutive empresses. It is designed with twenty-five large pearl drops suspended from delicate diamond mounts, thus allowing the pearls to swing freely within the arched openings. Professor A. E. Fersman, legendary mineralogist and member of the Academy of Sciences of Russia, dates the tiara to the reign of Alexander I. He suggests it was made as early as 1815 and says, "[it] is typical of the perfection of Russian workmanship in the beginning of the XIXth century."[71] Fersman's assumption of the date of manufacture was not entirely wrong. The pearls and diamonds set in this splendid piece came from dismantled crown jewelry and from the stock of diamonds kept in The Cabinet of His Imperial Majesty. At all times and at every court, outmoded objects have been taken apart then recycled and designed to suit the latest fashion. Judging a piece merely from examining the cut of the gemstones can lead even an expert astray in his endeavor to determine the date of manufacture.[72]

Another of the magnificent tiaras made by Bolin is described by Fersman as "one of the finest specimens of its kind."[73] It was often worn by the last empress Alexandra Feodorovna; in fact it seems designed with her in mind. It is well known from the series of official photographs taken of her

by Karl Karlovich Bulla in 1906 after the opening ceremony of the first Duma (see pages 116–117). Seven different photographic angles have superbly documented the tiara for posterity. Her Majesty stood immobile on a turntable for this portrait, enabling the photographer to work without disturbing the meticulously arranged court gown with its long train, thus making the procedure easier for all concerned. Sadly the present whereabouts of this piece are unknown. It has in all likelihood been dismantled as it was so closely linked to this ill-fated sovereign, whose memory the new regime wanted to erase.

Shortly after the death of his brother-in-law, Carl Bolin sent for his younger (by thirteen years) brother Henrik Conrad (in Russia called Andrei Ivanovich) from Sweden to join him in the business. He quickly learnt the trade, matured into an efficient collaborator, and was soon fluent in Russian.

Imperial commissions remained an important part of Bolin's production during the following decades. These included orders for official gifts and awards, the most prestigious of which was the diamond portrait badges of the emperor and empress, which were given to the most eminent men and women of the empire. During the reigns of Nicholas I and Alexander II, Bolin was the leading manufacturer of these valuable objects. In addition, the firm produced hundreds of gem-set presentation boxes, insignia, and stars of the highest orders, which were all conferred upon highly ranked Russians as well as foreign heads of state.

Bolin took part in the grand 1851 Crystal Palace exhibition in London alongside his St. Petersburg colleagues, the jewelers Heinrich Wilhelm Kaemmerer and Leopold Saefftigen. He displayed both fine jewelry set with precious stones and designs in the fashion of the day—brooches and bracelets in the form of dragons, knots, and flowers.[74] This same year Carl Bolin was appointed appraiser to the Russian imperial court.

In 1852, Henrik Bolin decided to try and make a go of it on his own in Moscow and founded a jewelry firm there together with an Englishman by name of James Stuart Shanks. Their shop, Shanks & Bolin, was soon renamed Magasin Anglais by the Muscovites (not to be confused with St. Petersburg firm Nicholls & Plincke, which also bore this designation), and became the ultimate place to go for luxurious novelties such as gloves, fur collars, fans, umbrellas, and parasols. Shanks handled the business side while Bolin designed and crafted jewelry as well as silver and crystal items. The latter soon became the most profitable product line of the fast growing company. The two branches of the Bolin firm worked closely together, successfully selling each other's products.

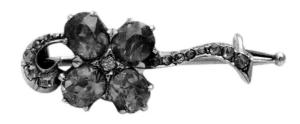

Brooch
C.E. Bolin, workshop of E.W. Schramm, St. Petersburg,
late 1890s
Gold, silver, demantoid garnets, diamonds
Private collection
Courtesy of Christian Bolin, Stockholm
Photo: Per-Åke Persson

The brooch has its original case with the name
C.E. Bolin printed on the silk lining of the lid.

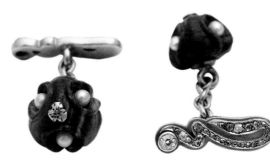

Cufflinks
C.E. Bolin, workshop of Vladimir Finikov,
St. Petersburg, late 1890s
Gold, malachite, pearls, diamonds
Private collection
Courtesy of Christian Bolin, Stockholm
Photo: Per-Åke Persson

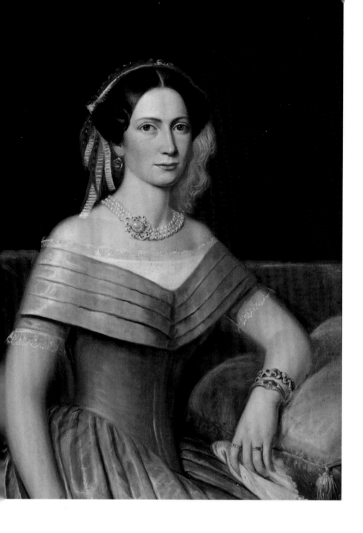

Bracelet of Baroness Munck
Jahn & Bolin, St. Petersburg, c.1847
Gold, cabochon almandine garnets, diamonds
Courtesy of the descendants
Photo: Katja Hagelstam

The garnets are set in the form of a cross. The piece was made to order by the court jeweler Jahn & Bolin for the wife of the well-known general of the infantry Baron Johan Reinhold Munck (1795–1865), former commander of the Preobrazhenskii Guards, the premier regiment of the Russian army formed by Peter the Great in the late seventeenth century. The bracelet, marked by the unknown workmaster CS, still has its original case with the name Jahn & Bolin printed on the silk lining of the lid.

Baroness Wilhelmina Margareta Munck
Possibly Johan Erik Lindh, c.1847
Courtesy of the descendants
Photo: Katja Hagelstam

Baroness Munck, née von Kraemer (1826–1889), wears two gold bracelets with garnets, the lower of which is seen on the right. She also wears a pearl necklace with a richly jeweled fermoir and earrings are in the shape of knots.

Carl Edvard Bolin died in 1864, leaving the business to his two sons Edvard Karlovich (1842–1926) and Gustaf Karlovich (1844–1916). The personal post of crown jeweler was renewed in favor of both brothers and that of appraiser of the Cabinet of His Imperial Majesty was "inherited" by Edvard. But more accolades were in store. In addition, to being given the title of commercial counselor, Edvard received the Order of St. Vladimir 3rd class and Gustaf that of St. Anne 2nd class, which brought with them hereditary honorary citizenship. The ultimate distinction, however, came in 1912 when both were elevated to the hereditary nobility by letters patent of Nicholas II. They were the only goldsmiths in Russia to be so honored, a clear indication of the importance of the firm's enduring service to the imperial family and court.

In 1869, the Bolin brothers purchased a house at Bol'shaia Morskaia 10 with the intent of moving the business to this address. The showrooms were situated on the *piano nobile* and the private apartments of the jewelers on the upper floors. The workshops were housed in the courtyard wings and had their main entrance on the opposite side of the block on the Moika canal.

The Moscow firm lost its founder, Henrik Conrad (Andrei Ivanovich) Bolin, in 1888. He had willed his fortune to his daughters and his business

Brooch
C.E. Bolin, workshop of Robert Schwan,
St. Petersburg, c.1896
Gold, silver, turquoise, diamonds
Private collection
Courtesy of Christian Bolin, Stockholm
Photo: Per-Åke Persson

Brooch
C.E. Bolin, workshop of Vladimir Finikov,
St. Petersburg, c.1900
Gold, sapphires, diamonds
Private collection
Courtesy of Christian Bolin, Stockholm
Photo: Per-Åke Persson

The brooch originally belonged to Grand Duchess Ol'ga Aleksandrovna.

to his son. Inheriting the firm was not altogether simple for Wilhelm (Vasilii Andreevich) (1861–1924), who was in great need of funding. It ultimately came from his St. Petersburg cousins, on the condition that the firm was to be called C.E. Bolin. That meant separation from Shanks, who continued under the name of Shanks & Co.

Vasilii Andreevich proved as brilliant a businessman as his father. C.E. Bolin of Moscow prospered with a growing line of silver items, many of which were designed in the Russian revival style as well as *stil' modern*, the Russian incarnation of Jugendstil and art nouveau in Western Europe. Vasilii Andreevich opened a branch office and showrooms in Bad Homburg, Germany, a spa frequented both by the German and Russian aristocracy. It proved to be propitious for Bolin the day the *ancien régime* of Russia came crashing down. He was able to transfer the stock from Germany to Stockholm, thus rescuing an important part of his valuable merchandise. All the assets of the Moscow firm were confiscated by the Soviets. The Bolin family had to bid farewell to their beloved homeland and settled in Stockholm, where they reopened their doors as W.A. Bolin, the name they still, as Swedish crown jewelers, bear today.

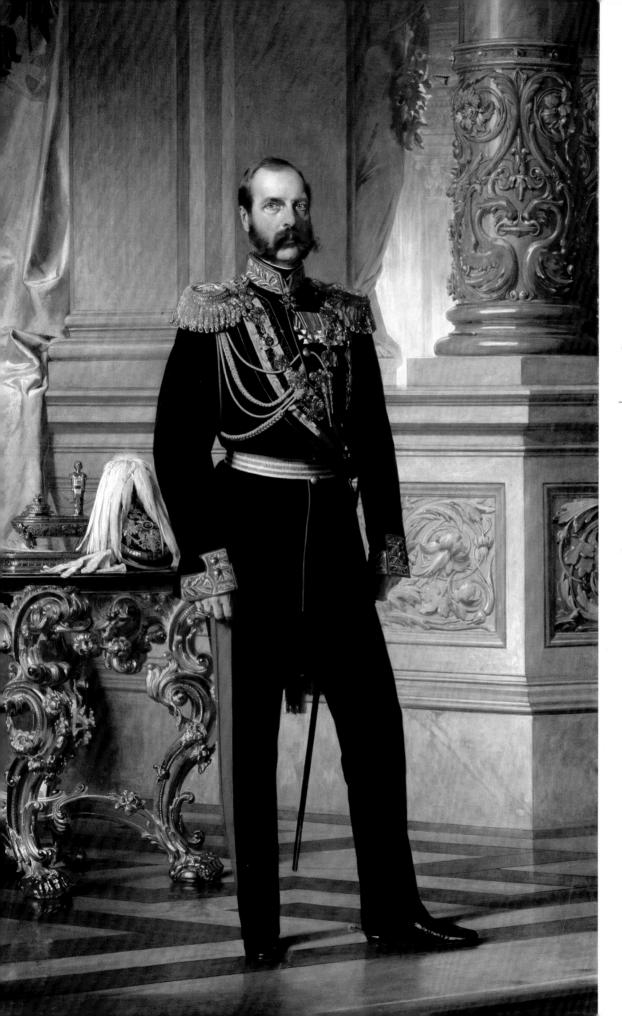

Emperor Alexander II
Heinrich von Angeli, 1876
The State Hermitage Museum,
St. Petersburg

*The emperor is wearing a full-dress
uniform of a general enrolled in the
Guards, along with the collar of the
Order of St. Andrew, the sash of the
Order of St. George first class, and the
insignia of general aide-de-camp
to his late father Nicholas I.*

Empress Maria Aleksandrovna
Franz Xaver Winterhalter, 1857
The State Hermitage Museum,
St. Petersburg

*The empress wears an abundance of
pearls, showcasing how they can el-
egantly be used to adorn the hair and
the wrist. The devant de corsage with
round and pear-shaped pearls
is a magnificent example
of its kind from the era.*

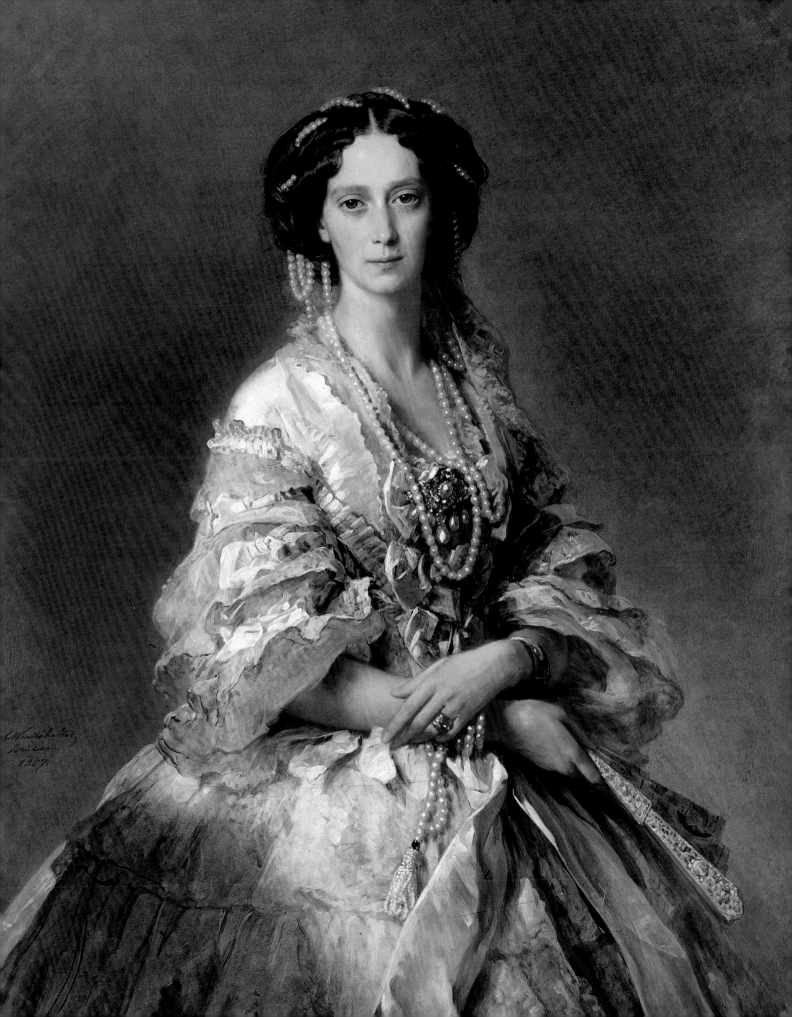

ALEXANDER II

1855–1881

Snuffbox with the cipher of Emperor Alexander II
Leopold Saefftigen, St. Petersburg, c.1876
Gold, diamonds, enamel
Porvoo Museum, Finland
Photo: Jan Lindroth

The snuffbox was given by Emperor Alexander II to the celebrated Finnish national poet Johan Ludvig Runeberg (1804–77) in recognition of his influential literary works. As it was only received a short time before his death, it was never used and is therefore in mint condition. The diamonds are of a superb quality and unusually large for this type of imperial award.

The reign of Alexander II coincided with historicism in the arts and crafts. This was the golden age of revival during which one style followed the other in rapid succession. Designers and artists delighted in combining elements that historically did not belong together. The era has playfully been described as the time of "the battle of the styles."

The goldsmiths also took part in this "style carousel," producing a profusion of the most imaginative and fanciful jewelry. It was neo-rococo, however, that dominated throughout the second half of the century. It had returned in the early 1840s, although in truth had never altogether disappeared from the jeweler's art since originally introduced during the reign of Empress Elizabeth Petrovna. It had endured throughout the time of Catherine the Great and her son Paul I, and traces of it were still to be seen under Alexander I. It was finally ready for a grand comeback when Alexander II ascended the throne.

Two neo-rococo jeweled bangles
Unknown makers, St. Petersburg, 1860s
Gold, silver, diamonds
Private collection
Photo: Katja Hagelstam

Brooch
Unknown maker, St. Petersburg, 1880s
Silver, tumbled amethyst quartz, rose quartz,
beryl, pearl, diamonds
Private collection
Photo: Katja Hagelstam

The rococo style was not stagnant during its long life, however, and continuously changed to reflect environment and culture. Its various phases had their own designations in Russia: "the second rococo" and even the "third rococo." The heyday of Petersburg's second rococo occurred mid-century. It was lush and exuberant. Jewelry at the time was crafted in a colorful gold alloy rich in copper and ornamented with an array of precious stones, pearls, and enamel. When it came to the latter, the majestic cobalt blue color dominated, in combination with diamonds or freshwater pearls. The deep purple amethyst, mined in the Ural Mountains, was one of the most popular gemstones of the era. The Urals, Siberia, and the Caucasus, so rich in minerals, made this profuse splendor possible. Virtually every precious mineral and gemstone known to man was to be found in the Russian deposits. One of the rarest is alexandrite, of the chrysoberyl family. Its wonderful ability to change color—from deep green in daylight to raspberry red in artificial light—has been an attraction since its discovery in Siberia in 1846.

Another gemstone worth mentioning is the apple green garnet known as the demantoid. The name fits this gemstone perfectly as it has the luster and brilliance of a diamond thanks to its high dispersion. Also named olivine, it was very popular in England during Victorian times.

The opal is possibly the only precious gemstone not found in the soil of Russia. It is human nature to want what we do not have, and for things exotic and distant to have a special allure. The opal, therefore, became especially popular during the reign of Alexander II.

St. Petersburg's second rococo got much of its inspiration from the French court. Empress Eugénie, consort of Napoleon III, had the French crown jewels (what was left of them after the Revolution) at her disposal. She commissioned her jewelers Bapst and Lemonnier to remodel many pieces from the imperial treasury.[75] The sophisticated Parisian rococo revival—to a great extent a creation of the empress herself—spread like wildfire all over Europe and soon came to Russia. Furthermore, the empress was fascinated with Marie-Antoinette and created something of a cult of the ill-fated queen, which was reflected in the jewelry designs of the era. Stiff bangles with graceful neoclassical floral and garland motifs were de rigueur, and jewelry was often lavishly set with diamonds in many different cuts, often recycled from old or outmoded pieces.[76]

Drawings of naturalistic jewelry
From the sketch books of the jeweler Butz, St. Petersburg, 1850s
Collection of his workmaster Tuomas Polvinen
Courtesy of Polvinen's descendants

NATURE AS A SOURCE OF INSPIRATION

The latter part of the nineteenth century was also the golden age of naturalism. A passion for motifs with flowers and foliage had been a distinctive trait of the Louis XV rococo. During the 1830s, jewelry designers once again created pieces with naturalistic motifs, a trend that culminated in the 1860s under the influence of a French goldsmith by name of Oscar Massin. Massin's jewelry designs could be seen at all of the large industrial and arts and crafts exhibitions throughout Europe and were copied by goldsmiths the world over. His pieces overflowed with flowers and foliage tied into bouquets along with fantastic feathers or mature ears of corn. Elements mounted on springs of metal trembled delicately, giving a natural effect. Massin was a master in creating an illusion of real life. Another of his impressive and refined innovations was the "cascade," known as *pampille*, where diamonds set in almost invisible settings were mounted in parallel rows to resemble a waterfall.

Naturalism as a way of life soon gained a firm foothold in St. Petersburg high society. A leisurely existence during the warm season of uninterrupted daylight at summer residences, with picnics and *fêtes champêtres*, became the norm. The Petersburg goldsmiths soon started to design nature-inspired jewelry. As a genre, this suited the Russian mentality so well. People who live in a climate with long, dark, cold winters yearn for summertime with all its outdoor pleasures, especially its flora and fauna. Flow-

Bracelet
K.F. Schneegas, St. Petersburg, 1857
Silver, seashells
Courtesy of the descendants of Mary von Schoultz
Photo: Katja Hagelstam

The young engineer Carl von Schoultz collected seashells on the shores of the Black Sea and had them set into a bracelet by the jeweler Schnegas in St. Petersburg. The bracelet was a gift to his future wife, Mary.

Brooch in the form of a gadfly
Nicholls & Plincke, St. Petersburg, c.1870
Gold, turquoise
Estate of Countess Olga Lewenhaupt
Photo: Per-Åke Persson

The wings of the fly open to reveal a space for a miniature or photograph. Countess Lewenhaupt, née af Nordin, was the daughter of Princess Hélène Shcherbatova.

Identical brooch in the form of a gadfly
Nicholls & Plincke, St. Petersburg, c.1870
Gold
Private collection
Photo: Katja Hagelstam

ers, fruits, birds, insects, fish, and reptiles abounded. The serpent has been a favorite among designers of jewelry since antiquity and was particularly so during these decades. The ancient Greek Ouroboros, a serpent swallowing its own tail, was a symbol of eternity, completeness, and inseparability.

Smooth tumbled agates in a variety of colors became very popular in jewelry, as did nature's small wonders—mollusks and shells of different species. Tortoise shell and coral from far-off beaches and grey lava from the slopes of Vesuvius were some of the more exotic materials that decorated the jewelry of the time.

Anna Sofia Tengström's bracelet was purchased in St. Petersburg—the jeweler is not known—and is composed of blue enameled volutes set with a large pearl surrounded by a gold trellis glittering with small diamonds. Most of the elements of the Petersburg second rococo are present in this piece.

DICTATES OF FASHION – ROYAL BLUE

Wide bracelets, predominantly in yellow gold, were especially popular during the era. There was seemingly unlimited variation in their design. Some were decorated with entwined foliage and volutes, others with enamel or colorful gemstones or ornaments borrowed from contemporary decor, such as tassels, fringes, braids, and knots. Anna Sofia Tengström (1826–1906), daughter of the professor of history at the Imperial Alexander University in Helsinki, Johan Jakob Tengström, wears a wonderful example of a gold tasseled bracelet in the portrait that was painted to commemorate an important event in her life. In the spring of 1844, when the Faculty of

Bracelet
Thomas Stenberg, St. Petersburg, 1870s
Gold, pearls
Private collection
Photo: Kuva-Paavo, Loimaa

The bracelet was purchased by the insurance broker Waldemar Stenberg
in St. Petersburg for his wife Agnes

Bracelet
Unknown maker, St. Petersburg, c.1853
Gold, pearls, diamonds, enamel
Private collection
Photo: Katja Hagelstam

The central part of the bracelet can be detached and used as a clasp (fermoir) of a necklace. The St. Petersburg jewelers were ingenious in creating jewelry with multiple functions. This piece is fascinating in its eclectic design: the center is typical of the second rococo, whereas the bracelet itself is neo-gothic. It is engraved with the date "3 avril 1853."

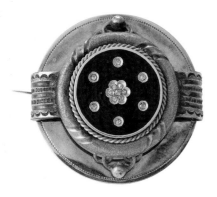

Brooch
Unknown maker, St. Petersburg, c.1880
Gold, diamonds, enamel
Private collection
Photo: Katja Hagelstam

Philosophy at the university arranged the graduation ceremony of doctors of philosophy and masters of art, Anna Sofia was chosen as the ceremonial "wreath binder." The first graduation held in Finland was in 1643, at the Royal Academy of Åbo (Turku).[77] The wreath binder—a young, unmarried daughter of a professor of the university—was, and still is, chosen by the graduating masters of art. She, as a symbol of youth and a bright future, assists in binding the laurel wreaths placed on the heads of the young masters at the ceremony and traditionally receives a fine gift of jewelry as a memento of her services.

Another popular type of bracelet from this era was designed as a belt complete with buckle. Such a bracelet was made around 1880 for Mrs. Bertha Stude, neé Fleischer. She was married to Konstantin Stude, whose family owned the well-known marzipan factory Georg Stude in Reval (now Tallinn). The factory is still in existence under the name Maias Mokk. Stude represented the new class of merchants and industrialists in St. Petersburg. A successful entrepreneur is often an individualist. He does not necessarily follow the trends, but rather his own path, an important attribute in the world of business. This new clientele was not encumbered by traditions

Bracelet with a buckle motif
Unknown maker, St. Petersburg, c. 1880
Gold
Private collection
Photo: Katja Hagelstam

The bracelet originally belonged to Bertha Stude.

A "doormat" bracelet
Unknown maker, St. Petersburg, 1870s
Gold
Courtesy of the Sinebrychoff family
Photo: Katja Hagelstam

Bracelet
C.E. Bolin, workshop of the unknown master CS,
St. Petersburg, 1860s
Gold
Private collection
Photo: Katja Hagelstam

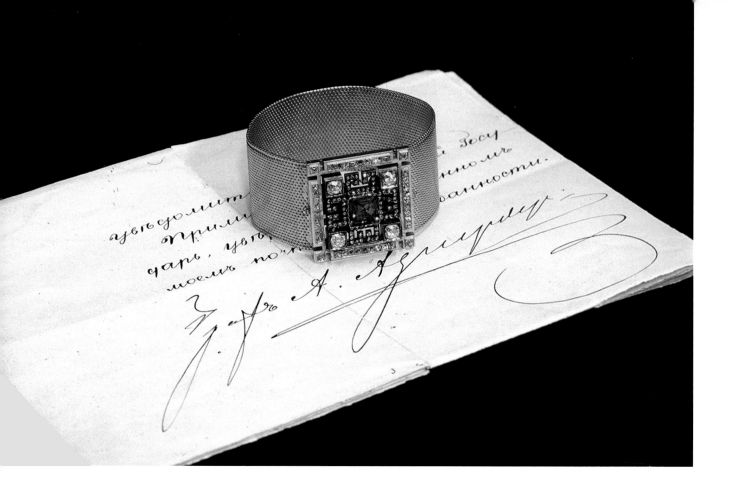

Bracelet of Baroness von Troil
C.E. Bolin, St. Petersburg, 1863
Gold, emerald, diamonds
Courtesy of the descendants
Photo: Per-Åke Persson

The bracelet was given by Emperor Alexander II to Baroness Jeanne-Marie von Troil. It is photographed on top of the transmission letter signed by the minister of the Imperial Court, Count Adlerberg.

that had to be followed, and their sound financial situation made it possible for them to spend substantial sums on art and luxury goods. Supported by these new wealthy and unbiased patrons, the art of the goldsmiths of St. Petersburg flourished and the number of enterprises increased markedly. The new buyers found pleasure in commissioning innovative and avant-garde models. Buckle and "doormat" bracelets are prime examples.

The luxurious bracelet shown above is made of fine gold mesh, an early example of machine-made chain. The central element, consisting of a square-cut emerald surrounded by a meander motif, can be detached and used as a *fermoir*, for example. The idea of transformability is very typical for St. Petersburg. It was made in 1863 by C.E. Bolin and given by Emperor Alexander II to Baroness Jeanne-Marie von Troil, née von Kothen (1807–1880).

The emperor with his sons, the young grand dukes Aleksandr Aleksandrovich (future Alexander III) and Vladimir Aleksandrovich, paid a visit at the end of July 1863 to the Grand Duchy of Finland in order to inspect the maneuvers of the Finnish army and to take a salute as the soldiers paraded by. The exercise grounds were situated at Parola in the vicinity of the town of Hämeenlinna (Tavastehus). The emperor entertained three hundred guests at dinner in a pavilion erected near the camp. Later he took his

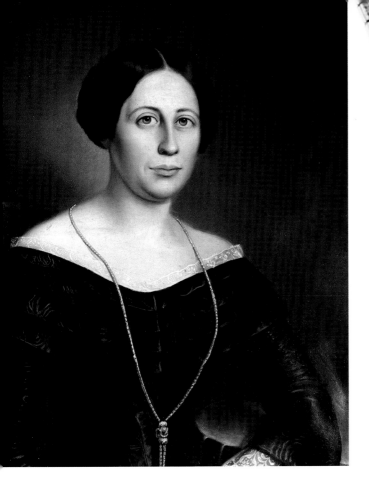

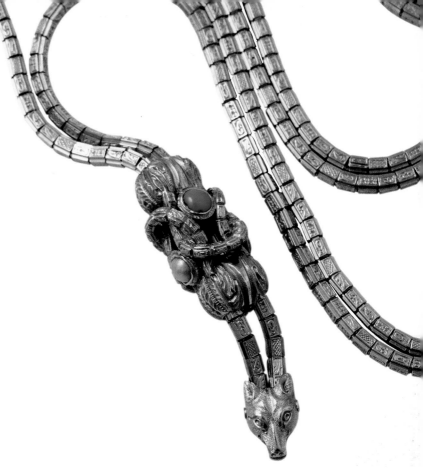

Baroness Alexandra Furuhjelm
Johan Erik Lindh, c.1855
Courtesy of the descendants
Photo: Katja Hagelstam

Alexandra Furuhjelm, who was the daughter of Baron Gustaf and
Baroness Gustava Hjärne, can be seen wearing her monocle chain. For
her family, see the chapter on Alexander I.

Detail of a monocle chain owned by Baroness Alexandra Furuhjelm
Unknown maker, c.1850
Gold, turquoises, pearls
Courtesy of the descendants
Photo: Katja Hagelstam

The chain, which has survived in mint condition, consists of small compo-
nents joined together terminating in a miniature fox head.
The monocle was attached through the jaws of the fox.

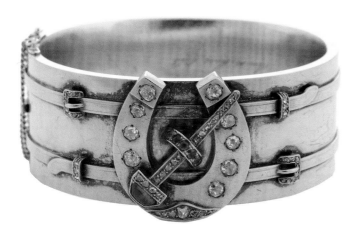

Bracelet of Wilhelmina Ehrnrooth
Friedrich Daniel Butz, St. Petersburg, 1869
Gold, cabochon rubies, diamonds
Courtesy of her descendants
Photo: Katja Hagelstam

Wilhelmina "Mimmi" Ottiliana Lovisa Ehrnrooth, née Countess De Geer
till Tervik (1834–1916), was the wife of General Gustaf Robert Ehrnrooth.
She was given the bracelet by Alexander II at the birth of her son Alexander
Casimir in 1869. The emperor had consented to be the boy's godfather.

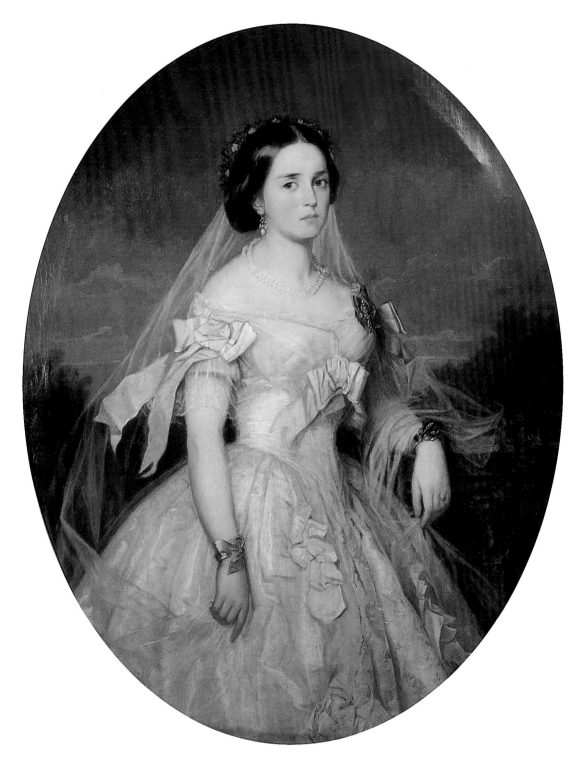

Baroness Olga Viveka Ramsay
Unknown artist, 1856

The portrait shows Olga Viveka Ramsay (1836–1887) on the day of her wedding to Major General Edvard von Ammondt. She was the daughter of Baron Anders Ramsay, a highly regarded general of the infantry. She was a maid of honor of Empress Alexandra Feodorovna. Baroness Ramsay wears the bracelet shown on the right.

Maid-of-honor cipher of
Empress Maria Aleksandrovna
Friedrich Daniel Butz, St. Petersburg, c.1874
Gold, silver, diamonds
Courtesy of the descendants
Photo: Katja Hagelstam

The cipher belonged to Countess Hedvig Lovisa Arm-
felt (1854–1923), daughter of Count Gustav Vilhelm
Artur Armfelt, major general of the suite of H.I.M.
She married the governor Anton Leonard
von Knorring in 1879.

sons to see the sights, for a tour in a steamer on the nearby lake, and for a swim to finish off the evening. The residence of Baron Samuel von Troil, governor of Häme (Tavastehus) province, was the most comfortable house in the small provincial town and therefore was seen as appropriate accommodation.

On the morning of their departure, the baroness was generously thanked for her hospitality, being presented with the abovementioned bracelet. The thank-you note that accompanied the gift is one of the very few imperial presentation documents of its kind that has survived. It was written and signed by the minister of the Imperial Court General of the Infantry Count Aleksandr Vladimirovich Adlerberg. Presentation letters were not written by the sovereign himself unless the recipient of a gift was a member of his own family or a member of another royal house. It reads:

Bracelet
Johan Edvard Fagerroos, Helsinki, 1856.
Gold, coral, pearl
Courtesy of the descendants of Countess
Olga Viveka Ramsay
Photo: Katja Hagelstam

The Commander of the Imperial Staff in the town of Tavastehus, 8/30 July 1863, N° 863.
To His Excellency Baron S. S. Troil
Your Honor Baron Samuel Samuelovich
HIS IMPERIAL MAJESTY has by HIS utmost grace deemed it his pleasure to present the wife of Your Excellency with a jeweled bracelet as a souvenir of the time HIS MAJESTY'S stayed in Your house during the present visit in Tavastehus of THE SAME.

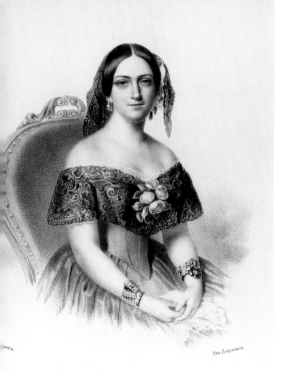

Aurora Karlovna Karamzina
A. Legrand after Rossi, lithograph by Kaslov, 1846
Helsinki City Museum

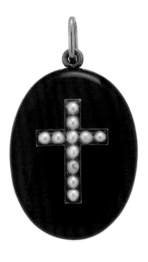

Mourning locket
Gustav Fabergé, St. Petersburg, c.1848
Gold, pearls, enamel
Courtesy of the descendants of Baron Bernhard Indrenius
Photo: Katja Hagelstam

The locket was probably purchased in memory of Natalia Indrenius, who died in 1848. It contains a lock of hair of the deceased.

I hereby hand over to Your Excellency the mentioned gift for Yourself to give to Your wife. I humbly beg You to inform me of the receipt of same. I beg Your Excellency to receive the assurance of my utmost esteem and devotion.

Count A. Adlerberg

It was fashionable during the 1840s and for a few decades afterwards to wear several wide bracelets on each wrist. A lithograph from 1846 of Aurora Karlovna Karamzina provides a good example of how unconventionally jewelry could be worn at this time. She wears an ornament in the form of an ear of rye instead of an earring in her left ear, and from her right sports what could very well be a miniature gold or platinum ingot, perhaps a symbol of the Demidov family's mining interests (her first husband was Pavel Nikolaevich Demidov). On her wrists are four imposing bracelets: on the left, a thin one in gold decorated with a rose, possibly in red enamel, and above it one in the second-rococo style; on the right, a wide *jarretière* and another in the shape of a belt.

A long gold chain, or sautoir, was another fashionable item of jewelry during the reign of Alexander II, and chain makers developed the most intriguing models. Two of the most popular are shown on page 138. They often had decorative clasps, many of them in the shape of a jeweled serpent's head. The parure, or set of jewels consisting of a tiara or hair ornament, necklace, bracelet, earrings, and brooch designed in a matching style, prevailed. It did not have to be complete; a demi parure of, for example, a necklace, bracelet, and earrings was quite common.

As has already been stated, cobalt blue was *the* color in the goldsmith's art during the reign of Alexander II. Jewelry and objets d'art were often decorated with blue enamel, especially imperial presentation gifts such as snuffboxes and rings. These often had the monarch's crowned diamond cipher set on a plaque of blue enamel. A number of such snuffboxes have survived, all of them with a known provenance. Commercial Counselor Andreas (Anders) Donner (1796–1857), "The Defender of Kokkola" (Gamlakarleby), is depicted in his portrait with three of his imperial awards: the Order of St. Anne third class, a ring with the cipher of Nicholas I (both presented to him in 1854), and a snuffbox with the cipher of Alexander II. Hailing from the coastal town of Kokkola, Donner was one of the most industrious businessmen of his time. He inherited his father's modest export and shipping company and turned it into a flourishing enterprise. This allowed him to exercise substantial patronage in his home town, both within popular enlightenment and community politics. He planned

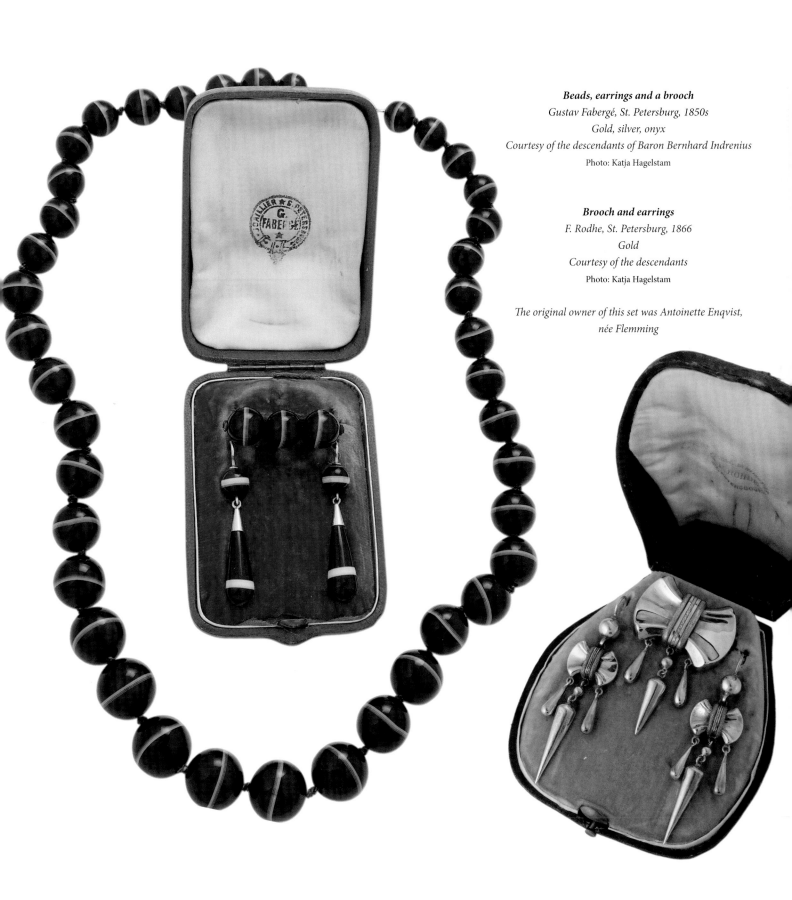

Beads, earrings and a brooch
Gustav Fabergé, St. Petersburg, 1850s
Gold, silver, onyx
Courtesy of the descendants of Baron Bernhard Indrenius
Photo: Katja Hagelstam

Brooch and earrings
F. Rodhe, St. Petersburg, 1866
Gold
Courtesy of the descendants
Photo: Katja Hagelstam

The original owner of this set was Antoinette Enqvist,
née Flemming

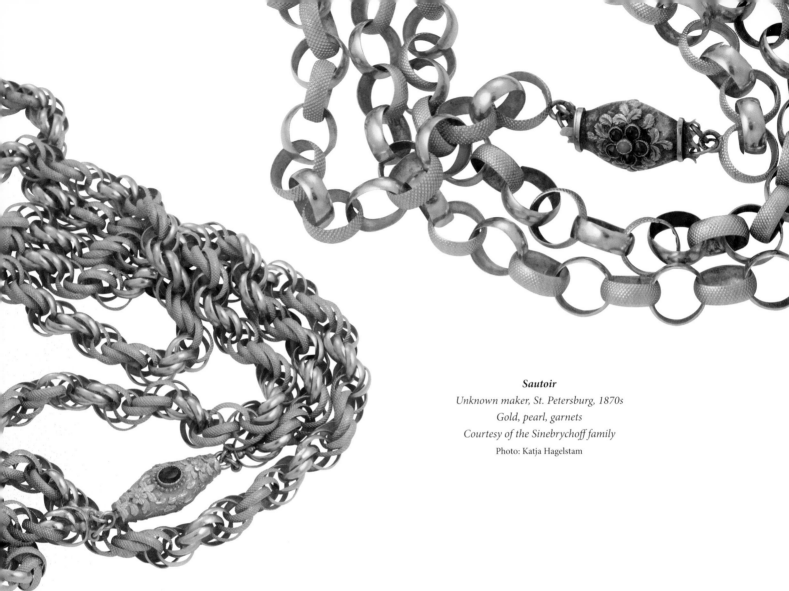

Sautoir
Unknown maker, St. Petersburg, 1870s
Gold, pearl, garnets
Courtesy of the Sinebrychoff family
Photo: Katja Hagelstam

Sautoir
Unknown maker, St. Petersburg, 1870s
Gold, garnet
Courtesy of the Thesleff family
Photo: Katja Hagelstam

and led the construction work on a new town hall and hospital in addition to his daily work. When the Crimean War broke out in 1853, the British navy launched a series of attacks against the coastal towns of the Gulf of Bothnia. Donner immediately saw that measures had to be taken in order to save the city of his birth. Much was at stake both for Donner personally and for the commercial and industrial life of Kokkola. In order to avoid the fate of the neighboring towns of Oulu (Uleåborg) and Raahe (Brahestad), where the enemy had burned the shipyards, ships, and buildings, Donner collected a group of volunteers—around one hundred men—to help save the properties and possessions of the city. Thanks to these measures Kokkola was spared.

Andreas Donner was invited to St. Petersburg to congratulate the newly crowned emperor Alexander II. The visit took place shortly after the emperor came to the throne in 1855, at which time Donner received a magnificent jeweled snuffbox in gold with the cipher AII. Personally presenting the gift in the Winter Palace, Alexander II embraced his loyal subject and thanked him for his valuable services.[78]

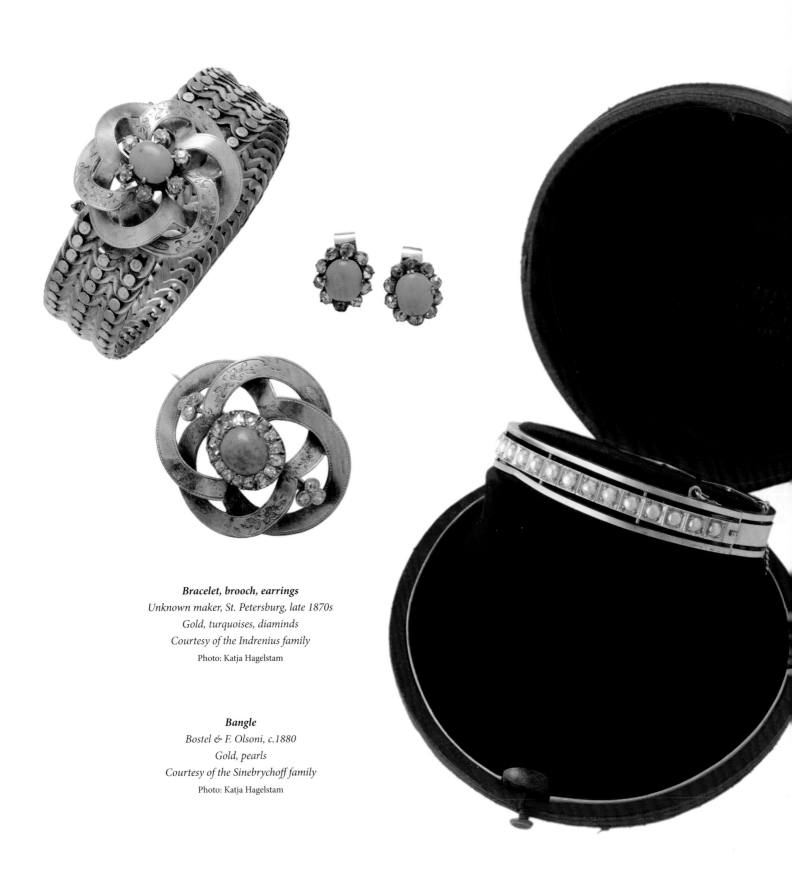

Bracelet, brooch, earrings
Unknown maker, St. Petersburg, late 1870s
Gold, turquoises, diaminds
Courtesy of the Indrenius family
Photo: Katja Hagelstam

Bangle
Bostel & F. Olsoni, c.1880
Gold, pearls
Courtesy of the Sinebrychoff family
Photo: Katja Hagelstam

Commercial Counselor Andreas Donner "The Defender of Kokkola"
Vladimir Sverchkov, c.1855
The Presidential Palace, Helsinki
National Gallery, Central Art Archive, Helsinki
Photo: Henri Tuomi

Andreas Donner showcases his three imperial gifts in the portrait: the Order of St. Anne third class, a diamond ring with the cipher of Emperor Nicholas I, and the snuffbox with the cipher of Emperor Alexander II.

Jeweled presentation ring
Unknown maker, St. Petersburg, c.1847
Gold, silver, diamonds
Courtesy of the descendants
Photo: Katja Hagelstam

This diamond ring was presented to Colonel (later Lieutenant General) Alexander von Wendt for his meritorious service.

Lieutenant General Alexander Jakob von Wendt
Unknown artist, c.1857
Courtesy of the descendants
Photo: Katja Hagelstam

General von Wendt commanded the Russian troops in the actions at Kokkola.

A PROMINENT INDUSTRIALIST
HENRIK BORGSTRÖM

Commercial Counselor Henrik Borgström (1799–1883) was one of Finland's most prominent industrialists during the reign of Alexander II. He founded a tobacco factory in 1834, which became an important employer in Helsinki, and a large cotton mill in Forssa. He was also one of the owners of *Suomen Yhdys-Pankki*, (United Bank of Finland), the first commercial bank of the grand duchy. Borgström's life, however, was not merely one of making money. He had a great love of culture and the arts and generously supported them. It has been said that he would have been Lorenzo de' Medici had he lived in Florence, but would have soon been forgotten if the green parks of Helsinki had not continued soughing his name for posterity.[79] Borgström took the initiative of beautifying his home town of Helsinki, which was close to his heart, by creating an exclusive spa on the seashore surrounded with parks and gardens and by establishing another large park that originally was planned as a home for animals of various kinds. His interests and activities had an unusually wide scope. His closest friends were the members of the intellectual elite of the day, among them the celebrated author, journalist, and professor of history Zacharias Topelius; the composer and teacher of music Fredrik Pacius; the philosopher, statesman, and author Johan V. Snellman; and the poet and physicist Johan Jakob Nervander.[80]

Commercial Counselor Henrik Borgström
Bernhard Reinhold, 1876
Courtesy of the descendants
Photo: Katja Hagelstam

*Henrik Borgström appears with the snuffbox that he received
from Emperor Alexander II at the coronation in 1856, where he
represented the burgher estate of the Grand Duchy of Finland. The
emperor had offered to ennoble him, but he courteously declined
with the words, "I prefer to be the foremost of burghers rather than
the most modest of nobles."*

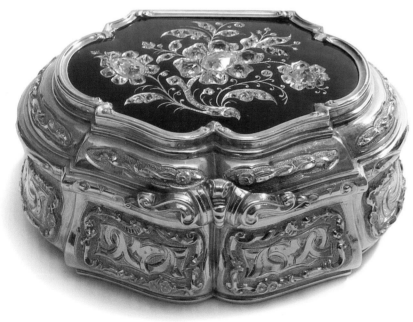

***Snuffbox of Commercial Counselor
Henrik Borgström***
Ludwig Breitfuß, c.1856
Gold, diamonds, enamel
Courtesy of the descendants
Photo: Lars Gustafsson

*This second-rococo style snuffbox was a gift to Com-
mercial Counselor Henrik Borgström at the coronation
of Alexander II in 1856. In accordance with the Rus-
sian imperial award system, Borgström, as a member
of the burgher estate, was not entitled to a gift with the
sovereign's portrait or cipher, hence the absence of the
imperial emblems on this important gift.*

Although Borgström was a very influential person, he chose not to mix in politics and never strove to obtain any honorary offices. In spite of this, Borgström was happily surprised to be elected a representative of the burghers at the coronation of Alexander II and his consort Maria Aleksandrovna in Moscow in 1856. In a letter to a friend he writes, "I am now able to arrange for a few weeks of absence from home...I am going there next Friday in the company of Count August Armfelt from Turku, Commercial Counselor Johan Hackman from Vyborg, and a peasant by the name of Kosonen from Mikkeli region. In addition to the honor bestowed upon me—greatly satisfactory because it (the honor) has been given me by a majority of delegates in our government and not by the grace of a single man—I feel privileged to be part of such grand celebrations, especially since it will be possible to show (the sovereign) my warmest and heartfelt feelings." At the coronation, Borgström was awarded an impressive snuffbox in the second-rococo style made of multicolored gold by the court jeweler Ludwig Breitfuß. It is handsomely engraved across the body. The lid is of cobalt blue guilloché enamel with a bouquet of flowers profusely embellished with brilliant- and rose-cut diamonds. Being the representative of the burgher estate, Borgström was not entitled to a gift with the emperor's portrait or cipher.

Countess Maria Musina-Pushkina
Laurent, late 1850s
National Gallery, Central Art Archive, Helsinki
Photo: Kirsi Halkola

THE COUNTESS WHO SHOCKED
HER CONTEMPORARIES

Nineteen-year-old Countess Maria Vladimirovna Musina-Pushkina (1840–1870) made her debut in Helsinki society in October 1859 at a ball arranged by Governor General Count Friedrich Berg. An elderly gentleman of sixty-five, he was exceedingly attentive to the young debutante. Maria herself commented in her diary, "That old fogey—that fool—tried 'to give me the treatment' at the ball!...Am I not a an odd figure—I felt great being the belle of the ball."

The round of festivities continued in St. Petersburg. Everyone wanted to see Aurora Karlovna Karamzina's niece and protégée, the daughter of the enormously rich former Decembrist. Even the emperor himself graciously exchanged a few words with Maria at a ball arranged by Grand Duchess Elena Pavlovna. Back in Finland that same year, on the second day of Christmas, the Helsinki nobility gathered once more. Anders Ramsay writes, "She is not a beauty in the strict sense of the word...But in her face there is something that fully makes up for it." He continues to say that

*Countess Maria Musina-Pushkina
and Lieutenant Constantin Linder*
Unknown photographer, 1860
Helsinki City Museum

The photograph was taken in St. Petersburg shortly
after they were engaged.

she has an unusual liveliness in her constantly changing facial expressions, an instinctive grace in all her movements, an almost hypnotic allure, and a talent for a quick and witty conversation.[81] The guests of the ball were spellbound by Maria. So was Constantin Linder, a young and very handsome lieutenant of the Finnish Guards.[82] Barely a week afterwards, at the New Year's ball arranged by the governor general, Maria and Constantin only had eyes for one another. The other young officers present were green with envy that their comrade Linder had been the chosen one and had made such a swift conquest.

The incipient romance was seconded by Mme Karamzina. Things progressed at a quick pace. Only five days later, at yet another ball, it was clear that the match was already made. The young couple received congratulations from their closest friends, although the engagement was not officially announced until a few days later in St. Petersburg. The wedding took place in July 1860 in the grand duchy. Marriages for love were not common in the upper class of the day, but this union seemed to have been made in heaven. The bride was now returned to her mother's country of birth, where a wide circle of relatives and friends received her with open arms.

Maria was only five when her mother died.[83] "Tante-Maman," Mme Karamzina, assumed partial responsibility for Maria and her older sister Alina. Maria, nicknamed Mashen'ka, became the apple of her aunt's eye.

The girls' father, Count Musin-Pushkin, spent less and less time at his estate Borisoglebskoe on the Mologa River in Iaroslavl' Governorate. Tormented by grief at the loss of his beloved wife, he threw himself into an evil circle of gambling and drinking. His financial situation went from bad to worse. At his death in 1854, his debts amounted to seven hundred thousand rubles. A large part of his assets therefore had to be sold in order to settle them.

The family residence in St. Petersburg was conveniently situated next door to the Demidov-Karamzin mansion on the Bol'shaia Morskaia. This proximity made it easier for Mme Karamzina to help her brother-in-law,[84] and when visiting the grand duchy, the two Musin-Pushkin girls stayed at their Tante-Maman's estate Träskända near Helsinki.

Alina Musina-Pushkina fell ill with pneumonia in 1856, which gradually became chronic. Tante-Maman arranged for her two protégées to stay all winter at Soden near Wiesbaden in southern Germany. The waters there were known for their medical qualities. Alas, they did not prove efficacious. The following winter Maria remained in St. Petersburg while her sister was cared for in the small town of Pau (the birthplace of Napoleon's

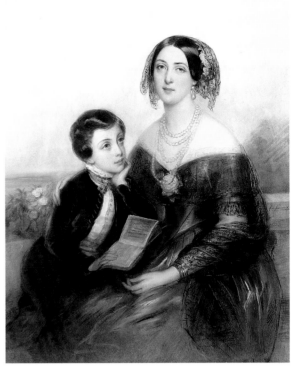

Demidov mansions in St. Petersburg
Vasilii Semenovich Sadovnikov, c.1836
The State Museum of History of St. Petersburg

These two buildings on the Bol'shaia Morskaia were purchased by Pavel Nikolaevich Demidov
for his bride, Aurora Stjernvall, as a wedding gift.

Aurora Karlovna Karamzina with her son
Pavel Pavlovich Demidov
Laure Houssaye de Liomenil, c.1850
Courtesy of Sotheby's

Aurora Karlovna wears her famous four-strand
necklace of South Sea pearls.

marshal Jean Bernadotte, who became king of Sweden) at the foot of the Pyrénées in France.

Maria received her education at home. Her cousin Pavel Pavlovich Demidov, the only child of Aurora Karamzina, was the same age as she. The two became very close and shared the same tutors and governesses, who gave them profound insights into their mother tongue and the history, literature, and culture of their great country. Maria had a Swiss governess, Fräulein Sophie Bachel, who taught her German, and an English governess, Miss Ellinor Ashton, who taught both Pavel and her English. Maria also took singing and piano lessons and spent a lot of time riding her favorite pony.

Married life unfortunately did not prove to be what Maria had hoped for. The model for an aristocratic family during that time was life on a country estate. When Maria received her father's inheritance, Constantin purchased Kytäjä (Nääs) in Nurmijärvi, north of Helsinki. The old wooden buildings of the estate were run down, far from what the young wife was used to from her childhood at Borisoglebskoe. A friend of the family, Bar-

on August Mannerheim, called the *corps de logis* of Kytäjä a "bear's nest or a wolf's cave." Admirably, Maria did all she could to make things work in her new home. She studied books on farming, bookkeeping, and personally took control of raising the animals and of the dairy. She established a cottage hospital, library, and school for the farmhands and their children. Maria's first child, a daughter Emilia, was born in 1861. But life in this rural setting soon proved lonely and isolated. Constantin and Maria therefore decided to spend their winters in Helsinki. Three further children were born: Hjalmar in 1862, Marie in 1863, and Voldemar (who only lived four days) in 1865. The many childbirths and her disappointment in not having accomplished anything of value in life weighed heavily on Maria. So she decided to change her life.

Maria had a talent for writing and had enjoyed working on texts since she was a child. She found stimulation in formulating her sentiments and viewpoints on life. But her initial attempts at publishing did not meet with success. Her first short story, *Le Cœur brisé*, was refused by the editor-in-chief of the *Journal de Saint-Pétersbourg* as being naive—"too much has been written about young love. Only an exceptionally talented author would have something new to say on the topic." In 1866, Maria succeeded in publishing a short story under the *nom de plume* Stella. She continued writing prose for several newspapers and also tried her hand at translations, both into French and Russian. Her first novel *En qvinna af* vår tid: karaktersteckning (A woman of our time: A description of a personage) appeared in 1867, again under the pseudonym Stella. The young heroine, Lady Suffridge, the author's alter ego, expressed her thoughts about women's emancipation, their rights and duties towards society, family, and themselves. The reviewers thought Lady Suffridge an inexplicable character. Spurred on by unjust opinions about the ideas discussed in the book, Maria felt like a revolutionary in her call for women's rights. She did not hide her indignation among people she trusted, but declined to speak up in public. Time was not ripe.[85] The book sold fairly well despite the negative reviews and was even translated into Danish. Maria could therefore pay her debt of 570 marks to Constantin, who had advanced the printing costs.

Maria's last two years were unhappy ones. She had severe problems with her health and was treated at resorts with questionable medical procedures. Chloroform eased her pain, and she soon became dependent on it. She passed away at the age of twenty-nine, an especially gifted and enlightened woman whose pioneering viewpoints shocked her contemporaries and heralded the development that took place in society during the first decades of the century to come.[86]

A FÊTE WORTHY OF AN EMPEROR

On September 16/28, 1863, two days before the opening of the Diet in Helsinki which Alexander II had come to attend, Mme Karamzina hosted a day full of spectacular events in honor of her highly esteemed sovereign. The scene of the fête was her estate Träskända.[87] She spared no expense or energy in her preparations for this extraordinary event, which was to include an early lunch, followed by a hunt, culminating in a gala dinner and a ball.

Two hundred guests were invited for the dinner and ball. A temporary annex to the main house therefore had to be built. It comprised a spacious dining room filled with costly furniture brought from the Demidov residences in St. Petersburg and an impressive ball room with full-length mirrors, lush greenery, and exotic flowers.

All the food was brought from Paris. The fashionable *traiteur* Chevet, whose establishment was located at the Palais-Royal, was commissioned

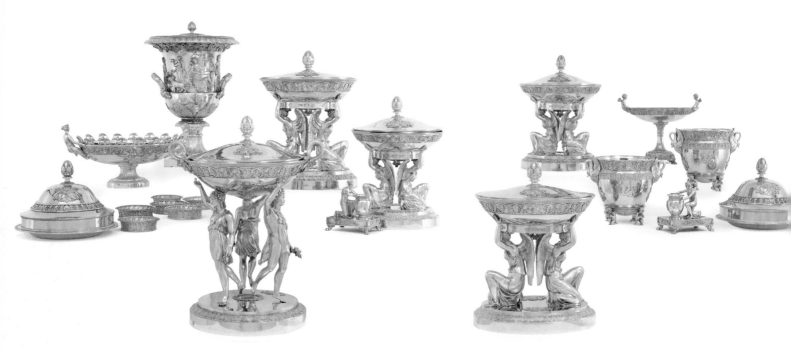

Demidov Service
Jean-Baptiste Claude Odiot, Paris, 1817
Silver gilt
Courtesy of Christie's

The service includes tureens, wine coolers, a fountain, a monteith, wine coasters, dishes, covers, a dessert stand, and mustard pots.

to compose the menu—which has survived and is truly impressive—and to bring the delicacies and wines from his Paris shop.[88] Chevet was known across Europe for his superb banquets prepared for official and important occasions. His staff included the best chefs in France, among them the celebrated Joseph Favre and Auguste Escoffier, emperor of chefs and chef of emperors. A head chef and his assistants set up their temporary kitchen at Träskända and worked day and night before the big day. The tables were laid with exquisite porcelain and the famous Demidov gold service.[89]

The guest of honor, Emperor Alexander II, arrived at Träskända at eleven in the morning accompanied by grand dukes Aleksandr, Vladimir, and Aleksii, his sons, and his nephews Grand Duke Nikolai Konstantinovich and Prince Sergii Maksimilianovich Romanovskii, Duke of Leuchtenberg. An imposing group of highly ranked dignitaries were part of the entourage, among them the chancellor of the empire, Prince Aleksandr Mikhailovich Gorchakov, the minister of the Imperial Court, Count Vladimir Fedorovich Adlerberg, his son Aleksandr Vladimirovich, and the minister of war, Dmitrii Alekseevich Miliutin.

The hunt took place early in the afternoon. It was an unparalleled spectacle and remained a topic of discussion in the grand duchy for decades.

Träskända estate
Magnus von Wright, 1850
National Gallery, Central Art Archive, Helsinki

Mme Karamzina had brought wild game from distant Prussia, Livonia, and Courland: deer, boar, fox, hare, and pheasants. The pitiable beasts were released in the nearby forest shortly before the chase began. Soldiers of the Guards were posted along the perimeter, forming a human fence, to ensure that the game did not escape the imperial guns. As the story goes, when the shoot commenced, hares leaped out of every bush; deer, boar, and fox emerged in herds from nowhere; and flocks of pheasants flapped their wings in panic.

The day culminated with the gala dinner and ball, which continued into the wee hours. As the orchestra played for the dancing guests, the night sky was lit by fireworks, the likes of which had never before been seen in the grand duchy.

The imperial retinue finally returned to its quarters in town, the luxurious carriages illuminated by roadside torches. Although the hour was late, the route was lined with crowds of people hurrahing at the sight of their sovereign and gazing in amazement at the many carts filled with the corpses of the day's kill. For them, Mme Karamzina's imperial hunt was decidedly a barbaric affair, which it indeed was, although it hardly differed from similar hunts arranged at the royal courts across the continent.

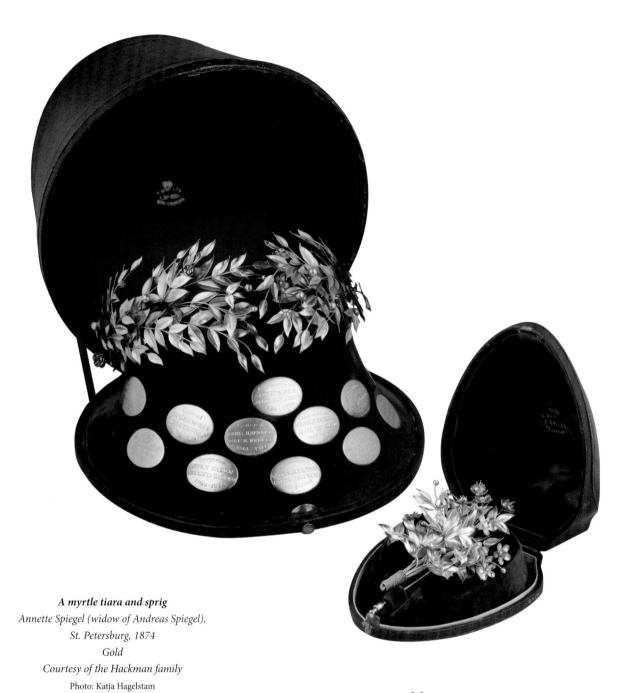

A myrtle tiara and sprig
Annette Spiegel (widow of Andreas Spiegel),
St. Petersburg, 1874
Gold
Courtesy of the Hackman family
Photo: Katja Hagelstam

*This myrtle tiara and sprig was commissioned in 1874
by the children of Commercial Counselor
Johan Friedrich Hackman and his wife Julia Sofia,
née Jaenisch, for their golden wedding anniversary.
The oval plaques on the original box are engraved with
the names of subsequent golden wedding couples of the
Hackman family.*

Myrtle
Symbol of a Happy Marriage

A wreath or sprig of myrtle since ancient times has been known as an attribute of Aphrodite, Olympian goddess of love, beauty, pleasure, and joy. The myrtle tree (Greek *myrrhina*) was sacred to her because it was from this tree that her beloved Adonis was born. Its sweetly scented white flowers, aromatic evergreen leaves, and magical properties have been a symbol of matrimonial happiness throughout Europe for centuries. Myrtle wreaths, crowns, and tiaras made of precious metals have adorned husbands and wives celebrating their anniversaries since the sixteenth century.[90] The

custom reached Scandinavia and the Grand Duchy of Finland during the first half of the nineteenth century.

A woman celebrating her twenty-fifth anniversary wore—and in many families still wears—a naturalistically crafted myrtle tiara made of silver; and for her fiftieth, a tiara or crown in shining gold. Her husband wore/ wears a miniature sprig of myrtle on the left lapel of his coat. Those made for families in the grand duchy were often by St. Petersburg goldsmiths, despite the fact that they were unknown in imperial Russia. Many of the goldsmiths and jewelers in St. Petersburg were of Finnish origin, so it is not at all surprising.

An especially fine myrtle parure was commissioned for the golden wedding celebrations in 1874 of the Vyborg industrialist Johan Friedrich Hackman and his wife Julia Sofia, née Jaenisch. It was made by the jeweler A. Spiegel, at the time headed by Annette Spiegel, widow of Andreas Spiegel (1797–1862), who was born in Reval and came to St. Petersburg in 1830, where he became a successful master goldsmith. One of his famous apprentices was Gustav Fabergé, father of Karl.

Johan Friedrich Hackman (1801–1879) was born in Vyborg. His father, also named Johan Friedrich (1755–1807), was from a family of merchants going back five generations, had founded a trading company in Vyborg in 1790. It supplied salt, sugar, chicory, and vodka to the Russian military stationed in the city. The business interests of Johan Friedrich senior subsequently turned to timber, and he was granted rights to foreign trade and the foundation of mills. A Vyborg girl, Marie Laube, twenty-one years his junior, became his wife and the mother of his children.

In 1807, when Marie Hackman lost her husband, chicory, grown on the family estate of Herttuala outside Vyborg, was the company's main product. Mrs. Hackman had no choice but to continue her husband's business, which she did with admirable skill and energy. After the Napoleonic Wars, the timber trade once again flourished, Hackman & Co. grew into an important enterprise, with its exports partly shipped in company-owned vessels.

Johan Friedrich junior, who was barely six years old when his father died, was groomed to take over the family firm. He received a thorough education, first at home in Vyborg, where he was tutored in foreign languages and mathematics. Baron Ludwig von Nicolay, a friend of his mother, opened his famous library at Monrepos for the boy, who showed a great interest in classical literature and music. His instruction was continued in Germany, Holland, and England. He returned home after several years abroad to assist his mother in the business.

Coat of arms of the Hackman family
Courtesy of Carl Fredrik Sandelin, Helsinki

The Hackman enterprise thrived under the leadership of the younger Johan Friedrich. The 1830s witnessed a booming world economy. By the end of the 1840s, Hackman & Co. owned six sawmills and large forested areas in southeastern Finland. Several sailing vessels were built for the company, to be followed by paddle steamers and steamships. The Hackman & Co. shipyard grew into one of the most important of the grand duchy.

In 1856, Hackman was invited to take part in the coronation of Emperor Alexander II in Moscow as one of the representatives of the burgher estate. This honor was shared by a colleague of his, Henrik Borgström (*v.s.*), from Helsinki.

The family's successes continued throughout the following decades. When gas became an important commodity for lighting cities, Hackman became a substantial co-owner of the newly established gasworks of Helsinki and Vyborg. Johan purchased The Mechanical Works of Vyborg (Wiborgs mekaniska verkstad) in 1866, which produced steamships, sawmills, and machinery for industrial plants throughout the empire. The workshops were reorganized during the Russo-Turkish War to produce munitions for the military.

For later generations both in Russia and Finland, Hackman was well known for its production of stainless-steel knives, scissors, and cutlery made at their Sorsakoski factory. Virtually every home in the grand duchy and the independent republic of Finland had and still has kitchen utensils marked "Hackman-Sorsakoski."

The importance of Johan Hackman's life work did not pass unnoticed in St. Petersburg. On the very day he celebrated his golden wedding anniversary, March 7, 1874, he was ennobled by Emperor Alexander II. The family had previously used a pick axe as a heraldic charge, a symbol of their humble beginnings as chicory growers. This symbol would have been a perfectly acceptable element for Hackman's family crest as a nobleman. Instead he chose the Roman numeral L encircled by a wreath of myrtle sprigs for fifty years of happy married life.

The golden-wedding myrtle tiara and sprig have been worn by successive generations of "golden brides and grooms" within the Hackman family since 1874. Their names are engraved on plaques at the base of the case that houses this unique parure.[91]

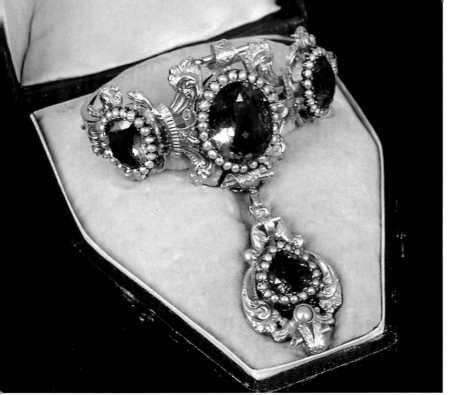

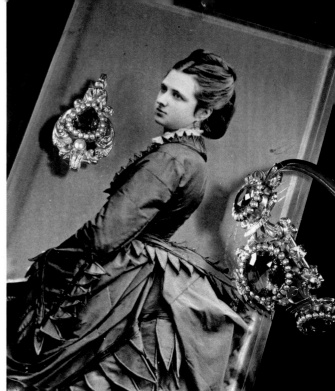

Demi parure of Anna Sinebrychoff
Wilhelm Christlieb, St. Petersburg, c.1850
Gold, amethysts, pearls
Private collection
Photo: Katja Hagelstam

The original owner of this bracelet and pendant set was the wife of Pavel Sinebrychoff the elder, Anna née Tikhonova. The jewelry was inherited by her daughter-in-law Anna, née Nordenstam, on whose photograph the pieces are depicted. The original fitted case has survived.

THE SINEBRYCHOFF BREWING FAMILY

Sinebrychoff—or rather its diminutive Koff—is today a household name in Finland and Russia, being synonymous with a popular beer. Behind the name is a success story worth relating.

At the end of the eighteenth century, a zealous man by the name of Petr Sinebriukhov (meaning blue belly) set off from his small home town Gavrilovskii Posad in Russia[92] to seek a better life for himself and his family. Where there are military operations, there are always soldiers with needs that must be satisfied. Petr set up a small tavern, which sold beer and staples, at the Ruotsinsalmi garrison (near present-day Kotka in Finland), where the Battle of Ruotsinsalmi was fought in July of 1790 between Russia and Sweden.[93]

Petr died in 1805 leaving his two sons, sixteen-year-old Nikolai and six-year-old Pavel, to carry on the business. Despite their young age, the brothers supplied the troops in the war of 1808–9, the conflict that resulted in Finland becoming a grand duchy of the Russian Empire. After the war, Nikolai and Pavel moved to Helsinki, where surprisingly enough, they soon had a monopoly on brewing and selling beer (and later vodka). When Nikolai Sinebrychoff (as the family spells the name in Finland) died in 1848 without an heir, his brother Pavel took over the entire business.

Pavel Sinebrychoff (1799–1883) turned out to be even more brilliant as the sole owner of the family firm. The brewery grew into a large emporium, soon making its proprietor the richest and most honored merchant in

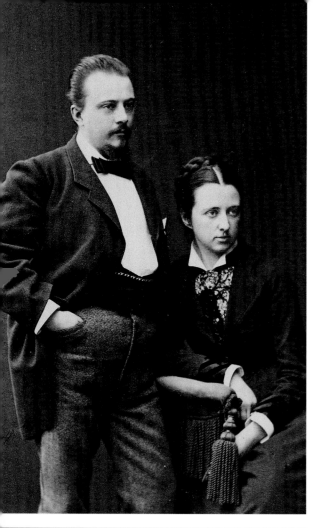

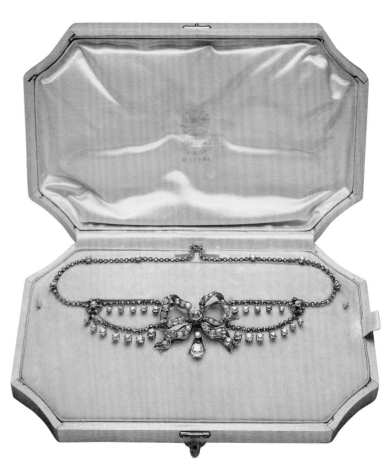

Commercial Counselor Nikolai Sinebrychoff and his wife Anna
Unknown photographer, c.1890
National Board of Antiquities Collections, Helsinki

Necklace
Fabergé, workshop of August Holmström,
St. Petersburg, 1892
Gold, silver, diamonds
Private collection

Mrs. Anna Sinebrychoff commissioned the necklace from Fabergé as a gift to her daughter Maria for her fortieth birthday. The central part of the necklace can be detached and used as a brooch.

Fanny Grahn
Unknown photographer, date unknown
National Board of Antiquities Collections, Helsinki

Fanny Grahn (1854–1921) was an actress and is depicted here in one of her roles. She married Pavel Sinebrychoff in 1883.

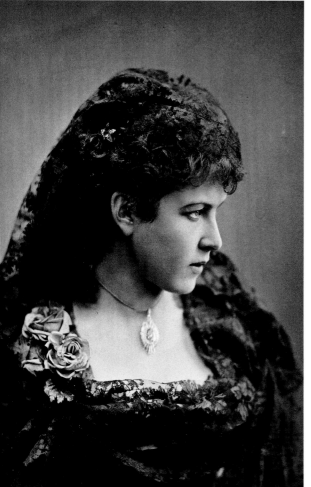

Helsinki. Pavel's success brought a great deal of money into the state treasury, and his benevolence helped many unfortunate fellow citizens. Emperor Alexander II showed his gratitude in honoring him with the title of commercial counselor.

A hardworking businessman does not have time to start a family, but at the age of fifty-one, Pavel married the daughter of his housekeeper. Anna Tikhonova, his bride, was thirty years his junior. She proved to be a good choice, presenting him with four children and with valuable assistance in the business later in life.[94] The oldest son in a family normally has his future staked out. And such was the case for Nikolai, Pavel's first-born son. However, he was more interested in travelling and outdoor activities— especially yachting and hunting—and spent his time in the company of the jet set of the day. He and his wife, Anna, née Nordenstam, entertained lavishly at their luxurious summer residence built on the family's estate Hagalund near Helsinki.[95] Sadly, Nikolai's life ended prematurely; he died of tuberculosis at the age of forty.

Nikolai Sinebrychoff's unwillingness (partly due to his health problems) to take responsibility for his father's business brought the younger son Pavel (1859–1917) into the enterprise. This was the right decision as the

The Sinebrychoff brewing family
Unknown photographer, c.1862

From left to right: Anna, Mme Sinebrychoff, Pavel, Maria, Pavel Sinebrychoff, and Nikolai.
The brewer Pavel Sinebrychoff became the richest man in the grand duchy. It was said that only the Bank of Finland had more money than he did.
His wife Anna, née Tikhonova, who was his closest collaborator in the business, was also an important philanthropist.

155

brewery prospered and was developed even further during his tenure. It is easier to be successful with the right spouse at your side. Pavel found the love of his life in the person of Fanny Grahn, a celebrated young actress. Fanny initially had great difficulties in deciding which to choose: a continued career on the stage or a lifelong vocation as Mrs. Sinebrychoff. She chose the latter. Married life for Fanny and Pavel was happy, although they never had children. They amassed an extraordinary art collection consisting of both modern Finnish pieces, European old masters, and an exquisite assemblage of miniatures. In 1921, a few months before her death, Fanny Sinebrychoff donated her and her husband's entire art collection, as well as their home, to the Finnish state. Today one can enjoy the generous bequest at the Sinebrychoff Art Museum of Helsinki.

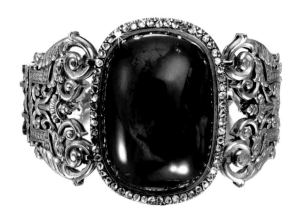

Bracelet
Samuel Arnd, St. Petersburg, c.1885
Gold, cabochon garnet, diamonds
Courtesy of Sotheby's

An Unlikely Friendship
Queen Olga of Greece and
Baroness Sophie von Kraemer

A charming story of an unlikely friendship is linked to the jeweled bracelet with a horseshoe motif seen here. It was a gift from Queen Olga of Greece to Baroness Sophie von Kraemer. The horseshoe, a symbol of good luck, can be detached and worn as a brooch. On its own, the bracelet is strikingly avant-garde with its five parallel, unadorned, stiff wires of gold. This is modernism long before its time. The centerpiece, on the other hand, is sumptuous. The nails of the horseshoe have been transformed into shimmering red cabochon rubies. What should be a black iron surface has been metamorphosed into a glittering layer of diamonds.

The bracelet was made in the late 1870s in St. Petersburg by the master goldsmith Johann Samuel Arnd.[96] He had a workshop on Gorokhovaia ulitsa in St. Petersburg and was an important collaborator of the celebrated court supplier Nicholls & Plincke, popularly known as the Magasin Anglais (English Shop) due to the nationality of its two proprietors. Arnd was married to Sophia Elisabeth Tegelsten, daughter of Carl Tegelsten, master silversmith and owner of a large bronze factory. He was another leading collaborator of Nicholls & Plincke.[97]

Arnd was known for his masterful jewelry. He used an abundance of precious stones in his designs and delighted in large bright-colored cabochons and either brilliant-cut or cushion-shaped diamonds.

The recipient of the bracelet, Sophie von Kraemer, née Baroness Cedercreutz, was born in the Grand Duchy of Finland. She had married her

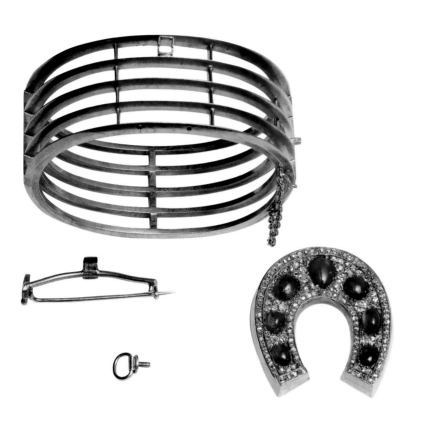

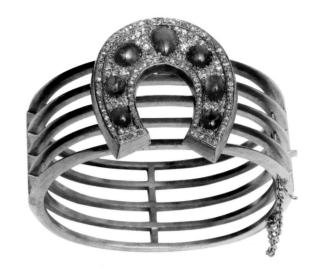

The horseshoe motif is detachable and can be used as a brooch.

A pin stem and rivet are needed to transform the horseshoe into a brooch. They are easily screwed onto the reverse of the piece.

fellow countryman, Captain First Rank Oscar von Kraemer, in 1868 The marriage took place in Piraeus, the port of Athens, during a short leave the commander of the frigate *Aleksandr Nevskii* had at his disposal. The thirty-nine-year-old bridegroom by this time had had an important career in the Russian imperial navy. He had served in the Black Sea Fleet and taken part in the war of 1854–55 and the defense of Sevastopol. He was injured during this command, but not to the extent that his career was interrupted. He had devoted himself totally to his vocation as a naval officer. But his life as a single and determined seafarer took a turn one autumn day in 1866 when he met young Sophie Cedercreutz. The two fell in love at first sight, and Oscar von Kraemer soon found himself making plans for his new role as a husband.[98]

Combining married life with an ascending career demanded much of both spouses. In 1878, von Kraemer was appointed chief of the Russian squadron in the Mediterranean. Then came his promotion to vice-admiral and adjutant of the emperor. After that he was named head of the general staff of the Russian navy and in 1890 squadron commander of the Black

Oscar von Kraemer
and his wife Sophie
Unknown photographer, early 1870s
Courtesy of Kurt Salvén

Facing page:
Queen Olga of Greece
Unknown photographer
Courtesy of the Library of Congress,
George Grantham Bain collection

The queen can be seen wearing diamond
rivières, pearls and an impressive diamond
and pearl devant de corsage.

Sea fleet. Von Kraemer worked in close and loyal contact with his sovereign his entire life.

Bernhard Estlander has written a book that records his extraordinary life and career. His source material is an abundance of private papers, correspondence, photographs, and personal accounts still in the collections of his descendants. It gives a delightful description of how a career in the Russian navy brought people from various strata of the society together. The warm and long-lasting friendship which developed between the royal family of Greece and the admiral's family is a prime example.

Late in life, von Kraemer came to work in close contact with Dowager Empress Maria Feodorovna. She expressed a desire that he become chairman of the central board of the Russian Red Cross in 1898. He agreed merely out of loyalty; his ardent desire, however, after a long and demanding career, was to retire to his beloved estate Pekkala in Ruovesi, Finland.

The story of the bracelet begins in Athens. Sophie and Oscar lived there between 1878 and 1881 and soon came into close contact with Their Majesties. Due to his high position, he and his wife were officially presented to the sovereigns upon their arrival in Greece.

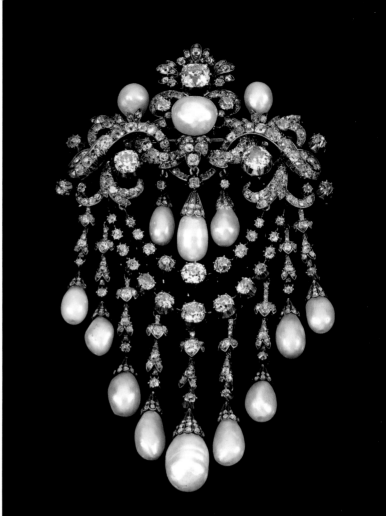

The king of Greece, George I, was born Prince Wilhelm of Denmark, son of King Christian IX, and had been elected to the throne at the age of seventeen. Queen Olga was a Russian grand duchess by birth, daughter of Grand Duke Konstantin Nikolaevich, a son of Nicholas I.

It is not difficult to understand the friendship that unfolded between the two young women, who during the summer months lived in neighboring seaside houses outside Athens. They were close in age, both had small children—and therefore shared the joy and distress that motherhood brings—and both were far away from home, family, and friends. Letters that have survived in the archives of the von Kraemer family shed light on this very special friendship.[99]

We meet with the royal family several times during the day. The queen comes to us more or less every day at 4 p.m. to have a cup of tea with us and to chat for a while. We sit in the shadow of the wall in our garden—the only shaded place we have in this sunny country. She almost always brings us something, a book for Sophie to read, photographs for us to look at, or toys for the children. The king joins her for a moment

almost every day. Sometimes we are invited to dine with them, but not more than once or twice a week because the king has a very small dining room and must invite so many other people. On the other hand, we are nearly every evening invited to his house for tea, which we take outdoors on the seashore. Every other day music is played during dinner in the king's residence. As we dine in our small garden at the same hour, we enjoy table music during our meal. Fairly often we go with "the royals" to Faleron to see a light opera performed by a French theatrical company. We often have the honor of taking them along in our boat, a means of transport they much prefer to the railroad. We often invite the "royals" onboard the frigate. I, for example, recently had a tea party onboard; and last Sunday, they took part in the church service onboard, after which I invited them to lunch.

Estlander quotes a number of little notes written in French by the queen to Sophie. They start off either with "Chère Amiralesse" (Dear Admiraless) or "Amiralesse de mon cœur" (Admiraless of my heart). They show with their sometimes bantering, sometimes serious tone, the queen's strong need to have a bosom friend.

Do You want to give me, no us, the pleasure of having lunch with us and to stay with me afterwards for a moment? Could You? Could Your husband do without You for a while? I feel I have earned the right to ask this of him as I haven't seen You for two whole days!

I almost feel ashamed of misusing Your patience!!!…Could You, do You want to come for a short walk with me in the park and to have some tea afterwards? Say yes or no to the courier of this letter, and I will resign myself to Your judgment without grumble.—What does the Admiral say: I'm beginning to dread that he will ask to be recalled from here! His family life is deranged as he is deprived of his wife on almost a daily basis.

Oscar writes to Sophie, who at the time was away from Greece, "I have yesterday received a small note from the king, who requests me to forward a thousand greetings from him to the dear admiral and his wife; he says that he hopes You will often come to see him um Dich durch ihre ungewöhnliche Liebenswürdichkeit zu erheiter" [sic]" (in order to cheer you up with their unusual kindness).

After three years in Greece, von Kraemer was called back to St. Petersburg to carry out new missions. The friendship between Queen Olga and Baroness von Kraemer was nevertheless kept alive through their lively correspondence and occasional get-togethers.

Portrait of Hermann Paul
Erik Johan Löfgren, early 1860s
Courtesy of the descendants
Photo: Katja Hagelstam

Daniel Hermann Paul (1827–1885), German by birth, was a versatile talent who had trained as a violinist in Berlin. Still a young man, he was employed by the Royal Court Orchestra and the Royal Opera in the Prussian capital, but moved to the Grand Duchy of Finland in 1858, from where he made many concert trips throughout northern Europe. His heyday as a violinist came when he was invited to perform at court in St. Petersburg. He played for both Alexander II and Alexander III, as well King Charles XV in Stockholm. His legacy is impressive, for not only was he an important composer of music, but also a teacher of the German language and a prolific author of textbooks.

Presentation ring of Hermann Paul
Unknown maker, St. Petersburg, late 1870s
Gold, amethyst, diamonds
Courtesy of the descendants
Photo: Katja Hagelstam

The ring was presented by Alexander II to Paul following a concert he gave at the imperial court in St. Petersburg. He also received a diamond ring from Emperor Alexander III.

Princess Tatiana Aleksandrovna Iusupova

Prince Feliks Iusupov has this to say of his grandmother:

My Grandmother Ribeaupierre was as good as she was intelligent and witty. She must have been very beautiful, judging by the portrait Winterhalter painted of her. She liked to surround herself with attendants whom we Russians call *prizhivalki*, vague persons whose duties were ill defined and who were to be found in most old family homes where they formed part of the household. Thus, for instance, the sole duty of a certain Anna Artamonovna was to watch over a very beautiful sable muff which my grandmother never wore but used to keep in a cardboard box. When Anna died, my grandmother opened the box: the muff had disappeared and in its place was a note written by the deceased:

'Forgive me, Lord Jesus-Christ! Have mercy on Your servant Anna for her voluntary an involuntary sins!'

My grandmother took great pains over her daughter's education. By the age of seven, my mother was well versed in social usage. She knew how to welcome guests and carry on a conversation. Once when my grandmother was expecting a visit from an ambassador, she asked her daughter, who was still a small child, to entertain him till she came downstairs. My mother laid herself out to please the old gentleman, offered him tea, biscuits, cigarettes… she labored in vain! The ambassador, as he waited in majestic silence for the mistress of the house to appear, paid no attention to the child. Having shot all her arrows, my mother could think of nothing else she could do for the guest until she had a sudden inspiration and asked: 'Perhaps you'd like to wee-wee?'[100]

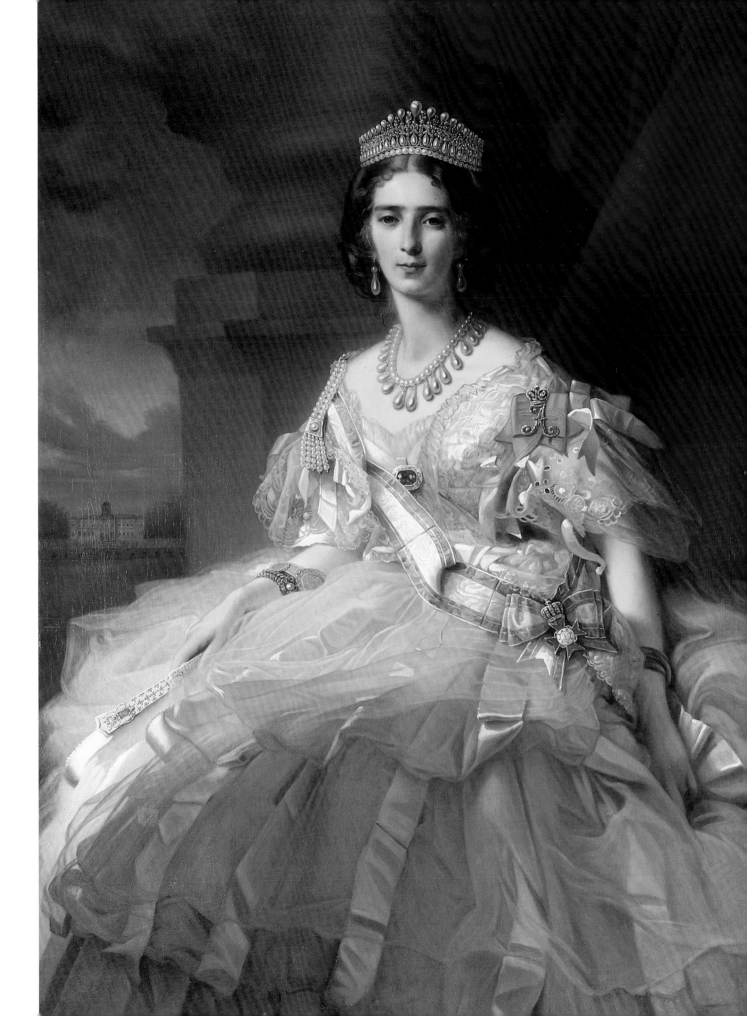

Emperor Alexander III
Fredrik Ahlstedt, 1897
Courtesy of Helsinki University Museum

Ahlstedt's portrait originally hung in
The Assembly Room of the Senate of
the Grand Duchy of Finland, and was
a copy of a portrait painted in 1883 by
Johann Köler. The emperor wears a gen-
eral's uniform of The Finnish Guards.

Empress Maria Feodorovna
Vladimir Egorovich Makovskii, 1912
The State Russian Museum,
St. Petersburg

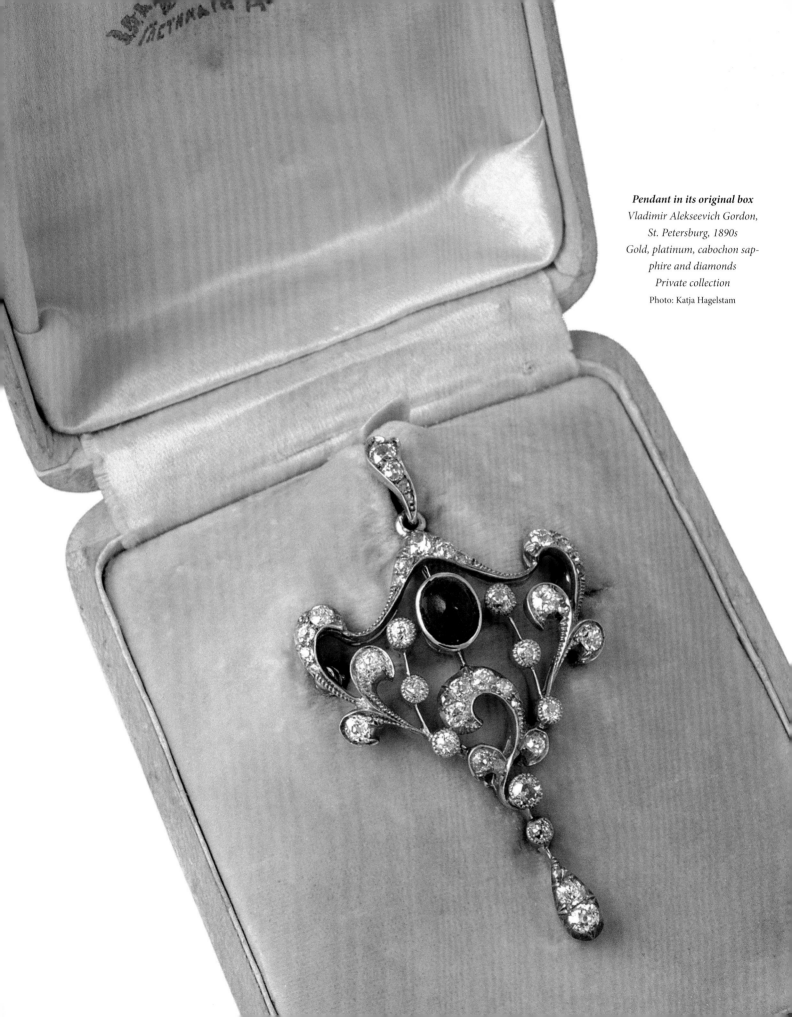

Pendant in its original box
*Vladimir Alekseevich Gordon,
St. Petersburg, 1890s
Gold, platinum, cabochon sap-
phire and diamonds
Private collection*
Photo: Katja Hagelstam

Fin de Siécle

ALEXANDER III

1881–1894

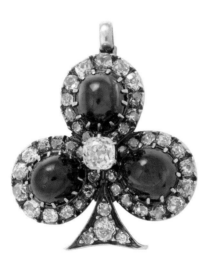

An abundance of style influences marked the two last decades of the nineteenth century in the Russian capital. The diverse elements of historicism persisted, more or less untouched, alongside all the new trends. The neo-rococo style changed once again during the 1880s and was referred to as the "third rococo." The designers of this decade looked at eighteenth-century models from a new perspective. This "third rococo" had little in common with its capricious forerunner of the days of Empress Elizabeth Petrovna. The playfulness was gone and the shapes and forms of the jewelry became more restrained. The lighthearted rococo motifs no longer seem to "belong" in this jewelry. More conservative in taste, it was jewelry for a new generation with a lifestyle far different from that of bygone days.

It would be interesting to do a separate study as to why the Louis XV style was reborn over and over again, thus seemingly inexhaustible. A possible explanation is that new groups of consumers, a well-to-do middle class, came on the scene during this time, and that the familiar historical styles seemed infallible to them.

Pendant
Unknown maker, St. Petersburg, early 1890s
Gold, silver, cabochon sapphires, diamonds
Courtesy of the descendants of Baron Bernhard Indrenius
Photo: Katja Hagelstam

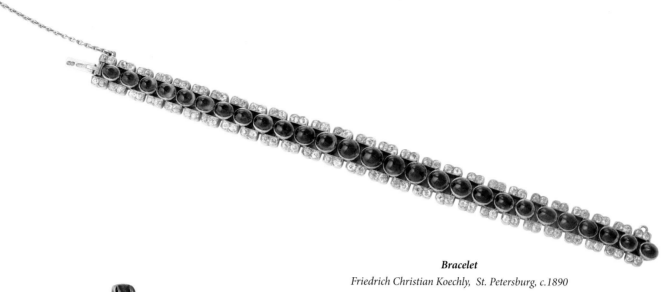

Bracelet
Friedrich Christian Koechly, St. Petersburg, c.1890
Gold, cabochon sapphires, diamonds
Private collection
Photo: Katja Hagelstam

Pendant / Brooch
Unknown maker, St. Petersburg, c.1890
Gold, diamonds, sapphires
Private collection
Photo: Katja Hagelstam

The fashion for Greek and Etruscan gold had already swept across Europe in the middle of the nineteenth century, beginning in Italy. In St. Petersburg, the first sparks of interest in reviving ancient jewels was awakened at the end of the 1860s in connection with the sensational finds of Scythian gold on the shores of the Black Sea. Copies of the jewels found there became quite fashionable in St. Petersburg.

The "old Russian style" came to be yet another trend of the *fin de siècle*. In 1870, Savva Ivanovich Mamontov (1841–1918), scion of a railroad magnate, and his wife, Elisaveta Grigor'evna (1847–1908), acquired an estate called Abramtsevo near Moscow. Both of them were interested in the Russian arts and crafts and were well aware of ideas akin to theirs elsewhere in Europe. The Mamontovs decided to open the doors of their estate to artists united by a common concern for Russian art and culture. Urbanization had accelerated during the reign of Alexander II, and industrially produced household goods, decorative objects, and textiles had become a threat to the traditional heritage of peasant art.

Mamontov's artists' colony developed into a center for creative thinking. Vasilii Polenov, his sister Elena, Il'ia Repin, and the two Vasnetsov brothers, Viktor and Apollinarii, painted, sculpted, designed furniture, created icons, crafted objects of utility, and did embroidery at the estate.

Activity of the same kind took place under the auspices of Princess Maria Klavdievna Tenisheva (1867–1928) at her estate Talashkino near Smolensk, where an artists' colony and workshops were set up at the turn of the century. Talented and inventive artists, among them Aleksandr Golovin, Mikhail Vrubel', Sergei Maliutin, and Nikolai Roerich, worked here.

Both artists' colonies left an important legacy, especially in the field of graphic art, illustration, scenic art, and decorative painting.

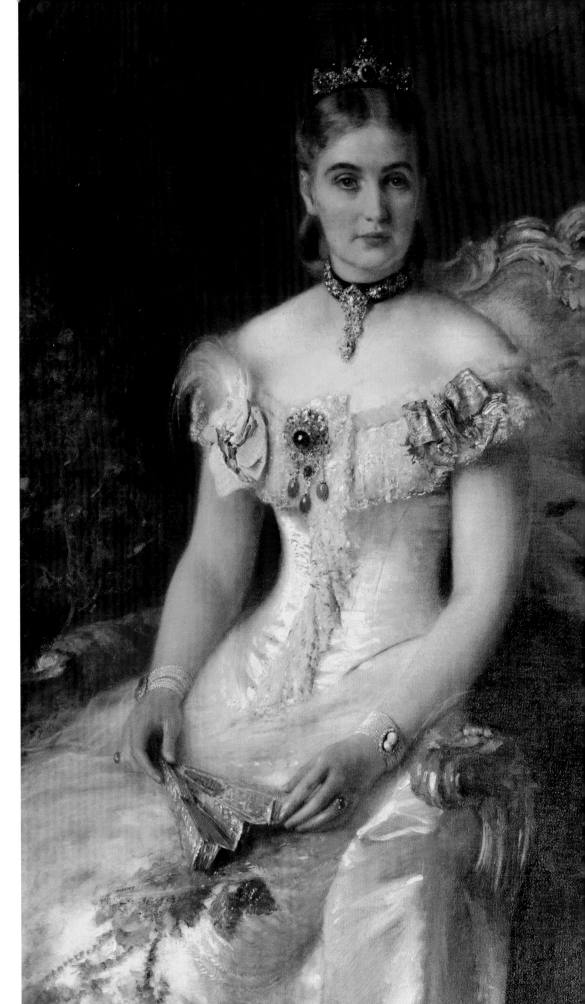

Princess Maria Mikhailovna Volkonskaia

Konstantin Egorovich Makovskii, 1884
The National Museum of Georgia, Tbilisi

Princess Maria Mikhailovna Volkonskaia (1863–1943) was the daughter of Prince Mikhail Sergeevich Volkonskii (himself the son of the Decembrist Sergei Grigor'evich Volkonskii) and Elisaveta Grigor'evna, née Her Serene Highness Princess Volkonskaia. She converted to Catholicism in 1901, in Switzerland, and later lived for many years in Rome. She was a philanthropist and translated the works of Catholic spiritual writers into Russian. She can be seen here wearing a beautiful array of jewelry consisting of a diamond and emerald tiara and brooch, a diamond choker on a black ribbon, jeweled rings on each hand, matching bracelets of small pearls with clasps set with large cameos, and a diamond brooch in the shape of a star on a pink ribbon. On her left shoulder she wears the maid-of-honor cipher of Empress Maria Aleksandrovna on the pale blue ribbon of the Order of St. Andrew.

Maid-of-honor cipher of
Empress Maria Feodorovna
N.S. Johanson, St. Petersburg 1894
Courtesy of the descendants
Photo: Katja Hagelstam

This cipher was presented to Sophie von Kraemer.

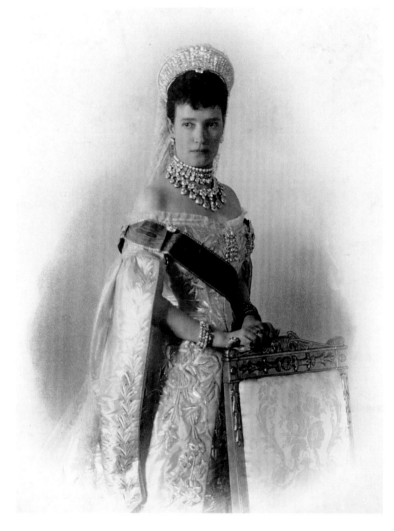

Empress Maria Feodorovna
A. Passetti, 1896

Empress Maria Feodorovna wears a magnificent assemblage of diamonds from the crown jewels: a kokoshnik tiara, three tightly fitting rivières, a collier d'esclavage, and solitaires in her ears. All of these pieces are described in detail in Fersman's Russia's Treasure of Diamonds and Precious Stones, 1925. The empress also wears the light blue sash of the Order of St. Andrew, and on her left shoulder, the star of the Order of St. Catherine.

Esclavage from the Russian crown jewels
Unknown maker, date unknown
Reproduced from A. E. Fersman, Russia's Treasure of Diamonds and Precious Stones, 1925

This necklace was a favorite of Empress Maria Feodorovna. She can be seen wearing it both in the Makovskii portrait that opens this chapter as well as in the photograph above. In 1909 it was valued at 498,715 rubles.

Bibliophile's Gift to You

Give your literate buddies a BIBLIOPHILE BOOKLIST.

Gain their permission and send us the names and addresses of your favourite bookaholics and we will send them our FREE catalogues.

It costs you nothing and when they **first order** you will receive:

£5 if they spend over £10

£7 if they spend between £15 and £20

£10 if they spend over £20

£15 if they spend over £30

£20 if they spend over £40

We try to avoid expensive advertising which inevitably puts up the book prices to our exisiting customers, and we rely on recommendations from you to maintain our mailing list. Please enjoy the scheme **as often as you like** and send us the names of friends, reading groups and book clubs, care homes and day centres, teachers or librarians who may be interested in Bibliophile and we will send you a voucher to reduce the cost of your future purchases.

Please give full postcodes to help us control postage costs.

Thank you.

TEL: 020 74 74 24 74

Names and addresses of your friends:

Name _____
Address _____

Postcode _____

Name _____
Address _____

Postcode _____

Name _____
Address _____

Postcode _____

PLEASE DON'T FORGET TO INCLUDE YOUR DETAILS ON THIS FORM BEFORE RETURNING.

Customer Ref (see over) _____
Name _____
Address _____

Postcode _____

POST TO: BIBLIOPHILE BOOKS
31 RIVERSIDE BUILDING,
55 TRINITY BUOY WHARF, LONDON E14 0FP

FAX: 020 74 74 85 89

BIBLIOPHILE®

BRITAIN'S BEST POSTAL BOOK BARGAINS

31 Riverside Building, 55 Trinity Buoy Wharf, London E14 0FP
Telephone: 020 7474 2474 • Fax: 020 7474 8589
email: orders@bibliophilebooks.com
www.bibliophilebooks.com

Ordered by:
MISS S COOPER
3 Thelma Grove
Teddington
Middlesex
TW11 9AQ

Deliver to:
MISS S COOPER
3 Thelma Grove
Teddington
Middlesex
TW11 9AQ

Product Code	Qty	Description	Unit Price	Amount	Location
84508	1	Jewels From Imperial St. Petersburg Paid By: CC	9.00	9.00	333

GOD IS MY HELP

By Appointment to
H.R.H. The Duke
of Edinburgh
Bookseller
Bibliophile Books
London

N

Many thanks for your custom. Happy Reading!

Weight: 1.48	
Total Product	9.00
Postage & Packing	3.50
Total Charge	£ 12.50

B095850
L095861
5
24/08/18

Many thanks for placing your order with Bibliophile Books. We hope you have received an excellent service and that you will be happy to order from us again.

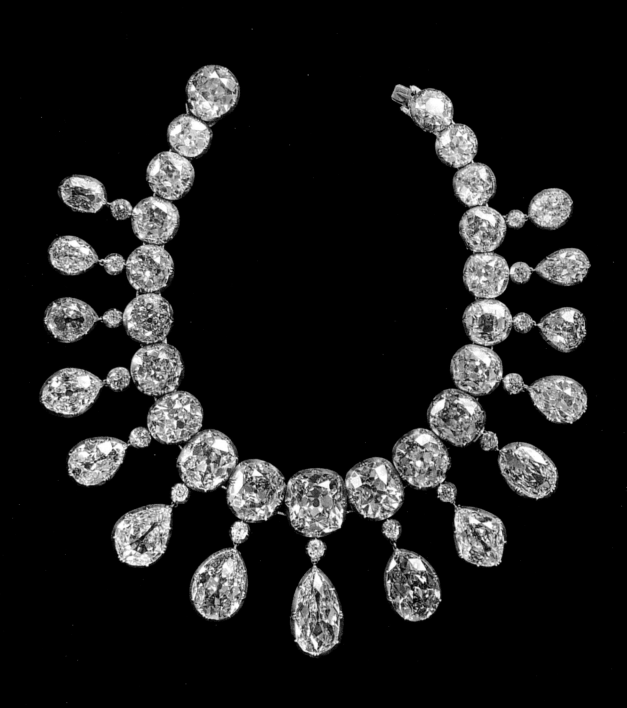

Brooch
Unknown maker, St. Petersburg, c.1890
Gold, diamonds
Private collection
Photo: Katja Hagelstam

*The brooch was a proposal of marriage: a turtle-dove brings
an eternity ring to a future bride*

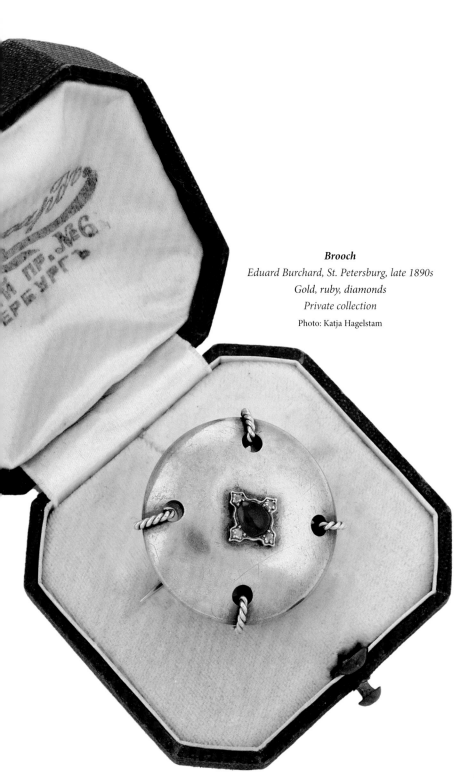

Brooch
Eduard Burchard, St. Petersburg, late 1890s
Gold, ruby, diamonds
Private collection
Photo: Katja Hagelstam

Brooch
Tuomas Koponen, St. Petersburg, 1890s
Gold, diamonds, amethysts, beryls
Courtesy of the descendants of the maker
Photo: Katja Hagelstam

*The samorodok technique producing a nugget effect on the surface of the
gold was a fashion of the time and especially used for cigarette cases*

172

Locket
Unknown maker, St. Petersburg, 1880s
Gold, pearl. diamonds
Private collection
Photo: Katja Hagelstam

Locket
Unknown maker, St. Petersburg, 1880s
Gold, ruby, diamonds
Private collection
Photo: Katja Hagelstam

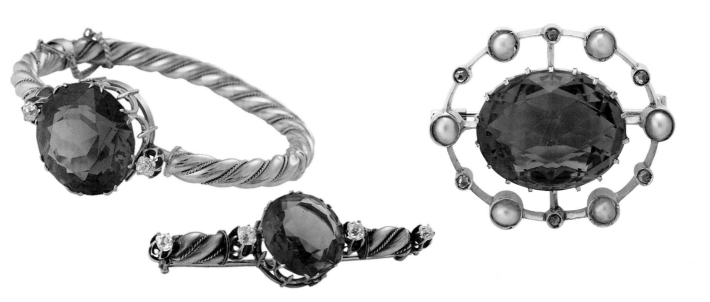

Bangle and bar brooch in the antique style
Unknown maker, St. Petersburg, 1880s
Gold, amethysts, diamonds
Private collection
Photo: Katja Hagelstam

Brooch
Tuomas Koponen, St. Petersburg, 1880s
Gold, amethyst, pearls, diamonds
Courtesy of the descendants of the maker
Photo: Katja Hagelstam

Emblem of the Vyborg Yacht Club
A. Tillander, St. Petersburg, 1890s
Gold, enamel
Private collection
Photo: Katja Hagelstam

Brooch in the form of anchor
Unknown maker, St. Petersburg, 1880s
Gold
Private collection
Photo: Katja Hagelstam

NAVIGARE NECESSE EST

St. Petersburg, the city of Peter the Great, his window to the West, with its strategic location on the innermost shores of the Gulf of Finland at the estuary of the Neva River, was from the very beginning planned to be an important center for shipping and commerce. Two crossed anchors were chosen as the symbol of the new capital. Its naval port was placed at Kronstadt, outside the river delta, but the mercantile harbor was established at the Strelka, the peninsula of Vasilii Island where the river parts.

Yachting was a fashionable pastime during the reign of Alexander III, and St. Petersburg had many yacht clubs. The foremost was the legendary Imperial St. Petersburg Yacht Club, founded in 1846, to which only members of the nobility—limited to 150 at a time—could apply for admission.[101] The elegant club house on Bol'shaia Morskaia gradually became a meeting place for the elite. The core members consisted of grand dukes, courtiers, and the diplomatic corps. The discussions inside were more about politics than yachting. The Neva River Yacht club (Rechnoi Iakhtklub), later the Imperial River Yacht Club, however, was the place for those seriously interested in sailing.

It does not come as a surprise, then, that nautical motifs were commonplace in the art of the St. Petersburg goldsmiths at this time, with bracelets, brooches, cufflinks, miniature eggs, and jetons decorated with pennons, anchors, sheets, ropes and anchor chains. *Navigare necesse est…*

Alexander III and his family, as all other Northern people, enjoyed the warmth and light of the summer months, and there was no better place to appreciate this season than in the islands of the archipelago along the southern coast of Finland. The emperor himself loved nature and outdoor activities, a love he imparted to his children, and vacations at sea became equally important for the next generation.

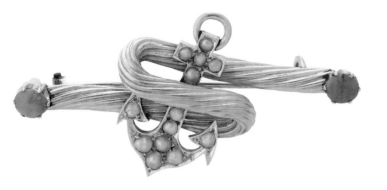

Bar brooch with an anchor
Unknown maker, St. Petersburg, 1880s
Gold, turquoises, pearls
Courtesy of the descendants of Tuomas Koponen
Photo: Katja Hagelstam

Cufflinks
Unknown maker, St. Petersburg, c.1890
Gold
Private collection
Photo: Katja Hagelstam

The imperial family made a total of ten long sojourns in the Finnish archipelago, the first in 1880, the last in the summer of 1894, the year Alexander III prematurely passed away. These often quite informal visits to the grand duchy were given a lot of coverage in the local newspapers, frequently with detailed information of the activities of the august seafarers. In this way, the sovereigns met with many of their loyal subjects in a most spontaneous way, greatly increasing the popularity of Their Majesties.

Many lovely pieces of jewelry presented during these trips have happily survived in the families of the original recipients. One such gift is a ring with the cipher of Emperor Alexander III, complete with its original presentation box and transmission letter, given in the summer of 1888 to Adolf Fredrik Leander (1833–1899), bandmaster of the Finnish Rifle Guards Battalion. During the twenty-five years of Leander's conductorship, the band developed into a premier musical ensemble. It became a fixture at the maneuvers of the Russian army at Krasnoe Selo, as well as at festivities at Peterhof, the summer residence of the imperial family. Between 1885 and 1893, the band regularly accompanied Alexander III and his family on their summer cruises in Finland.

Within the context of the Russian imperial award system, a gift decorated with the sovereign's cipher held a significant place in the overall hierarchy of official awards, preceded only by a gift incorporating the emperor's miniature portrait. Its prestige value was therefore high. Leander's ring, which was the most costly gift presented during this specific visit to the Grand Duchy of Finland, was priced at 232 rubles, an amount estimated to have been around one fourth of his annual income.

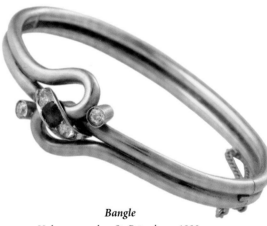

Bangle
Unknown maker, St. Petersburg, 1880s
Gold, sapphire, diamonds
Private collection
Photo: Katja Hagelstam

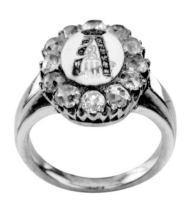

*The chest, which contains the silk pennant of
the Imperial River Yacht Club in St. Petersburg,
was a gift to their sister club in the grand duchy,
the Nyländska Jaktklubben, which celebrated
its fiftieth anniversary in 1911.*

Presentation tiepin of
Lieutenant General Otto Viktorinus Gadd
Friedrich Daniel Butz, St. Petersburg, late 1880s
Gold, diamonds
Courtesy of the descendants
Photo: Matias Uusikylä, Bukowskis, Helsinki

The tiepin, in its original red morocco case with the
imperial double-headed eagle stamped on the lid,
was a gift of Emperor Alexander III.

THE VISIT TO RILAX

The summer cruise of 1884 was on the imperial yacht *Tsarevna*, which
was a large propeller steamer with a shiny black hull. The imperial squad-
ron anchored at sunset on July 2 in an idyllic bay at Bromarv, which be-
longed to the manor of Rilax. In the morning, Count Adolf Aminoff, aide-
de-camp of the emperor and master of the estate, had himself rowed out to
welcome the guests and asked for the honor of paying his respects to Their
Majesties. His request was granted, and the count was invited to lunch in
the dining room of the *Tsarevna* and was seated next to the empress. "Dur-
ing the *déjeuner*," reports the local paper,[102] Count Aminoff suggested that
Their Majesties take a promenade up to his house. The emperor replied
that such an excursion was not part of the program and therefore declined.
The empress, however, expressed a desire to accept the invitation as she
had heard that the road leading up to the manor was exceptionally beauti-
ful. His Majesty, who in cases like this listened to his wife, agreed to devi-
ate from the official itinerary. After lunch, Their Majesties, with their chil-
dren and the entourage, disembarked into a small steam launch which took
them to the shore. Upon arrival at the manor, Count Aminoff invited his
guests to see his library; the retinue waited outside. They took their time
inspecting the entire house, even the private study of the count. A tray with

**Presentation ring of Lieutenant General
Otto Viktorinus Gadd**

Unknown maker, St. Petersburg, c.1889
Gold, turquoise, diamonds
Courtesy of the descendants
Photo: Katja Hagelstam

*The ring was a gift to Gadd for his services to
Their Majesties during their cruise of the Finnish
archipelago in the summer of 1889. The original
morocco leather case has the imperial double-head-
ed eagle stamped on the lid.*

ice cold champagne was passed around, but the emperor passed. He said he would much prefer a *filbunke*, a simple Finnish dish of sour whole milk. A modest bowlful of *fil* was thereafter enjoyed by the entire party.

When the visit was over, a number of unpretentious carriages, a chaise, and a surrey were brought to the entrance of the house. The empress swiftly climbed onto the coach seat of the chaise, her two boys took a place in the back. They much enjoyed the drive down to the waterfront with their mother at the reins.

Another warm and friendly visit took place in July 1889. The imperial family had as their guests Queen Olga of Greece, her two children, Prince Nicholas and Princess Maria, and the emperor's sister, Grand Duchess Maria Aleksandrovna, Duchess of Saxe-Coburg and Gotha.

Upon reaching the archipelago on the northern coast of the Gulf of Finland, the imperial squadron anchored in the Bay of Haiko near Porvoo (Borgå). The local newspaper reported that the steamship *Runeberg*, filled to the brim with passengers, made a special detour to the anchorage so that the people onboard could catch a glimpse of the splendid imperial flotilla. It was truly imposing—the *Tsarevna* carrying the imperial family, their august guests, and retinue, the steam frigate *Aleksandriia*, the steam yacht *Narva*, the warships *Onega* and *Krasnaia Gorka*, and the pilot steamer *Eläköön*,[103] pride of the grand duchy. The commander of the *Eläköön* was the director of the grand duchy's pilotage service, General Otto Viktorinus Gadd (1831–1898). Gadd, whose services were often needed by Their Majesties, received three valuable gifts from his sovereigns: two diamond-set tiepins in gold with the crowned initials of the emperor and empress and a gold ring with two diamonds and a turquoise.

On July 2, the imperial squadron reached Fridhem, the summer residence of the von Kraemer family (see An Unlikely Friendship – Queen Olga of Greece and Baroness Sophie von Kraemer). Anchors were dropped in the bay of Espoo (Esboviken). The *amiralesse* was rowed out to greet the imperial yacht. An hour later she had the honor of receiving the entire group of eminent visitors in her home.

Baroness von Kraemer happily kept Queen Olga with her long after the other guests had departed. The two women spent hours talking about the good old days in Greece, catching up on everything that had happened since they last saw one other. Only at eleven in the evening was the queen rowed back to the *Tsarevna*.

The imperial fishing lodge at Langinkoski
Hjalmar Munsterhjelm, c.1889
Courtesy of Hagelstam Fine Art Auctioneers
Photo: Katja Hagelstam

SALMON FEASTS AT LANGINKOSKI

When still heir to the throne, Grand Duke Aleksandr Aleksandrovich, future Emperor Alexander III, paid a visit to the rapids of the Kymi River—Siikakoski and Langinkoski—near the town of Kotka in Finland. He apparently admired the natural beauty of the region, but was primarily impressed by abundance of salmon in its waters. Emperor Paul I granted territorial fishing rights in 1797 to the monks of Valaam, who for a good fifty years enjoyed the bountiful catch. In 1850, the rights were assigned to Sergei Druzhinin for an annual fee. He was an industrious Russian merchant who expanded the fishery along the streams. The imperial family visited the region during their summer cruises and had many opportunities to enjoy the locally caught salmon at their table onboard the *Tsarevna*. In 1887, the emperor decided that a lodge was to be built for him at the rapids of Langinkoski and had the fishing rights transferred to himself. For the emperor to have a residence, albeit a most modest one, on the soil of the grand duchy was seen as a compliment to the loyal subjects of Finland. A building committee was formed and two promising young men were given the task of drawing up the plans for the lodge. They were the architect Magnus Schjerfbeck and the artist Jac. Ahrenberg. The two of them created a charming building with specially crafted furniture in a national romantic

179

The imperial family and their guests at Langinkoski
Unknown photographer, 1889
The National Museum of Finland

Taken during the inaugural visit to the newly completed fishing lodge at Langinkoski, the photo shows the imperial family, members of the retinue, and the crew gathered at the tempo-rary entrance gate of the property. Emperor Alexander III stands in the back row on the left. Next to him is General Otto Gadd, head of the pilotage of the grand duchy. Standing at the right is Queen Olga of Greece. Seated in the middle with a straw hat is Grand Duchess Maria Aleksandrovna, Duchess of Edinburgh and of Saxe-Coburg and Gotha, sister of the emperor. Next to her Empress Maria Feodorovna. Four members of the younger generation can be seen as well: Prince Nicholas of Greece (behind his mother), Princess Maria of Greece (on the left of Grand Duchess Maria Aleksandrovna), Grand Duke Mikhail Aleksandrovich in his sailor suit, and Grand Duchess Ksenia Aleksandrovna in her lovely summer outfit.

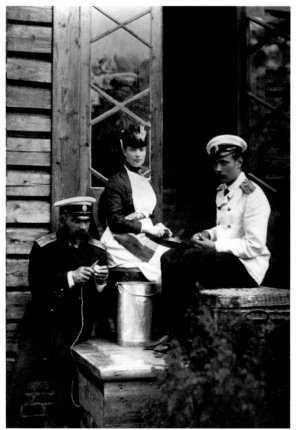

Preparations for salmon soup on the kitchen steps of Langinkoski
Unknown photographer, c.1891
Courtesy of Jorma Tuomi-Nikula

The charming snapshot bears witness to the fact that the imperial family also enjoyed the simple things in life. Empress Maria Feodorovna, armed with kitchen utensils, can be seen with her son Grand Duke Georgii (on the right) and A.A. Andreev, commander of the imperial yacht Tsarevna, seated on the left.

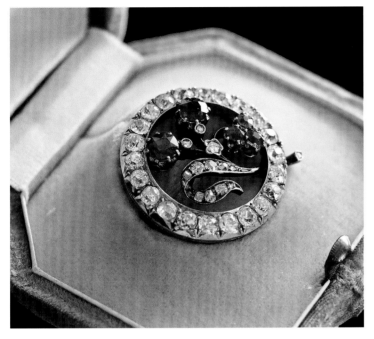

Brooch of Quita Björnberg
Carl Hahn, St. Petersburg, 1893
Gold, sapphires, diamonds
Courtesy of the descendants
Photo: Katja Hagelstam

Maria Luisa Dolores "Quita" Björnberg, who was born in 1893, received this brooch from Empress Maria Feodorovna as a christening gift. Her father, Fredrik Björnberg, was at the time chief of security of the Palace of Gatchina outside St. Petersburg, where the family of Alexander III lived. The original light blue velvet box with the empress's cipher in silver on the lid has survived as well.

style. The project was completed in the summer of 1889, during which the imperial family visited twice. Many delightful stories about the goings-on of the sovereigns circulated within the grand duchy: His Majesty the Emperor of All the Russias was seen chopping fire wood and Her Majesty the Empress puttering about the kitchen preparing salmon soup for her family.

Alexander III sadly had only five years left to live from the time the fishing lodge was completed. His last cruise and visit to Langinkoski took place in the summer of 1894, half a year before he passed away at his summer palace in the Crimea.

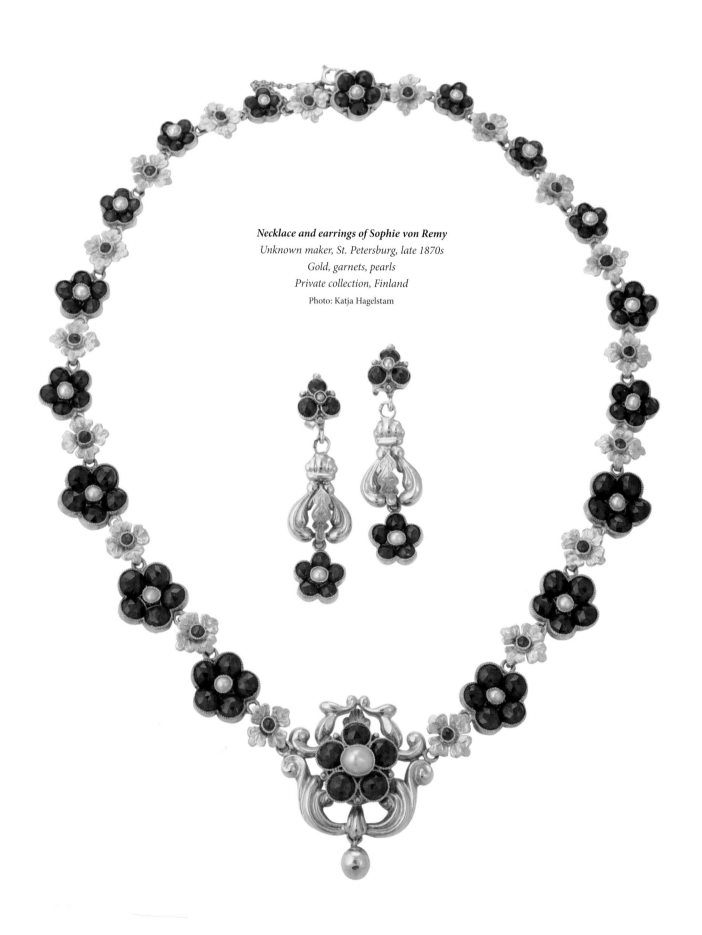

Necklace and earrings of Sophie von Remy
Unknown maker, St. Petersburg, late 1870s
Gold, garnets, pearls
Private collection, Finland
Photo: Katja Hagelstam

Sophie von Remy – A Lonely Soul

Sophie von Remy, the owner of the elegant garnet and pearl necklace and earrings illustrated here, was born in 1864 in the ancient Tatar city of Kazan. Her father, General Friedrich Remy, of Huguenot descent, served there from 1853 until 1864 it the 4th Corps of Internal Guards (Kazanskaia Strazha).[104]

Sophie, who was named after her mother Sofia Vasil'evna Tikhanovskaia, was the youngest of thirteen children. Nicknamed Sonia, she was only five when her mother died and eight when her father passed away. Her eldest brother, Woldemar (Vladimir Fridrikhovich), barely twenty-one and at the outset of a military career, had to assume responsibility for his younger sisters and brothers. The obligation weighed heavily on his shoulders for many years to come and was possibly the reason why he himself never had a family.

Sophie was enrolled soon after her father's death at the Smol'nyi Institute for Noble Girls in St. Petersburg. A Russian general's daughter was eligible for a place in this elite school founded by Catherine the Great. She became a protégée of the emperor thanks to her late father's high position and was also freed from paying the high fees of the institute.[105]

The loss of her beloved parents as a small child marked Sonia for life. The Smol'nyi, with its severe rules that seemingly prevented a child from being a child, became her home for eight years.[106] Sonia's reminiscences from her years at the school were not altogether happy. She could never forget having been denied permission to attend the wedding of her older sister Adelaida, although it took place in St. Petersburg.

The youngest of the pupils, yearning for love and comfort, often went hungry. Sophie was reminded later in life of the kindly gas-lamp lighters who shared loaves of black bread with the girls while performing their duties in the dormitory corridors.

On a more positive note, the superior education she received was of great value to her. The Smol'nyi curriculum was tailored to prepare young ladies for a future life in the upper echelons of Russian society as wives of highly ranked men of the nobility. They were taught foreign languages—primarily French and German—and tutored in etiquette, music, dance, and entertaining on an elevated level. Many important practical subjects were also part of their course of study.

Visits of the imperial couple were the highlights of the school year. Emperor Alexander II and his wife, Empress Maria Aleksandrovna, held their protective wings over the young girls at this time. As the empress

Locket
Gold, turquoises, pearls
Unknown maker, St. Petersburg, 1880s
Courtesy of the descendants of Sophie von Remy
Photo: Katja Hagelstam

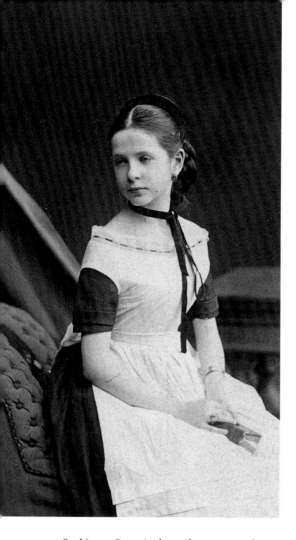

Sophie von Remy in the uniform worn at the
Smol'nyi Institute on festive occasions
Unknown photographer, c. 1876
Courtesy of the descendants of Sophie von Remy

Brooch
Unknown maker, St. Petersburg, 1870s
Gold, diamonds, enamel
Courtesy of the descendants of Sophie von Remy
Photo: Katja Hagelstam

The brooch was commissioned by Sophie and her
two closest friends in commemoration of their happy
times together.

was severely ill with tuberculosis, it was the emperor who paid regular visits. The institute had a special place in his heart as Princess Ekaterina Mikhailovna Dolgorukova, his inamorata and future morganatic wife, had been a pupil there.[107] The emperor was obviously greatly admired by the young girls, and the magnificence of the imperial residences they occasionally were invited to visit made an unforgettable impression on them all.

Sophie met her future husband, Colonel Victor Tuderus, while visiting Crimea with her brother Woldemar. Tuderus at the time was posted at the Sevastopol railroad supervising the transport of military forces. The summer palaces and estates of Russia's aristocracy were scattered along the southern coast of the Crimea, and the imperial family had their luxurious residences at Livadia and Oreanda. Yalta, an elegant resort town, was the early hub of tourism on the Black Sea.

According to family tradition, the romance between Sophie and Victor was ignited over a rather trivial encounter. The young girl happened to be suffering from a light headache and the gallant officer came to her rescue offering her the remedy—a headache powder.

Victor Tuderus, twelve years Sophie's senior, was an interesting man with a fascinating background.[108] Being the son of a general, his father gave him no alternative as to his education. He was enrolled at the Nikolaevskii Cavalry School in St. Petersburg, more or less against his will. On graduating, he joined the Dragoon Regiment of the Guards with the rank of cornet. His own interest lay in the arts, and his dream had been to train as an artist. His parents lived in St. Petersburg between 1872 and 1877, and during this time he had sporadic opportunities to take elementary courses at the Imperial Academy of Arts. He was even able to take lessons in painting from Il'ia Efimovich Repin, the well-known painter.

When the Russo-Turkish War broke out in 1877, Victor, then a lieutenant, was sent to fight. He wrote comprehensive diaries describing the campaigns and illustrated these with skillfully rendered watercolors. His diaries, along with his art, were published in 2009.[109]

Victor proposed to Sophie in 1881, shortly after they had become acquainted. The bride was no more than seventeen. Not long before their engagement, all of Russia was shocked by the assassination of their beloved emperor. Life came to an abrupt halt. The many reforms Alexander II had initiated after the emancipation of the serfs were annulled by his son and successor Alexander III.

The emperor's violent death was obviously also a severe blow to Sophie. Her feelings of grief for her august benefactor culminated during the two hours she, as a representative Smol'nyi pupils, stood in attendance at his

Miniature orders
Samuel Arnd, St. Petersburg, late 1880s
Gold, enamel
Courtesy of the descendants of Victor Tuderus
Photo: Katja Hagelstam

Colonel Tuderus commissioned miniatures of the decorations awarded to him during his career. They include the Order of St. Anne with swords third class, the Order of St. Stanislas with swords third class, the sword of St. Anne fourth class, "for bravery", the Medal for the Russo-Turkish War 1877–78, the Commemorative Medal for the reign of Alexander III (added later), and the Iron Cross of Rumania. Tuderus received the Order of St. Stanislas second class in 1892.

Sophie von Remy and her future husband Colonel Victor Tuderus
Unknown photographer, 1881
Courtesy of the descendants

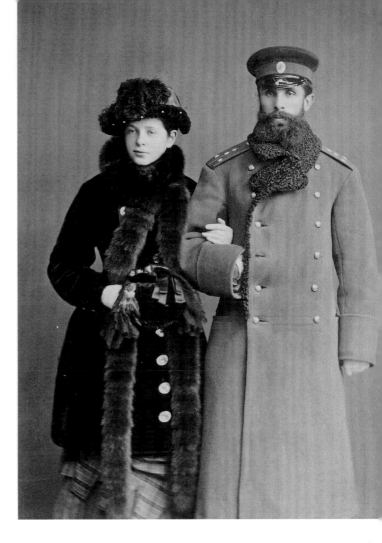

catafalque in the Cathedral of Peter and Paul. She never got the chance to show her gratitude to him for his generous dowry of 2,000 gold rubles.[110]

Sophie and Victor were married in St. Petersburg on April 13, 1883, at the church of St. Anna. Marriage, however, did not prove to be the key to happiness for Sophie. The newlyweds settled at the Tuderus family's Löytö estate located in the picturesque lake district of the Grand Duchy of Finland, near the small provincial town of Mikkeli. At the time, Victor's mother, Maria, ruled the roost, and his sister, Lovisa, kept house at the neighboring estate of Kosoniemi.

Without a network of close friends, and her siblings far away, Sophie was lonely and unhappy. The Tuderus family had a privileged place in the society of the region and a lively social life, but Sophie found it difficult to make new friends among the members of the many aristocratic families in their circle.

Victor Tuderus did everything in his power to make his young wife happy. He showered her with beautiful clothes and jewelry. He gave her the freedom to travel, to visit with friends in St. Petersburg, and to take the waters

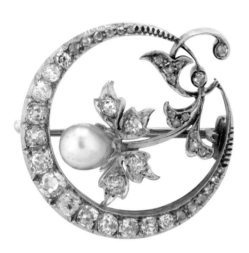

Brooch
Tuomas Koponen, St. Petersburg, late 1890s
Gold, silver, diamonds, pearl
Courtesy of the descendants of the maker
Photo: Katja Hagelstam

at various health resorts. He rented an eight-room apartment in Helsinki so that she could be close her older brother Woldemar, who was posted there.

Sophie gave birth to the couple's one and only child in 1884, a son named Edvard Voldemar. The baby was born and baptized on the estate. One would have hoped that motherhood would have finally brought contentment into Sophie's life, but alas, no. She complained of having too much household work and demanded more pin money. She mistrusted her servants and treated them badly. She was constantly looking over their shoulders with the aim of catching them stealing. On one occasion, she had a servant scrub a floor in the middle of the night after having noticed that the poor girl had done a bad job.

After fifteen years of marriage, Victor had had enough and filed for divorce. Their son, who was fourteen at the time, remained with his father and was not even allowed to visit his mother. Sophie moved into the home of her brother Woldemar in Helsinki. He died in 1906, leaving his sister penniless. Sophie was in a desperate financial situation as she had not been receiving the maintenance she was entitled to from her former husband. Matters between the two were finally settled a decade after their bitter divorce, and Sophie received a small monthly allowance. This was Victor's revenge for, as he said, having spoiled his life. He sold his estates soon after the divorce proceedings were finalized, remarried, and moved to Nice on the French Riviera.

Sophie spent the latter part of her life in rural simplicity living in a modest house in the small village of Karjaa (Karis) in western Finland. On the day of his engagement, her son reestablished contact with his mother, which was a great consolation for her. For him it meant breaking ties with his father.

In her new environment, Sophie was an odd figure from the *beau monde* which was totally foreign to villagers. Being a grumbler by nature, she was constantly quarreling and arguing with people, never giving up what she considered her rights. Fortunately for her, she had her son, and later her grandson, to smooth out the troubles in which she frequently found herself. She died at the age of ninety without ever changing her eccentric ways and behavior.

Life had offered Sophie many good opportunities for success and happiness, but for some reason she could not overcome what life had deprived her of: the warmth of a childhood home, a beloved mother, father, siblings, and friends. Married life in a foreign land, a new language, a home in the country far away from the urban life of St. Petersburg she knew so well, it all added to the heartache, distress, and torment she must have borne in her soul throughout her life.

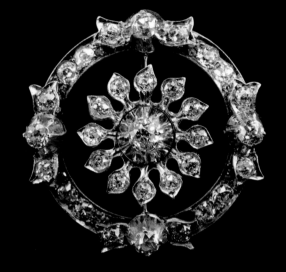

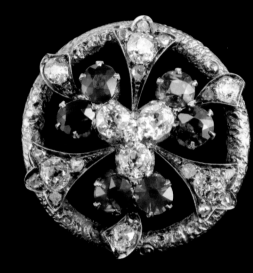

Bracelet
Unknown maker, St. Petersburg, 1880s
Gold, diamonds, pearl, enamel
Private collection
Photo: Katja Hagelstam

Cross
Unknown maker, St. Petersburg, 1880
Gold, malachite
Private collection
Photo: Katja Hagelstam

Locket & earrings
Unknown maker, St. Petersburg, 1880s
Gold, onyx cameos
Private collection
Photo: Katja Hagelstam

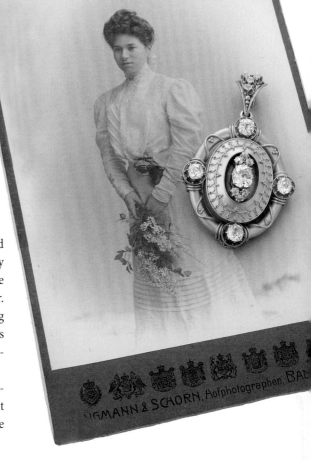

A Parcel from Leningrad with Surprising Contents

One day in May of 1952, a thickly padded envelope, originally dispatched from Leningrad, was brought to the B—— manor in western Finland by the local postman. The carefully sealed parcel had made a detour via the Swedish embassy in Stockholm before being delivered to the addressee. Mr. R——, owner of the estate, instantly discerned the distinctive handwriting of his sister-in-law "Lilly" Berg on the package. Since the day the borders between Russia and Finland were closed by the Bolsheviks in 1918, all contact with "Lilly" and her family had been lost.

When the enigmatic parcel was opened, small bundles, each neatly folded in creased silk paper, revealed family heirlooms of jewelry, all in mint condition. There was no accompanying letter and no way of contacting the sender.

The family at the B—— manor has kept this costly cache intact, including the envelope and the creased silk paper. For them, it is a valuable piece of family history that needs to be preserved.

With the fall of the Soviet regime, the story of the padded envelope became clear.

Caroline "Lilly" Berg, née Ebert (St. Petersburg 1874–Siberia 1946), was the wife of the engineer Robert "Boba" Berg (1870–1939), who had had a brilliant career in Russia before the revolution broke out. The family had two daughters, Mary Irene "Ira" (b. 1907) and Margarethe "Gigi" (b. 1908). The Berg family had lively contacts with their large family, all of them meeting frequently at their estates and summer residences in Estonia. But life took a radical turn with World War I and the Russian Revolution. The entire Berg family, including the daughters with their husbands and babies, were deported to Siberia in 1935. Their fate is unknown.

In 1926, Caroline Berg took her jewelry to the Swedish consulate for safekeeping. From there it was later sent by diplomatic pouch to Stockholm. It may seem odd that she chose to part with valuables that she may have needed as an economic safeguard. The family in Finland has, however, come to the conclusion that she saw her heirlooms as a manifestation of the good life she once had had and wanted them preserved for posterity.

Locket
F. Koechly, St. Petersburg, 1880s
Gold, diamonds
Private collection
Photo: Katja Hagelstam

The photograph shows Caroline "Lilly" Berg, née Ebert.

Bracelet
Unknown maker, St. Petersburg, late 1890s
Gold, diamonds, cabochon sapphires
Private collection
Photo: Katja Hagelstam

The small charm with the text
"Remembrance July 9, 1915" may refer to the day
the young woman companion returned to her home-
land, the Grand Duchy of Finland.

Brooch in the form of a three-leaf clover
Unknown maker, St. Petersburg, 1890s
Gold, silver, diamonds, cabochon sapphires
Private collection
Photo: Katja Hagelstam

GIFTS FROM AN UNKNOWN PRINCESS

A small collection of jewelry lovingly preserved by descendants of a great-aunt is a silent witness to a unique and presumably warm relationship between an aristocratic lady from St. Petersburg and her Finnish woman companion.

The precise details of the story sadly have been lost. Anecdotes of days gone by are frequently told to young generations who disrespectfully let the stories go in one ear and out the other. Only much later, when the older members of the family are gone, does their interest awaken—alas, too late.

What is known about this small collection of jewelry from the reigns of Alexander III and Nicholas II is that an unidentified lady belonging to a Russian princely family, residing in a grand St. Petersburg house, took a liking to her young woman companion of humble birth. She opened her jewel box at New Year, Easter, birthdays, and name days, and gave her companion mementoes of the good times the two of them had spent together.

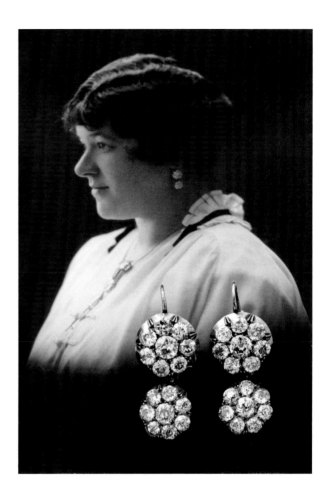

A descendant of the lady companion with a modern-style brooch
Unknown maker, St. Petersburg, 1890s
Gold, silver, diamonds
Private collection
Photo: Katja Hagelstam

A descendant of the lady companion with earrings
Unknown maker, St. Petersburg, 1890s
Gold, silver, diamonds
Private collection
Photo: Katja Hagelstam

Pendant
Unknown maker, St. Petersburg, 1880s
Gold, crystal, diamonds, rubies, sapphires
Private collection
Photo: Katja Hagelstam

The pendant carries a religious missive. A golden fly on the reverse is the Christian symbol for ungodly acts. The crowned Church Slavonic script, interwoven to form a decorative ornament, reads, "У Бога чужих нет" (essentially, the Almighty forgives and protects us all, even though we are the most insignificant of insects).

PRINCESS ZINAIDA NIKOLAEVNA IUSUPOVA

Princess Zinaida Nikolaevna Iusupova (1861–1939) was one of the richest heiresses in Russia and possessed an amazing collection of jewels by the best Russian and European makers. Her son Feliks paints a delightful picture of her in his memoirs *Lost Splendour*:

My mother was lovely. She was slim and had wonderful poise; she had very black hair, a soft olive complexion and deep blue eyes as bright as stars; she was clever, cultured and artistic, and above all she had an exquisitely kind heart. No one could resist her charm, and far from being vain and proud of her exceptional gifts she was modesty and simplicity itself. 'The more you have,' she used to tell us, 'the more you owe to others. Be modest, and if you do happen to have any advantages don't let those who are less favoured know it.'

She had had numerous suitors from every country in Europe. But she refused all offers, even those of royalty, as she was determined to choose her own husband. My grandfather, who in his mind's eye saw his daughter on a throne, lamented her lack of ambition. He was bitterly disappointed when be found that she had decided to marry Count Felix Soumarokoff-Elston, a mere officer in the Guards.

My mother had a natural gift for dancing and acting which would have enabled her to vie with the best professionals. At a great fancy-dress court ball where all the guests had to appear as sixteenth-century boyars, the Tsar asked her to perform the Russian national dance. Although she had not rehearsed with the orchestra, she improvised so skilfully that the musicians followed her movements with ease. She took five curtain calls.

Stanislavsky, the famous manager of the Moscow theatre, after seeing her act in a charity performance of *Les Romanesques*, play by Edmond Rostand, begged her to enter his company, insisting that her right place was on the stage.

Wherever my mother appeared she brought a delightful feeling of light and well-being. Her eyes shone with kindliness and sweetness. She dressed with quiet elegance, was not fond of jewellery, and although she owned the most beautiful gems wore them only on great occasions.

The Infanta Eulalia, aunt of King Alfonso XIII of Spain, once came to Russia on a visit and my parents gave a reception for her in our house at Moscow. In her memoirs, the Infanta gives a description of my mother:

'Of all the parties given in my honour, none impressed me more than that of Princess Youssoupoff. The princess was a most lovely woman, whose marvellous beauty stands out as typical of a period. She lived in extraordinary luxury, in a setting of unsurpassed splendour, surrounded by works of art of the purest Byzantine style, in a great palace the windows of which gave onto the city of a thousand cupolas. The magnificence and luxury of Russia, blended with the refinement and distinction of France, reached its culminating point in the Youssoupoff palace. At the reception in question, the Princess wore a court gown studded with the finest diamonds and pearls. Tall, exquisitely beautiful, she wore a *kokoshnik* set with enormous pearls and equally large diamonds, worth a fortune. A dazzling array of fantastic jewels from the East and the West completed her costume: ropes of pearls, massive gold bracelets of ancient design, pendants of turquoises and pearls, multicoloured, glittering rings. … All these gave to Princess Youssoupoff the majestic splendour of a Byzantine Empress' [the *kokoshnik* is our court tiara].

On another official occasion, things turned out quite differently. My parents accompanied the Grand Duke Serge and the Grand Duchess Elisabeth to England to attend Queen Victoria's jubilee celebrations. The wearing of jewels was obligatory at the Court of St. James, and the Grand Duke had asked my mother to bring her finest sets. A large red leather bag containing jewels was entrusted to a manservant. On the evening of her arrival at Windsor Castle, when my mother was dressing for dinner, she asked her maid for the jewels, but the bag could not be found. So Princess Youssoupoff appeared in a sumptuous gown without a single jewel. The bag was found next day in the rooms of a German princess whose luggage had also gone astray.

When I was a small child, my greatest pleasure was to see my mother in evening dress. I remember particularly a dress of apricot velvet trimmed with sable which she wore at a dinner given in our house on the Moïka in honour of Li-Hung-Chang, a Chinese statesman who was making a short stay in St. Petersburg. To complete her toilette, she wore a set of diamonds and black pearls.[111]

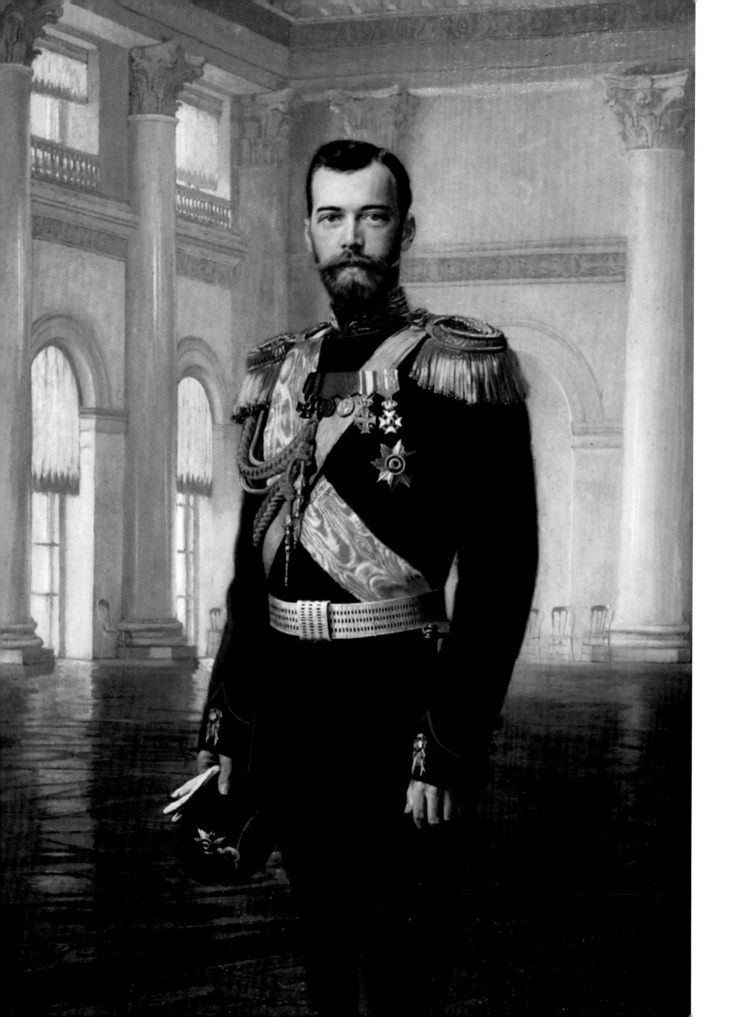

Emperor Nicholas II
Ernst Friedrich von Liphart, 1900
The State Museum-Preserve "Tsarskoe Selo"

Throughout his reign, the emperor retained
his military rank of colonel, the rank he had
when he came to the throne. In the portrait the
sovereign is wearing aide-de-camp aiguillettes
and epaulettes with the monogram of his father,
the Order of St. Andrew, and on his medal bar
the Order of St. Vladimir fourth class, the service
medals of his father's coronation and reign, the
cross of honor of the Order of the Dannebrog (of
Denmark), and the Order of the Redeemer (of
Greece). He wears the uniform of the Guards
Horse Artillery. Since his accession to the throne,
he was Chief of the 1st "His Majesty's" Battery.

Empress Alexandra Feodorovna
Nikolai Kornil'evich Bodarevskii, 1907
The State Museum-Preserve "Tsarskoe Selo"

The empress wears an emerald and diamond
tiara made by C. E. Bolin (see page 116). As
this is not an official portrait, she is depicted
wearing personal jewelry, predominantly two
of her beloved strands of pearls, a betrothal gift
from her parents-in-law, which she has combined
with pendants of large emerald cabochons and
diamonds. An emerald and diamond brooch and
four bracelets similarly set (most likely also made
by Bolin) complete her elegant ensemble.

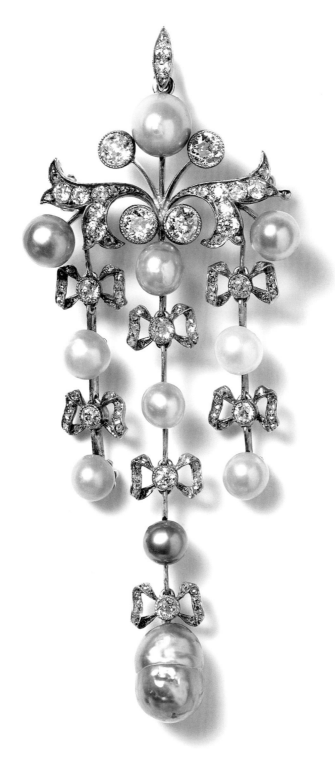

Devant de corsage
Fabergé, 1899–1908
Gold, colored pearls, diamonds
Courtesy of Wartski, London

A corsage ornament such as this would have been worn pinned to the bodice of an elegant evening dress.

The New Century

NICHOLAS II

1894–1917

K arl Fabergé was the central figure among the St. Petersburg jewelers at the dawn of the new century. His importance cannot be exaggerated. His innovative genius and unparalleled artistic talent challenged his foremost competitors in the trade—Bolin, Butz, Hahn, Keibel, Koechly, and Ivanov. But there were obviously other pioneering craftsmen during this time. Denisov-Ural'skii was one of them. Like his illustrious colleague, he made use of Russia's rich treasure of indigenous gemstones and decorative minerals. Other contemporary St. Petersburg jewelers and goldsmiths successful in their own genre were Bock, Britsyn, Morozov, Gordon, Tillander, Sumin, as well as their competitor in Moscow, Lorié.

Fabergé took part in the Paris world exhibition in 1900, showing examples of his spectacular production in the styles of the glorious days of Versailles, albeit in a new way and in a new cultural climate. Already well known in the West, he was honored with a knighthood in France's Legion of Honor, and his colleagues in the French capital acclaimed him with the words, "Louis XIV, Louis XV, Louis XVI! Where are they now?" and replied themselves to the question, "In St. Petersburg. Now we call them Fabergé!"[112]

Brooch
Unknown maker, St. Petersburg, c.1900
Platinum, gold, pearls, diamonds
Private collection
Photo: Studio Ibis, Loviisa

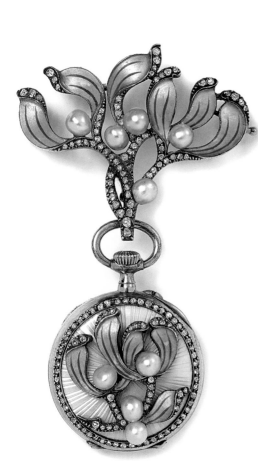

Pendant watch with a mistletoe motif
Fabergé, workshop of August Hollming,
St. Petersburg, early 1900s
Gold, diamonds, pearls, enamel
Courtesy of the Woolf Family Collection

Even though Fabergé first became known for his jewels in the styles of the past centuries, his production was far from merely retrospect. His work included art-nouveau motifs and even more interesting designs heralding modernism. In this he prepared the ground for a new design philosophy that embraced sleek forms and shapes stripped of superfluous decor. This was a style that triumphed in Western Europe much later, when it had recovered from the agonies of World War I. Fabergé's work is examined in greater detail later in this chapter.

The first decade of the new century and the last decade of the previous were primarily a time of regeneration in the arts and crafts. In 1898, a group of young artists and writers—among them Aleksandr Benois, Lev Bakst, Ivan Bilibin, Mstislav Dobuzhinskii, Evgenii Lanceray, Konstantin Somov and Dmitrii Filosofov—came together to form a movement called Mir iskusstva (World of Art).[113] They were inspired by the Arts and Crafts movement in England in that one of its ambitions was to replace what in their opinion was the decadence of design with something artistically genuine. The two prominent art institutes, the Stroganov school in Moscow and the central institute for technical drawing, the Stieglitz School of Applied Arts in St. Petersburg, joined forces with the movement and together greatly improved the level of Russian design.[114]

AMONG THE BIRDS AND THE BEES

Art nouveau—the new style of the 1890s in Western Europe—found its way to St. Petersburg at the beginning of the twentieth century. In the more independent world of art that had developed in Russia, this Western European style took two different directions: one was influenced by the French version of the style and was named *stil' modern*, and the other took its motifs from the treasure trove of the indigenous art. Fabergé's Franz Birbaum was one of the exponents of the style. Being Swiss, he was familiar with the latest trends in Western Europe. He was employed by the firm in 1893 and soon became the head designer. Among his well-known art nouveau designs are, with a definite *genius locus*, the three imperial Easter eggs: the Lily-of-the-Valley Egg of 1898, the Pansy Egg of 1899, and the Clover Egg of 1902.[115]

In the spirit of French art nouveau, the Russian modern style took its motifs from nature, primarily the world of insects and flowers. The handsome stag beetle (*Lucus cervus*), Europe's largest, with its long antler-like jaws, was a preferred choice. Jeweled versions in many varieties exist, with

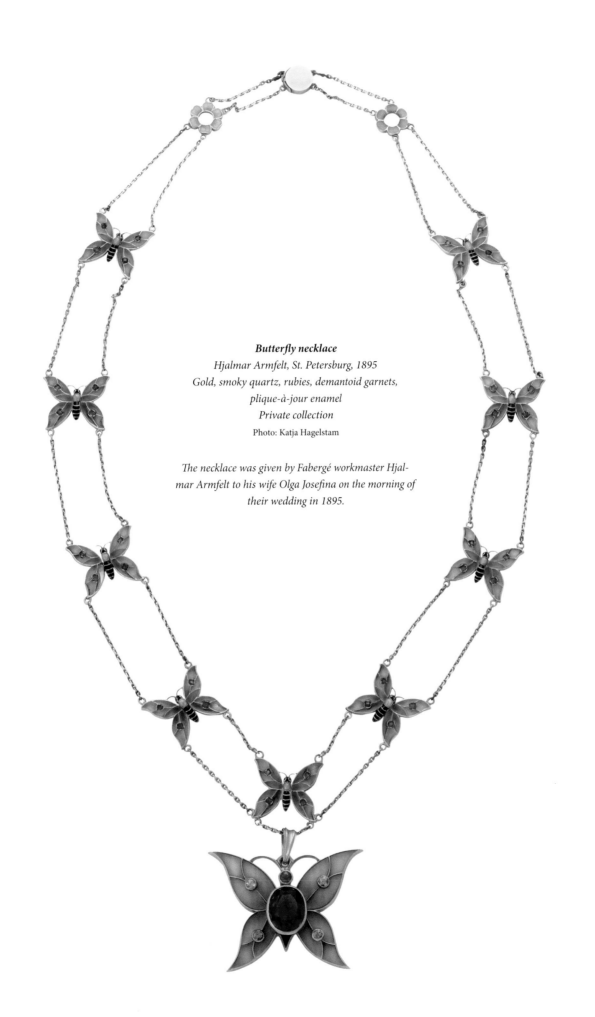

Butterfly necklace
Hjalmar Armfelt, St. Petersburg, 1895
Gold, smoky quartz, rubies, demantoid garnets,
plique-à-jour enamel
Private collection
Photo: Katja Hagelstam

The necklace was given by Fabergé workmaster Hjalmar Armfelt to his wife Olga Josefina on the morning of their wedding in 1895.

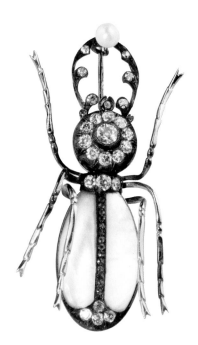

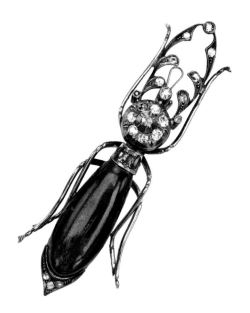

Brooch in the form of a stag beetle
Unknown maker, St. Petersburg, early 1900s
Gold, silver, diamonds, rubies, pearls
Private collection
Photo: Studio Ibis

Brooch in the form of a stag beetle
Unknown maker, St. Petersburg, late 1890s
Gold, diamonds, lapis lazuli
Private collection
Photo: Rauno Träskelin

Brooch in the form of a stag beetle
Unknown maker, St. Petersburg, late 1890s
Gold, tiger's eye, rubies, emeralds, quartz, diamonds

The brooch originally belonged to Fanny Heimbürger (1824–1915), whose husband's family were the first shipping agents of St. Petersburg as well as the most important shipbrokers.

Brooch in the Egyptian-revival style
Unknown maker, St. Petersburg, early 1900s
Gold, carnelian scarab, plique-à-jour enamel, diamonds
Courtesy of Sotheby's

Brooch in the form of a stag beetle
Unknown maker, St. Petersburg, late 1890s
Gold, silver, purple sapphire, ruby, opal, diamonds
Courtesy of Bonhams, New York

Brooch in the form of a stag beetle
Nikolai Linden, St. Petersburg, early 1900s
Gold, diamonds, emeralds, rubies
Photo: Katja Hagelstam

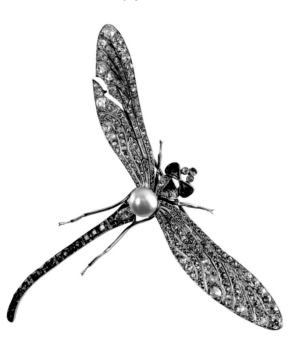

Brooch in the form of a dragonfly
Unknown maker, St. Petersburg, early 1900s
Gold, diamonds, emeralds, pearl

Pendant in the form of a ladybug
Unknown maker, St. Petersburg, c.1900
Gold, silver, diamonds, ruby, enamel
Courtesy of the Sinebrychoff family
Photo: Katja Hagelstam

Brooch
Hjalmar Armfelt, workmaster of Fabergé,
St. Petersburg, early 1900s
Gold, diamonds, enamel
Private collection
Photo: Katja Hagelstam

Hjalmar Armfelt made this brooch as a gift
for his wife

Lily-of-the-valley brooch
C. Hahn, St. Petersburg, late 1890s
Gold, silver, diamonds, pearls
Courtesy of the descendants
Photo: Katja Hagelstam

The brooch was purchased by Admiral Oscar
von Kraemer for his wife Sophie.

Pendant
Tuomas Koponen, St. Petersburg, early 1900s
Green and red gold, rubies, pearl, diamonds
Courtesy of the descendants of the maker
Photo: Katja Hagelstam

bodies in colorful lapis lazuli, agate, almandine, hematite, and even large baroque pearls. The heads were set with small precious stones such as rubies, emeralds, or sapphires, in addition to glittering diamonds. There seemed to be no limits to the imagination. Other insects and beetles, cockchafers, butterflies, hymenoptera, dragonflies, ladybirds, and spiders in their decorative webs were also frequent subjects of the goldsmith's art.

The lily-of-the-valley was a favored flower in jewelry of the time. It appeared as if pressed in an herbarium, like one made by Alexander Tillander, or more naturalistic, with the small flower bells *en tremblant*, as made by Butz, Hahn, and Fabergé. Stylized compositions of flowers and leaves are often seen in pendants and brooches. *Stil'-modern* rings are charming, low-key interpretations of French designs and employ the entire range of precious stones. Designers mixed different colors of gems and enamel in one and the same piece without a sign of reluctance.

Two rings
Gold, turquoise, pearl, rubies, diamonds
Tuomas Koponen, St. Petersburg, early 1900s
Courtesy of the descendants of the maker
Photo: Katja Hagelstam

Ring
A. Tillander, St. Petersburg, early 1900s
Gold, opal, diamonds
Private collection

Ring
Unknown maker, St. Petersburg, early 1900s
Gold, pearls, diamonds
Courtesy of the descendants of Baron Bernhard
Indrenius
Photo: Katja Hagelstam

Bar brooch
Unknown maker, St. Petersburg, early 1900s
Gold, opals
Courtesy of the descendants of Tuomas Koponen
Photo: Katja Hagelstam

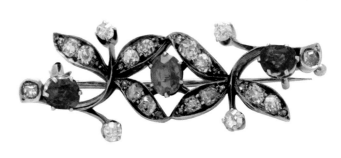

Flower-spray brooch
Unknown maker, St. Petersburg, early 1900s
Gold, silver, rubies, diamonds
Private collection
Photo: Katja Hagelstam

Brooch
Karl Bock, St. Petersburg, 1890s
Gold, silver, rubies, diamonds
Courtesy of the descendants of Baron Bernhard Indrenius
Photo: Katja Hagelstam

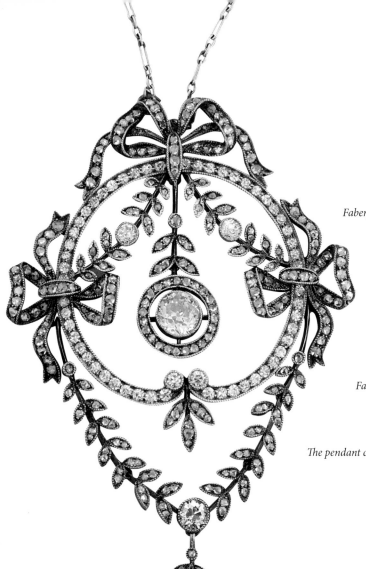

THE *BELLE ÉPOQUE* AND THE GARLAND STYLE

It may come as a surprise that the styles of the eighteenth century were revived once more, especially during a time of great scientific and technological progress, as well as one of social awakening. A comparison, however, between the idea-world of the privileged classes in France during the years leading up to the Revolution in 1789 and the lifestyle preceding World War I and the Russian Revolution reveals many similarities. During both of these eras, the upper classes seemed out of touch with reality. Exaggerated pleasure seeking, narcissism, and a lack of social conscience characterized the privileged classes of both epochs. Posterity has labeled the years preceding World War I the *belle époque*. St. Petersburg was on equal footing with Paris as far as indulgence and elegance was concerned.

In reading Marcel Proust's monumental opus *A la recherche du temps perdu* (Remembrance of Things Past), one is wistfully transported to a world of distinguished salons, fashionable dinners, diplomatic receptions, hunting parties, fancy balls, and nights at the opera in Paris, London, Venice, Biarritz, Deauville, and Monte Carlo. St. Petersburg should definitely be added to the list of places where social events of the same kind took place, amidst "une mer houleuse de diadems" (a stormy sea of diadems).[116]

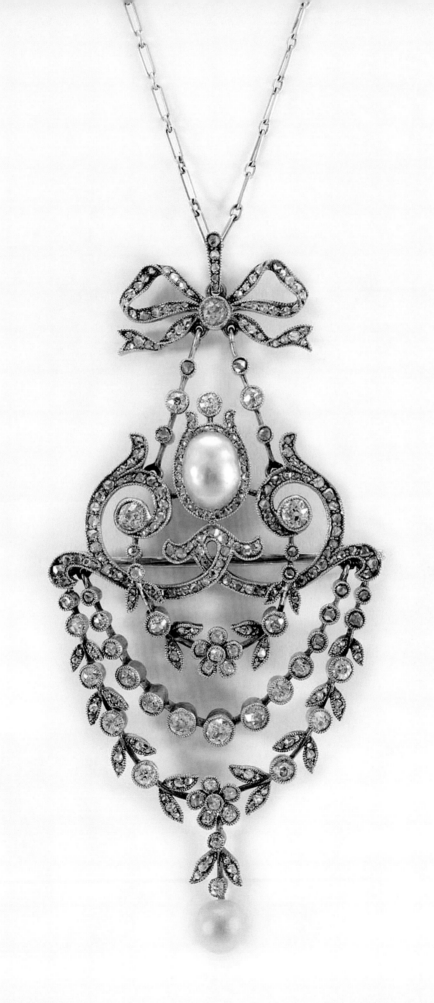

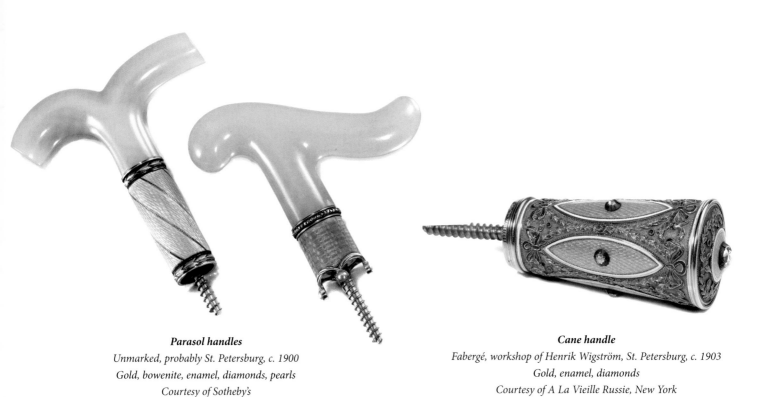

Parasol handles
Unmarked, probably St. Petersburg, c. 1900
Gold, bowenite, enamel, diamonds, pearls
Courtesy of Sotheby's

Cane handle
Fabergé, workshop of Henrik Wigström, St. Petersburg, c. 1903
Gold, enamel, diamonds
Courtesy of A La Vieille Russie, New York

The ladies of the era, with their tightly laced corsets, have been compared to walking hour glasses. Upon waking, they would don a negligee or *robe de chambre*, then change into a morning dress, a walking dress, an afternoon dress, a tea dress. Hair was worn up, and immense plumed and beribboned hats were de rigueur. Although jewelry was kept to a minimum during the day, and generally very simple, the era afforded other avenues for display. Parasols were quite common, and Fabergé produced an elegant array of handles made from a variety of materials, such as bowenite, rock crystal, and guilloché enamel set with small pearls and precious stones.

Full evening dress, magnificent creations of silk, velvet, tulle, and sequins, was worn for dinner and other gala receptions. It was with these ensembles that the jewelers' art could be seen in all its glory. At this time of extravagance, the most refined jewelry ever—ethereal and elegant—known as the "garland" or "Marie-Antoinette" style, was produced, much of it in the workshops of imperial Russia.

Tightly fitted *colliers de chien*, frequently composed of pearls with a luxurious diamond plaque at the front, were much in fashion. Pendants, necklaces, and rivières adorned the neck...elaborate *devants de corsage*, brooches, and epaulettes graced the bodice...to which one can add a vast array of earrings, bracelets, and rings. Waist-long ropes of pearls (as seen in the portrait of Princess Orlova), sautoirs, and long necklaces called lavallières, from which one or more gemstones were suspended, were all the rage. Empress Alexandra had a lavallière with large amethysts.[117] As already noted, life in high society demanded a constant change of dress, hence the jewelry of the era was often constructed so that it could be easily transformed

and used in various ways: a necklace or a group of brooches could be put on a frame and transformed into a tiara...a *devant de corsage* could be taken apart to form earrings and a pendant...or a long necklace could be separated to make a choker and bracelet.

A craze for Persian-inspired motifs swept Europe following the tremendous success of the Ballets Russes productions, such as *Schéhérazade*, which premiered at the Opéra Garnier in Paris on June 4, 1910. Diamond aigrettes became the fashionable hair ornament and jewelers vied with one another to come up with an ever increasing range of exotic models to choose from. The Countess de Chabrillan and the Countess de Clermont-Tonnerre both hosted celebrated Thousand and One Nights balls in Paris in 1912, to which several members of St. Petersburg high society were invited, including Grand Duchess Maria Pavlovna, Mme Ignat'eva, M. Soldatenkov, and M. Benardaki.[118] Similar balls followed shortly thereafter in the Russian capital. Countess Maria Eduardovna Kleinmichel describes the one she gave in the last social season before the war:

> In 1914 my sister-in-law, the Countess Konstantin Kleinmichel, settled in Petersburg for her daughters' *début*, and I gave a fancy dress ball for my nieces which was quite a social event.
>
> My three nieces and the young Princess Kantacuzen were to dance the classic minuet to Mozart's music. Countess Marianna Zarnekau, the daughter of Princess Paley, whose beautiful dancing was well known, was to perform an Egyptian dance with a naval officer. Baroness Wrangel and her friend, Mlle. Ohotnikoff, whose partners were Count Roman Potocky and Comte Jacques de Lalaing, were to perform a Hungarian dance; Prince Konstantin Bagration, son-in-law of the Grand Duke Konstantin, had arranged Caucasian dances, and the Princesses Kotchoubey were to figure in the Little-Russian Quadrille. Finally, the Grand Duchess Cyrille and Grand Duke Boris headed the Eastern Quadrille, in which Princess Olga Orloff, Countess Maya Koutouzoff, Miss Muriel Buchanan, Princess May Gortchakoff, Mrs. Jasper Ridley and many others took part. Among the men were Prince Alexander of Battenburg, since killed at the front, some members of the English Embassy, and many Guardsmen, handsome youths, who have since died on the plains of Lithuania, in the Carpathians, or who have fallen victims to their own soldiers.
>
> I sent over three hundred invitations, for my house could not hold a greater number, and as the Russian custom is to give supper at little tables, it was also as much as my kitchen could undertake.

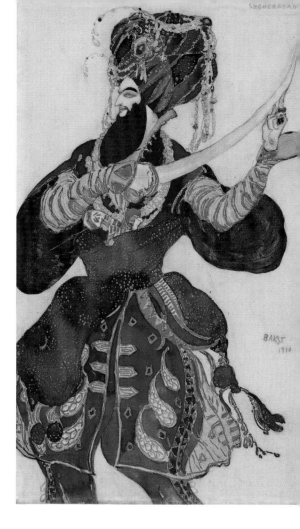

Costume design for Shah Zeman
From the Ballets Russes' production of Schéhérazade
Lev Samoilovich Bakst, 1910
Gouache, pencil, watercolor, gold paint on varnish paper
National Gallery of Australia, Canberra

I was inundated with demands for invitations, for people took an immense interest in this Imperial Quadrille, but with the best will in the world I could not satisfy everybody. Every man or woman who had ever left cards on me thought he or she had a right to an invitation, and became my enemy on not receiving it. At least another hundred people asked for permission to see the Imperial Quadrille from the top of the staircase, and I had to refuse that request also, since so many people standing would block all the passages…

My ball went without a hitch, and the next day the same people danced again at the Grand Duchess Vladimir's.[119]

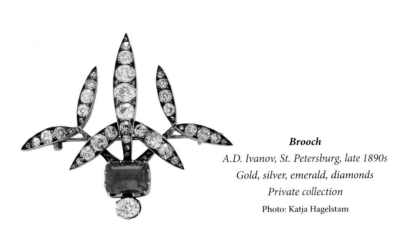

Brooch
A.D. Ivanov, St. Petersburg, late 1890s
Gold, silver, emerald, diamonds
Private collection
Photo: Katja Hagelstam

Countess Ol'ga Valerianovna von Hohenfelsen
Unknown photographer, 1912

The Countess (created Princess Palei in 1915), who is dressed by Worth for a Hungarian-themed fête given by Mme Manuel de Yturbe in Paris in 1912, wears her Cartier diamond tiara as a corsage ornament and her Cartier devant de corsage as a clasp for the aigrette on her fur hat. In attendance were the Infanta Eulalia and the Infante Luís Fernando of Spain, Grand Duke Paul of Russia (husband of Countess von Hohenfelsen), Princess Stéphanie of Belgium, Prince Heinrich of Bavaria, Prince and Princess Lucien Murat, and the ambassadresses of Russia, Austria-Hungary, and Germany, to name but a few.

Design of a fancy-dress costume for Princess Orlova
Lev Samoilovich Bakst, 1914
Courtesy of Bonhams

THE MOST ELEGANT AND BEST-DRESSED WOMAN IN PETROGRAD

An anonymous memoirist has left us with this captivating account of Princess Ol'ga Konstantinovna Orlova:

Princess Olga Orloff, by birth a Princess Belosselsky-Belosersky, is the most elegant and the best-dressed woman in Petrograd. Although not a beauty, she has breeding and is an aristocrat to the tips of her fingers. Endowed with the lovely blue "Skobeleff eyes" (her mother was a sister of the famous "White General"), she has a graceful willowy figure. In her early married life she was very thin, too think in fact, though it suited her style. On the other hand the Prince is decidedly stout. At a Court ball, as the Prince and Princess Orloff were entering the State chamber, a wit remarked to his neighbour: "Behold the Prince and Princess Orloff in flesh and bone." The next day this epigram spread all over the town, and since then it has clung to them.

Pendant
Unknown maker, St. Petersburg, c.1910
Platinum, diamonds
Courtesy of Bukowskis, Helsinki
Photo: Matias Uusikylä

Princess Ol'ga Konstantinovna Orlova
Philip Alexius de László, 1908

*Considered the best-dressed woman in St. Petersburg, the
princess can be seen wearing an elegant diamond tiara
(possibly by Fabergé), an indispensable part of any great
lady's attire at the time.*

Pendant
A. K. Denisov-Ural'skii & Co, St. Petersburg, c.1910
Platinum, aquamarine, diamonds
Courtesy of the Furuhjelm family
Photo: Katja Hagelstam

The reverse of the pendant has a latticework set with small diamonds, a charming "surprise" effect seen only by the owner of the jewel. The lid of the original case has the name of the maker on the silk lining.

Dress is the Princess's pet weakness. She spends fabulous sums to gratify her passion for chiffons, and seldom wears a gown twice. Sometimes she orders several frocks for some special occasion, and dons the one that finds favour in her eyes, while the rest are discarded. Some of her gowns are perfect triumphs of the dressmaker's art. She is unanimously recognised as society's leader of fashion, and at important receptions everyone is interested as to what "creation" Princess Orloff will wear.

One day, not very long ago, this supremacy in matters of toilette was put to a severe test. At an evening-party in one of the smart private houses of Petrograd, a bevy of ladies in marvellous evening-dresses, scintillating with their family diamonds, together with men in brilliant uniforms, or in faultless evening-dress, were assembled. Enter Madame Polovtsoff—a handsome woman on a large scale, whose husband is very wealthy—in a lovely evening-gown from a famous firm that is the fairy-godfather of all would-be well-dressed women in Europe and America. Madame Polovtsoff is instantly surrounded, complimented and becomes the cynosure of all eyes, when the folding-doors open again to give admittance to the Princess Orloff, who, with a view to secure an effective entrance, always arrives late. To the consternation of everyone present, the Princess Orloff's dress is identical with the one worn by Madame Polovtsoff. Material, colour, intricacies of trimming, diamond-studded osprey of a particular shade, every item exactly alike...!

By some fatal error the same model had been sent to two clients moving in the same set. The two ladies looked like twin-sisters. The onlookers felt expectant, the hostess looked uncomfortable... A moment's ominous silence reigned. But the innate breeding of the Princess helped her to carry off the situation triumphantly. She approached Madame Polovtsoff, exclaiming: "It is only since I see my dress on Madame Polovtsoff, that I really begin to admire it"; she then boldly sat down next to that lady and spent some time in amicable conversation with her, in full view of an appreciative audience.[120]

Countess Betsy Shuvalova

The same anonymous memoirist has taken up her pen in description of the inimitable Countess Elisaveta Vladimirovna Shuvalova:

Brooch in the art deco style
Unknown maker, St. Petersburg, c.1910
Platinum, gold, emerald, diamonds
Private collection
Photo: Katja Hagelstam

Brooch in the art deco style
Unknown maker, St. Petersburg, c.1910
Platinum, diamonds
Private collection
Photo: Katja Hagelstam

> One of the most important society leaders in Petrograd is Countess Elisabeth or, as she is more generally known, Countess Betsy Schouvalov. By birth a Princess Bariatinsky, she was married to one of the richest members of the Schouvalov family, Count Paul Schouvalov, who died about fifteen years ago, leaving his childless widow a life interest in one of the richest estates in Russia.
>
> The Countess lives in one of the handsomest houses in Petrograd, on the Fontanka Quay, palatial in its dimensions and artistically luxurious in its arrangements. One must have seen and felt the magnificence of the receptions given here by the Countess Schouvalov, for otherwise it would be difficult to give an adequate description of them.
>
> An imposing white marble staircase branches up in two flights of steps, with a white marble gallery running around leading into a long suite of different-sized drawing-rooms, with stuccoed walls covered with beautiful old brocade. Empire style predominates everywhere, and the furniture is somewhat old-fashioned and ponderous, which corresponds perfectly with the large size of the rooms. The walls of the lofty white ballroom, with its enormous windows, are covered with sculptured bas-reliefs. At the end of the room is a good-sized stage (occasionally the Countess lends her state apartments for amateur theatricals got up for a charitable object). When supper-time comes the folding-doors of another neighbouring suite of brilliantly lit-up rooms are opened, and a row of marvellously laid out, flower-decked supper tables is exposed to view, with beautiful old china, cut glass and antique silver on all the tables, prepared sometimes for over six hundred guests.
>
> Being one of the richest women in Russia, the Countess Schouvalov considers it her duty to use her income judiciously for the benefit of her fellow-countrymen as well as for her own satisfaction. In the course of the season she generally gives several brilliant festivities, because she thinks she owes it to her position in society; she likewise deems it indispensable to support various kinds of philanthropic and charitable institutions.
>
> Very tall, with an exquisite figure that has retained its youthful lines in all their purity, the Countess is a very fine woman, and in evening dress, with her magnificent diamonds scintillating all over her, she is a most imposing figure.

During the last season in Petrograd before the war...great preparations were made by the Countess for three grand receptions. The first was a black and white ball, given in January, 1914. All the ladies had to be dressed in either black or white, or in a combination of the two. All the flowers for the cotillon [*sic*] were pure white, and the other items, such as scarves, tulle bows, etc., were black and white. The whole of Petrograd society was at the ball—over six hundred guests. The members of the foreign diplomatic corps were present, [and] several members of the Imperial family graced the occasion by their presence.

The second ball was even more brilliant than the first, though the guests were less numerous they were more select. All the ladies were in coloured wigs—it was the first introduction in Petrograd of this new fashion, and the effect created was marvellous.

The Schouvalov mansion was graced by numerous members of the Imperial Family, eager to witness the novel sight of elegant women in evening attire wearing their hair in all the colours of the rainbow.

On the last day of Lent, Countess Schouvalov gave her last reception, which was to surpass all the rest in its magnificence. The festival was to commence with a short French comedy, and character dances beautifully organised, followed by a ball.[121]

Countess Elisaveta Vladimirovna Shuvalova, née Princess Bariatinskaia (1855–1938), was the daughter of Prince Vladimir Ivanovich Bariatinskii and Princess Elisaveta Aleksandrovna Chernysheva. She was married to Count Pavel Petrovich Shuvalov (1847–1902). In addition to being known for sumptuous receptions in her palace on the Fontanka, she also created, in this same palace, workshops for poor women where they could learn how to sew and shops for the merchandise, called "Kustari," that were made by the peasants on her estates. During World War I, she converted her home into a hospital and devoted herself to nursing as head of her own hospital train at the front. She died in Paris and is buried at the Russian cemetery of Sainte-Geneviève-des-Bois. A list of the countesses jewels, confiscated at the time of the revolution, can be found at the Russian State Historical Archives. There are a total of 122 entries on eight pages, including: 2 tiaras, 1 bow, 2 combs, 2 necklaces, 14 brooches, 3 brooch settings, 1 maid-of-honor cipher, 8 pair of earrings, 5 pendants, 1 pearl necklace, 13 bracelets, 2 watches, 5 medallions, 3 buckles, 1 fan, 12 buttons, 1 man's watch, 7 pair of cufflinks, 26 pins, 2 rings, 1 tassel, plus 1,480 unset brilliants and a variety of other unset gems and pearls.[122]

Countess Elisaveta Vladimirovna Shuvalova
Unknown photographer, c.1910
Private collection

Countess Shuvalova can be seen wearing the requisite diamond tiara and a long diamond epaulette over her left shoulder.

Ring in the art deco style
Unknown maker, St. Petersburg, c.1910
Gold, silver, rubies, diamonds
Courtesy of the Furuhjelm family
Photo: Katja Hagelstam

213

THE WEDDING JEWELRY
OF PRINCESS IRINA IUSUPOVA

On February 22,1914, in the chapel of the Anichkov Palace in St. Petersburg, Prince Feliks Feliksovich Iusupov, Count Sumarokov-Elston, sole heir of one of Russia's wealthiest and distinguished families, married Her Highness Princess Irina Aleksandrovna of Russia, the niece of Emperor Nicholas II, daughter his sister Grand Duchess Ksenia Aleksandrovna and her husband Grand Duke Aleksandr Mikhailovich.

Irina took all of her jewelry with her on her honeymoon as she wanted to have it reset. In his memoirs, Feliks writes, "we had long discussions with Chaumet, the jeweller who was to modernize it." The couple left for Egypt, and when they passed through Paris again on their way home, Feliks relates that "old Chaumet brought us Irina's jewels, which he had reset during our absence. He had not wasted his time: the five sets he had designed in diamonds, pearls, rubies, emeralds and sapphires seemed each more beautiful than the other. They were much admired in London, but no jewels were needed to add to Irina's beauty."[123]

Princess Irina Aleksandrovna Iusupova
Unknown photographer, c.1914
The princess wears her Chaumet sunburst tiara.

JEWELS OF PRINCESS IRINA ALEKSANDROVNA IUSUPOVA

Reproduced from *Stolitsa i usad'ba* 1914, № 5, p. 9
The text accompanying the image reads:

Wedding Gifts of Her Highness Princess Irina Aleksandrovna.

Taken in the oval hall of the palace of Grand Duke Aleksandr Mikhailovich.

1. On the table at the left: family diamonds of the Princes Iusupov—tiara and necklace.

2. Rosewood cabinet with bronze—gift of Meltzer.

3. In the cabinet, on the top shelf, in the center, gift of the groom—openwork diamond tiara, remarkable as the diamonds alternate with rock crystal—work of the jeweler Cartier; Her Highness was married in this tiara.

4. Diamond earrings, made from the family diamonds of the Princes Iusupov, with round pendants—pear-shaped pearls.

5. Brooch—light emerald, encrusted with diamonds, gift of Gr. Dss. Ol'ga Aleksandrovna.

6. Bracelet of two large diamonds—gift of the groom.

7. Pendant from Prince and Princess Iusupov.

Second shelf:

8. Miniature—gift-portrait, of the Queen Mother of England.

9. Brooch—gift of Empress Maria Feodorovna.

10. Two strings of pearls—gift of the Sovereign Emperor.

11. In the same case a diamond rivière and an emerald—from the Gr. Duchess Ksenia Aleksandrovna.

12. Diamond brooch—gift of Grand Duke Nikolai Mikhailovich.

13. Bracelet—Princess Victoria.

14. Diamond ring—gift of Gr. Duchesses Ol'ga Nikolaevna and Tatiana Nikolaevna.

15. Brooch—from the British Embassy.

Jewels of Princess Irina Aleksandrovna Iusupova

Reproduced from *Stolitsa i usad'ba* 1914, № 11, p. 23.

The text, in Russian and French, accompanying the image reads:

The marriage of Her Imperial [*sic*] Highness Princess Irina Aleksandrovna with Prince Feliks Feliksovich Iusupov, Count Sumarokov-Elston, was the largest social event of past season. At the time, pictures and descriptions of the wedding gifts presented to the Grand Duchess [*sic*] appeared in № 5 of *Stolitsa i Usad'ba*.

We supplement this with pictures of gifts presented to the August bride of Prince Iusupov.

Most of the diamonds and other precious stones for these gifts are from the Iusupov family jewels. Their settings and mounts were made by the famous Parisian jeweler J. Chaumet.

1. Tiara—rubies and diamonds.
2. Chain—rubies and diamonds.
3. Earrings—rubies and diamonds.
4. Bandeau—diamonds with a large emerald.
5. *Devant de corsage*—emeralds and diamonds.
6. Earrings—emeralds cabochons and diamonds.
7. Rivière large diamonds.
8. Ear clips—rose-cut diamonds.
9. Large tiara—sun diamonds.
10. Large chain—sapphires, cabochons and diamonds. [*not shown*]
11. Earrings—sapphires, cabochons and diamonds. [*not shown*]
12. Bar brooch—diamonds and sapphires. [*not shown*]

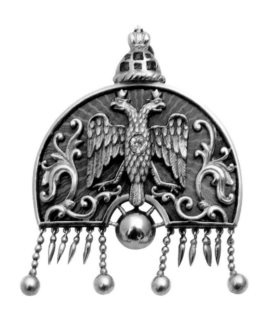

Pendant commemorating the Tercentenary in 1913 of the Romanov dynasty
Unknown maker, St. Petersburg, c.1913
Gold, diamond, enamel
Courtesy of Christian Bolin, Stockholm

According to family tradition, the pendant was a gift by Empress Alexandra Feodorovna to one of her chamber maids at the time of the tercentenary of the Romanov dynasty in 1913.

A SUMPTUOUS FANCY BALL

Nicholas II arranged a spectacular fancy-dress ball at the Winter Palace in February 1903. "I smiled sadly on reading the text of the invitation which demanded that all the guests wear the costumes of the seventeenth century: for at least one night Nicky wanted to be back in the glorious past of our family," writes Grand Duke Alexander Mikhailovich.[124] This was simply another manifestation of the national Romantic movement and the infatuation for ancient Russian culture. The emperor dressed as Tsar Aleksei (1629–1676); the empress as his consort, Maria Il'inichna Miloslavskaia (1625–1669); and the two hundred plus guests as members of the entourage and court of the early tsars.

The best tailors and fashion houses were employed for months making the costumes. The jewelers were also put to work as family gems were redesigned to and integrated into the period costumes.

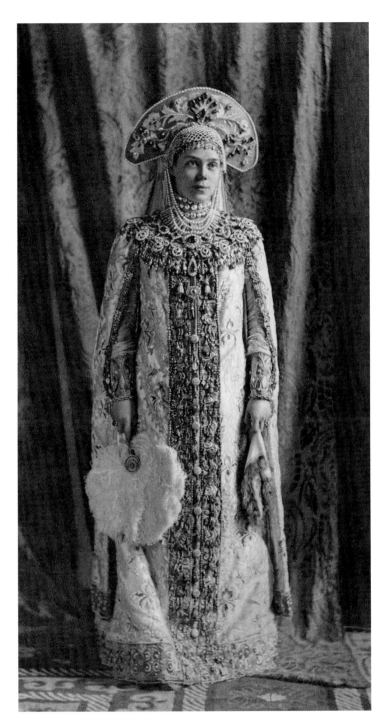

Grand Duchess Ksenia Aleksandrovna
Boissonnas et Eggler, 1903
The National Library of Finland

The photograph was taken in connection with the famous fancy-dress ball at the Winter Palace on February 11/22, 1903. "Xenia wore a very becoming costume of a 'boyarina', richly embroidered and covered with glittering jewels…The ball was pronounced a huge success. It was repeated in all its details a week later in the house of Russia's multimillionaire Count Aleksandr Sheremetev." (Russia 1932, 211)

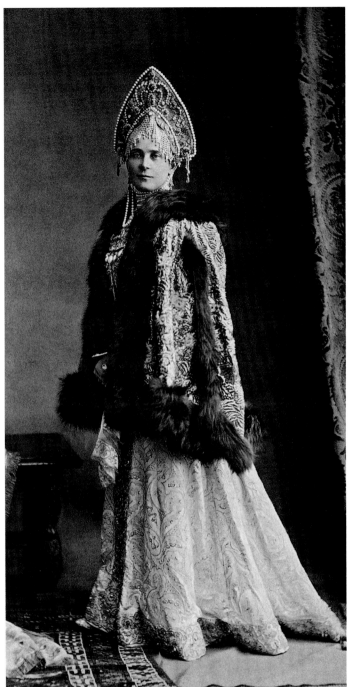

Princess Zinaida Nikolaevna Iusupova
Boissonnas et Eggler, 1903
The National Library of Finland

"The chief honors of the night were disputed between Ella (Grand Duchess Elizabeth) and Princess Zinaida Yousoupoff. My heart ached a bit at the sight of these two 'mad devotions' of my early youth. I danced every dance with Princess Yousoupoff, until it came to the famous 'Russkaya'. She did it better than any ballerina but I limited my participation to hand-clapping and silent admiration." (Russia 1931, 211)

Centenary badge of The Emperor's
Own Personal Chancellery
Unknown maker, St. Petersburg, 1912
Gold, platinum, diamonds
Private collection
Photo: Per-Åke Persson

Aleksandr Sergeevich Taneev
Unkown photographer, 1903
Central State Archive of Film, Photographic and
Phonographic Documents, St. Petersburg

Taneev appears in his costume for the fancy-dress
ball at the Winter Palace in 1903.

JEWELRY FROM
THE TANEEV PISTOLEKORS FAMILIES

The badge shown above was an imperial gift in 1912 to Aleksandr Sergee-vich Taneev (1850–1918), head of the Emperor's Own Personal Chancel-lery from 1896 to 1917, on the day the chancellery celebrated its centena-ry. Founded in 1812 by Alexander I, its many duties included preparing imperial rescripts and correspondence as well as running the civil service inspectorate. It was an extremely powerful institution up until the early 1880s. Its third section, the Russian security police, was transferred in 1880 to the Ministry of Internal Affairs, and two years later, its second, the cod-ification section, was moved to the State Chancellery. The fourth section, which handled schools and charities, became independent in 1880 and was known as the Institutions of Empress Maria.

Aleksandr Sergeevich Taneev took over the post as head of the chancel-lery from his father, Sergei Aleksandrovich. He was named state secretary, grand master of the Imperial Court, and was a member of the Council of the Empire. He was at heart, however, a composer, but being born into the aristocracy, a career as a musician was out of question. Taneev nevertheless wrote a great deal of music, including two operas, orchestral suites, a sym-phony, as well as chamber music.

He married Nadezhda Illarionovna Tolstaia (1860–1937) and had three children. The eldest, Anna Aleksandrovna (1884–1964), was appointed maid of honor and married Aleksandr Vasil'evich Vyrubov in 1907 (the marriage was never consummated). She later became a close friend of Em-press Alexandra Feodorovna and has left memoirs which shed light on her life at court and her years of suffering during the revolution. The son,

218

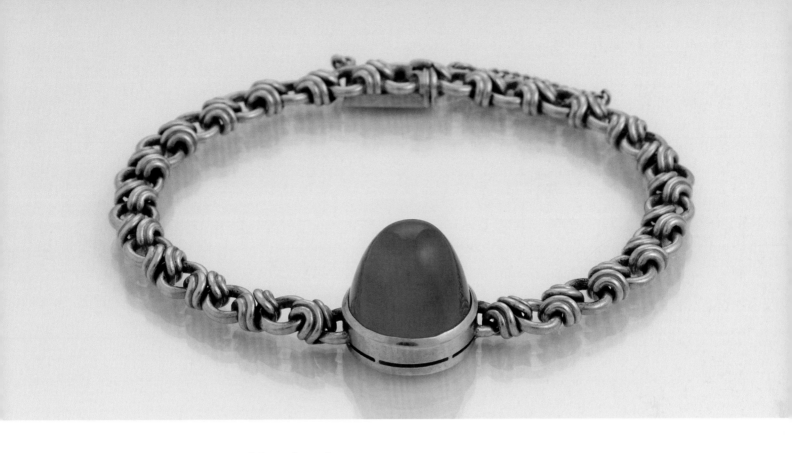

"The Tear" Bracelet
Fabergé, workshop of August Holmström, chain by Friedrich Rutsch, St. Petersburg, c.1903
Gold, chalcedony (Mecca stone)
The National Museum of Finland
Photo: Katja Hagelstam

The bracelet was given by Empress Alexandra Feodorovna to Anna Vyrubova,
née Taneeva. The empress called the bracelet "The Tear," saying it symbolized the tears
the two of them had shed over the illness of the young tsesarevich Aleksii, who suffered
from hemophilia. It was in turn given by Anna to her Finnish friend Baroness
Mathilda Wrede, who was known for her charity toward prisoners and for assisting Rus-
sians who escaped the Bolsheviks after 1918.

Sergei Aleksandrovich (1886–1975), studied mathematics at the universities of St. Petersburg and Charlottenburg, served from 1912 at the Ministry of Internal Affairs, and received the title of master of ceremonies at the Imperial Court. The youngest child, Aleksandra Aleksandrovna (1888–1968), was a maid of honor like her older sister. She married Aleksandr Erikovich von Pistolekors, the son of Erik Avgustovich von Pistolekors and Ol'ga Valerianovna Karnovich, who in 1902 became the morganatic wife of Grand Duke Pavel Aleksandrovich, receiving the title Countess von Hohenfelsen in 1904 and that of Princess Palei in 1915. See page 209.[125]

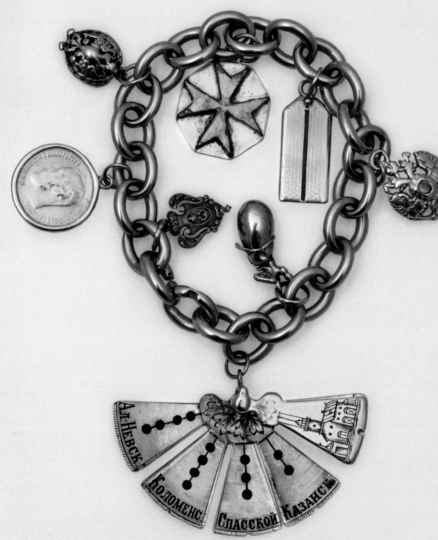

Charm bracelet
Unknown maker, St. Petersburg, c.1910
Gold, enamel
Private collection
Photo: Per-Åke Persson

The bracelet was owned by Ol'ga Nikolaevna Bobrikova,
daughter of Nikolai Nikolaevich Bobrikov and Ekaterina
Nikolaevna Frolova. She probably received the bracelet as a gift
from her mother-in-law at the time of her marriage to Count
Aleksandr Aleksandrovich Kreutz in Paris in 1941. The charms
(counterclockwise from the top) are: a miniature badge of the
Corps of Pages, a regimental badge, a gold coin from the reign
of Nicholas II, an unknown badge, five triangular plaques with
special signals for fire brigades in different parts of St. Petersburg,
a miniature Easter egg with a Chevalier Guards helmet on top, a
double-headed eagle, and an epaulette with an illegible name and
the dates 9 May 1903–14 April 1906. With regard to the triangular
plaques, the four (left to right) designate the fire districts of
St. Petersburg (Aleksandro-Nevskii, Kolomenskii, Spasskii,
and Kazanskii). A fire in any of these districts activated the alarm
signal on the tower of the fire district, and at the same
time alarmed the fire units from the nearest districts.
The fifth plaque depicts a fire station.

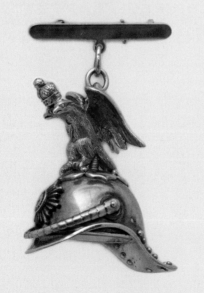

Miniature helmet of the Horse Guards Regiment
Unknown maker, St. Petersburg, c.1908
Gold
Photo: Per-Åke Persson

Miniature helmets of the various elite guards regiments were given
as gifts to the ladies of the young officers and were worn as good-
luck charms. Aleksandr Erikovich von Pistolekors (1885–1944) was
enrolled as an officer in the Horse Guards Regiment after having
graduated from the Corps of Pages in 1905. He gave the miniature
helmet to his future bride, Aleksandra Aleksandrovna Taneeva
(1888–1968), at the time of their engagement in 1908. There is a
photograph of von Pistolekors inside the bottom.

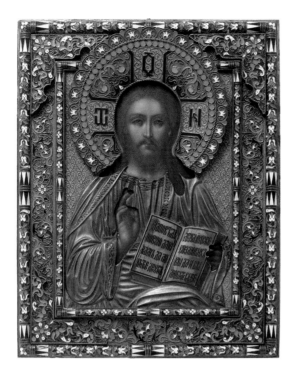

Wedding icon of Christ Pantocrator
Pavel Ovchinnikov, Moscow, c.1895
Silver, cloisonné enamel
Private collection
Photo: Per-Åke Persson

Wedding icon of the Kazanskaia Mother of God
Pavel Ovchinnikov, Moscow, c.1895
Silver, cloisonné enamel, seed pearls
Private collection
Photo: Per-Åke Persson

*The icon was given by Dowager Empress Maria Feodoro-
vna to Vladimir Nikolaevich Voeikov on the occasion of
his wedding. The empress was the honorary chief of the
Chevalier Guards where Voeikov served as a cavalry staff
officer.*

*This icon was given by Emperor Nicholas II and Empress
Alexandra Feodorovna to Baroness Eugenie Vladimirovna
Freedericksz, daughter of Baron (later Count) Vladimir
Borisovich Freedericksz, minister of the Imperial Court,
on the occasion of her wedding to Vladimir Nikolaevich
Voeikov, May 5, 1895.*

August Gifts

As commandant of all the imperial palaces, General Vladimir Nikolaev-
ich Voeikov and his wife, née Baroness Eugenie Vladimirovna Freederick-
sz, had the great honor of receiving Emperor Nicholas II and Empress Al-
exandra in their home. They purchased a pair of small icons in order to
commemorate the visit and had them engraved with a text indicating how
important the visit was to them. It was very unusual for subjects to receive
Their Majesties in their private home.

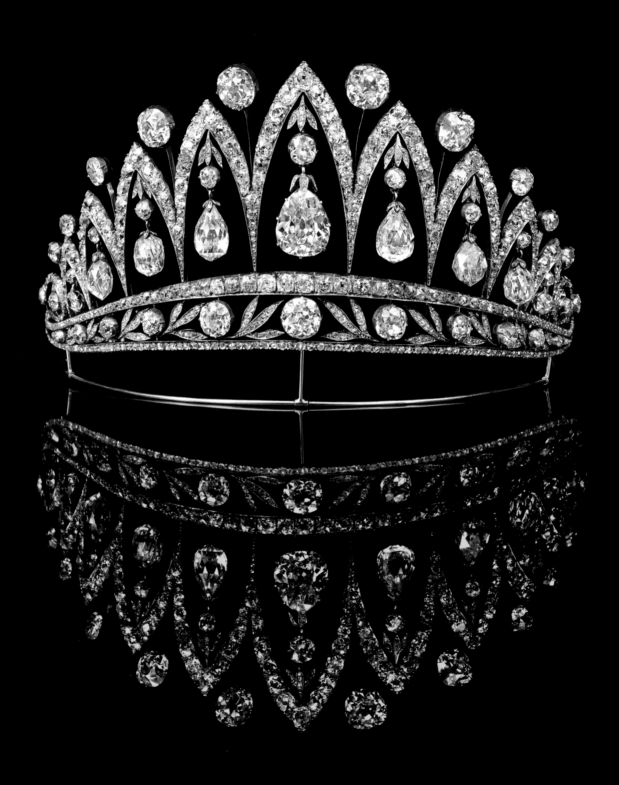

The Jeweler Karl Fabergé

The photograph of Karl Fabergé (1842–1920) shown here depicts St. Petersburg's celebrated jeweler in a typical pose of his profession. Tweezers in hand, he selects precious stones to be set in a piece of jewelry. It bears witness to the fact that the head of the company, even though surrounded by an enormous staff of specialists and assistants, still remained personally engaged in the creation of his products. A hands-on boss is one of the most motivating things for the workforce of a company. Fabergé's former collaborators have verified that he, in addition to so many other things, was a forerunner of "employee welfare."

By the turn of the century, Fabergé's enterprise was a huge emporium employing several hundred craftsmen, many designers, and a great number of sales personnel. A new building at 24 Bol'shaia Morskaia in central St. Petersburg, which housed the most important production units, the artists' studios, the retail store, and the offices of the management, had been completed in 1900, making the running of the business highly efficient. A five-story wing in the back courtyard housed the key workshops.[126]

How Fabergé grew from a schoolboy and apprentice to a full-fledged jeweler and an exceptionally successful entrepreneur is a fascinating story. There is much to learn from it.

Karl Gustavovich Fabergé was a second-generation St. Petersburg jeweler. His father Gustav (1814–1893) had established himself in 1842 as an

Brooch in the form of a snake
Fabergé, workshop of Erik Kollin, 1880s
Gold, cabochon sapphire
Private collection
Photo: Katja Hagelstam

Brooch
Fabergé, workshop of August Holmström, c.1890
Gold, cabochon sapphires
Private collection
Photo: Katja Hagelstam

Between the years 1870 and 1886, the Finnish-born goldsmith Erik Kollin (1836–1901) was Fabergé's head workmaster. This brooch is a free interpretation of a Greek model—a wriggling serpent, the symbol of vigor. A blue cabochon sapphire ornaments its head; this in accordance with an ancient Oriental belief that snakes kept costly gemstones hidden.

This highly stylized snake has taken the form of a Gordian knot. The original owner of the brooch was Erika Gustafsson (1847–1936), matron of the household of the Imperial Palace for the Grand Duchy of Finland in Helsinki.

independent master with a workshop and a retail store.[127] Gustav was well connected and set on developing his business. He therefore needed an assistant to run the workshop while he himself concentrated on the retail aspect of the business. He found a good collaborator in Hiskias Pöntinen (later Pendin), a craftsman born in Finland. Pöntinen was more than a workmaster to Gustav Fabergé; he was a good friend and, most importantly, a mentor and instructor for young Karl. In the spirit of the old guild system, a master had his own home nearby his workshop. His children were thus from early childhood familiar with their father's craft. Youngsters, inquisitive and eager to be part of the realm of their parents, were given small tasks in the workshops.[128] This was no doubt also the scenario within Gustav Fabergé's family.

At the end of the 1850s, Gustav Fabergé made plans for himself and his family to leave St. Petersburg for Dresden, capital of the Kingdom of Saxony. The move took place in 1860. It remains an open question as to why he decided to leave St. Petersburg. He was at the time a man of forty-six with an established jewelry business in the capital of the Russian Empire, where the possibilities for success were endless. Leaving his enterprise to be run by Pendin (at the time a co-owner of the shop) and a colleague, Valerii Andreevich Zaionchkovskii,[129] implies a temporary arrangement—he may well have had the intention of returning to St. Petersburg one day.

Bangle
Fabergé, workshop of Edvard Helenius, St. Petersburg, early 1900s
Silver, gold, cabochon sapphires, diamonds
Courtesy of Christie's

Attesting to Gustav's aspiration for continuity is the profound education he planned for his first-born son. Preparations for the boy's future vocation as a jeweler were drawn up early in his life. At the age of twelve, in 1858, Karl was enrolled in the prestigious German Annenschule in St. Petersburg, where classes were taught in German. Learning this language and the basics of German culture was essential for the boy because of the relocation to Dresden. Languages in general were not a problem for the Petersburg goldsmiths of the day; they were multilingual by necessity. Russian was obviously foremost, being the language of the country, German and French came in second and third. French, the language of the court and aristocracy, was essential for a retail jeweler who was in direct contact with his clientele. English was not widely spoken at the time.

Dresden was an excellent starting point for a student of the goldsmith's art. The city had a fine tradition of crafting the decorative hardstone unearthed in the region. Nearby Erzgebirge was rich in gemstones, and the Saxon stone-cutting skills were excellent. The royal palace of Frederick Augustus I, elector of Saxony and king of Poland (1670–1733), housed Europe's finest treasury of the goldsmith's art, the foremost attraction of the city of Dresden. Called The Green Vault, it had been reorganized as a museum during the first half of the eighteenth century. Its holdings include the finest masterpieces in precious materials of Europe's Renaissance and

Baroque, spectacular jewels, precious stones and pearls, carvings in decorative minerals, ivory, amber, coconut, nautilus shell, ostrich eggs, enamel work, bronzes, woodcarvings, and glasswork—altogether some three thousand objects of art.

Young Karl Fabergé was enrolled at the Dresdner Handelsschule, a mercantile school. His father, with an entrepreneur's background, rightly knew that proficiency in a craft, albeit combined with an extraordinary artistic vein, was not enough. To be successful it is vital to know how to make the business profitable.

The Green Vault was nevertheless where the boy spent much of his free time. He was a talented draughtsman and filled his sketchbook with drawings of the marvels on display. Many of these splendid pieces became models for his production decades later. Objects in decorative hardstones—bowls, cups, dishes, jeweled snuffboxes, cane handles, imaginative figures of animals, miniature human figurines, decorative table clocks, watches, and mechanical toys—were marvels that stayed with him throughout his professional life. They were part of his inexhaustible mine of inspiration.

After graduating, Karl's father arranged for him to apprentice with the jeweler Josef Friedmann in Frankfurt am Main, at the time a free city of the German Confederation and the seat of its Bundestag. London was the next step on his educational path. The purpose of the sojourn was to learn the language, but all his time was not spent in the school room. He no doubt visited the museums and collections, saw the ancient treasures of the British Museum—the art from ancient Mesopotamia, Egypt, and Greece. More important was the newly opened South Kensington Museum (from 1899 the Victoria and Albert Museum), which had its initial holdings of arts and crafts from the very first universal exposition, The Great Exhibition of the Works of Industry of All Nations, arranged at the Crystal Palace in 1851. The raison d'être of the new museum was to assemble contemporary art in ceramic, glass, textile, sculpture, silver, and gold, thus creating educational material for the craftsmen of the country. The South Kensington Museum was the model for the Central School of Technical Design founded by Baron Stieglitz in St. Petersburg, which opened in 1881, and where many of Fabergé's future artists and craftsmen studied.

Karl Fabergé and his childhood friend Julius Butz visited Florence in 1864. Julius was the son of the well-known St. Petersburg jeweler Alexander Butz. The two fathers saw to it that their offspring acquaint themselves with this classic stopover on the grand tour, essential for every young man on his path towards cultivation. The two youngsters saw the Duomo Santa Maria del Fiore with its imposing cupolas designed by the architect Filippo

Brooch
Fabergé, St. Petersburg, c.1910
Gold, enamel, diamonds, pink topaz, pearls
Courtesy of André Ruzhnikov

Pendant in the garland style
Fabergé, workshop of Albert Holmström, c.1913
Gold, silver, chalcedony, diamonds
Private collection
Photo: Katja Hagelstam

Pendant watch
Fabergé, workshop of Albert Holmström, c.1910
Gold, diamonds, Mecca stones
Courtesy of André Ruzhnikov

Pendant in the garland style
Fabergé, workshop of Albert Holmström, c.1913
Gold, platinum, cabochon sapphire, diamonds
Private collection
Photo: Katja Hagelstam

Brooch
Fabergé, workshop of August Holmström,
St. Petersburg, c.1890
Gold, silver, almandine garnet, diamonds
Courtesy of John Atzbach,
Redmond, Washington

Bracelet
Fabergé, workshop of August Hollming, St. Petersburg,
early 1900s
Gold, agate, diamonds
Courtesy of Wartski, London

Brooch
Fabergé, workmaster of August Hollming,
St. Petersburg, c.1910
Gold, diamonds, enamel
Courtesy of the Hollming family
Photo: Katja Hagelstam

Brooch
Fabergé, workshop of August Hollming,
St. Petersburg, early 1900s
Gold, platinum, diamonds
Courtesy of John Atzbach, Redmond, Washington

Brunelleschi, who himself had trained as a goldsmith. They also saw Ghiberti's and Pisano's magnificent gilded bronze gates of the Baptistery and the refined sculpture of the celebrated goldsmith Benvenuto Cellini. They also familiarized themselves with the enamels and cameos of the famous Florentine masters.

In 1865, Karl arrived in Paris. Once again he studied at a mercantile institute, but in his spare time he immersed himself in the culture and art later to become so important for his own creations. In Galerie d'Apollon, the treasury of the Louvre, *les gemmes de la couronne* were on display, among them a magnificent rock crystal vase that had belonged to Louis XIV. The crown jewels, rescued from the turmoil of the French Revolution were, however, not yet on view. Karl no doubt also saw the marvels of Versailles, as well as the incredible Campana collection, purchased by Emperor Napoleon III for the staggering amount of 4,500,000 francs.[130] It was on display in Palais de l'Industrie on the Champs-Élysées, and later in the Louvre. It consisted of gold jewelry, some one thousand pieces, from Etruscan graves: diadems, necklaces, bracelets, fibulae, and earrings. This ancient jewelry came to be a source of inspiration for Fabergé when he himself, early in the 1880s, created a collection of antique pastiches.

Back in St. Petersburg in 1866, Karl, age twenty, continued his education, but now in a most special way. The Imperial Hermitage housed—and still does house—a glorious collection of the goldsmith's art. Young Fabergé was introduced to the director of the museum, possibly with the help of Alexander Butz, who was an appraiser to the Cabinet of His Imperial Majesty. For the next fifteen years (1866–81), he assisted with the imperial collections in precious metals. This gave him the extraordinary possibility of closely examining the amazing treasures collected by generations of Romanov sovereigns. He was entrusted with repairs, restoration, and cataloging of the archeological gold found in the Scythian burial mounds, giving

Pendant
Fabergé, workshop of Albert Holmström,
St. Petersburg, c. 1910
Gold, cabochon chalcedony (Mecca stone), diamonds
Private collection
Courtesy of Wartski, London

Dowager Empress Maria Feodorovna purchased this
pendant in March 1911 for 950 rubles.

Brooch
Fabergé, workshop of August Hollming,
St. Petersburg, c. 1910
Gold, silver, star sapphire, diamonds
Courtesy of the Hollming family
Photo: Katja Hagelstam

him the chance to study the long-forgotten techniques mastered by gold-smiths of the ancient world. It goes without saying that there is no better way of learning the essence of a craft! Gradually Fabergé was also consulted about repairs and restoration of the rare eighteenth-century pieces. In handling and studying the precious bibelots of the empresses Elizabeth and Catherine—snuffboxes, pillboxes, bonbonnières, vessels, cups, Easter eggs, miniature automatons, hardstone figurines, and jeweled flower studies—the idea to produce something in this genre for a contemporary clientele must have come to his mind.[131]

Karl Fabergé officially assumed responsibility for his father's shop in 1872. Pendin, at the time a man of forty-nine, was still active. Only his death in 1881 could part him from his cherished seat at the workbench. August Holmström (*v.i.*), employed already during the time of Gustav Fabergé, worked as the firm's jeweler. He had his own atelier, but was under contract to Fabergé. This was the beginning of a concept later to be perfected by Karl.

The shop Karl took over was a traditional establishment with a production of gold and diamond-set jewelry in the fashion of the day. The clientele was made up of the moneyed haute bourgeoisie of St. Petersburg with a taste for the conventional. Clearly the young Karl possessed the qualifications to take his father's store to the next level, but for some reason, he bided his time for another six years, continuing his work at the Imperial Hermitage. Whether the obstacle towards something new was the old generation, namely his father's faithful confrere Hiskias Pendin, is an open question.

His breakthrough came in 1879 with the assistance of the Hermitage. It was an offer to produce a collection of gold jewelry based on the archeological finds on the Black Sea shores. It was produced in close cooperation with Erik Kollin, who was now head workmaster of the firm.[132] The success of these archeological pieces opened doors for Fabergé, and he created a name for himself by winning gold medals and honors at fairs and exhibitions at which they were displayed.

At the death of Pendin in 1881, time was ripe for the young generation to take over. Karl's younger brother Agathon (1860–1895) had graduated from the school of arts and crafts at Dresden and was ready to try his wings as his older brother's assistant. Karl Fabergé had an exceptional talent for finding skilled craftsmen. He saw a naturally gifted young journeyman with obvious potential in Erik Kollin's workshop. He was Mikhail Evlampievich Perkhin (1860–1903), a peasant's son from Karelia. Perkhin was encouraged to pass the examinations for the occupational rank of master goldsmith. In 1884, certificate in hand, he was assisted in opening his own workshop. Two years later he was appointed head workmaster at Fabergé.

It was at this juncture that Fabergé decided to launch a completely new production line. To create it, he needed this young, unbiased crew, eager to take the leap into something fundamentally novel: a range of elegant gift items, superb in craftsmanship, harkening back to the days of Louis XV and XVI, an age when refinement, delicacy and grace reigned supreme.

Fabergé himself described the philosophy of his concept in an interview in the journal *Stolitsa i usad'ba* (January 15, 1914):

It is clear that if my production is compared to those of enterprises like Tiffany, Boucheron, and Cartier, they have much more costly objects than I have. In their production can be found a necklace costing 1.5 million rubles. But they are merchants, not artist jewelers. A jewel, which is expensive only because it is overladen with brilliants and pearls, is of no interest to me.

Fabergé's personal interpretation of eighteenth-century French styles and their translation into a Russian idiom, linked with the revival of old techniques such as guilloché enamel, became an enormous success among his clientele both at home and abroad. Through his imaginative work, the art of the lapidary once again was in demand, with a rich variety of material such as agate, Siberian nephrite, rhodonite, lapis lazuli, aventurine quartz, rock crystal, and obsidian (a volcanic glass). He combined enamels and hardstone to create an endless variety of attractive functional objects such as miniature table frames, pillboxes, cigarette and cigar boxes, perfume bottles, and desk sets. His most mesmerizing pieces were those that were created for no other reason than to delight the beholder—the flower studies. These remarkable objects often combine the arts of the goldsmith, enameller, lapidary, and jeweler.

Two key persons on Fabergé's team, his artist brother Agathon and his head workmaster Mikhail Perkhin, died prematurely, the former in 1895, the latter in 1903. The loss of two members of this well-oiled, pioneering team was a severe blow, but good fortune soon brought two other remarkable talents on the scene. They were the Swiss artist and designer Franz Birbaum (1872–1947) and the Finnish master goldsmith Henrik Wigström (1862–1923), a close friend of Perkhin, who had worked shoulder to shoulder with him since 1884. With these excellent collaborators, success continued until the day the empire crumbled. But the story of Fabergé does not have an end as his life and body of work continues to astonish and delight the world to this day and surely will for generations to come. In the words of John Keats, "A thing of beauty is a joy forever," and perfection is a momentous thing...

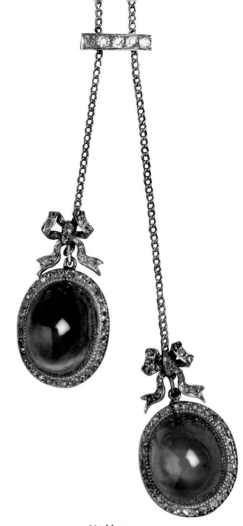

Necklace
Fabergé, workshop of August Holmström,
St. Petersburg, early 1900s
Gold, platinum, cabochon sapphires, diamonds
Courtesy of the Nobel family
Photo: Katja Hagelstam

August Holmström
Unknown photographer, c.1900
Private collection

Cufflinks
Fabergé, workshop of August Holmström, c.1890
Gold, diamonds
Courtesy of Bonhams

HOLMSTRÖM FAMILY OF JEWELERS

August Wilhelm Holmström (1829–1903) was the patriarch of an extraordinary family of jewelers. He was Fabergé's oldest retainer, being responsible for the production of the firm's fine jewelry for close to half a century.

Holmström came to the firm in 1857, thus working for three years with Gustav Fabergé. He continued there until his death in 1903 and was thus the only member of the Fabergé team to have witnessed its development from its modest beginnings to its heyday.

August Holmström's background was humble as that of all of Fabergé's workmasters. He was the son of a journeyman mason. At the age of sixteen, he left his home in Helsinki for St. Petersburg, where he became apprenticed to the German master goldsmiths Karl Herold. He qualified as a master himself in 1857 and established a workshop of his own.

Holmström's workshop gradually became the nursery for many talented young craftsmen, many of whom later had important careers at Fabergé. Among those who either apprenticed or worked for him were Erik Kollin, Mikhail Perkhin, Antti Nevalainen, Anders Mickelsson, and his future son-in-law Knut Oskar Pihl, who became Fabergé's head jeweler in Moscow. Holmström's son and successor, Albert, grew up in the family workshop.

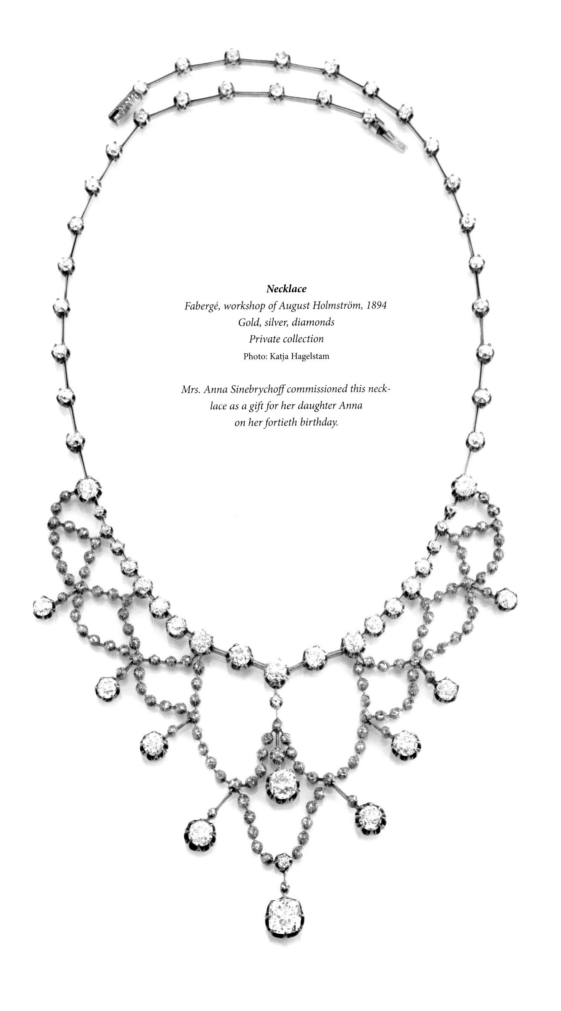

Necklace
Fabergé, workshop of August Holmström, 1894
Gold, silver, diamonds
Private collection
Photo: Katja Hagelstam

Mrs. Anna Sinebrychoff commissioned this neck-
lace as a gift for her daughter Anna
on her fortieth birthday.

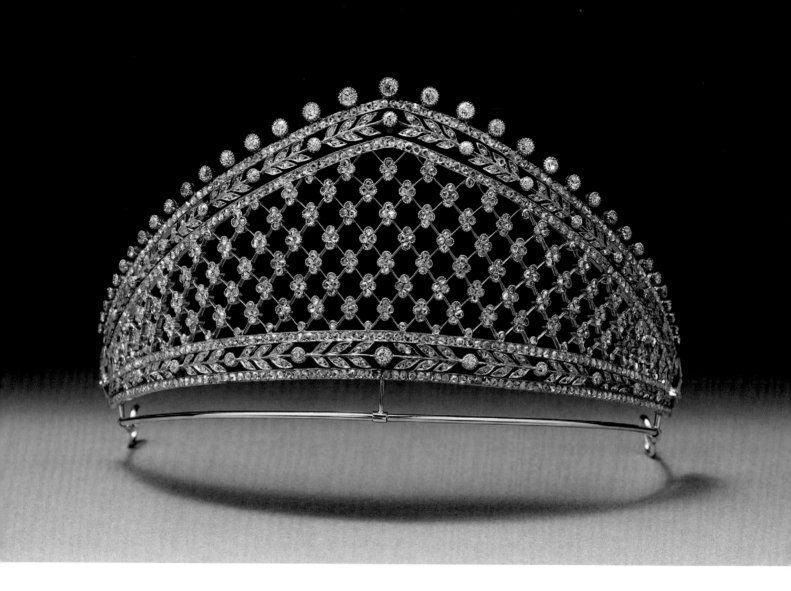

Tiara
Fabergé, workshop of Albert Holmström, St. Petersburg, c.1900
Gold, platinum, diamonds
Courtesy of Wartski, London

*This attractive kokoshnik tiara has a trelliswork of platinum interspersed
with small stylized forget-me-nots.*

Albert Holmström
Unknown photographer, c.1896
Private collection

The second generation

Albert Woldemar Holmström (1876–1925), son of August, apprenticed for his father after finishing his schooling, became a journeyman, and completed his master's training. His dream, however, was to become a musician. Albert played the violin and actually became quite proficient. His father's workshop, however, was a lucrative family concern and it needed a dynamic leader. No mention of the struggle father and son waged over the selection of Albert's profession has been preserved within the family, but in the end, the son acquiesced to his father's will.

Little imagination is required to see how different these two generations were. Father August was a self-made man—he had worked hard his whole life to achieve his position. His son Albert, on the other hand, had been born with a silver spoon in his mouth. It is readily apparent from photographs of Albert that he was very particular about his outward appearance; he was very stylish. Henry Bainbridge, the director of the Fabergé London branch, observed, "I never saw the elder Holmström, but I remember the younger very well; he presented himself as a man of the world and was very exacting in his dress."

Albert married a general's daughter, Lidia Aleksandrovna Protsenko (1889–1974). In the rigorous class society that still prevailed at the time, it was most unusual for a man of the merchant class to marry a daughter of a highly ranked person. To give his wife a suitable milieu, Albert had a large house built on the outskirts of St. Petersburg. The facade was ornamented with decorative mosaics of colorful hardstones. In the left wing there was a dining room large enough to accommodate sixty guests; and in the right, a music room with a grand piano for his young wife, who was a budding concert pianist.

Albert Holmström nevertheless became the dynamic leader that the business needed. The workshop flourished—employing as many as sixty craftsmen in good years—and valuable, high-quality pieces were produced during his tenure as Fabergé's principal jeweler.

When the revolution came and Fabergé was shut down, Holmström tried for a little while to work for the new government. This part of his life is not particularly well documented, but much is revealed by the fact that he attempted to adapt his workshop to the production of hypodermic syringes, even with his greatly reduced labor force. The attempt failed, however, and he was arrested and jailed along with many other private entrepreneurs.

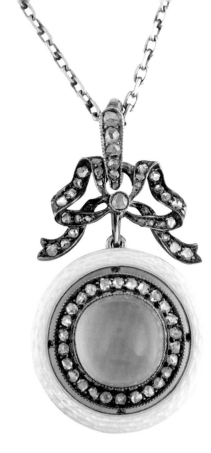

Pendant
Fabergé, workshop of Albert Holmström, 1908–17
Gold, silver, cabochon chalcedony (Mecca stone),
diamonds, guilloché enamel
Private collection
Photo: Katja Hagelstam

Locket
Fabergé, workshop of Albert Holmström, 1908–17
Gold, diamonds, guilloché enamel
Courtesy of Sotheby's

Office of Albert Holmström
Unknown photographer, 1912
Private collection

Albert Holmström furnished a large office for himself the likes of which none of the other Fabergé workmasters had. One can see the master himself, next to his desk, in a dark suit and dazzlingly bright white shirt and starched cuffs. The workshop's two artists, his sister Alina Holmström Zverzhinskaia and niece Alma Pihl (on the left), have their desks next to the windows. The assistant artist, nephew Oskar Pihl, has a table on the workshop side. Alina's husband, Evgenii Vasil'evich Zverzhinskii, who served as bookkeeper, can be seen surrounded by an impressive amount of paper.

The revolution brought an end to the happy and carefree life which Albert Holmström and his wife had enjoyed. Their son Edgar was born in 1918, but life in Petrograd (St. Petersburg's name from 1914 to 1924) became a hopeless struggle. Their son describes the family's life after the revolution:

Father applied for travel documents to Finland, but he was jailed and taken to Moscow. Mother stood for two days on the street outside Litvinov's office in order to get Father pardoned.[133] On the return trip, Mother, who was dressed as a nurse, was forced to travel on a troop train with the soldiers. A nail ended up in Mother's foot and she came down with typhus and lay sick in bed for six weeks. All of us, Father, Mother, her siblings, and I, lived together in the same small room, but none of us caught it.

The winter was cold in Petrograd, and Father burned furniture to keep us warm. It was cold inside, and our shoes froze to the floor. The water pipes in the building froze so solid that the contents of the toilet had to be thrown out of the window. We made money to live on by selling furniture covers and table linens. Then Father—a gifted jeweler—worked in the mu-

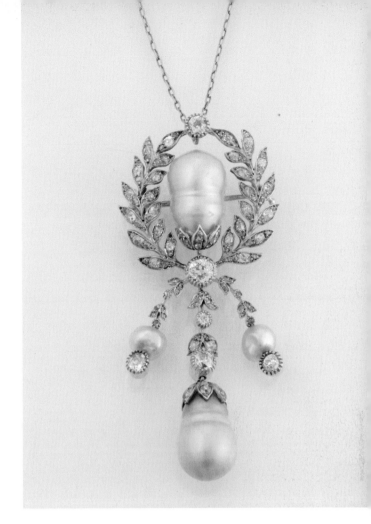

Brooch
Fabergé, workshop of Albert Holmström, St. Petersburg, c.1910
Gold, platinum, sapphires, diamonds
Private collection
Photo: Katja Hagelstam

Pendant
Fabergé, workshop of August Holmström,
St. Petersburg, c.1895
Gold, baroque pearls, diamonds
Private collection
Photo: Katja Hagelstam

sic library. We waited a whole year for travel visas, and our departure for Finland occurred in 1921, when I was three years old. [This was followed] by quarantine in Tyrisevä and Kellomäki.

Having settled in Helsinki, Albert set up a goldsmith business in his home along with Väinö Hollming, another former Fabergé workmaster. The year was 1921. The two goldsmiths ran repeated ads in the daily newspapers with the words, "Long-time K. Fabergé employees. Jewelers A. Holmström and W. Hollming purchase gemstones, platinum, gold, and silver. Address Fabianinkatu 8, apartment 10, stairwell B. Hours 10–4." This modest operation ended with Holmström's sudden death on April 16, 1925. The general hopelessness which this gifted master jeweler felt in his new situation certainly sped his far too early demise.

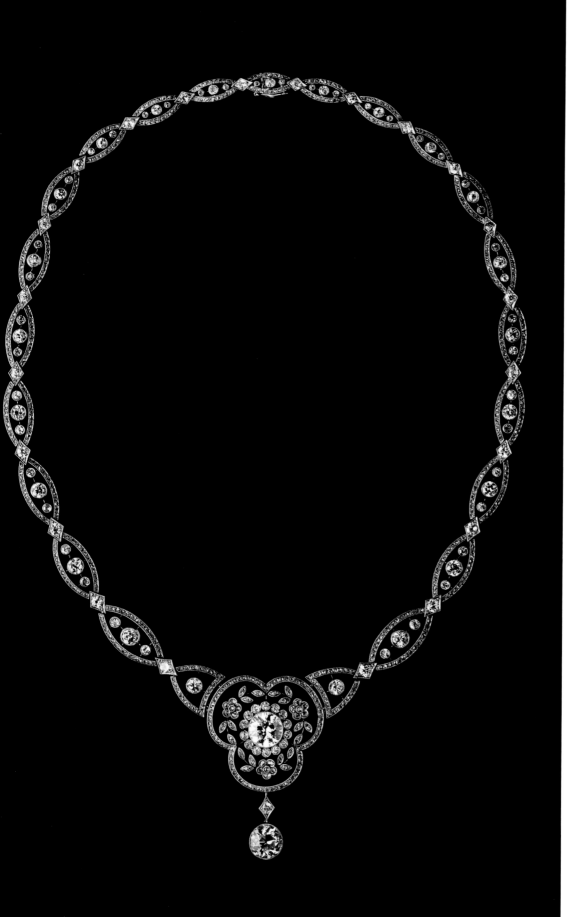

Necklace
Fabergé, workshop of Albert Holm-
ström, 1911
Platinum, gold, diamonds
Courtesy of Uppsala Auktionskam-
mare

This necklace was most likely
designed by Alina Holmström. It
was a gift from Hendrik van Gilse
van der Pals to his daughter-in-
law Baroness Sara Stjernvall, who
married his son Max Hendrik in
1916. The Russian-American Rub-
ber Company "Treugolnik", Russia's
most important rubber industry,
was owned by van Gilse van der
Pals in partnership with Max
Othmar-Neuscheller.

Alina Holmström

Hilma Alina Holmström (1875–1936), daughter of August, studied to become a jewelry artist upon completion of her primary schooling. She attended courses at the Stieglitz school, as did many other Fabergé employees.

Alina was able to begin work at a very young age as a full-time drafting apprentice in her father's workshop. She was a gifted drawer and had a talent for fashioning extremely small details. Her specialty was the garland style that came into fashion right at the end of the nineteenth century.

Alina Holmström
Unknown photographer
Private collection

Her responsibilities extended beyond design work, however. Just as she was sitting absorbed in drawing at her drafting table, she might be called to the shop downstairs. Alina herself reported that several of the Fabergé female customers were somewhat difficult and, if anything, pampered. When their precious strings of pearls had to be retied, they expected the work be done while they waited. The owners in fact feared that the worker restringing the pearls would swap them with lower quality ones, and for this reason, they wished to be on the premises when the work was being done. Alina could not imagine anyone coming up with such a scenario (that the girl stringing the pearls could be a thief) as she thought well of everyone.

In 1903, Alina married Evgenii Vasil'evich Zverzhinskii, a clerk who later worked as an insurance agent. They had no children.

Albums of Alina Holmström's jewelry designs have been preserved. They came with her nephew Oskar Pihl to Finland after the revolution and were kept for decades in the shop of the jeweler A. Tillander, where Pihl worked as a jewelry designer. Russian émigrés who engaged in second-hand retail often visited Oskar, and since they were of no use to him, he disposed of his aunt's drawings for a minimal sum to a traveling salesman named Mihail "Mikko" Reppolt, who later sold them. Today these albums are in the collection of the famous New York antique shop A La Vieille Russie.

Browsing the album one is immediately struck by how skilled jewelry artist Alina was. The garland style dominates her refined, ethereal, and stylish designs. There are necklaces, bracelets, diadems, and brooches, the majority of which were made of platinum, which had come into fashion at the time. The dominant gemstone is the diamond.

Alma Pihl
Unknown photographer, 1912
Private collection

ALMA PIHL

In November 1997, fifty-five former pupils of a provincial school in Finland gathered to spend an enjoyable dinner together, savoring happy memories of their postwar school days in the late 1940s. But there was a very special purpose for this evening. By pure chance, they had found out that "Auntie Alma," their kind and generous art teacher, with peppercorn eyes, immutably attired in rustic homespun knit outfits, was in fact a celebrated designer of breathtaking jewels and precious Easter eggs for the Russian imperial family which were selling for millions of dollars on the international art market and creating headlines the world over. This was astounding news to all the alumni of the Kuusankoski School, situated in a small community built around an important paper mill.

The evening, which also included an illustrated talk on Alma Pihl's designs for Fabergé by the author of this text, resulted in a veritable Auntie-Alma craze among the enthusiastic attendees. Three days after the dinner party, a small "delegation" of former pupils paid their respects to Alma, placing flowers on her grave in Helsinki.

Interest in Alma Pihl has by no means fallen off since the 1997 get-together. Since then, much information has been gathered on her life, primarily on her work as a designer of jewelry.

Alma Theresia Pihl (1888–1976) had already made an impressive career for herself by age twenty-four. Marrying that same year, her husband "allowed" her to continue working because, in her own words, she was "not a very skilled wielder of pots and pans in the kitchen." However, the Russian Revolution cut short her promising career. She left Russia for Finland, where she lived for fifty-five years, first in Kuusankoski, to the east of the capital, and then in Helsinki proper, with no one except her immediate family knowing of her previous career.

Alma Pihl was born in Moscow. Her mother, Fanny, was the daughter of Fabergé's leading jeweler August Holmström and her father, Knut Oscar Pihl, was head of Fabergé's jewelry workshop in Moscow. The five children of the Pihl family thus had excellent qualifications for entering the jewelry profession. The two oldest, Alma and Oskar, viewed their father's and grandfather's career as a natural choice for themselves as well.

Kuusankoski sv. Samskolan. våren
Pia Lindbohm (Wessman) Nora Byckling (Jansson-Knuk) Sigurd Hannén Lilly Sevón

Gathering of teachers at the Kymi factory school
at Kuusankoski, Finland, 1948.
The teacher of drawing and calligraphy,
Alma Pihl-Klee, is seated in the center.

The Pihl children lost their father at a very young age. Their widowed mother returned to St. Petersburg with her children and settled in the large and comfortable villa at Shuvalovo, home of her parents. There, at the edge of the city on the "banks of the second lake," the entire family congregated on Sundays.

After attending preparatory school for a few years, Alma was admitted to the upper-class Annenschule, which Karl Fabergé had also attended. She was a gifted student and received the best possible certificate of graduation in 1906. Her drawing teacher was Eugen (Evgenii Eduardovich) Jakobson (1877–1940), who had Swedish roots. Jakobson had graduated from the Stieglitz school of applied arts and also worked as an artist for Fabergé. He is known to have given private pattern-drawing lessons to Alma.

At age twenty, Alma started work with her uncle Albert Holmström, who in 1903 had succeeded his father as Fabergé's head jeweler. She was initially hired as a trainee. It was the practice of the workshop at that time to draw as detailed a picture as possible of every item produced for archival purposes. The drawings were life-size and accompanied by detailed information about the gems used and labor costs. This task gave the young Alma excellent instruction and experience.

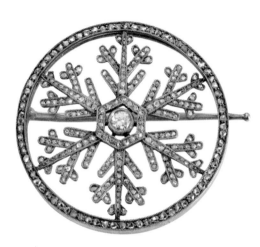

Ice brooch
Fabergé, workshop of Albert Holmström,
St. Petersburg, c.1913
Designed by Alma Pihl
Gold, platinum, diamonds, rock crystal
Private collection
Photo: Katja Hagelstam

This brooch was a gift from Emanuel Nobel to a
wife of one of his business associates. The lid of the
original box in hollywood is engraved with the text
'A snowflake from Russia 1913'

Alma quickly learned how to calculate production costs and rose to the post of cost accountant. She sketched her own ideas in her few free moments. When Uncle Albert saw her handiwork, he took the sketches downstairs to the shop, returning triumphant with news that everyone had considered them excellent and they had been ordered for the store's stock. Thus began Alma's career as a jewelry designer. She was barely twenty-one years old and largely self-taught.

After two years of work and practice at her drawing table, Alma Pihl's life took another important turn. One January day in 1911, Dr. Emanuel Nobel, director of the Nobel oil empire and one of Fabergé's best clients, paid a rushed visit to his jeweler on Bol'shaia Morskaia. He wanted to order forty small items of jewelry, preferably brooches, to be delivered on an accelerated schedule. The items were to be completely new, and although fine materials were to be used in their production, they could not be costly. If the jewels were removed and the rest of the item was melted down, the value of the constituent elements should be insignificant. The recipients should not consider the items as bribes. This was Alma's moment to shine and to display her skill as a jewelry designer.

January is generally the coldest month in St. Petersburg, and the drafty workshop's windows were covered in ice. When the sun shone, the effect was dazzling, like a garden of exquisite frozen flowers. Alma's desk was next to one such window, and this sight inspired her to transfer the ice crystals into Dr. Nobel's brooches. Ideas are sometimes closer than we think! Alma drew six different brooch designs in her sketchbook, all of which had as their subject those sparkling ice flowers.

The workshop rushed to produce thirty-seven brooches, six or seven of each design. The base and pin were gold, the settings were made of an alloy combining platinum and silver, and the tops were dotted throughout with tiny rose-cut diamonds. Dr. Nobel was completely taken by them and purchased exclusive rights to the design concept. After the first thirty-seven brooches, Nobel ordered a large number of different items with a frost motif: necklaces, bracelets, pendants, and miniature eggs. These were presented as gifts to female guests at Nobel company parties, hidden in white linen napkins, or distributed during large celebrations and family functions, for example to Nobel family brides at their weddings. They spread around Europe and America, serving in these nations as beautiful reminders of Russia.

Alma became acquainted with her husband, Nikolai Klee, through her two younger brothers, Oskar and Georg. The young men played tennis together. He was the son of Commercial Counselor Wilhelm Klee

Grand Duchesses Ol'ga and Tatiana Nikolaevna
Boissonnas et Eggler, 1913
Getty Images, Popper photo

The grand duchesses can be seen wearing diamond necklaces designed by Alma Pihl for Fabergé.

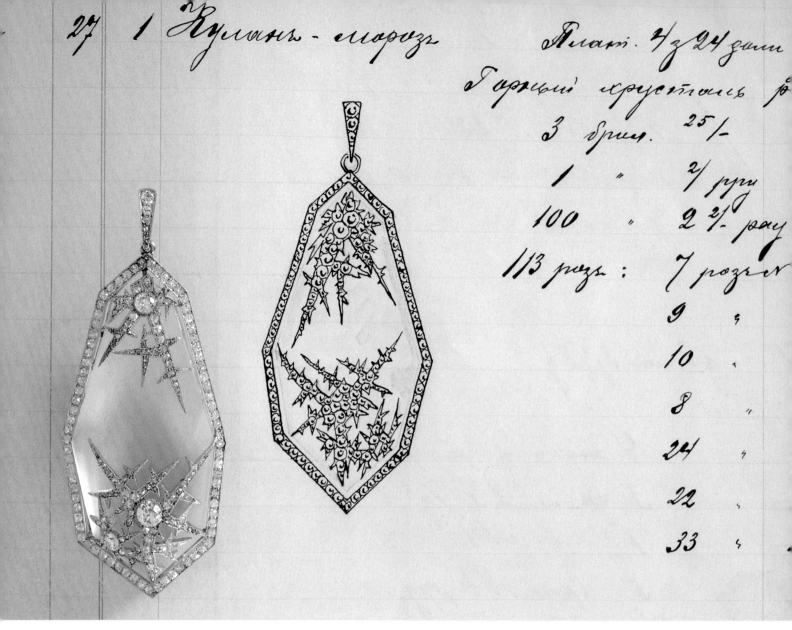

Ice pendant on its sketch from the Holmström album

Fabergé, workshop of Albert Holmström,
St. Petersburg, 1913
Designed by Alma Pihl
Platinum, rock crystal, diamonds
The McFerrin Collection, Texas
Photograph courtesy of Wartski, London

The pendant was a wedding gift of Dr. Emanuel Nobel
to his niece Andriette "Andri" Nobel.

from Sortavala in Karelia, on the northern tip of Lake Ladoga. The family had once owned the large Hôtel de l'Europe along the Nevskii prospekt in St. Petersburg, where Nikolai was born and grew up. He had a thorough business education and worked at and was later director of the St. Petersburg office of the Kymi paper mill located at Kuusankoski, Finland. Alma and Nikolai's wedding was celebrated in the summer of 1912, and the young couple moved into the Klee family home, where the Nikolai's mother lived alone.

The Russian Revolution changed life completely. When Fabergé was shut down, Alma was left without work. She began studying to become a German teacher; as a teachers' college student, she could receive a few more food vouchers. When the St. Petersburg Kymi office was likewise closed, Nikolai was left to singlehandedly oversee the company's interests. Alma and Niko-

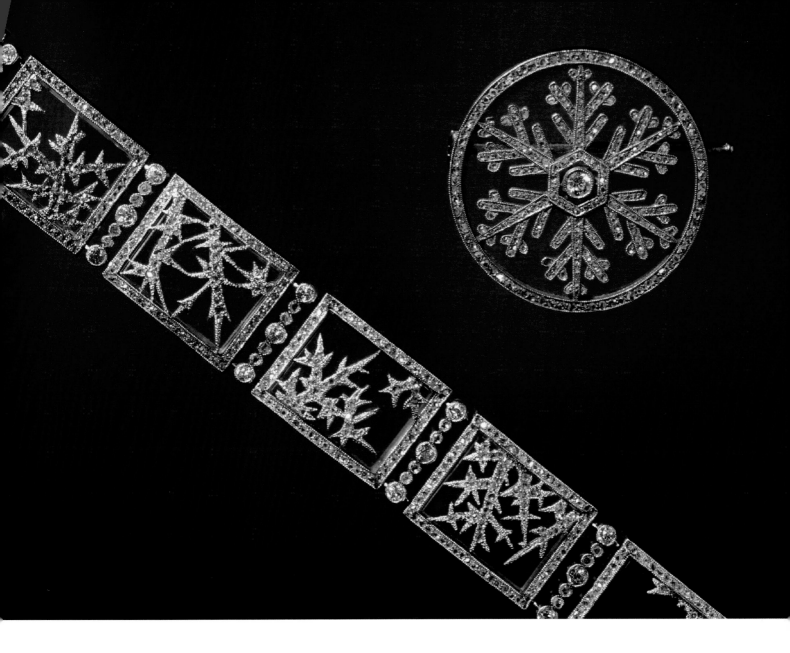

Ice brooch and bracelet
Fabergé, workshop of Albert Holmström,
St. Petersburg, c.1913
Designed by Alma Pihl
Gold, platinum, rock crystal, diamonds
Courtesy of the Nobel family
Photo: Katja Hagelstam

lai succeeded in obtaining passports to leave the country in 1919, but Niko-
lai was detained and thrown into prison for a time. His passport expired
during his prison term, and it took until 1921 for a new one to be issued.

Alma and Nikolai crossed the border into Finland in June 1921. On July
1, after two weeks of quarantine, they were set free in Kellokoski, and their
goal became the Kymi factory in Kuusankoski. Nikolai was given a position
at the head office, gradually learned the language, handled the sales depart-
ment's German language correspondence, and was promoted to holder of
procuration. Alma found a job as a drawing and calligraphy teacher at the
Kymi factory's Swedish language coeducational school in 1927, continuing
in this position for twenty-four years, until her retirement in 1951.

Alma never spoke of her design work at Fabergé. Her students only
learned much later, to their great astonishment, who Alma Pihl Klee really

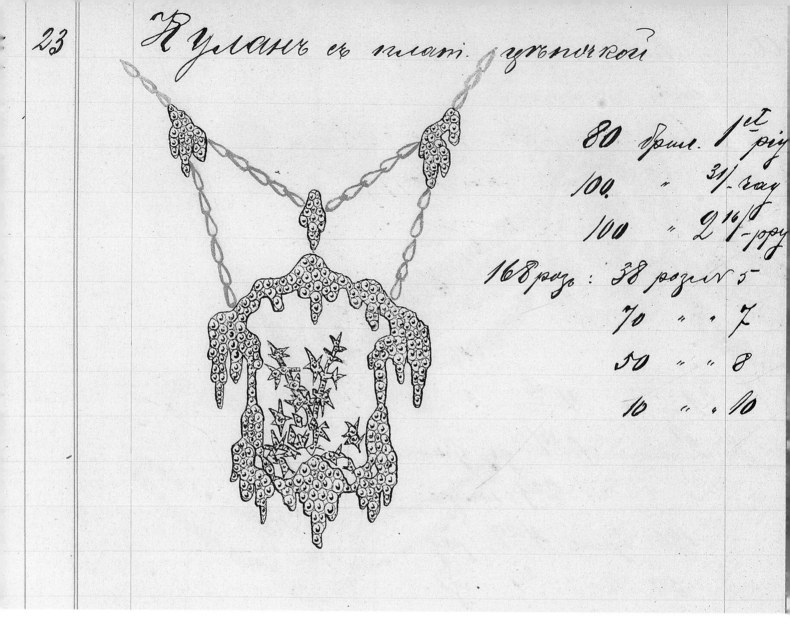

Drawing of ice pendant from the album
of Albert Holmström, 1913
Courtesy of Wartski, London

was. To her students, she was an inspiring teacher whose artistry and drawing ability aroused admiration. They remember her as a warm, magnanimous, and refined person whose speech had a soft, Russian lilt. She gave her students the opportunity to create masterworks, but was also critical if they did not achieve their goals. Waving her pen like a magic wand while teaching, she would add a line here and a line there, miraculously changing their drawings into works of art. With that pen she breathed life into their sketches, creating shadows, tone, and depth. Alma was their most inspirational instructor. Everyone who remembers her is sorry she never knew how much posterity valued her art.

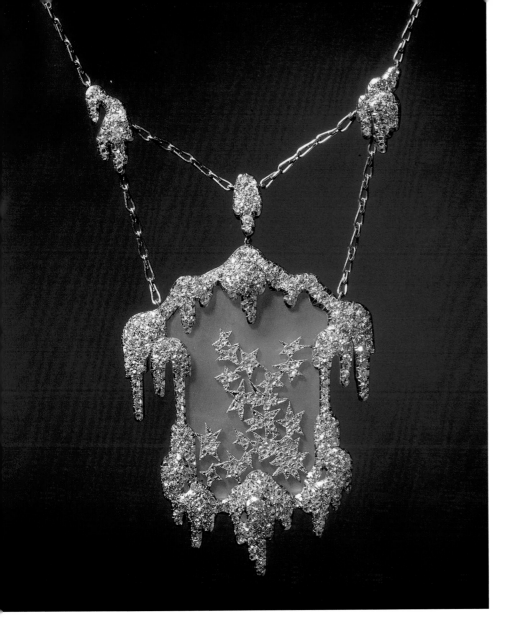

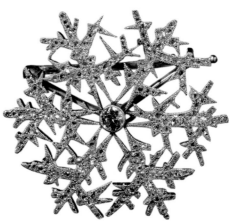

Two splendid albums containing production sketches from the workshop of Albert Holmström from the years 1909–15 have been preserved and are now possessed by the renowned jeweler Wartski in London. They were saved from the workshop by one of Holmström's gem setters by the name of Osvald K. Jurison. The 1,221 large pages are full of drawings of jewelry representative of the output of the workshop: tiaras, necklaces, bracelets, brooches, pendants, etc. They are an excellent time capsule of the styles of the period. In addition to jewelry produced for stock and orders from private individuals, the albums also include descriptions and information about hundreds of objects that were made as official gifts for the Cabinet of His Imperial Majesty.

Brooch

Fabergé, workshop of Albert Holmström, c.1914. Designed by Alma Pihl
Gold, platinum-silver, aquamarine, diamonds
Private collection

Photo: Katja Hagelstam

Alma Pihl designed this brooch for herself and it was her favorite piece of jewelry.

These volumes are also full of jewelry designed by Alma Pihl. When they were discovered, Alma's talent became internationally known.[134] Her frost-inspired collections, as seen in the albums, form an interesting case study. Their success is exceptional for several reasons. First of all, the designer was a young woman and more or less self-taught. She did not fit the Fabergé mold, which demanded both education and long experience of its employees, and a female designer was a new thing within the company. Alma Pihl's designs also differed stylistically from the neoclassical-influenced production for which Fabergé was famous. Her style was completely independent. Ice and snow themes had never been used before, but the winter motifs spoke to both the customer and the recipients of the gifts. Winter at its most beautiful—biting cold with a pale sun playing on a field of snow—this was Alma Pihl's tribute to the grandeur of the northern winter.

The maturing of the idea can be observed in the Holmström workshop albums, and the popularity of the designs resulted in an ever increasing production. In the beginning, Alma's creative joy practically gushes off the page. She feels she is creating something new and obviously enjoys being able to fulfill herself. But by 1915, the frost motif had become stereotypical. Alma became bored with her theme and wished to take her stylistic universe in new directions.

Large-scale celebrations were organized in both St. Petersburg and Moscow in connection with the three-hundredth anniversary of the Romanov

dynasty in 1913. The emperor gave hundreds of jeweled gifts at these events to his prominent guests, royalty and other dignitaries who had come from around the world to participate in the festivities and honor the head of the dynasty and his family. The Holmström production drawings also reveal Alma Pihl's role in the design of these tercentenary jewelry. Themes were not chosen freely, but rather followed directions from the Cabinet of His Imperial Majesty. The jewelry had to have a connection with the Romanov dynasty, and it was also to be metaphorically linked to the ruling family. Alma often spoke of the difficulty of attaching dynastic symbols to jewelry, particularly the double-headed imperial eagle and the Cap of Monomakh, or as Alma mockingly referred to it, the "fur hat." The Cap of Monomakh is made of gold decorated with copious filigree work, rubies, emeralds, and pearls, and is trimmed with sable.

Brooch commemorating the Tercentenary
of the Romanov dynasty
Fabergé, workshop of Albert Holmström, c.1913
Design Alma Pihl
Gold, aquamarines, rubies, diamonds
Courtesy: Hillwood Estate, Museum & Gardens,
Washington DC
Photo: E. Owen

One's attention is repeatedly drawn in Alma Pihl's drawings to the dynamism that marked her work. She was truly a child of her time, a product of the new century, who lived in an age when fresh winds were blowing in the arts and handicrafts. These rich currents included, among others, art nouveau, art deco and modernism. As a jewelry designer, Alma Pihl was a pioneer in many ways. Her drawings and ideas could have easily been dated twenty years later. It is unfortunate that we never got to see her mature period. We can only guess what her work would have become.

As has already been stated, Dr. Nobel had reserved exclusive rights to Alma Pihl's ice jewelry and decorative objects, but when a request came directly from the emperor, Nobel was happy to make an exception. There is no doubt that Karl Fabergé himself suggested that Alma be afforded the opportunity to design the 1913 winter-themed Easter egg. He gave Alma free rein, but emphasized that her creation must be in the shape of an egg and that it must contain a surprise.

This task may have been Alma's greatest challenge ever. The creation of the sketches for such a large custom order, getting them approved, and the further development of the models into their final state, based entirely on her own ideas, was an opportunity to shine given only extremely rarely to young, inexperienced artists. The Winter Egg was also the most valuable of the fifty imperial eggs produced by Fabergé.

This particular egg, the product of the feelings of a romantic girl, reflects the budding spring and awakening of nature. It was important for Alma that an Easter gift clearly express the idea of resurrection connected to the time of year. In northern Europe, Easter falls at a time when the snow and ice are gradually beginning to melt. The light is increasing after nearly half a year during which the light of day was only visible for some six hours

The Winter Egg was a gift from Nicholas II to his mother, Dowager Empress Maria Feodorovna

each day. However, on Easter, the sun often shines from a bright blue and cloudless sky.

The Winter Egg depicts this time of year superbly. All residents of northern climes have seen the sort of melting lump of ice on which the Winter Egg stands. In March, small brooks gurgle along, carving the sides of nature's ice sculptures. Drops of water glisten like diamonds in the sun. Jewelers believed that Siberian quartz was the right material to depict ice. Cut as fine as can be, this lovely stone is almost as transparent as window glass. When engraved or etched, it becomes white.

At the end of April, after the northern sun has melted the snow, a magical carpet of anemones appears in the forests and hollows. Few flowers are awaited so fervently in the North as white wood anemones. There is something heroic in these unassuming buds as they push through the layers of dead leaves after withstanding the brutal weather of winter. Alma's idea for the egg's surprise was beguiling: a small platinum basket of these harbingers of spring made from white quartz. The capillary leaves are gold and the green centers demantoid garnets. The leaves are of green nephrite. The flowers are pressed into moss, which is made of an almost brown alloy of gold. The egg is crowned by a polished, round moonstone inscribed with the year 1913.

Although we do not have any written account of the dowager empress's reaction, we can be sure that she was delighted to receive her Easter gift. The Winter Egg also undoubtedly greatly pleased the emperor since he was both a person who loved the outdoors and was deeply religious. We do not know whether their appreciation ever reached the ears of the young designer, the skilled jewelers, the goldsmiths, or the gem polishers; that is, those who together had created this incredible object. It is possible that this did happen, because Alma was also asked to design an Easter egg the next year for Empress Alexandra.

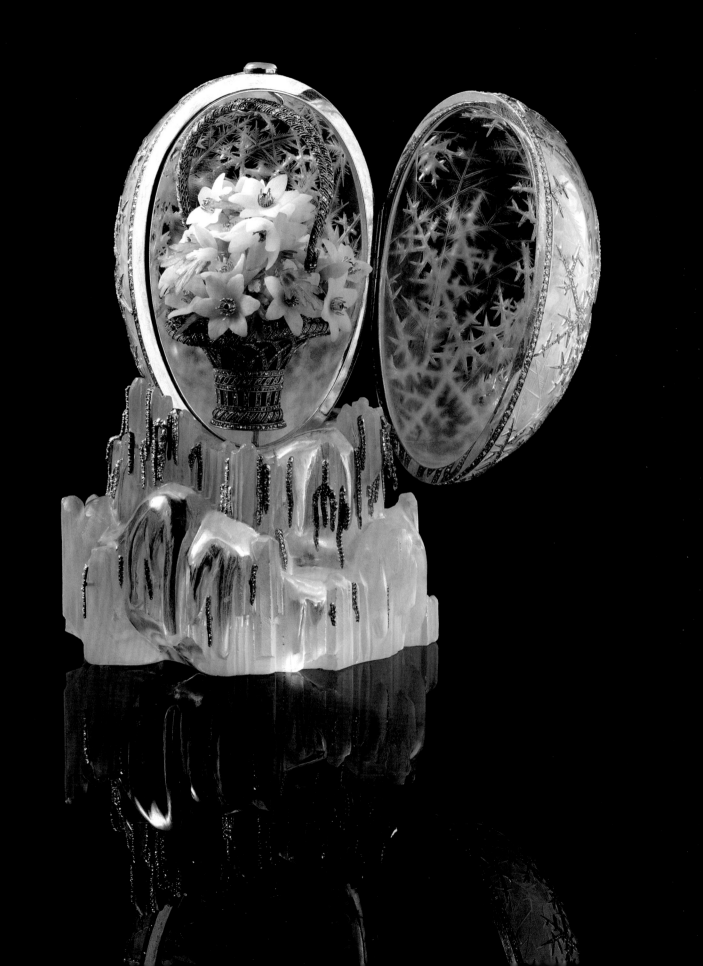

The success of the Winter Egg gave Alma Pihl the opportunity to concentrate on the design of the following year's imperial Easter gift. In 1914, the next in line was Nicholas II's gift to his spouse, Alexandra Feodorovna. It took a long time to design these stupendous works, at least a year, but in some cases as many as three.

One can see from Alma's sketches that the idea had already begun to take shape a year earlier. Two small brooches were made in the workshop in 1913, one round and one rectangular, with her new motif. Alma reported herself that she weighed and considered options for a long time until the ultimate idea suddenly came to her.

As has already been mentioned, Alma and Nikolai Klee lived together with Nikolai's mother at the beginning of their marriage. It was a winter night in 1913. The family had just sat down to spend the evening in the lamplight, Alma lost in her own thoughts and her mother-in-law working on her colorful cross-stitch embroidery. When the light fell on the decorative sewing, the idea came to Alma in a flash: an Easter egg patterned with petit-point embroidery. Karl Fabergé approved the idea, and Uncle Albert began the technical execution in conjunction with the design work with

*Knut Oscar Pihl was the father of Alma Pihl. He was the head of Fabergé's
jewelry workshop in Moscow, but died prematurely at the age of thirty-seven.*

his skilled artisans. The two small brooches functioned as prototypes; how
to make embroidery look realistic when made of metal and gemstones. It
is interesting to note how meticulously Fabergé's workshops planned the
preparation of their large custom orders. Likewise, from the perspective of
the researcher, it is important to know precisely how each design idea was
born.

Alma Pihl's Mosaic Egg is closely connected to Empress Alexandra Fe-
odorovna as she was known to enjoy relaxing with her embroidery. The egg
itself is constructed of a platinum mesh, which corresponds to the metallic
mock leno used in embroidery. The framework is made of gold. The flow-
er and foliage work consists of small, closely set calibrated gemstones: red
rubies, blue sapphires, green emeralds and garnets, yellow citrines, all of
which are square cut, as well as rose-cut diamonds, small pearls, and enam-
el. The egg is crowned with a round-cut moonstone.

As usual, inside the egg a surprise awaits: a small, oval stand, the front
of which features an enamel profile painting of the five imperial children—
Olga, Tatiana, Maria, Anastasia, and Aleksei—and on the reverse, a flow-
er basket edged with ornamentation formed from the children's names.[135]

Alexander Edvard Tillander

Craftsmen of A. Tillander, 1910
Silver, red granite
Photo: Photo Mauritz, Loviisa

The craftsmen of A. Tillander presented their employer with this miniature sculpture for his fiftieth anniversary in 1910. It depicts Alexander Edvard Tillander at the anvil standing next to a rolling mill.

THE JEWELER A. TILLANDER

Alexander Edvard Tillander (1837–1918) was the son of a tenant farmer at Tali, now part of the present-day capital of Finland. His father sent him to St Petersburg at the age of eleven to learn a trade. A peasant on his way to the Russian capital agreed to take boy on his cart filled with produce destined for an outdoor market. He first stayed in St. Petersburg with his older brother Gustaf Adolf, who had been there for a year learning to become a shoemaker. Alexander initially obtained an apprenticeship with a barber, but left within a week as he realized he would never be the Figaro of St. Petersburg. His ambition was to become a jeweler. He heard through the grapevine of Fredrik Adolf Holstenius, a Finnish master goldsmith with a workshop in Tsarskoe Selo, and was accepted as an apprentice.[136] The tranquil "village of the tsars," with its magnificent imperial palaces and enchanting summer residences of grand dukes and members of the aristocracy, was an inspiring environment in which to live and work. The start of eleven-year-old Alexander's professional life began under a happy star.

Alexander apprenticed seven years with Holstenius, after which he qualified as a journeyman (1856). He found his first employment with Carl Becks, a German who had become a master goldsmith in St. Petersburg in 1849. After two years with Becks, young Tillander was employed by the master jeweler Carl Reinhold Schubert,[137] whose workshop was located in the Zhadimirovskii house on Gorokhovaia ulitsa, then at Moika 42. He worked for Schubert for three years, gradually acquiring proficiency in his craft, at the same time improving his general education and knowledge of languages. These studies required stamina and late hours; at that time the workday lasted from seven in the morning until late at night, and usually on Sundays as well in winter.

Pendant
A. Tillander, St. Petersburg, early 1900s
Gold, enamel
Private collection
Photo: Katja Hagelstam

The pendant has the form of a helmet (kaska) for a
student at the Corps of Pages, St. Petersburg.

Presentation brooch
A. Tillander, St. Petersburg, early 1900s
Gold, sapphires, diamonds
Private collection
Photo: Katja Hagelstam

The brooch was a presentation gift commissioned by Grand Duchess Maria Aleksandrov-
na, Duchess of Edinburgh and of Saxe-Coburg and Gotha, sister of Alexander III.

Tillander earned his master's certificate at the age of twenty-two and decided to set himself up as an independent workmaster. On March 7/19, 1860, he rented a room on the second floor of a building on the Bol'shaia Morskaia, at the corner of Gorokhovaia ulitsa. He was joined by two other young masters as the room was big enough for three workbenches, appliances, and the tools necessary for a goldsmith's workshop. Tillander's total savings mounted to a humble two hundred rubles, but was sufficient for the purchase of gold for the very first pieces of jewelry of his own design. Wide gold bangles were in fashion at the time, and Tillander found his first customers for these among the important jewelers of St. Petersburg, mainly C.E. Bolin, J. Vaillant, and Clément & Guibert.

Gradually Tillander acquired a number of private customers. All through his life, he especially remembered with immense gratitude an estate owner from southern Russia by name of Tulinov. This wealthy and genteel man not only became a good customer, he also recommended the

young entrepreneur to his numerous acquaintances and friends, and once even helped him out of a quandary. Inexperienced in financial transactions, Tillander had unwittingly signed a large bill of exchange to help a Moscow dealer in precious stones and was faced with the responsibility of paying out an incredibly high sum of money. He was at risk of losing his entire business, but was saved by his benefactor.

Alexander Tillander married a girl from his country of birth, Mathilda Gustava Ingman.[138] Most young girls of humble background came to St. Petersburg to look for employment as maids in private homes, and they usually succeeded as the need for domestic help was immense. But life in a big city was full of hazards. A young girl could easily land in a brothel without herself understanding how it happened, whereas an ill-fated young boy could end up working in a sweatshop for hardly any pay at all. To avoid tragedies of this kind, assistance was offered to the newcomers. Each and every one was obliged to register at one of the Lutheran churches.[139] This allowed the pastors to keep them under a watchful eye. They saw to it that they came to Sunday school every week, to service in church, and that they participated in one or several of the many leisure-time activities arranged for them. The young people from the grand duchy thus received through their church a network of friends. The contacts often led to happy unions. To marry somebody with the same background and mother tongue made life much easier.

A son was born in 1870 to Mathilda and Alexander. The child was named Alexander after his father. That same year, Tillander moved to larger premises at Bol'shaia Morskaia 28 (Gorokhovaia 13), directly opposite his previous address. There a large room with granite columns was furnished and decorated as a reception room for private customers. In accordance with the ancient guild system, the master and his family set up their home in the back of the shop.

In 1874, Alexander began to travel regularly abroad, to the big cities of Western Europe, in order to find new ideas and models for his production. His retail shop and atelier were enlarged in the early 1880s, and the original trade description "Office and Workshop for Gold and Diamond Goods" on the letterhead was changed to "Jeweler."

At the age of fifteen (1885), having finished school, Alexander Tillander junior began his training in the family workshop, first under the direction of his father, then under tutorship of the old and experienced craftsman Johan Lönnström. That same year, his father celebrated his twenty-fifth anniversary as entrepreneur. His work brought him a silver medal at the Exhibition of Applied Arts in St. Petersburg, as it also did at the next exhibition

Brooch commemorating a tenth anniversary
A. Tillander, St. Petersburg, 1890s
Gold, sapphires, diamonds
Private collection
Photo: Katja Hagelstam

Brooch
A. Tillander, St. Petersburg, 1880s
Gold, lapis lazuli
Private collection
Photo: Katja Hagelstam

This brooch was purchased by Admiral Oscar von Kraemer as a gift to his wife

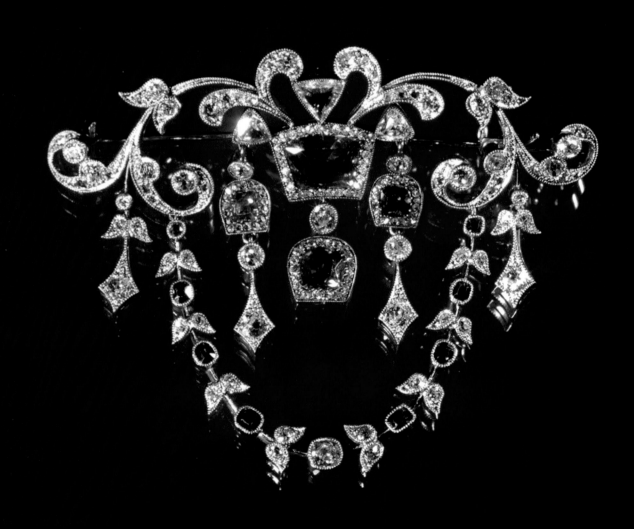

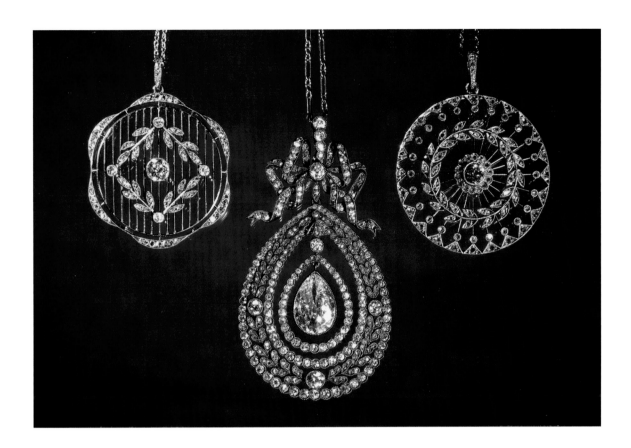

Corsage ornament
A. Tillander, St. Petersburg, 1912
Platinum, diamonds, sapphires
Private collection
Photo: Katja Hagelstam

Pendants
Unknown maker / C. E. Bolin / A. Tillander,
St. Petersburg, c.1910
Platinum, diamonds
Private collections
Photo: Katja Hagelstam

The piece was a gift from the attorney Bertil Godenhielm
to his wife Countess Karin Godenhielm, née Creutz.

held in Ekaterinburg in 1887, which brought the firm new customers, and the sales were noted as passable.

After a three years apprenticeship at home, young Tillander was sent abroad to practice at various jewelry firms. In Paris, he worked as a journeyman goldsmith at the jeweler Smets & Fournier, Marché Saint-Honoré; then at Messrs L. Lhomme, 2, rue Vivienne. He moved on to London where he practiced at the workshops of Brothers Gugenheim, then at those of the jeweler White, who specialized in fine jewelry made for the Indian market. He then worked for the jeweler Paul Kämpfe in Dresden. Back home, yet another three years later (1891), he was employed for five months as representative of the jeweler L. Coulon & Cie, of the rue de la Paix in Paris, at the important French Exhibition of Applied Arts in Moscow.

The younger Alexander was now ready to assume his share of the responsibility for running the family firm. At the age of twenty-five (1895), he made his first long business trips abroad. Father and son had made good contacts with gemstone dealers in Ekaterinburg, mainly with firms that dealt in demantoid garnets, called olivine in Russia. Alexander acquired an agency for the sale of this attractive gemstone to Western European jewelers, and this business became an important source of income up until the beginning of World War I. An amusing story has survived from one of his visits to Paris. Alexander indulged in studying jewels on display in the windows of the fine jewelers of the Place Vendôme. His attention was caught by a few exquisite pieces in the vitrines of the famous court jeweler Chaumet. Standing close to the window, he took out his pen and started sketching the objects onto the starched white cuff of his shirt—discretely so that his trade espionage would not be spotted from the inside of the shop. While he was drawing, the front door was flung open, out stepped a clerk with a chair in his arms, who said, "Monsieur, we have the pleasure of making your copying work a bit easier. Please take a seat!"

The years round the turn of the century and up to the Russo-Japanese War of 1904–5 were ones of marked expansion. Now that there were more than thirty employees at the workshop, a specially trained expert took over the stock of precious stones, and fulltime designers were employed. Turnover began to exceed one hundred thousand rubles a year. Jewelry was the mainstay, with commemorative medals, badges, and jetons, as well as cigarette cases and small objects in gold and silver set with precious stones, also an important part of the production line.

Russia enjoyed a trade boom in 1908 and 1909. The firm was at the time on a sure foundation and free from debt. Among its customers were the Cabinet of His Imperial Majesty; the Chancellery of Dowager Empress Maria Feodorovna; those of Grand Duke Vladimir Aleksandrovich, his consort, and children; the Duchess of Saxe-Coburg and Gotha, née Grand Duchess Maria Aleksandrovna; and many well-known people from the high nobility, as well as ministers, officers, magnates from the world of industry and commerce, and representatives of the cultural elite.

In 1910, shortly before the firm's fiftieth anniversary, Alexander Theodor took over the business from his father for 100,000 rubles, payable at the rate of 500 rubles a month during his father's lifetime.

The firm moved to new premises at Nevskii 26 (the Bank of Finland building) on April 15, 1911. The court jeweler Carl Hahn was closing its business at this address following the death in 1911 of Dmitrii Karlovich Hahn, the last member of this highly esteemed jewelry establishment. The

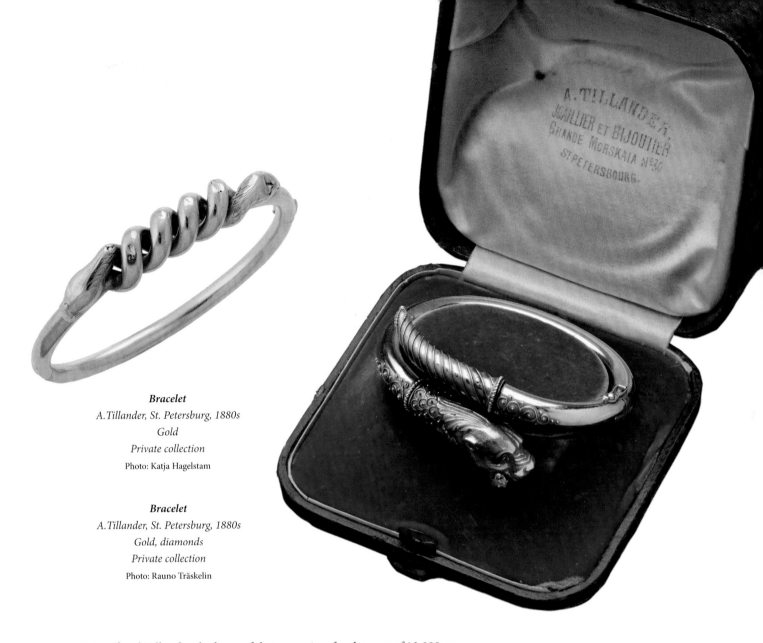

Bracelet
A. Tillander, St. Petersburg, 1880s
Gold
Private collection
Photo: Katja Hagelstam

Bracelet
A. Tillander, St. Petersburg, 1880s
Gold, diamonds
Private collection
Photo: Rauno Träskelin

estate offered Tillander the lease of their premises for the sum of 12,000 rubles. The better location resulted in a considerable increase of business for the new owners. Tillander now turned over responsibility of the workshop to the firm's long-time head workmaster, German-born Theodor Weibel, who set up his atelier on Gorokhovaia ulitsa, next to the Kamennyi most (Stone Bridge).

Tillander gained even more prestige when the firm took over the entire Russian stock of the Paris jeweler Boucheron, whose Moscow branch had just closed on the heels of a tragic episode. On April 1, 1911, at 8 p.m., Boucheron's Moscow director, Georges Delavigne, and his twenty-four-year-old son, Henri, were shot to death on the train between Baku and Moscow, at the Mineral'nye Vodi station. The murderers were caught in the act. Boucheron Moscow arranged an exhibition each year in Baku, where they displayed and sold jewelry and precious stones. The exhibitions were well attended, with customers coming from many countries in Eastern

Workshop of A. Tillander, St. Petersburg
Unknown photographer, c.1900
The address was at the time Bol'shaia Morskaia 28

Business card of A. Tillander, c.1900

Bar brooch
A. Tillander, St. Petersburg, 1880s
Gold, garnet, diamonds
Private collection
Photo: Katja Hagelstam

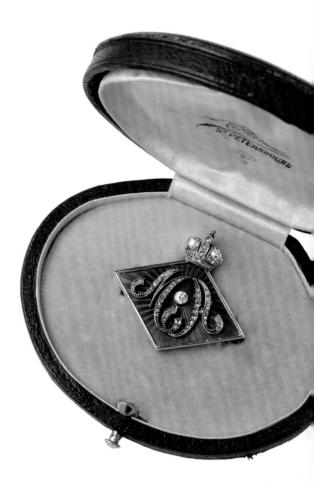

Presentation brooch
A. Tillander, St. Petersburg, c.1910
Gold, diamonds, enamel
Private collection
Photo: Katja Hagelstam

The brooch was commissioned as a presentation gift by Grand Duchess Maria Aleksandrovna, Duchess of Edinburgh and of Saxe-Coburg and Gotha, sister of Alexander III.

Europe, the Middle East, and the Orient. When the exhibition closed in 1911, father and son Delavigne returned to Moscow with the unsold merchandise, a bag full of diamonds, and a considerable sum of money in cash. The death of their two representatives was a severe blow to Boucheron.

This transaction was the beginning of an inspiring and long-lasting collaboration with Boucheron, doubling the firm's turnover overnight. Since there was no room to enlarge the workshop to keep pace with the increased business, part of the production was outsourced to other Petersburg workshops. Important suppliers of both jewelry and precious stones were C. H. Bucknall and A. Beilin. A number of smaller workshops run by Finnish masters were also used, including Häyrynen, Nykänen, Lindroos, Åström, Tiitta, Helenius, Gardberg, Taivainen, Nylander, and Strandholm.

As would be expected, the picture changed with the outbreak of World War I, and the effects of inflation soon began to be felt. The revolution in

March 1917 not only halted the firm's rapid expansion (the annual turn-over had reached four million rubles), but put an end to the business in Petrograd. By the time the firm officially closed its doors on September 1, 1917, Alexander Theodor Tillander had already moved to Finland with his family. Alexander senior and his wife Mathilda remained in Petrograd, de-claring that Russia was their homeland after having lived there for so long. Even though the shop was closed, the old man worked there a few hours each day. One day in November 1917, on his way home, he was attacked by five bandits. He had a firm grip on his leather case containing valuable jewels and steadfastly held on to it although badly injured by the hooli-gans, who fled when people rushed to the rescue of the old man. Little over a year later, in December 1918, Alexander Edvard Tillander passed away.

A few months earlier, in September 1918, Alexander Theodor had re-opened the firm in Helsinki. At first the retail store and workshop were run in partnership with Victor Lindman, a respected grand old man of the goldsmith trade. He had represented Tillander successfully for many years, selling jewelry made in St. Petersburg. When Lindman retired in 1921, the name of his firm was changed to A. Tillander.

The confused conditions after the revolution caused countless Russians to flee the country—many of them escaped to Finland. Usually their jewels were among the few possessions they managed to take with them. A large

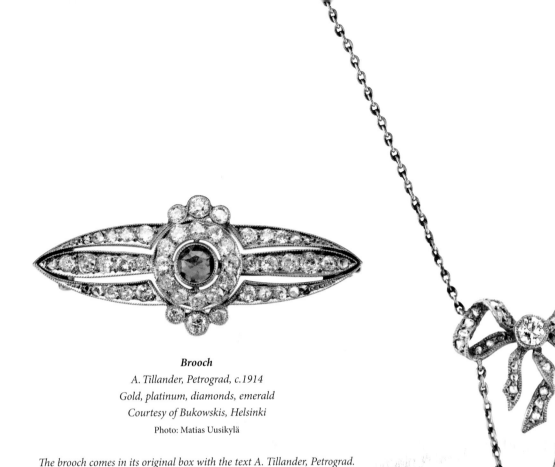

Brooch
A. Tillander, Petrograd, c.1914
Gold, platinum, diamonds, emerald
Courtesy of Bukowskis, Helsinki
Photo: Matias Uusikylä

The brooch comes in its original box with the text A. Tillander, Petrograd.

quantity of jewelry arrived in this way, much of it too costly for the straitened circumstances of the small country. Tillander had an intimate knowledge of such articles and the prices they could fetch on the open market. He was thus able to buy in almost unlimited quantity and sell immediately to foreign colleagues, whom he invited to call on him at his office, which helped reestablish contacts with the outside world and get the business fully back on its feet. Known in the large cities of Europe before World War I, the firm now worked to maintain active contact with the international market from Finland.

The third generation of Tillander jewelers, the three sons of Alexander Theodor—Leo, Herbert, and Viktor—all born in St. Petersburg, received their initial training in Finland. They all earned masters' certificates in the craft of their forefathers, all practiced for several years abroad, and all came into the family business. Until the 1950s, the workshops of the firm were manned by gold- and silversmiths, the majority having received their training in St. Petersburg. Oskar Pihl, son of Fabergé's Moscow workmaster Knut Oscar, grandson of Fabergé's head jeweler August Holmström, and brother of the designer Alma Pihl, was employed as head designer and worked with the firm until his death in 1959. Thus the design and technique of Tillander's early production in Helsinki had a very specific "flavor" of St. Petersburg.[140]

Pendant
A. Tillander, St. Petersburg, c.1910
Platinum, diamonds
Private collection
Courtesy of Alexander Tillander, Helsinki

The von Etter family at Haiko
Unknown photographer, 1910
Courtesy of Marion von Etter

Seated from left to right: Emilie von Etter (née von Jacobson), her grandson Vladimir, and her sons Paul and Johan. Standing from left to right: Nikolai, Emilie "Lily", Alexander, and Marie (née Countess Kleinmichel). The white Samoyed Sibirka was also an important member of the family.

HAIKO MANOR
RETREAT AND SHELTER

Haiko, near Porvoo (Borgå), Finland, was and still is a charmingly simple manor set in a pastoral environment on the waterfront of the innermost archipelago of the Gulf of Finland. The history of the manor, owned by the von Etter family since 1870, goes back to medieval times.

This extraordinary family, originating in Switzerland, found its way to the Russian Empire during the reign of Catherine the Great; then, in the 1840s, to the Grand Duchy of Finland. In 1843, the commandant of Helsinki, Lieutenant General Paul (Pavel Sevastianovich) Etter (1790–1878) was ennobled by Emperor Nicholas I, and his family was registered under the name von Etter at the House of Nobility in the grand duchy.[141]

Four sons were born to the family, each having a brilliant career in the service of the empire: Sebastian (Sevastian Pavlovich) (1828–1883), was a lieutenant general; Alexander (Aleksandr Pavlovich) (1831–1902), a privy counselor; Nikolai Pavlovich (1833–1891), a lieutenant general; and Paul (Pavel Pavlovich) (1840–1910), a general of the cavalry.

The story of Haiko manor as a retreat and shelter begins with the scion of the family Sebastian Albrekt and his wife Emilie (1842–1923), daughter of Actual Privy Counselor Johan von Jacobson. She was highly educated with rare social talents. The house was always open to family, friends, and friends of friends. The guest books overflow with celebrated names of the era, those of royalty, politicians, military men, artists, actors, and writers. The family initially lived in St. Petersburg, but spent holidays at Haiko. The five children—four sons and one daughter—grew up longing for summer which was spent at their beloved Haiko.

The four sons, as had previous generations, all served the empire, and all graduated from the elite Corps of Pages. The eldest, Paul (1861–1938), major general and master of the horse, served as assistant to the minister state secretary of the grand duchy. Johan Emil "Vania" (1863–1941) attained the rank of major general, was commander of the Semenovskii Regiment, and took an active part in World War I. He married Countess Maria Vladimirovna Kleinmichel (1872–1950), maid of honor of the empresses, in 1898. She was the daughter of Major General of the suite Count Vladimir Petrovich Kleinmichel and Princess Ekaterina Petrovna Meshcherskaia. Nikolai "Koki" (1865–1935) had a career as a diplomat, serving in many countries of Europe and the Near East. His last position in 1915 was envoy extraordinary and minister plenipotentiary in Teheran. He married Stepanida Viktorovna Spechinskaia, a niece of Emilie von Etter, in 1925. She was the daughter of Lieutenant General Viktor Viktorovich Spechinskii and Princess Maria Alekseevna Meshcherskaia. The youngest, Alexander "Shura" (1867–1939), entered the civil service, working for a time at the Ministry of the Imperial Court, and from 1897 was employed as the private secretary of Grand Duchess Maria Pavlovna.

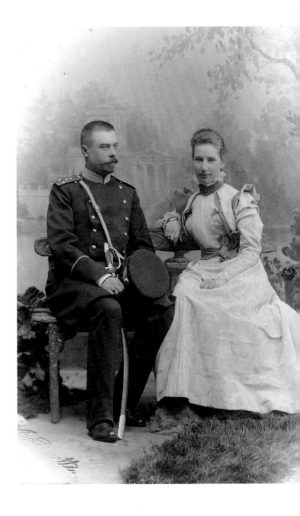

Maria and Johan von Etter
Unknown photographer, c.1898
Courtesy of Marion von Etter

Countess Maria Vladimirovna Kleinmichel and Johan Emil von Etter at the time of their wedding. He wears the uniform of an officer of the Semenovskii Regiment.

A LIVELY SOCIAL LIFE

The *corps de logis* of Haiko was a delightful fairy castle built of wood, its facade adorned with an array of mid-nineteenth-century architectural details. The spacious salon was furnished as a cozy "assembly room" with comfortable sofas, armchairs, and polar-bear skins. It was the heart of the house, where family and friends enjoyed music and parlor games. Being entertained in this salon was known to be inspiring—a waft of St. Petersburg in a rural setting.

The daughter of the house, Emilie Johanna Dagmar "Lily" von Etter (1869–1919), maid of honor of the empresses, was an excellent horsewoman

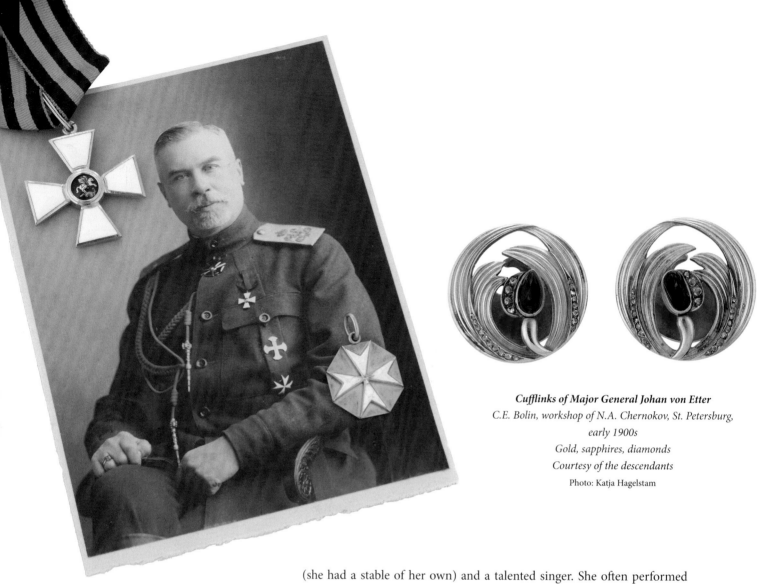

Cufflinks of Major General Johan von Etter
C.E. Bolin, workshop of N.A. Chernokov, St. Petersburg,
early 1900s
Gold, sapphires, diamonds
Courtesy of the descendants
Photo: Katja Hagelstam

Major General Johan Emil von Etter
Courtesy of the descendants
Photo: Katja Hagelstam

The general's Order of St. George fourth class, which
he received in 1915 for exceptional bravery in battle, is
shown on the top left of the photograph. Below on the
right is his gold and enamel jeton made on his gradua-
tion from the Corps of Pages in 1883.

(she had a stable of her own) and a talented singer. She often performed at small gatherings, at times in duet with her singing teacher or a visiting guest. She received the gold medal of the Russian Red Cross in 1916.

Members of the imperial and other princely families were often guests at Haiko and came to know the grand duchy through the von Etters. Many highly ranked visitors arrived in their private yachts, anchoring in the bay outside the manor. Grand Duke Vladimir and his wife, Grand Duchess Maria Pavlovna, visited in 1907. Their hosts arranged an excursion by boat in the archipelago during their stay. Touring the ancient cathedral of Porvoo, Grand Duke Vladimir was moved to tears when reading the manifest written by Alexander I to the Finnish people. The grand duchess returned several times to Haiko, often in the company of her radiantly beautiful daughter Elena, who, with her husband Prince Nicholas of Greece and their children, made more lengthy sojourns. Grand Duke Boris Vladimirovich, the Prince and Princess of Saxe-Altenburg, Princess Eleonore Reuß zu Köstritz (later tsaritsa of Bulgaria) also appear on the pages of the guest books. The name of Princess Daisy of Pleß, née Cornwallis-West, a noted beauty of the Edwardian era, is a surprise. It is not known how and why she visited Haiko. She was married to one of the wealthiest men in Germa-

Pages from a Haiko souvenir album
Private collection

The first features a drawing by Grand Duchess Viktoria Feodorovna; the second, a drawing of Grand Duchess Maria Pavlovna after a well-known photograph of her in which she wears her pearl and diamond tiara, now in the collection of Queen Elizabeth II.

ny. After divorcing her husband, she led a colorful life as a social reformer. She was a friend of both William II of Germany and King Edward VII. She served as a nurse during World War I, and later wrote several books on her life. Among the well-known ambassadors and politicians who visited were Sir Georges Buchanan, British ambassador to Russia, and Count Leopold Berchtold von und zu Ungarschitz, Austro-Hungarian ambassador to Russia and imperial foreign minister at the outbreak of the war.

On the evening of December 31, 1910, fire destroyed the old *corps de logis* of Haiko. Hardly anything was saved from the flames. Emilie von Etter and her daughter Lily did not themselves witness the conflagration as they spent the dark and chilly winter months on the French Riviera. The old lady bore the loss of her beloved home stoically. She furnished a new residence for herself and her daughter in one of villas on the grounds. A new *corps de logis* was planned on the foundation of the old. Construction began in 1913 after designs by the architect Armas Lindgren. But the revolution that followed World War I totally changed the lives of the von Etter family. The four sons, all with high positions in Russia, left the crumbling empire for Finland and settled permanently at Haiko. All assets were lost in the revolutionary turmoil, and the once wealthy family now found themselves in financial straits. Construction work on the new main building at Haiko also came to a halt.

IMPERIAL REFUGES

Despite the strained circumstances caused by the upheavals in Russia and Finland, the doors of Haiko remained open for friends and those in need of shelter. Grand Duke Georgii Mikhailovich briefly stayed at Haiko before he was arrested in Helsinki and returned to Petrograd, where he met his tragic fate. Prince Gavriil Konstantinovich also made a stopover before leaving for France. A great number of other refugees from Russia found sanctuary

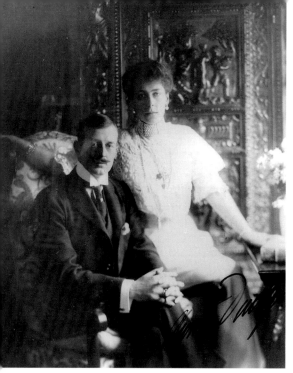

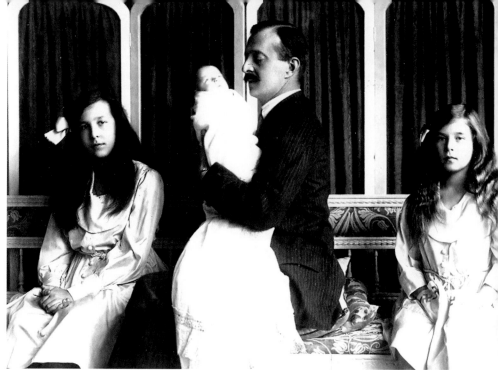

Grand Duke Kirill Vladimirovich and Grand
Duchess Viktoria Feodorovna
Unknown photographer, 1905
Courtesy of Marvin Lyons, Richmond, B.C.

Grand Duke Kirill Vladimirovich with his three children, Maria, Kira, and Vladimir
Unknown photographer, Haiko, 1917
Courtesy of Marion von Etter

Madame Emilie von Etter with baby Vladimir
Kirillovich in her arms
Unknown photographer, 1917
Courtesy of Marion von Etter

The photograph was taken in Haiko at the baptism of
the newborn prince.

at Haiko before they continued their search for a new life, most of them in Paris, which became a center for the Russian aristocracy in emigration.

Grand Duke Kirill Vladimirovich and his family resided at Haiko for almost five years, until 1922. Kirill had become heir to the throne after the abdication of Nicholas II and it being declined by his younger brother Mikhail. As such, he needed a temporary home close to the border in order to be able to return to his country at a moment's notice. The von Etter family gladly welcomed him and his family. The grand duke, his very pregnant wife, and their two daughters, Maria and Kira, age eleven and nine respectively, had succeeded in crossing the border to Finland by train in June 1917. Grand Duchess Viktoria Feodorovna gave birth to her son Prince Vladimir Kirillovich on August 30, 1917. The baby was brought into the world in Porvoo by the von Etter family doctor, Gunnar Nyström, and was christened at Haiko.

The escape of the family was certainly both adventurous and hazardous, but not as dramatic as the version Grand Duke Aleksandr Mikhailovich gives in his memoirs. He says that his cousin "had, perhaps, the most exciting story to tell: he crossed the frozen Gulf of Finland on foot, carrying his pregnant wife Grand Duchess Viktoria (who is a sister of Queen Marie of Rumania), and being hotly pursued by Bolshevik patrols."[142] When the Soviet Union was established, the grand duke, no longer seeing any

possibility of returning to Russia as emperor, decided to move to Coburg and later to France.

There are many reminiscences of life at Haiko during these troubled years. The position of the imperial house guests, as well as for their hosts, must have demanded both great patience and adjustment. The unsettled political conditions and the ongoing civil war in Finland also caused great concern. However, an engaging recollection, from February 1918, bears witness to how dignified the days and evenings nevertheless were. Baron Herbert Standertskjöld, a twenty-five-year-old friend of the von Etter family, came to Haiko seeking help. He was one of the many young men who took part in the chaotic clashes between the Whites and Reds, an extension of the revolution in Russia, which led Finland into a civil war. Standertskjöld had been badly wounded in the battle of Pellinge and needed to recover before returning to the camp of his comrades. The unexpected young guest remained at Haiko for several days. He had dinner with the family and their august house guests, and was captivated by the way Grand Duchess Viktoria, as the foremost lady of the table, led the conversation, which was held in French and English. She expressed herself with authority, and her dark, muffled voice gave her speech an extraordinary spell. The evening usually continued at the card table in the salon after dinner. Standertskjöld admired the talent of the grand duke at the piano. He must have loved Chopin as his concertos repeatedly echoed throughout the house. At eleven sharp every evening, the grand duchess cast an eye at her wristwatch, rose from her chair, went across to her hostess, Madame von Etter, and said, "Il est déja onze heures" (It is already eleven o'clock). The old lady, already very tired, always in the same surprised voice replied, "Est-ce possible, Madame?" (Is it possible Madame?) She stood up, kissed the hand of the grand duchess while dropping a low curtsey. The grand duchess reciprocated by kissing her hostess on the forehead.[143]

Standertskjöld fell ill with a catarrh while at Haiko and gives a delightful description of how Grand Duchess Viktoria personally tended to him:

> She knocked on the door and came in holding a rectangular "parcel" wrapped in white batiste between her hands. Inside the cloth there was warm dough, which the grand duchess said she had learnt to prepare during the war when assisting in a military hospital. She placed the warm parcel on my chest, saying in jest that the ingredients of her dough had magical power. It indeed did me well, but the thought of the august hand that performed this philanthropic deed had an even more heart-warming effect on me.

Brooch
Fabergé, workshop of Alfred Thielemann,
St. Petersburg, c. 1900
Gold, platinum silver, cabochon chalcedony
(Mecca stone), diamonds
Private collection
Photo: Katja Hagelstam

The brooch was given by Grand Duchess Viktoria Feodorovna to Anna Lyydia Kukkonen, head nurse at Grankulla Bad, a spa where the family of Grand Duke Kirill Vladimirovich took therapeutic treatments in 1917.

NOTES

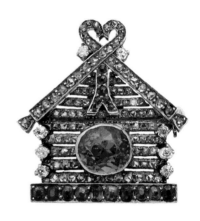

***Brooch in the shape
of a Russian izba (cottage)***
Unknown maker, St. Petersburg, early 1900s
*Gold, silver, demantoid garnet, diamonds,
rubies*
Courtesy of Christian Bolin, Stockholm

1 Engman 1980, 83; Bäcksbacka 1951, passim.

2 Olausson 1998, 153–64.

3 Countess Ekaterina Andreevna Ushakova (1715–1779) married in 1738 Count Petr Grigor'evich Chernyshev (1712–1773), actual privy counselor, ambassador to various countries in Europe, among them Paris and Copenhagen.

4 For a similar souvenir, see Count Gustaf Mauritz Armfelt in the chapter on Alexander I.

5 Her name is spelled Sophie Dorothee Auguste Louise in *Königlich-Württembergisches Staatshandbuch* 1808:15.

6 Communication of Lilia K. Kuznetsova, senior research fellow, The State Hermitage Museum, St. Petersburg.

7 Colonel was class six in the Russian table of ranks (*tabel' o rangakh*), a very high rank for a craftsman. This type of appointment was most unusual and is evidence of the fact that Jacob David Duval was indeed highly appreciated by the sovereign. The title "civil colonel" was a peculiarity in the Russian ranking system. A military title was more respected than a civil one. The rank equivalent to a colonel in the civil service was that of collegiate counselor.

8 Galiffe 1857, 311.

9 Galiffe 1857, 312. Marie, b. 1791 in St. Petersburg, was a goddaughter of Grand Duchess Maria Pavlovna (at the time a child of five). François Louis, b. 1795 in St. Petersburg, D.C.R. from 1825, had a military career in Switzerland and became mayor of Cartigny in 1845. Jacob Louis, b. 1797 in St. Petersburg, D.C.R. 1827–42, was a professor of law at the Academy of Geneva in 1840, of the assemblée constituante and of the Grand Conseil 1842–46. He married his cousin Marie Louise Jacqueline Duval. Marie Henriette Philiberte Jeanne, b. 1798 in Berlin, married her cousin Francis David Duval.

10 Communication of Valentin Skurlov and Lilia Kuznetsova.

11 Communication of Vasilisa Pakhomova-Göres, Potsdam, Germany.

12 RGIA *fond* 468 *opis* 32 *delo* 1266. Реестръ брилiянтовымъ вещамъ принадлежавшимъ Ея Императорскому Высочеству поконой Государынѣ Великой Княгинѣ Александрѣ Павловнѣ, Эрцъ Герцогинѣ Австрiйской. NB: What appears to be the Cyrillic letter *y* is frequently met with in the notations in the right-hand column. It has not been possible to date to determine its significance or meaning.

13 The original reads: Пара Серегъ брилiянтовыхъ съ банделоками.

14 The original reads: Склаважъ съ банделоками и цѣпочками изъ большихъ розъ и брилiянтовъ, и на концѣ онаго алмазъ восточной грани въ видѣ банделока.

15 The original reads: Перо составленное изъ 3x вѣтвей связанныхъ въ низу узломъ съ 12ю алмазными грушами восточной грани и 9тью брилiянтовыми банделоками съ осыпью изъ мѣлкихъ брилiянтовъ. *The Complete Russian-English Dictionary* by A. Alexandrow (St. Petersburg 1904) translates *брильянтовое перо* (bril'iantovoe pero) as "a sprig of diamonds."

16 The original reads: Ободокъ ордена св. Екатерины.

17 The original reads: Взнесенъ въ комнату Ея Высочества Великой Княгини Анны Павловны въ Февралѣ мѣсяцѣ 1816го года.

18 This sum is written in a different hand.

19 The original reads: Поясной аграфъ состоящiй изъ 2x овальныхъ медалiоновъ здѣланныхъ каме изъ пату. *Каме* is most likely a transcription of the French *camée*. As for *изъ пату*, the same word appears in the following entry (25): *съ патами*. That parure is

currently in the State Hermitage and is described as being made of papier-mâché. *Пат-* is most likely a transcription of the French word *pâte*, as in *pâte à papier* or *carton-pâte*.

20 The original reads: Большая цѣпь съ двумя другими концами цѣпочки.

21 The original reads: Берлока [*sic*] въ видѣ яичка украшенная розами, на коей финифтъ попорчена .

22 The original reads: Ожерельѣ состоящее изъ десяти большихъ и двадцати семи малыхъ антиковъ каме.

23 The original reads: Сломано въ 1804ᴹ году и вынутыя брилiянты употреблены: 1ᵉ на склаважъ и на гребень здѣланныя для Ея Высочества Великой Княгини Марiи Павловны на 25612 рублей, 2ᵉ въ 1809ᴹ году на приданое Ея Высочеству Великой Княгини Екатерины Павловны на 888 рублей, да исключено за фасонъ 1500 рублей.

24 RGIA, Fond 759, opis' 1, delo 53, list 30. "Ce 13 Septembre 1811…Un Assortiment en Topaces et Brillans." Communication of Lilia K. Kuznetsova.

25 Lilia K. Kuznetsova has communicated the passage from the empress's diary (written in French), which was published by M. I. Semevskii in his book *Pavlovsk: An Historical Sketch and Description 1777–1877*.

26 "Compte des objets fournis par Duval et employés le voyage pour compte de Sa Majesté Impératrice-Mère…à la Princesse Auguste de Saxe-Weimar le 22 Novembre [*sic*]." Communication of Lilia K. Kuznetsova.

27 Herzogl. Archiv Mecklenburg, Hemmelmark, Landeshauptarchiv, Schwerin, V 2012. N.B.: The text of the original list, written in French, has been transcribed exactly as received. The original archival document has not been consulted by the author. Archival photographs taken c. 1907 of the parure in emeralds and brilliants (number 24 on the list of jewels) and pieces possibly from the parure in amethysts and brilliants (number 27 on the same list), have been discovered by Alexander von Solodkoff in the archive. Many thanks to Mr.

von Solodkoff for sharing this piece of information.

28 Koninklijk Huisarchief, Archief A40-II-23. The original archival document has not been consulted by the author. The numbers that appear in the present list do not appear in the original; they have been added for ease of reference.

29 For the descendants of Countess Nadezhda Ivanovna Kutaisova see Boettger 1996.

30 The full text can be found at: http://feb-web.ru/feb/rosarc/rad/rad-061-.htm.

31 Finland, having been a part of the Swedish kingdom, had the Western European administrative system of four estates, which included free peasants, in contrast to imperial Russia, where the nobility had limited power in the administration of the empire and the peasants were still serfs. Alexander I, in an effort to create loyalty in his new grand duchy, chose not to change the existing system. This act of benevolence made his Finnish subjects very loyal.

32 Carl Adolf Möllersvärd (1744–1828) married Maria Charlotta L'Estrade (1756–1823) and had the following children: Carl Magnus (1775–1846), Maria Charlotta (1780–1782), Johan Gabriel (1782–1782), Johan Adolf (1784–1868), Catharina Charlotta (1785–1855, married 1802 Blechard Magnus Nordenstolpe), Maria Lovisa (1788–1868), Ulrika Ottiliana 'Ulla' (1791–1878, married 1813 Odert Reinhold von Essen), and Gustaf Reinhold (1795–1867).

33 Nervander 1906, 75–79.

34 The famous Finnish author Mika Waltari wrote a book in 1944 entitled *Tanssi yli hautojen* (Dancing on the graves), referring to the recent Finnish War, which romanticized the story of the emperor and his attention towards Ulrika Möllersvärd. The story about the fan may well be a product of Waltari's pen.

35 The five other maids of honor were Baroness Magdalena Wilhelmina De Carnall, daughter of Baron Carl Konstantin De Carnall; Hedvig Charlotta Cronstedt, the daughter of Vice-Admiral Carl Olof Cronstedt;

Countess Dorotea Vivika Brita de Geer, daughter of Marshal of the Diet Count Robert Wilhelm de Geer; Maria Gustava Tandefelt, younger niece of President Baron Adolf Tandefelt; and Anna Carolina Tengström, daughter of Archbishop Jacob Tengström. State Secretariat Archive 11/4 1811, 1809.

36 There were two categories of maids of honor. The maids of honor of the suite (*komplektnye* or *svitnye freiliny*) were instituted by Nicholas I in 1826 and were designated as being "attached to Her Majesty" (*sostoiashchie pri Eya Velichestve*). These ladies had extensive duties and generally served every other day. For that reason, they had their own apartment in specific suites of rooms in the imperial palaces. Maids of honor "of the city" (*gorodskie freiliny*) were so called because, as opposed to the former, they were not required to live at the palace. Officially they were known as maids of honor of Their Imperial Majesties the Sovereign Empresses (*Ikh Imperatorskikh Velichestv Gosudaryn' Imperatrits freiliny*). Typically appointed at the age of twenty, they were, therefore, already of marriageable age, and once wed, were obliged to "retire."

37 Odert Reinhold von Essen married firstly 1793 Baroness Johanna Lovisa von Fersen (1758–1796), secondly 1800 Juliana Maria Ramsay (1779–1812), and fourthly 1814 Fredrika Lovisa Boije af Gennäs (1789–1866).

38 Hämeenlinna Borough Administrators' Archive (HMA); Porvoo Borough Administrators' Archive. Protocol 11 May 1814, § 3.

39 National Archives of Finland, State Secretariat Office (VSV), 11/4, 155/1809 and 302/1811.

40 Hedvig Helena Wallenius was the eldest daughter of Lars Niclas (Nils) Aschan and Kristina Elisabet Alopaeus. She was born in Liperi on September 27, 1783, and died in Tohmajärvi on July 12, 1853. She married Petrus Wallenius (1773–1838) in 1804 and had eleven children.

41 Kungliga Akademien (The Royal Academy) was founded in 1640. It is today the University of Helsinki.

42 Pflaum 1984, 57. Communication of Timothy F. Boettger.

43 The Biedermeier style was a simplified version of the French Empire style, which suited the mode of life of the new urban and industrial classes. The name only came into use at the beginning of the twentieth century.

44 According to Iraida Bott in her comprehensive historical study of Russia's furniture designers and makers, the first Russian neo-rococo interior was the salon created in 1836 at the Znamenka Palace, Peterhof, acquired the previous year by Nicholas I as a gift for his wife Alexandra Feodorovna.

45 Fedor Grigor'evich Solntsev (1801–1892) was the son of serfs on the estate of Count Ivan Alekseevich Musin-Pushkin. The count recognized Fedor's talent and freed the family, which allowed him to attend the Academy of Fine Arts, which he entered in 1815. At the end of the 1824 academic year, he earned a gold medal for his painting entitled *Krest'ianskoe semeistvo* (Peasant family), and another in 1827 for his painting *Vozdadite Kesarevo Kesariu, a Bozhiia Bogovi* (Render unto Caesar the things which are Caesar's, and unto God the things that are God's).

46 Martin Wilhelm Mandt (Bayenburg an der Wipper 6.VIII.1799–Frankfurt and der Oder 20.XI.1858), privy counselor (1850) and knight of the Order of St. Anne, was a homeopath and developed the atomist system of medicine. He received his initial training from his father, and by 1816, the chief doctor of Düsseldorf allowed him to treat wounded soldiers. After attending university in Berlin, he served as a ship's doctor in 1821 on a voyage to Greenland, where he undertook zoological research. He passed his state medical examination in 1823 and was named district physician in Küstrin in 1825, then professor of surgery in Greifswald, and later director of the school of surgery there. He was appointed personal physician of Grand Duchess Elena Pavlovna in 1835, then of Empress Alexandra Feodorovna, and ultimately the emperor himself. He also opened a private surgical clinic at the Imperial Academy of Medicine in St. Petersburg

and lectured there. Communication of Timothy F. Boettger.

47 Mandt is referring to the famous Orlov diamond set in the scepter of the imperial regalia; it was not kept in the empress's personal jewelry chests.

48 Bonde 1949, 80–82. The Bonde family is one of Sweden's preeminent noble houses.

49 Many thanks to Timothy F. Boettger for deciphering and translating the text of the trousseau. The list contains 34 pages: Linen 1–4. / Lingerie 4–7 / Ribbons 8 / Fichus and scarves 9. / Wedding dress 10 / Court dress 11 / Ball dresses 12 / (13 blank) / Evening dresses 14 / Afternoon dresses 15 / Negligees 16 / Mantillas 17 / Coats 18 / Furs 19 / Headdresses 20 / Bonnets 21 / Flowers 22 / Shoes 23 / Furniture) 24 / (25 blank) / Silverware 26 / (27 blank) / Jewel casket 28 / Miscellaneous jewels 29 / (30 blank) / Bibelots 31 / (32 blank) / Carriages 33 / Miscellaneous objects 34.

50 Württemberg, 1955, 80.

51 Qvarnström, 1937, 165. There is no account of how the diamond was set at this time. Neither has a portrait of Aurora wearing the jewel survived.

52 Qvarnström, 1937, 160.

53 Communication of Diana Scarisbrick, London.

54 Ibid.

55 Qvarnström, 1937, 242–3.

56 Boettger 2006.

57 Natalia L'vovna Beketova was the daughter of Titular Counselor Lev Beketov (?–a.1851) and Anna Petrovna Pomo (1793–1870). Communication of Timothy F. Boettger.

58 The *Pridvornyi Mesiatseslov* (Court monthly) for 1840, p. 102, lists the following staff attached to the apartments (*pri komnatakh*) of Empress Alexandra Feodorovna: Anastasia Aleksandrovna Ellis (1794–1864), *kamer-frau*; Wilhelmine (Vil'gel'mina Ivanovna) von Rohrbeck (1803–1889), *starshaia kamer-iungfera*; Nadezhda Ivanovna Walter, *mladshaia kamer-iungfera* (possibly Johanna Mathilde Walter (1805–?), known in Russian as Nadezhda, dau. of Johann Christian Walter (1777–?),

who married firstly (1864) Johann Bernhard Weber, and secondly (1884) Karl Hermann Wiesel); and Natal'ia L'vovna Beketova, *mladshaia kamer-iungfera*. A *kamer-frau*, or woman of the (bed)chamber, would roughly be the equivalent of a lady's maid in English parlance. A *kamer-iungfera* is probably best translated as maid of the (bed)chamber. Anastasia Ellis was also a "keeper of the State diamonds" (*pri khranenii Gosudarstvennykh brilliantov* / the *Almanac de la cour* translates this post as "garde des diamants de la couronne"), a post she held from 1840 until her death. Communication of Timothy F. Boettger.

59 Information from Olga Aminoff's reminiscences, written in 1913, in Swedish. The manuscript is now in the collection of her descendants.

60 Translated from Swedish by the author.

61 Lydia Torrigi-Heiroth was a pupil of Pauline Viardot and founded a conservatory of music in Geneva.

62 Ehrström's diaries, which he entitled *För mig och mina vänner* (For me and my friends), consist of three parts totaling 632 pages. They are in the collection of Dr. Christman Ehrström, a descendant of the author.

63 Ehrström, Gustaf. 1815. *Översigt av ryska språkets bildning* (Synopsis of the construction of the Russian language). While studying in Moscow, Ehrström and his classmate Carl Ottelin wrote *Rysk språklära för begynnare* (Russian grammar for beginners), 1814.

64 Christina Andreetta Fredrika Schulman (1807–1836), daughter of Colonel Carl Fredrik Schulman and Fredrika Margareta Elisabet von Platen.

65 Several of the new *freiliny* were members of the Armfelt family. Minister Secretary of State Count Alexander Armfelt's daughter Hedvig Agnes received the honor in 1841; her sister Mariana Gustava, in 1843; the third daughter, Sigrid Augusta, in 1846; and finally the youngest, Ebba Eugenia, at the beginning of the new decade. Their three cousins, daughters of Count Gustav Magnus Armfelt, were also appointed maids of honor: Matilda Hedvig Sara in 1843,

Adelaide Augusta Vilhelmina in 1846, and Olga Lovisa Axelina in 1847. In this group of first cousins there were traditions from two royal courts: the grandmother of the girls was Countess Hedvig Ulrika De la Gardie, wife of Count Gustaf Mauritz Armfelt (see the chapter on Alexander I), had been a lady of honor at both the Swedish and Russian courts.

66 Prince Aleksandr Sergeevich Menshikov (1787–1869) was a close friend of Alexander I, accompanying the emperor on his campaigns during the Napoleonic Wars. He held the post of governor general of the Grand Duchy of Finland between 1831 and 1855. He was appointed admiral in 1833, and three years later became naval minister, still retaining his previous posts. The emperor made him a Finnish subject in 1833, and as the one and only prince of the grand duchy, his became the first and foremost family of the Finnish nobility. He was given Anjala in eastern Finland as an entailed estate in 1842.

67 Thesleff 1925.

68 Grot 1896. Petr Aleksandrovich Pletnev (1792–1865) was a poet, critic, academician of the St. Petersburg Academy of Sciences, and actual privy counselor. He served as professor of Russian literature at the University of St. Petersburg, 1832–49; as principal of the university, 1840–61; and as editor of the literary journal *Sovremennik* (The Contemporary), founded by Aleksandr Pushkin, 1838–46.

69 Ribbing 1996, 24.

70 Communication Lilia K. Kuznetsova.

71 Fersman 1925, 1:28: "№ 10. Plate XIII, phot. 17 (reduction 0,9). IMPERIAL DIADEM, LARGE PEARLS «EN PENDELOQUES». Somptuous [sic] «parure» composed of 25 big pearls, gently hanging from a solid diamond frame, like large leaves from a branch. Although the pearls are heavy, the general composition of this piece is light and supple. This specimen is typical of the perfection of russian [sic] workmanship in the beginning of the XX-th century. Dimensions: length (top) – 50 cent.; (below) – 44 cent. Width (middle) – 5,4

cent.; (sides) – 2,8 cent. The **pearls** are faultless and of uncommon size; their assortment perfect. Weights (inv. 1898) 6 p. – 50½; 6 p. – 73¾; 3 p. – 33⅞; 5 p. – 58⅝; 1 p. – 35¾; 1 p. – 8¼; 1 p. – 19¼; 1 p. – 20¾ and 1 p. – 1014/32 (anc. car.). **Diamonds**: brazilian [sic] gems weighing (anc. car. as. p. old inv.); 5 br. – 1714/32; 2 br. – 213/32; 22 br. – 17½; 115 br. – 45 and 40 car. of smaller br. + 900 «roses». Silver setting gold-lined. Date: (probably) 1815. Inv. 1898, № 231/224. «From the Private Apartments of H. I. M. Maria-Feodorovna» (old label). Inv. 1922, № 290."

72 The tiara was bought by the Duke of Marlborough for £3,500 for his wife, née Gladys Marie Deacon (1881–1977), who can be seen wearing it in photograph she took of herself in 1928. It was once again sold by Christie's in 1979, for £36,000, this time to Imelda Marcos. It was confiscated along with her other jewels at the fall of the Marcos regime in 1986 and has been in a bank vault ever since. It made a recent appearance in 2009 and 2010 Philippine news telecasts of the proposed government auction of Marcos's jewels. Experts from Christie's London had come to Manila to appraise them in 2010, but at the last minute the auction was called off by President Gloria Macapagal-Arroyo. Communication of Timothy F. Boettger.

73 Fersman 1925, 1:28: "№ 9. Plate XII, phot. 16 (full size). IMPERIAL DIADEM, PEARLS AND DIAMONDS. Regal assemblage of pearls and old diamonds. This diadem is, past question, one of the finest specimens of its kind. Circumferences (base) – 52 cent.; (top) – 58¼ cent.; central width – 12,7 cent.; width (back) – 4,7 cent. **Pearls**: ancient gems partly bored (some slightly damaged). – Weight (as per 1898 inv.): 12 pearls – 35¾ anc. car.; 42; 29; 26; 25; 24; 23; 22¾; 22; 19; 17 and 14 (in this lot: one round pearl and one «pendant»). Other pearls – 3 of 39 (anc. car.); 2 – 22; 2 – 20; 1 – 9¾; 1 – 8¾; 2 – 16; 6 – 47; 3 – 17; 9 – 47 and 17 round pearls. Total weight – 160 anc. car. **Diamonds**: fine brazilian [sic] specimens. Weight (old inv.) 1 br. – 10⅞ (specked); 2 br. – 213/16; 4 br. 53/16; 49 br. – 49; 52 br. – 43; 60 br. – 38; 172 br. – 54. Sundry br. – 84 and 500 «roses». Silver setting gold-lined, «à

jour». This diadem has been purchased during the early decades of the XIX-th century. Inv. 1898 № 215/209. Inv. 1922 № 397."

74 See the 1851 Crystal Palace exhibition catalog.

75 Morel 1988, 339 onwards.

76 For the historical diamond cuts see Tillander 1995.

77 The Regia Academia Aboensis (The Royal Academy of Åbo) was founded by Queen Christina of Sweden in 1640. The academy was moved to Helsinki after the fire of Turku in 1827 and was renamed Keisarillinen Aleksanterin-yliopisto / Kejserliga Alexanders Universitetet i Finland (Imperial Alexander University) in honor of Emperor Alexander I. The university was once again re-named in 1919 and is now Helsingin yliopisto / Helsingfors universitet (University of Helsinki).

78 Hirn 1956, 91.

79 Hoving 1949, 7. Letter by his friend Zacharias Topelius to Fredrik Pacius.

80 Zacharias Topelius (1818–1898), journalist, historian, and rector of the Imperial Alexander University in Helsinki, was one of Finland's most important authors with great social influence. Johan Vilhelm Snellman (1806–1881), journalist, author, and statesman, was known as the "national philosopher of Finland." Through his influential life's work, the Finnish language attained official status. He was also instrumental in creating a native currency, the Finnish mark. Fredrik (Friedrich) Pacius (1809–1861) was born in Germany but lived most of his life in Finland. He was a composer and teacher and is considered the father of Finnish classical music. Johan Jakob Nervander (1805–1848) was a celebrated poet, as well as a physicist and meteorologist.

81 Ramsay 1904–7. The Finnish nobleman Anders Gustaf Ramsay (1832–1910) was a businessman and author of both historically important and exceedingly entertaining reminiscences. He owned the estates Björkboda and Sunnanå.

82 Constantin Linder, born Åminne estate, Pohja, Finland, September 19, 1836, died

275

Kytäjä (Nääs) estate, Nurmijärvi, Finland, September 20, 1908.

83 Count Vladimir Alekseevich Musin-Pushkin and Emilie Stjernvall had the following children: Aleksei 1830–1831, Vladimir 1832–1865 (m. Azbukina), Aleksei 1834–1889 (m. Ekaterina "Kitty" Musin-Pushkin); Aleksandra "Alina" 1835–1858, Ol'ga 1837–1839, and Maria 1840–1870 (m. Constantin Linder).

84 See the chapter on Nicholas I.

85 Information from text written by Zacharias Topelius.

86 Lehto, Katri. 1985. *Kytäjän kreivitär: Marie Linderin elämä.* (The countess of Kytäjä: The life of Marie Linder). Otava, Helsinki. Communication of Kerstin Ilander, Mustio manor, Finland.

87 The estate Träskända is located in Espoo (Esbo), some fifteen kilometers from Helsinki. The garden and park still exist; the houses on the property serve as a home for aged people.

88 La Maison Chevet, located at the Palais-Royal (Galerie de Chartres), was founded by Hilaire Germain Chevet. He was a horticulturist from Bagnolet who had supplied roses to Queen Marie-Antoinette. He opened his *magasin de comestibles* shortly after the French Revolution and soon had a monopoly on the sale of early fruit and vegetables, shellfish, and rare fish. He became a supplier to the likes of Talleyrand, Mme Tallien, and the Count d'Orsay. He died from cholera in 1832 and his son Joseph (Chevet II) took over the business. Joseph was succeeded in 1857 by his two sons, Charles Joseph (Chevet III) and François (Chevet IV). Communication of Timothy F. Boettger, who has also transcribed and translated the menu.

89 Most likely the service consisting of 219 pieces made by Jean-Baptiste Claude Odiot, after a design by Adrien Louis Marie Cavelier, and delivered to Nikolai Nikitich Demidov (1773–1828) on December 5, 1817. Several pieces from this service are now at the Louvre. Communication of Timothy F. Boettger.

90 Bringéus 2007.

91 The text is based on Enbom, S. & Sandelin, C.F. *Ett handelshus i Viborg* (A trading enterprise in Viborg) 1991.

92 Today's Gavrilov Posad, southeast of Ivanovo.

93 The Swedish king Gustav III launched a surprise assault on the Russian fleet, in order to recapture territory in Finland that had been lost in the war of 1741–43. The plan was to conquer Kronstadt and attack St. Petersburg from there. The Battle of Ruotsinsalmi (Swe: Slaget vid Svensksund / Ru: Второе Роченсальмское сражение) fought on July 9, 1790, was victorious for the Swedes, but further plans were never realized.

94 The Sinebrychoff children were: Maria, born in 1852; Anna, born in 1854; Nicolas, born in 1856; and Pavel, born in 1859.

95 She was the daughter of General of the infantry Johan Mauritz Nordenstam, who had a very unique career. As a young officer he took part in the Turkish War of 1828–29. He was then sent to fight in the Caucasus Mountains. He served many years there and as the commander of the Black Sea troops and was generously decorated for his bravery and meritorious service. On his return to the grand duchy, he was appointed governor of Uusimaa (Nyland), and then in 1856, superintendent of the Imperial Palace in Helsinki. Nordenstam served as acting governor general of the Grand Duchy of Finland during the periods when generals Berg and Adlerberg were on command elsewhere. He was married to Ol'ga Panova from Tbilisi and had three daughters, Anna being the youngest.

96 Johann Samuel Samuelovich Arnd (1812–1890) worked for the court jewelers Nicholls & Plincke between 1845 and 1890.

97 Carl Johan Tegelsten (1798–1852) was born in Karjalohja (Karis Lojo), Finland. He came to St. Petersburg in 1817, became a journeyman 1821, and a master silversmith in 1833. He founded a silver and bronze factory in 1849, which produced an impressive amount of silver objects, including the complete trousseaus of the daughters of Nicholas I and Alexander II, gala dinner services, coffee and tea services, candelabras, trays, cutlery, etc. Tegelsten also produced imposing furniture in silver and bronze. His massive bronze chandeliers still hang in the imperial palaces and churches of St. Petersburg. The bronze decorations of St. Isaac's Cathedral were also made in his factory.

98 Baroness Sophie Maria Julia Dorotea Cedercreutz (1844–1923), born in Finland, daughter of Senator Baron Carl Emil Cedercreutz. Johan Fredrik Oscar von Kraemer (1829–1904), born in Finland, son of Colonel Johan von Kraemer.

99 The letters written by Oscar von Kraemer to Axel Boije, a close friend in Finland, record life during the summer months of 1879–80. The king and queen had two small children at this time: George, born in 1869, and Nicholas, born in 1872; the von Kraemers, four: Alexis, born 1871, Sophie, born 1874, Karl, born 1875 and Emmy, born 1877. Sophie had had a stillborn child in 1869.

100 Youssoupoff 1954, 35.

101 In 1846, when the club was founded, it had 19 members and 5 registered yachts. By 1884, there were 125 members, few of whom had yachting as a hobby.

102 *Hufvudstadsbladet* (The Gazette of the Capital), July 4, 1884.

103 The *Eläköön* was built in the latter part of the 1880s. Emperor Alexander III gave the vessel its unusual name, which in translation means "long live (the Emperor)!" During the imperial visit to Lappeenranta in 1885, the emperor heard a woman repeatedly and with great fervor shout at the top of her voice "*eläköön*." He inquired after its meaning, and when he received the explanation, decided that the name of the pilot ship being currently built in the grand duchy should be named *Eläköön*.

104 Although Sophie used the name *von* Remy in Finland, the family appears as Remy (Реми) *tout court* in contemporary Russian sources. It was not uncommon for untitled Russian nobles to add a nobiliary particle (de, von, etc.) to their name when travelling or living abroad. Sophie Marie (von) Remy (Kazan, Russia 25.IV.1864–Karjaa (Karis), Finland 22.IX.1954). Her father, Lieutenant General Friedrich (Fridrikh Gavrilovich)

Remy (Orenburg Governorate, Russia 29.VII.1803–St. Petersburg 11.X.1872), served in the Izmailovskii Regiment of the Guards, received the Order of St. George 4th class on Dec. 25, 1831, and was retired from the Pavlovskii Regiment of the Guards with the rank of colonel. Her mother, Sof'ia Vasil'evna Tikhanovskaia (16.IX.1824–26.IV.1869), from an old noble family inscribed in the sixth part of the registers of the nobility of Smolensk, was the daughter of Lieutenant-Colonel Vasilii Ivanovich Tikhanovskii, who took part in the war of 1812. Sophie had the following siblings: Adelaida *m.* Komenko (7.X.1849–before 1916), Woldemar (3.I.1851–Viapori, Finland 24.III.1906), Nikolai (3.IV.1852–before 1872?), Elisabeth (7.X.1855–St. Petersburg 30.VI.1912), Nadezhda *m.* Kupinskaia (18.II.1857–after 1917), Alexander (30.IV.1858–1916), Henriette Sophie (25.VI.1859–after 1919), Seraphine (2.XI.1860–1919), and Ludwig (17. VI.1862–1904). Her brother Major General of the Artillery Woldemar (Vladimir Fridrikhovich) Remy served at the fortress of Viapori (Sveaborg) outside Helsinki, where he died.

105 See Cherepnin 1915.

106 According to Elena Remi, Sophie graduated from the Smol'nyi Institute on June 4, 1881. However, she does not appear on the list of graduates for 1881—or any other year—in Cherepnin 1915. Her sister Nadezhda appears in the forty-fifth promotion (1877), no. 40; and her sister Seraphine, in the forty-seventh promotion (1879), no. 51. The only other Remy to appear is Charlotte (Sharlotta Gavrilovna), in the twentieth promotion (1833), no. 87 (Communication of Timothy F. Boettger). It is quite possible, therefore, that she left the institute without having graduated. She definitely attended as there are many photographs of her in her Smol'nyi uniform.

107 The emperor married Princess Ekaterina Mikhailovna (Katia) Dolgorukova (1847–1922) on July 6, 1880, after the death of Empress Maria Aleksandrovna. Katia had borne the emperor four children, three of whom reached maturity. She and her children were created Prince Iur'evskii / Princess Iur'evskaia with the title of Serene Highness.

108 Colonel Victor Edvard Ludvig Tuderus (Zamość, Poland 27.II.1852–Nice, France 22.XII.1925). He was the son of Major General Gustaf Edvard Tuderus (Kosoniemi, Ristiina, Finland 30.XII.1812– Kosoniemi 11.X.1877) and Maria Veronica Dorothea von Hetsch (Riga 17.V.1839–Kosoniemi 17.III.1890). His siblings were Valdemar (Kherson, Russia 1840–Kiev, Russia 14.III.1841) and Lovisa Maria Kristina (Ochakov, Russia 13.X.1839–Mikkeli (St. Michel), Finland 26.IV.1898). The family was ennobled in 1863.

109 See Knapas 2009, which contains an essay by John Screen on the Russo-Turkish War and biographical notes on Tuderus by Rainer Knapas and Eva Gädda.

110 Smol'nyi pupils under the sovereign's protection received a gift of money at the time of their marriage.

111 Youssoupoff 1954, 38–40.

112 Bainbridge 1949, 38.

113 *Mir iskusstva* was the name of the journal published by this group of artists. It first appeared in 1899 with Sergei Diaghilev as editor-in-chief and Benois and Bakst as collaborators.

114 One of the first undertakings of the group was to arrange an art exhibition with colleagues from Finland. It was held in the museum of the Stieglitz School of Technical Drawing.

115 The Lily-of-the-Valley Egg is now in the Sviaz' Vremen foundation in Moscow, the Pansy Egg is in a private collection in the United States, and the Clover Egg is in the collection of the Moscow Kremlin museums.

116 Proust 1913–27.

117 Nadelhoffer 1984, 50.

118 Boettger 2011.

119 Kleinmichel 1923, 176–78. Communication of Timothy F. Boettger.

120 *Russian Court Memoirs* 1917, 52–53. Communication of Timothy F. Boettger.

121 *Russian Court Memoirs* 1917, 258–63. Communication of Timothy F. Boettger.

122 RGIA fond 1092, opis' 1, delo 368, listy 1–8. Communication of Galina Korneva. See also Boettger 1996.

123 Youssoupoff 1954, 172, 176–77. Communication of Timothy F. Boettger, who also translated the *Stolitsa i usad'ba* articles.

124 Russia 1932, 211.

125 Boettger 1996.

126 For more details on Fabergé, see: Bainbridge 1949 (Bainbridge was a collaborator of Fabergé in London and visited the St. Petersburg firm on several occasions); Snowman 1952, 1962 (a proficient art historian's excellent reference work and analysis of techniques used by Fabergé, as well as first-hand information from Fabergé's sons); Habsburg/Lopato 1993 (exhibition catalog with extensive information and examples of Fabergé's production); Tillander-Godenhielm 2011 (interviews and archival material on Fabergé's workmasters); Fabergé, Kohler, and Skurlov 2012 (comprehensive archival material on the Fabergé production and his collaborators).

127 Fabergé (originally Favry) was of Huguenot descent. One branch of the family moved from France at the end of the seventeenth century to Schwedt an der Oder in Germany. In 1800, the carpenter Peter Favry moved to Pernau, Livonia, where his son Gustav was born. Gustav in turn moved to St. Petersburg, where he apprenticed for the master goldsmiths A. F. Spiegel and J. W. Keibel.

128 This piece of information is based on numerous interviews made by the author with descendants of master goldsmiths from St. Petersburg.

129 The jeweler Walery Zajączkowski (in Russia Valerii Andreevich Zaionchkovskii) was of Polish origin. His own business, which he did not discontinue during this time, was located across the street from Gustav Fabergé at 20 Bol'shaia Morskaia.

130 The Italian archeologist and banker Giampietro Campana, marchese di Cavelli (1808–1880), was a collector of ancient jewelry and objects and a connoisseur of the arts (see Munn 1984, 88).

131 The source of the information on Karl Fabergé's training and formative years was provided by his oldest son Eugen, and was retold by Snowman 1952 and 1962.

132 Erik Kollin (1836–1901), born at Brödtorp, Pohja, Finland, was trained by and later worked for August Holmström. He opened his own workshop in 1870. Fabergé gradually contracted a network of skilled master goldsmiths, all of whom were owners of their workshop. The entire production of Fabergé was carried out in these ateliers according to designs provided by the employer. Before a contract was signed, the prospective craftsman underwent intense scrutiny—only the best of the best was good enough for Fabergé. A workshop collaborating with him was the foremost "nursery" for new independent workmasters. Kollin in turn trained the future workmasters Antti Nevalainen and Gabriel Nykänen. Nevalainen later trained and worked with Hjalmar Armfelt. Henrik Wigström worked with Mikhail Perkhin from 1884 until his colleague's death in 1903, at which time he became Fabergé's third head workmaster. August Holmström trained his own son and successor Albert and his son-in-law Oscar Pihl, who headed Fabergé's jewelry workshop in Moscow.

133 Maksim Maksimovich Litvinov (1876–1951) handled immigration affairs and permits. He was minister of foreign affairs in 1930, later the ambassador of the Soviet Union to the United States.

134 The legendary doyen of Fabergé research A. Kenneth Snowman, proprietor of the well-known jewelry firm Wartski in London, in 1993 published a delightful study in text and picture of the albums entitled *Fabergé Lost and Found: The Recently Discovered Jewelry Designs from the St. Petersburg Archives.*

135 The Mosaic Egg is now in the Royal Collection Trust, England.

136 Fredrik Adolf Holstenius was born in 1821 in Siuntio (Sjundeå), Finland. He came to St. Petersburg from Helsinki, where he had qualified as a goldsmith journeyman. He established himself, after receiving his master's certificate,

in Tsarskoe Selo, later moving to St. Petersburg. He married in 1847 Sofia Wilhelmina Fogelström (1817–?) in Jomala, Åland Islands, Finland. After her husband's death in 1857, Mrs. Holstenius moved to Iaroslavl'. (Bäcksbacka 1951, 204).

137 Carl Becks, of German descent, was born in 1793 and died in 1867. He qualified as a master in St. Petersburg in 1849. He specialized in gold jewelry (Bäcksbacka 1951, 441). Carl Reinhold Schubert was a Baltic-born jeweler from the medieval town of Rakvere (Wesenberg in German) in northern Estonia, some one hundred kilometers from Tallinn (Reval). He was the son of the jeweler Johann Heinrich Schubert, learnt the craft with his father, then moved to St. Petersburg, where he became a master jeweler in 1844. After his death, his son Eduard and widow Sophia, née Henrichsen, continued the workshop and retail store at Moika 42. Schubert had a reputation for being a skillful jeweler (Bäcksbacka 1951, 61).

138 Mathilda Gustava Ingman (1834–1925) was born in Lohja (Lojo), Finland. She came to St. Petersburg in 1860.

139 The majority of Finns belonged to the Evangelic Lutheran Church. There were two Lutheran churches for Finnish subjects in St. Petersburg: St. Maria (Bol'shaia Koniushennaia) for those whose mother tongue was Finnish and St. Catherine (Malaia Koniushennaia) for those who were Swedish speakers. The church and congregation of St. Catherine served the entire Scandinavian colony.

140 A fourth and fifth generation of the Tillander family have continued the business. The son of Leo Tillander, Torbjörn, established himself independently. His two daughters, Annette and Tina, today run their respective workshops and retail outlets. A. Tillander, its retail store, and workshop were headed by the author of the present book between 1977 and 1992.

141 Carpelan 1942, 92–94.

142 Russia 1932, 333.

143 Standertskjöld 1934.

144 The main sources for the list are: Foelkersahm 1907, Bäcksbacka 1951, Postnikova-Losseva 1974, Solodkoff 1981, Kostiuk 2000, Ivanov 2002, Lopato 2006, Kuznetsova 2009, and Polynina 2011. Many thanks to Valentin Skurlov for reviewing the list, pointing out errors, and for his valuable additions.

GLOSSARY

The terminology of jewelry has strong influences from the French language

Agraffe: (Fr.) a jeweled clasp to fasten a garment.

Aigrette: (Fr.) a long plume (especially one of egret feathers) or a jewel in the shape of plume worn in the hair or on a hat.

Bandeau: (Fr.) a narrow band or fillet encircling the forehead.

Baroque pearl: a pearl of irregular shape.

Breloque: (Fr.) small pendant or charm.

Cabochon: (Fr.) a stone of convex form, highly polished, but not faceted.

Collier de chien: (Fr.) tightly fitting necklace reminiscent of a wide dog's collar.

Demantoid: a yellowish to bright leaf green variety of andradite garnet with a high dispersion (fire); it is the most highly prized of the garnets in commercial use, and fine specimens are rare; called olivine in Russia.

Devant de corsage: (Fr.) a large brooch decorating the front of a low-cut dress.

Epaulette: (Fr.) a shoulder ornament; a gem-set version for men was in fashion during the eighteenth century and revived as a jewel for women during the early twentieth.

Esclavage: (Fr.) in reference to chains worn by slaves (*esclaves*); a type of necklace incorporating chains or chain-like elements in diamonds or precious stones that descends in a half-circle on the bosom; also *collier d'esclavage*.

Fermoir: (Fr.) a jeweled clasp for a necklace or bracelet.

Girandole: (Fr.) a type of earring with three pendants.

Jarretière: (Fr.) a strap bracelet with a sliding buckle reminiscent of a ladies garter (*jarretière*).

Lavallière: (Fr.) a long necklace with pendants.

Olivine: another name for demantoid.

Parure: (Fr.) a set of jewelry normally consisting of a tiara, necklace, a pair of bracelets, a *devant de corsage*, and earrings; called a demi parure when only two or three of these elements are present.

Plastron: synonym of *devant de corsage* or stomacher.

Poire: (Fr.) a natural pearl in the shape of a pear (*poire*).

Rivière: (Fr.) a necklace of solitaires (mainly diamonds), often increasing in size towards the central stone, forming a "river" (*rivière*) of precious stones.

Sautoir: (Fr.) a long necklace or chain, often with a jeweled tassel at the end.

Sultanne: (Fr.) a jeweled feather worn in the hair; synonym of aigrette.

Telesia: the term was coined in the eighteenth century by the French mineralogist René Just Haüy and comes from the Greek word τελεσιος (telesios), meaning "perfect"; there were three main varieties: red telesia (or oriental ruby), yellow telesia (or oriental topaz), and blue telesia (or oriental sapphire).

Tremblant: (Fr.) a gem or pearl set on a wire so that it trembles with the wearer's movements; such a jewel is described as "*en tremblant.*"

Zolotnik: (Ru.) a Russian standard for alloys of gold and silver.

Cuts of diamonds or other transparent precious stones

Briolette: drop-shape covered with facets.

Brilliant: round cut (mainly diamonds) of fifty-seven facets, the idea being to minimize the escape of light and maximize brilliance.

Carré: (Fr.) a square cut (mainly diamonds).

Eight cut: a modification of the brilliant cut having eighteen facets; used for small diamonds.

Marquise: (Fr.) Elliptical in shape with points at both ends.

Navette: (Fr.) another name for marquise.

Pavé: (Fr.) calibrated stones set tightly together to conceal the metal base.

Pendeloque: (Fr.) a pear-shaped cut with a narrow point at one end.

Rose: flat base with twenty-four facets across a domed surface; popular from the seventeenth to mid eighteenth century; was superseded by the brilliant cut.

Glyptic arts (stone engraving).

Cameo (agate): a gemstone of several layers with the design cut in relief; in later periods also cut in shell.

Intaglio: sunken or incised engraving in stone or other hard material (the opposite of a cameo).

Enameling techniques

En plein: (Fr.) transparent or translucent enamel baked on a metal surface.

Guilloché: (Fr.) translucent enamel on an engraved ground.

Plique-à-jour: (Fr.) not backed by metal as in other enameling techniques; akin to a stained-glass window.

REFERENCES

Alm, Göran et al. 1976. *Smycken för Drottningar tillhöriga de Bernadotteska stiftelserna* (Jewels for Queens belonging to the Bernadotte Foundations). Stockholm: Skattkammaren, Stockholms slott.

Anonymous. 1917. *Russian Court Memoirs 1914–16: With Some Account of Court, Social and Political Life in Petrograd.* London: Herbert Jenkins Limited.

Backström, Ragnar. 2009. *Langinkoski: Keisarillisen perheen kesäinen keidas* (Langinkoski: A summer refuge of the imperial family). Helsinki: Suomalaisen Kirjallisuuden Seura.

Bäcksbacka, Leonard. 1951. *St. Petersburgs Juvelerare, Guld- och Silversmeder, 1714–1870* (St. Petersburg's Jewelers, Gold- and Silversmiths, 1714–1870). Helsinki: privately published.

Bainbridge, Henry C. 1949. *Peter Carl Fabergé: His Life and Work.* London: B.T. Bratsford, Ltd.

Boettger, Timothy F. 1996. *La descendance d'Alexandre Andréïevitch, Iᵉʳ prince Bariatinskii: Une généalogie biographique.* Seattle: privately published.

Bolin, Christian and Pavel Bulatov, eds. 2001. Болин в России: *Придворный ювелир конца XIX–начала XX вв.* (Bolin in Russia: Court jeweler from the end of the nineteenth to the beginning of the twentieth century). Moscow: Novyi Ermitazh-odin.

Bonde, Knut. 1949. *Juveler och juveldyrkare* (Jewels and lovers of jewels). Stockholm: Lars Hökerbergs Bokförlag.

Born, Elsa von. 1933. Haiko: Det gamla och det nya hemmet (Haiko: The old and the new home). In *Allas Krönika.* Helsinki.

Bott, I. K. and M. I. Kaneva. 2003. *Русская мебель: История, стили, мастера.* (Russian furniture: History, styles, masters). St. Petersburg: Iskusstvo-SPB.

Bringérus, Nils-Arvid. 2007. *Livets högtidsdagar* (The festivities of life). Stockholm: Carlsson.

Carpelan, Tor. 1942. *Ättartavlor för de på Finlands Riddarhus inskrivna efter 1809 adlade, naturaliserade eller adopterade ätterna* (Genealogies recorded at the Finnish House of Nobility of those ennobled, naturalized, or adopted after 1809). Helsinki: Frenckellska Tryckeri Aktiebolagets Förlag.

Carpelan, Tor. 1954–66. *Ättartavlor för de på Finlands Riddarhus inskrivna ätterna* (Genealogies recorded at the Finnish House of Nobility). 4 vols. Helsinki: Frenckellska Tryckeri Aktiebolagets Förlag.

Cherepnin, Nikolai Petrovich. 1915. *Императорское Воспитательное Общество Благородных Дѣвицъ: Историческій очеркъ, 1764–1914* (Imperial Educational Society for Noble Girls: An Historical Overview). Petrograd: Gosudarstvennaia Tipografiia.

Christie, Manson & Woods. 1927. *Catalogue of an Important Assemblage of Magnificent Jewellery mostly dating from the 18th Century which Formed Part of the Russian State Jewels.* London.

Donner, Eeva, ed. 1992. *Släkten Donner i Finland II* (The Donner family in Finland II). Helsinki: Släktföreningen Donner.

Ducamp, Emmanuel, ed. 1994. *The Winter Palace, Saint Petersburg.* Paris and St. Petersburg: Alain de Gourcuff Éditeur and the State Hermitage.

Ehrström, Christman. 1984. *Moskva brinner* (Moscow burning). Stockholm: Legenda.

Enbom, S. and C. F. Sandelin. 1991. *Ett handelshus i Viborg: Hackman & Co 1880–1925* (A trading company in Vyborg: Hackman & Co 1880–1925). Helsinki: Hackman.

Engman, Max. 1980. Finnish Goldsmiths in St. Petersburg during two centuries. In *Carl Fabergé and His Contemporaries.* Helsinki: Oy A. Tillander Ab.

———. 1986. *S:t Petersburg och Finland: Migration och influens 1703–1917* (St. Petersburg and Finland: Migration and influence). Helsinki: Societas scientiarum Fennica.

Estlander, Bernh et al. 1931. *Från hav och hov* (From sea and court). Helsinki: H. Schildt.

Fabergé, Oleg Agafonovich. 1990. *Glimtar* (Glimpses). Helsinki: Söderström.

Fabergé, Tatiana Fedorovna and Valentin Vasil'evich Skurlov. 1992. *История фирмы Фаберже: По воспоминаниям главного мастера фирмы Франца П. Бирбаума* (History of the Fabergé firm: According to the recollections of the head designer of the firm Franz P. Birbaum). St. Petersburg: privately printed.

Fabergé, Tatiana Fedorovna, Aleksandr Sergeevich Gorynia, and Valentin Vasil'evich Skurlov. 1997. *Фаберже и Петербургские ювелиры: Сборник мемуаров, статей, архивных документов по истории русского ювелирного искусства* (Fabergé and the St. Petersburg jewelers: A collection of memoirs, articles, archival documents on the history of the art of Russian jewelry making). St. Petersburg: Neva.

Fabergé, Tatiana Fedorovna, Eric-Alain Kohler and Valentin Vasil'evich Skurlov. 2012. *Fabergé: A Comprehensive Reference Book.* Geneva: Slatkine.

Fedoseenko, Olga A., ed. 1996. *Стиль и эпоха в декоративном искусстве 1820-е–1890-е годы* (Style and epoch in the decorative arts 1820s–1890s). St. Petersburg: Slaviia.

Fersman, Aleksandr Evgen'evich, ed. 1924–26. *Алмазный фонд СССР* (Diamond fund of the USSR). Moscow: Narodnyi komissariat finansov.

———. 1926. *Russia's Treasure of Diamonds and Precious Stones.* Moscow: Commissariat of Finance. English version of the preceding.

Foelkersam, Baron Armin (Arminii Evgen'evich) von. 1907. *Описи серебра Двора Его Императорского Величества* (Lists of the silver of the Court of His Imperial Majesty). 2 vols. St. Petersburg: R. Golicke & A. Wilborg.

Galiffe, John Barthélemy Gaifre. 1857. *Notices généalogiques sur les familles genevoises depuis les premiers temps jusqu'à nos jours.* Vol. 4. Geneva: Chez Jullien Frères, Libraires-Éditeurs.

Gorewa, Olga W. 1991. *Joyaux du Trésor de Russie*. Paris: La Bibliothèque des Arts.

Gripenberg, Sebastian. 1828. *Berättelse om Kejsar Alexanders färd från Nissilä Gästgifveri till staden Kajana* (The story of Emperor Alexander I's journey between Nissilä Inn to the town of Kajaani). St. Petersburg and Paris: Engelmann.

Grot, Jakob Karlovich. 1896. *Perepiska Ia. K. Grota s P. A. Pletnevym*. St. Petersburg: Soobshcheniia.

Guzanov, Aleksei Nikolaevich. 1993. 1781–1782: The Grand Tour of the Comte and Comtesse du Nord. In *Pavlovsk: The Palace and the Park*. Paris: Alain de Gourcuff Éditeur.

Habsburg-Lothringen, Géza von and Marina Lopato. 1993. *Fabergé. Imperial Jeweller*. St. Petersburg: A.Zwemmer, Ltd.

Hirn, Marta. 1956. *Från Bomarsund till Sveaborg: Kriget 1854–1855* (From Bomarsund to Sveaborg: The war 1854–1855). Helsinki: Holger Schildt.

Hoving, Victor. 1949. *Henrik Borgström: En storborgare i det gamla Helsingfors* (Henrik Borgström: An important burgher of old Helsinki). Helsinki: Söderström.

Ivanov, A. N. 2002. *Мастера золотого и серебряного дела в России (1600–1926)* (Gold- and silversmiths in Russia [1600–1926]). 2 vols. Moscow: Russian national museum.

Knapas, Rainer et al. 2009. *Militär och målare: En skildring från rysk-turkiska kriget 1877–1878* (Soldier and painter: An account from the Russo-Turkish War 1877–1878). Helsinki: Svenska Litteratursällskapet i Finland.

Korneva, Galina and Tatiana Cheboksarova. 2006. *Empress Maria Feodorovna's Favorite Residences in Russia and Denmark*. St. Petersburg: Liki Rossii.

———. 2010. *Россия и Европа: Династические связи, вторая половина XIX–начало XX века*. St. Petersburg: Liki Rossii.

———. 2012. *Russia and Europe: Dynastic Ties, Second Half of the Nineteenth to the Beginning of the Twentieth Century*. St. Petersburg: Liki Rossii. English translation of the preceding.

Kostiuk, Olga G. 1995. Einführung: Die Gilde der ausländischen Meister (Introduction: The guilds of the foreign masters). In *Zarengold*. Stuttgart: Arnoldsche.

———. 2000. *Петербургские ювелиры XVII–XIX века* (Petersburg jewelers seventeenth to nineteenth centuries). St. Petersburg: The State Hermitage.

Krog, Ole Villumsen, ed. 1997. *Kejserinde Dagmar Maria Fjodorovna: En udstilling om den danske prinsesse som blev kejserinde af Rusland* (Empress Dagmar Maria Feodorovna: An exhibition about the Danish princess, who became empress of Russia). Copenhagen: Christiansborg Slot. Catalog of an exhibition held in Christiansborg slot, Copenhagen.

Kuznetsova, Lilia Konstantinovna. 1998a. О жемчужной диадеме, исполненной в 1841 г. Карлом Эдуардом Болином (On the pearl diadem completed in 1841 by Carl Edvard Bolin). In *Эрмитажные чтения памяти В. Ф. Левинсона-Лессинга: Краткое содержание докладов*.

———. 1998b. О жемчужной диадеме, исполненной Карлом Эдуардом Болином в декабре 1841 г. Экспертиза и атрибуция произведений изобразительного искусства (On the pearl diadem completed by Carl Edvard Bolin in December 1841: An examination and attribution of decorative works of art). In *Материалы Э-й научной конференции, 25–27 мая 1997 г. Объединение «Магнум Арт»*. St. Petersburg: The State Hermitage.

———. 2009. *Петербургские ювелиры: Век восемнадцатый, бриллиантовый…* (Petersburg jewelers: Eighteenth century, diamond [century]…) St. Petersburg: Zentrpoligraf.

Lehto, Katri. 1985. *Kytäjän kreivitär: Marie Linderin elämä* (The Countess of Kytäjä: The life of Marie Linder). Helsinki: Otava.

Lewenhaupt Gustaf C:son. 1936 *Askegreven berättar vidare* (The Askecount continues his stories). Stockholm: W & W.

Lopato, Marina N. 2006. *Ювелиры Старого Петербурга* (The jewelers of old St. Petersburg). St. Petersburg: Izdateľstvo Gosudarstvennogo Ermitazha.

Lowes, William and Christel Ludewig McCanless. 2001. *Fabergé Eggs: A Retrospective Encyclopedia*. Landham, Maryland: Scarecrow Press.

Löfving, Elisabeth. 1988. Finländska flickor i jungfrustiftet Smolna i Petersburg (Finnish girls in the Smol'nyi Institute for Young Girls in Petersburg). In *Historiska och litteraturhistoriska studier* 63:277–307.

Malmström, Stig Rurik. 1938. *Dagmar: Prinsessa av Danmark, Kejsarinna av Ryssland* (Dagmar: Princess of Denmark, Empress of Russia). Stockholm: Fahlcrantz & Co.

Mandt, Martin Wilhelm. 1955. Reminiscenses. In Treue, Wilhelm. *Mit den Augen Ihrer Leibärtzte*. Düsseldorf: Droste Verlag.

Morel, Bernard. 1988. *Les Joyaux de la couronne de France*. Anvers: Fonds Mercator.

Munn, Geoffrey C. 1984. *Castellani and Giuliano: Revivalist Jewellers of the Nineteenth Century*. London: Trefoil Books.

Munn, Geoffrey C. 2001. *Tiaras: Past & Present*. London: V & A Publications.

Nadelhoffer, Hans. 1984. *Cartier: Jewelers Extraordinary*. London: Thames and Hudson.

Nervander, Emil Fredrik. 1906. *Kejsar Alexander I:s Resor i Finland* (Emperor Alexander I's travels in Finland). Helsinki: Aktiebolaget Lilius & Hertzberg.

Néret, Gilles. 1988. *Boucheron: Histoire d'une dynastie de joailliers*. Fribourg, Switzerland: Pont Royal.

Olausson, Magnus, ed. 1998. *Katarina den stora & Gustav III* (Catherine the Great and Gustav III). Stockholm: Nationalmuseum.

Olga, Queen of Württemberg. 1955. *Traum der Jugend, goldner Stern: Aus der Aufzeichnungen der Königin Olga von Württemberg* (Dream of youth, golden star: From the reminiscences of Queen Olga of Württemberg). Pfullingen: Neske.

Papi, Stefano. 2010. *The Jewels of the Romanovs: Family and Court*. London: Thames & Hudson, Ltd.

Pflaum, Rosalynd. 1984. *By Influence and Desire: The True Story of Three Extraordinary Women – The Grand Duchess of Courland and Her Daughters*. New York: M. Evans and Company, Inc.

Postnikova-Loseva, M. M., N. G. Platonova, B. L.Ul'ianova. 1983. *Золотое и серебряное дело XV–XX вв.* (Gold and silversmiths from the fifteenth to twentieth centuries). Moscow: Izdatelstvo Nauka.

Proust, Marcel. 1913–27. *A la recherche du temps perdu* (Remembrance of Things Past). Paris: Bernard Grasset.

Purcell, Katherine. 2006. *Fabergé and the Russian Jewellers*. London: Wartski.

Qvarnström, Ingrid, 1937. *Ett legend-omspunnet liv: Aurore Karamsin och hennes samtid* (A legendary life: Aurora Karamzina and her time). Helsiniki: Holger Schildts Förlag.

Ramsay, Anders. 1907. *Från barnaår till silfverhår [8]* (From childhood years to silver hair [8]). Helsinki: Söderströms.

Rangström, Lena. 1997. *Kläder för tid och evighet: Gustav III sedd genom sina dräkter* (Clothes for time and eternity: Gustav III seen through his costumes). Stockholm: Livrustkammaren.

Ribbing, Magdalena. 1996. *Smycken & silver för tsarer, drottningar och andra* (Jewelry and silver for tsars, queens, and others). Västerås: Media Tryck.

Russia, Grand Duke Aleksandr Mikhailovich. 1932. *Once a Grand Duke*. New York: Farrar & Rinehart, Cosmopolitan Book Corp.

Snowman, A. Kenneth. 1952, 1962. *The Art of Carl Fabergé*. London: Faber and Faber Limited.

———. 1966, 1990. *Eighteenth Century Gold Boxes of Europe*. London: Antique Collectors' Club.

———. 1993. *Fabergé Lost and Found: The Recently Discovered Jewelry Designs from the St. Petersburg Archives*. London: Thames and Hudson.

Solntsev, Fedor Grigor'evich. 1846–1853. *Древности Россійскаго государства* (Antiquities of the Russian state). 4 vols. Moscow: Tipografiia Aleksandra Semena.

Solodkoff, Alexander von. 1981. *Russian Gold and Silver*. London: Trefoil Books.

Standertskjöld, Herbert. 1934. Ett storfurstepar: Kirill och hans gemål på Haiko 1918 (A grand ducal couple: Kirill and his consort at Haiko 1918). In *Hels:(ingfors) Journal* nr 4.

Thesleff, Wilhelm. 1925. *Släkten Thesleff 1595–1925*. (The Thesleff family 1595–1925). Helsinki: privately published.

Tillander, Herbert. 1980. A Short History of the Firm of Tillander. In *Carl Fabergé and his Contemporaries*. Helsinki: Oy A. Tillander Ab.

———. 1995. *Diamond Cuts in Historic Jewellery, 1381–1910*. London: Art Books International.

Tillander-Godenhielm, Ulla. 1996. *Smycken från det kejserliga S:t Petersburg* (Jewels from imperial St. Petersburg). Helsinki: Förlagsaktiebolag W. Hagelstam,

———. 2005. *The Russian Imperial Award System during the Reign of Nicholas II, 1894–1917*. Helsinki: Journal of the Finnish Antiquarian Society 113.

———. 2008, 2011. *Fabergén suomalaiset mestarit* (Fabergé and his Finnish workmasters). Helsinki: Kustannus Oy Tammi.

Tuomi-Nikula, Jorma and Päivi. 2002. *Keisarit kesälomalla Suomessa.* (The emperors on summer vacation in Finland). Jyväskylä: Atena Kustannus Oy.

Twining, Lord Edward Francis. 1960. *A History of the Crown Jewels of Europe*. London: B. T. Batsford.

Viherjuuri, Irmeli, ed. 1988. *Anna Virubova: Kejsarinnans hovdam* (Anna Vyrubova: The empress's maid of honor). Helsinki: Holger Schildts Förlag.

Vorres, Ian. 1964. *The Last Grand Duchess*. London: Hutchinson & Co. Memoirs of Grand Duchess Olga Aleksandrovna.

Vyrubova, Anna. 1924. *Memories of the Russian Court*. New York.

Wacklin, Sara. 1919. *Hundrade minnen från Österbotten* jämte österbottniska anekdoter (Hundreds of souvenirs from Ostrobothnia and Ostrobothnian anecdotes). Published and annotated with a biography by Helena Westermarck. Helsinki: Schildt.

Youssoupoff, Prince Felix. 1954. *Lost Splendour*. London: Cape.

Zimin, Igor. 2011. *Царские Деньги* (The tsar's money). St. Petersburg: Zentropoligraf, Russkaia Troika.

Communications

Boettger, Timothy F., MLS, librarian, genealogist, and researcher (Waterloo, Ontario, Canada).

Brière, Daniel, military historian (Montreal, Canada)

Cheboksarova, Tatiana N., Ph.D., author and specialist in St. Petersburg history, the cultural history of Russia, and the Romanov dynasty (St. Petersburg, Russia).

Korneva, Galina N., Ph.D., author and specialist in St. Petersburg history, the cultural history of Russia, and the Romanov dynasty (St. Petersburg, Russia).

Kostiuk, Olga G., Deputy Director of the State Hermitage's Department of History of Western European Applied Art (St. Petersburg, Russia).

Kuznetsova, Lilia K., senior research fellow at the State Hermitage (St. Petersburg, Russia).

Lopato, Marina N., Ph.D., Director of the State Hermitage's Department of History of Western European Applied Art (St. Petersburg, Russia).

Salvén, Kurt, specialist in Russian, Baltic and Finnish makers' marks and hallmarks

Skurlov, Valentin V., Dr., researcher, specializing in the art of Russian goldsmiths (St. Petersburg, Russia)

Descendents of the following families in Finland and Sweden who have kindly shared information from their archives and photo albums: Aminoff, Armfelt, Björnberg, Borgström, Ehrström, von Etter, von Heiroth, Hjärne, Hollming, Holmström, Hornborg, Knape, von Kraemer, Kutaisov, Linder, Munck, Möllersvärd, Nobel, af Nordin, Paul, Pihl, von Remy, Roediger, Rotermann, Schildt, Sederholm, Sinebrychoff, Thesleff, Topelius, Tuderus, and Wigström.

Unpublished sources

Aminoff, Olga. 1913. *Minnesanteckningar* (Reminiscenses). MS. Collection of the family.

Armfelt, Hjalmar. *Erään ihmisen elämä* (The life of a man). MS. Collection of the author's family.

Behm, Oscar. *Kirjola gård: En historik* (Kirjola estate: A history). MS.

Boettger, Timothy F. 2005a. *Register of the Titled Families and Persons of the Russian Empire.* MS.

———. 2005b. *Court Jewellers: A Collection of Genealogies of the Families that Served as Jewellers to the Russian Imperial Court.* MS.

———. 2006a. *A Brief History of the Sancy Diamond.* MS.

———. 2006b. *The Russian Recipients of the Royal Order of Therese of Bavaria.* MS.

———. 2010. *Russia's Noble Ladies: Their Alliances with Europe's Aristocratic Families, 1727–1917.* MS.

———. 2011. *Mille et Une Nuits: The Thousand and One Nights Balls Given by the Countess de Chabrillan and the Countess de Clermont-Tonnerre on 29 May and 4 June 1912.* MS.

Haikonen, Jalmari. Drawings, 1908–18, 1920s. Collection of Ulla Tillander-Godenhielm.

Holmström, Albert. Stock books, March 6, 1909–March 20, 1915. Wartski, London.

Lowes William. Fabergé at Auction Index. Database.

Polvinen, Tuomas. Albums of drawings. Collection of his descendants.

Polynina, Irina F. *The Diamond Treasures of Russia.* (DVD).

Tillander, Alexander Theodor. Stock books and ledgers of the family jewelry firm. Collection of Ulla Tillander-Godenhielm.

———. Business records of the family jewelry firm. Collection of Ulla Tillander-Godenhielm.

Wigström, Henrik. Album of drawings, 1909–16. Vol. 1. Private collection.

———. Album of drawings, 1909–16. Vol. 2. National Archives of Finland.

St. Petersburg Jewelers

This chronological list records the principal goldsmiths, jewelers, and luxury-goods makers (галантерейные мастера) of St. Petersburg from the reign of Peter I to Nicholas II. A few of the earliest master silversmiths have been included as their production also included jewelry and luxury goods.

Some individuals or firms that spanned more than one reign have been placed in the one during which their production was most prominent. Families of jewelers have been kept together for ease of reference.

[SH] or [DF] following an entry indicate that works by said master can be found in the State Hermitage or Diamond Fund respectively.[144]

Peter I (1682–1725)

Jasper, Johan
Active 1714–24
[Holland?] Called to St. Petersburg by Peter I. Silversmith. First alderman of the foreign guild.

Hildebrandt, Gottfried, the elder
Active 1714–25
[Estonia, Dorpat] Son of the jeweler Wilhelm Hildebrandt, who worked in Reval. Apprenticed for Paul Schröder in Reval. Later a goldsmith in Dorpat. Taken prisoner in the Great Nordic War. Sent to Moscow, then transferred to St Petersburg by order of Peter I. Member of the foreign guild, alderman 1724–25.

Hildebrandt, Valentin Wilhelm
Active 1739–52
[Estonia] Son of Gottfried Hildebrandt the elder (*v.s.*) Registered master in St. Petersburg. Member of the foreign guild.

Hildebrandt, Gottfried, the younger
Active 1740–56
[Estonia] Son of Gottfried Hildebrandt the elder (*v.s.*) Registered master in St. Petersburg. Member of the foreign guild.

Dom (Don), Nicolas
Active 1714–46
[France or Belgium] One of the earliest masters. Mainly commissions in silver. Worked for the imperial court.

Reymer (Römer / Reimare), Johan
Active 1718–58
[Finland] Goldsmith and jeweler. Member of the foreign guild. Workshop first on the Bol'shaia Morskaia, then after 1736, on the Malaia Morskaia.

Larionov, Samson
Active 1720s–30s
[Russia, Moscow] One of the skilled jewelers at the Kremlin Armory ordered by Peter I to move to St. Petersburg. Court jeweler of Praskovia Feodorovna, née Saltykova, consort of Tsar Ivan V. Made the diamond crown worn by Catherine I at her coronation in 1724.

Matveev, Mikhail
Active 1720s–?
[Russia, Moscow] One of the skilled jewelers at the Kremlin Armory ordered by Peter I to move to St. Petersburg.

Danckwart, Joachim, the Younger
Active 1724–33
[Finland] His father worked at Nyen and Vyborg, where Joachim became a goldsmith in 1687. Member of the foreign guild. His widow continued the business after his death assisted by the journeyman Mathias Wessel, whom she married so that he officially could take over the rights to the workshop. Master of the foreign guild 1734–51.

Anna Ioannovna (1730–1740)

Gravereaux, Benoît
Active 1717–46
[France, Paris] Arrived in St. Petersburg in September 1717. Court jeweler and talented craftsman. Diamond cutter and expert for the court. Not a guild member. Workshop in the Winter Palace "under the eye of Empress Anna." Received the title of court jeweler in 1746. Died in St. Petersburg April 4/15, 1766.

Dunckel, Gottfried Wilhelm
Active 1725–44
[Germany or Austria] Goldsmith and jeweler. Workshop on the Malaia Morskaia. Member of the foreign guild. Made the crown of Empress Anna Ioannovna, now in the Kremlin Armory.

Bok, Mathias Mickelson
Active 1726–72
[Sweden] Alderman of the foreign guild 1750. Worked as a jeweler for the imperial court at the end of the 1740s. Titled "snuffbox maker." [SH]

Rokontin, Jan (Johan)
Active end of 1740s–?
[Unknown] Silversmith. Worked as a jeweler for the imperial court at the end of the 1740s.

Elizabeth Petrovna (1741–1761)

Deichmann, Zacharias, the elder
Active 1731–76
[Russia, Olonets] Apprenticed in Moscow, where he became a journeyman. Master in St. Petersburg. Member of the foreign guild. Large commissions of silver for the imperial court.

Deichmann, Zacharias, the younger
Active 1776–1802
[Russia, St. Petersburg] Apprenticed for his father (*v.s.*) Continued the family business.

Liebmann, Johann
Active 1739–63
[Germany] Master. Not a guild member. Substantial orders from the imperial court. Called to Moscow in 1762 to oversee the goldsmiths work done for the coronation of Catherine II.

Pauzié, Jérémie
Active 1740–64
[Switzerland, Geneva] Jeweler favored by the empress. Came to St Petersburg in 1729 with his father. Apprenticed for Gravereaux. Journeyman 1740. Financed by Liebmann. Master 1742. Not a guild member. Left St. Petersburg in 1764. Workshop taken over by Mathieu Vauttelin. Master's mark unknown. He left memoirs. [SH] [DF]

Dubolon, Martin Charles
Active 1742–65
[France] Master July 20, 1742. He worked for the imperial court. Large commissions in silver. First master to receive the title of court jeweler. Title subsequently given to Lazarev, a broker and purchaser for the empress (he was not a goldsmith, but received it nonetheless).

Dubolon, Jacob Hannias
Active 1747–61
[France] Master May 19, 1741. Produced diamond rings and jewelry for the imperial court.

Kuntzendorff, Georg
Active 1748–75
[Livonia, Riga?] Important maker of silver for the imperial court.

Posse, N.
Active 1748–62
[France] Apprenticed for Gravereaux (*v.s.*) Became a jeweler. Worked for the cabinet of the empress in 1762.

Feuerbach, Johann Wendel
Active 1749–67
[Germany] Large commissions of silver objects for the imperial court. Worked with Johan Fredrik Köpping and Martin Charles Dubolon. Member of the foreign guild.

Hoppe, Johan Henrik
Active 1749–1801
[Sweden, Gothenburg] Trained in Sweden and Finland. Goldsmith, jeweler, and fancy-goods maker in St. Petersburg. Member of the foreign guild. A gold goblet made by him has survived, see Bäcksbacka, 1951 306.

Auroté
Active 1750s–60s
[France] One of the best jewelers in St. Petersburg during the 1750s. Not a guild member. Worked for the cabinet of the empress in 1762.

Bernardi
Active 1750s
[Italy] Worked for the empress personally as well as members of the aristocracy. Competitor of Pauzié.

Conrady, Samuel Gottlieb
Active 1754–86
[Estonia, Narva] Jeweler. Worked with the assistance of two journeymen.

Pfisterer, Leopold
Active 1760s
[Austria, Vienna] Jeweler. Worked at the imperial court in collaboration with Pauzié. Headed the Diamond Workshop established by the empress and supervised by the chamberlain Nikita Vozhinskii. Whenever a large-scale work was planned, independent masters were called to court to assist with the work; for example, J. W. Feuerbach and M. C. Dubolon, who made the large imperial crown. [DF]

CATHERINE II (1762–1796)

Duval, Louis David
Active 1754–88
[Switzerland, Geneva] Jeweler. See The Duval Family of Jewelers in the chapter on Paul I. [DF]

Duval, Jacob David
Active 1788-1837
[Russia, Moscow] Son of Louis David (*v.s.*) See The Duval Family of Jewelers in the chapter on Paul I.

Duval, Jean François André
Active 1793–1837
[Russia, St. Petersburg] Son of Louis David (*v.s.*) See The Duval Family of Jewelers in the chapter on Paul I.

Duval frères (Firm)
Active 1793–1837
See The Duval Family of Jewelers in the chapter on Paul I. [SH] [DF]

Eckhardt, Georg Friedrich
Active 1758–63/67
[Livonia, Bauska] Apprenticed in Mitau. Received substantial commissions for silverware from the imperial court. His widow continued the production after his death in 1763. Workshop taken over by another master in 1767. [SH]

Goebel, Christian Gottlieb
Active 1760–80
[Germany] Signed his work GOEBEL à St. Pétersbourg. Goldsmith. Member of the foreign guild. Titled "jewelry dealer." Johann Gottlieb Scharff (*v.i.*) worked as subcontractor to him.

Hasselgren, Joachim
Active 1766–96
[Sweden, Stockholm] Engraver, goldsmith, and silversmith. Known to be skillful. He worked for the cabinet of the empress. Member of the foreign guild, alderman 1787. [SH]

Meissner, Johann
Active 1766–81
[Germany, Berlin] Goldsmith. Member of the foreign guild.

Ador, Jean Pierre
Active 1770–85
[Switzerland, Vuitebœuf, canton of Vaud] Master's mark IA surmounted with a coronet or with initials inside the coronet. Worked as an enameller and jeweler in Geneva. Moved to St. Petersburg at the beginning of the 1760s. Became one of the most successful craftsmen there. Not a guild member. Founded a manufactory of fancy goods in 1764. Produced silver services, objets d'art, vases, fans, decorative weapons, and snuffboxes. [SH]

Herbst, Paul François Frédéric
Active 1771–?
[France, Paris] Possibly a son of the Parisian goldsmith Frédéric Guillaume Herbst. Apprenticed in Berlin, then London. Became a goldsmith in St. Petersburg. Member of

the foreign guild. King Gustav III of Sweden purchased a number of presentation gifts from him in 1777 when visiting Catherine II. See *Chère Cousine* in the chapter Early History.

Scharff, Johann Gottlieb
Active 1772–1808
[Russia, Moscow] Of German parents. Apprenticed in Moscow. Master in St Petersburg. Member of the foreign guild, alderman 1798. Worked for the jeweler Christian Gottlieb Goebel (*v.s.*) [SH]

Kayser, Johann Christian
Active 1773–1801
[Germany, Groß Wiederitzsch] Goldsmith. Member of the foreign guild. [SH]

Lang, Alexander
Active 1773–77
[Russia, St. Petersburg] Of German ancestry. Apprenticed with Johann Balthasar Gass. Goldsmith and jeweler. [SH]

Duc, Jean Jacques
Active 1777–85
[Germany, Frankfurt am Main] Born in Germany of French parents. Maker of snuffboxes. Alderman of the foreign guild 1778–85. One of the best jewelers of the time according to Foelkersahm.

König, Georg Andreas
Active 1777–1800
[Germany, Suhl, Thuringia] Goldsmith, jeweler, and stone cutter. [SH]

Rudolph, David
Active 1779–96
[Denmark, Copenhagen] Goldsmith and maker of fancy goods. Member of the foreign guild, alderman 1793. [SH]

Seguin, François
Active 1779–95
[France, Paris] Became a goldsmith in St. Petersburg. Member of the foreign guild. His daughter Andrienne married Louis Étienne Jean François Duval, son of Louis David (*v.s.*), in 1807.

Bouddé, Jean François Xavier
Active 1780s
[France] Came to St Petersburg via Hamburg, where he became a goldsmith and skilled jeweler. Member of the foreign guild, alderman 1779–85. Maker of objets d'art and snuffboxes. Marked his production FXB in a three-leaf-clover cartouche, at times with an addition of "Bouddé à St. Pétersbourg." [SH]

Dahlberg, Andreas
Active 1781–1818
[Sweden, Berghammars, Södermanland] Luxury-goods master and engraver. Came as a journeyman from Stockholm. Settled in St. Petersburg in 1781. Goldsmith 1786. Member of the foreign guild. See the chapter on Alexander I for an example of his work.

Cattany, Kecko
Active 1782–1820
[Germany, Dresden] Of Swiss parents. Became a jeweler in St. Petersburg. Member of the foreign guild. A skillful craftsman. His wife continued his business after his death.

Licht, Nathaniel Gottlieb
Active 1785–1805
[Poland] Goldsmith and jeweler. Alderman of the foreign guild 1800. Six apprentices, among them Daniel Gottlieb Breitfuß, journeyman 1796, and Carl Ludwig Küster, journeyman 1802.

Mertz, Christoph Friedrich von
Active 1785–1809
[Germany, Elsnitz, Saxony] Journeyman and especially important master in St. Petersburg. Member of the foreign guild, alderman 1797. Later applied to become a member of the Russian guild. Worked for the Cabinet of H.I.M. Many known apprentices, among them Gottlieb Ernst Jahn (*v.i.*)

Schopp, Peter Friedrich
Active 1786–1806
[Livonia, Riga] Goldsmith and jeweler. Member of the foreign guild, alderman 1803–4.

Karmarck, Peder (Peter)
Active 1787–97
[Denmark, Hobro] Goldsmith and fancy-goods maker. Moved to Copenhagen in 1797.

Wichmann, Gottfried
Active 1787–1820s
[Livonia, Riga] Goldsmith, silversmith, and luxury-goods master. Member of the foreign

guild. Maker of snuffboxes and table services in silver. See the chapter on Alexander I for an example of his work.

Römpler, Christoph Andreas (Andrei Grigor'evich)
Active 1790–1829
[Germany, Saxony] Diamond merchant and jeweler of the imperial court. See Serving Seven Sovereigns in the chapter on Nicholas I.

Römpler & Jahn (Firm)
Active 1829–36
Produced jewelry and objects in gold. Successor: Jahn & Bolin (*v.i.*) See Serving Seven Sovereigns in the chapter on Nicholas I.

PAUL I (1796–1801)

Loubier, Jean François
Active 1776–1824
[Germany, Berlin] Goldsmith and jeweler. Member of the foreign guild, alderman 1792. Worked for the imperial court. Known as a skillful jeweler.

Loubier, Jean Pierre
Active 1801–56
[Germany, Berlin] Son of Jean François (*v.s.*). Journeyman 1792. Master 1801. Member of the foreign guild, alderman 1821–22.

Theremin, Pierre Etienne
Active 1793–1801
[France] Goldsmith, jeweler, and maker of fancy goods. Early career in Paris, Geneva, and London. Came to St. Petersburg in 1793. Shortly thereafter joined by his brother François Claude, both working for the imperial court until at least 1801. Member

of the foreign guild, alderman 1800–1801. Married Marianne Jacqueline Renée Duval, daughter of Louis David (*v.s.*), in 1794. See the chapter on Alexander I for an example of hiw work. [SH]

Jannasch, Johann Friedrich
Active 1796–1850s
[Hungary] Apprenticed in Warsaw. Came as journeyman to St Petersburg. Worked for the imperial court for at least fifty years. Appraiser of the Cabinet of H.I.M. Received a gold medal decorated with diamonds and the inscription "for diligence" in 1852. Important supplier of jewelry to the imperial court during the reigns of Alexander I and Nicholas I.

Mingou
Active first quarter of the *19th* century [Unknown] Foelkersahm mentions a commission of three diamond rings for the Cabinet of H.I.M., for which he was paid 1,650 rubles.

ALEXANDER I (1801–1825)

Keibel (Firm)
Active 1797–1910
Founded by Otto Samuel Keibel (*v.i.*) and run by three generations of the same family. Produced jewelry and objects in gold and silver. Important supplier of presentation pieces, including swords and field-marshal batons, to the Cabinet of H.I.M. and of orders and decorations to the Chapter of the Imperial and Royal Orders from 1836.

Keibel, Otto Samuel
Active 1797–1809
[Germany, Pasewalk, Prussia] Goldsmith and jeweler. Member of the foreign guild, alderman 1807–8. An excellent craftsman with important commissions for the imperial court. [SH]

Keibel, Johann Wilhelm
Active 1812–62
[Germany, Pasewalk, Prussia] Alderman of the foreign guild 1828. Important commissions for the Cabinet of H.I.M. The Chapter of the Imperial and Royal Orders commissioned J. W. Keibel and Wilhelm Kaemmerer to produce the official orders and decorations in 1836.

Keibel, Albert Konstantin
Active 1882–1910
[Russia, St. Petersburg] Produced orders and decorations. Lost the tender to the firm of Eduard, marking the end of his collaboration with the chapter. Company dissolved at the death in 1910 of Albert Keibel.

Barbé, Johann Christian
Active 1804–43
[Germany, Frankenthal, near Frankfurt am Main] Brother of goldsmith Carl Helfried Barbé. Apprenticed from 1794 with A. W. Reinhardt. Journeyman 1798. Goldsmith and luxury-goods master. Member of the foreign guild. Worked for the Cabinet of H.I.M. A fine example of his work, a gold military cup, can be found at Hillwood Estate, Museum & Gardens, Washington, DC. See also the chapter on Nicholas I.

Kochendörfer, Bernhard Johann
Active 1806–49
[Livonia, Fellin] Apprenticed with Johann Friedrich Möring. Had shop, Magasin de bijouteries et d'orfèverie, in the Kotomin House, Malaia Millionnaia, in 1831.

Kolb, Friedrich Joseph
Active 1806–26
[Germany, Würzburg] He apprenticed for Christoph Friedrich Mertz in St. Petersburg. Gold- and silversmith. Member of the foreign guild. Known as one of the best jewelers of the time. Had many commissions from the imperial court. [SH]

NICHOLAS I (1825–1855)

Eckhardt, Johann (Ivan Petrovich)
Active ?–1840s
[Unknown] Goldsmith and jeweler. Collaborated with Gustav Fabergé (*v.s.*) His workshop passed to F. Bühler, then to Karl Bock (*v.s.*)

Ehlers, Gottlieb Hermann
Active 1810–49
[Germany, Greifswald, Pomerania] Goldsmith and jeweler. Had retail shop in the 1830s that among other things sold diamonds and jewelry. Thal House, Nevskii 6.

Breitfuß (Firm)
Active 1812–*90s*
Founded by Heinrich Ludwig Breitfuß (*v.i.*) Court jewelers 1867. Workshop at Gorokhovaia 17 and retail shop at Bol'shaia Morskaia 15.

Breitfuß, Heinrich Ludwig
Active 1812–68
[Germany, Rastenburg, Prussia] A successful and skilled jeweler. Founder of the firm Breitfuß (*v.s.*) Member of the foreign guild, alderman 1827. Appraiser of the Cabinet of H.I.M. 1859. Court jeweler and hereditary honorary citizen 1867.

Breitfuß, Karl Ludwig
Active 1820–68
[Germany, Rastenburg, Prussia] Court jeweler. Appraiser of the Cabinet of H.I.M. 1851. Cataloged the crown jewels in 1868 with Bolin and Saefftigen. Order of St. Stanislas 3rd class and hereditary honorary citizenship 1867.

Breitfuß, Daniel Gottlieb
Active 1801–39
[Germany, Rastenburg, Prussia] Jeweler and goldsmith. Apprenticed in St. Petersburg with Nathaniel Licht (*v.s.*) Goldsmith 1801. Member of the foreign guild, alderman 1818–19. Worked with sixteen apprentices.

Breitfuß, Alexander (Aleksandr Karlovich)
Active 1844–90s
[Germany, Rastenburg, Prussia] Son of Heinrich Ludwig (*v.s.*). Continued the family business. Merchant of the second guild.

Jahn, Gottlieb Ernst
Active after 1812–36
[Germany, Elnitz, Saxony] Goldsmith. See Serving Seven Sovereigns in the chapter on Nicholas I.

Jahn & Bolin (Firm)
Active 1829–36
Founded by Gottlieb Ernst Jahn (*v.s.*) and Carl Edvard Bolin (*v.i.*). Successor: C. E. Bolin (*v.i.*). See Serving Seven Sovereigns in the chapter on Nicholas I.

Tapper, Henrik
Active 1815–27
[Finland] Apprenticed with C. F. Bredenberg. Journeyman 1808. Maker of snuffboxes.

Heyde, Johann Christian

Active 1819–56

[Unknown] Goldsmith with a workshop and retail shop.

Nicholls & Plincke / Magasin Anglais (Firm)

Active 1829–1910s

Founded by the Englishmen Constantine Nicholls and William Plincke (*v.i.*) Court jewelers from 1844. Sold silver and jewelry in the English style produced locally, as well as imported from England. Most important court jeweler during the reign of Nicholas I. Supplied items and jewelry for the dowries of the emperor's daughters. Provided part of the dowry for Grand Duchess Olga Aleksandrovna in 1901. Shop at Nevskii 16.
Workmasters:
Arnd, Samuel (*v.i.*).
Falck, Johan Fredrik *active 1838–1845*
Hacklin, Henrik *active 1846–1879*. Produced part of the dowry of Grand Duchess Ol'ga Nikolaevna.
Henrikson, Johan, *active ?–?* Silversmith. Worked also for the merchant Kudriashev.
Lång (Long), Henrik August, active 1824–42
KA (unknown).
PK (unknown).
Tegelsten, Carl (*v.i.*).
Tobinkov, A., *active 1870s*.

Nicholls, Constantine

Active 1829–*52*

[England] Jeweler. Russian citizen from 1804. Merchant of the first guild and hereditary honorary citizen 1808. Died in Cornwall Terrace, Regent's Park, London, 4 Jan. 1852.

Plincke, William

Active 1829–*52*

[England] Jeweler. Russian citizen from 1804. Merchant of the first guild and hereditary honorary citizen in 1808. Died in Montague Square, London, 4 Feb. 1852. His son, Henry Plincke, merchant of the first guild, took over the business for a number of years.

Tegelsten, Carl

Active 1833–*52* (1855)

[Finland, Karis-Lojo] Enormous production of silverware. His bronze factory produced chandeliers for the Winter Palace, churches (including St. Isaac's Cathedral), and

important institutions in Russia and Finland. His son and widow carried on the business, although not very successfully, between 1852 and 1855.

Christlieb, Wilhelm

Active 1834–50s

[Unknown] Goldsmith and jeweler. Member of the foreign guild. Workshop on the Bol'shaia Morskaia. See the chapter on Alexander II for an example of his work.

C. E. Bolin (Firm)

Active 1836–1917

See Serving Seven Sovereigns -- The Court Jewelers Bolin in the chapter on Nicholas I.
Workmasters:
CS (unknown), *active 1847–1860s*
Chernokov, Nikolai Andreevich, *active early 1900s?–1917?* Moika 55.
Finikov, Vladimir Iakovlevich *active 1880–1908*. Fifteen workers in 1897, Moika 55.
JM (unknown). See a gold brooch with diamonds and sapphires in the chapter on Bolin.
Schwan, Alexander Robert Friedrich, *active ?–1895*. Moika 55.
Schwan, Sophie (Sofia Ivanovna), his widow, *active 1895–?*. Moika 55.
Schwan, Robert (Roman Robertovich), her son, *active 1895–1917*. Moika 55.

Bolin, Carl Edvard

Active 1836–64

[Sweden] Crown jeweler. See Serving Seven Sovereigns in the chapter on Nicholas I.

Bolin, Edvard Karlovich

Active 1864–1917

[Russia, St. Petersburg] Jeweler and goldsmith. See Serving Seven Sovereigns in the chapter on Nicholas I.

Bolin, Gustaf Karlovich

Active 1864–1917

[Russia, St. Petersburg] Jeweler. See Serving Seven Sovereigns in the chapter on Nicholas I.

Arnd, Johan Samuel Samuelovich

Active 1845–90

[Russia, St. Petersburg] Goldsmith and jeweler. Subcontractor to Nicholls & Plincke (*v.s.*) Married a daughter of Carl Tegelsten (*v.s.*). Workshop on Gorokhovaia ulitsa.

ALEXANDER II (1855–1881)

Saefftigen, Adolf Leopold (Leopol'd Karlovich)

Active 1822–88(?)

[Estonia, Reval] Founder of the firm Leopold Saefftigen (*v.i.*) Paid guild duties from 1849. Appraiser of the Cabinet of H.I.M. 1861. Court jeweler 1869–88. Hereditary honorary citizen. According to the journal *Russian Jeweler*, he was the richest jeweler in St. Petersburg. Made the diamond crown for the coronation of Empresses Maria Aleksandrovna, which was modeled after that made by Duval for Empress Maria Feodorovna, wife of Paul I. Shop at Bol'shaia Morskaia 16.

Leopold Saefftigen (Firm)

Active 1840s–99

Founded by Adolf Leopold Saefftigen (*v.s.*) Important makers of jewelry. Run by several generations of the same family. Purveyor of the Imperial Court 1869.

Saefftigen, Konstantin Friedrich (Konstantin Karlovich)

Active 1840s–99

[Estonia, Reval] Brother of Adolf Leopold (*v.s.*) Participated in the Great Exhibition in London in 1851. Appraiser of the Cabinet of H.I.M. Worked for Alexander II and his consort Maria Aleksandrovna. Made a crown for the coronation of Alexander II. Produced the highest orders set with diamonds, the empresses' diamond portraits, maid-of-honor ciphers, jeweled swords, field-marshal batons, chamberlain keys, and jeweled snuffboxes. Carl Hahn (*v.i.*) gradually took over these imperial commissions. A rare diamond badge made by him is preserved at the State Historical Museum, Moscow.

Saefftigen, Julius Otto
Active 1888–late 1890s
[Russia, St. Petersburg] Son and successor of Leopold (*v.s.*) Supplied three drawings in emeralds and diamonds for the 1894 competition for a parure for Empress Alexandra Feodorovna.

Tiander, Fredrik
Active 1823–69
[Finland] Apprenticed in Porvoo, Finland, where he also became a silversmith. Worked for a time with C.G. Savary in St. Petersburg. Workmaster for I. E. Morozov (*v.i.*) Returned to Finland where he set up his workshop in Loviisa.

Spiegel, Andreas Ferdinand
Active 1830–62 (1870s)
[Estonia, Reval] Jeweler. Apprenticed with Carl Emanuel Saefftigen in Reval. Gustav Fabergé apprenticed with him. Workshop in the Lubomirski House on the Offitserskaia ulitsa in 1849. His widow Annette continued the business after his death in 1862. See Myrtle – Symbol of a Happy Marriage in the chapter on Alexander II.

Kaemmerer, Heinrich Wilhelm
Active early 1830s–*54*
[Germany, Saxony] Maker of luxury goods. Goldsmith and jeweler. Member of the foreign guild. Appraiser of the Cabinet of H.I.M. 1835. Court jeweler 1839. Exhibited at the Great Exhibition in London in 1851. It was said of him, "The importance of the articles in this collection, the superior taste in composition, and, above all, the perfection of settings, not excelled by the works of any jeweler in the Exhibition."

Reimann, Jan
Active 1840–1912
[Unknown] Jeweler. Mentions that he makes modern jewelry in his frequent advertisements, showing a stag-beetle brooch as an example. Retail shop was at Nevskii 29–31.

Reimann, Zdeneck Ivanovich
Active 1908–13
[Russia, St. Petersburg] Sold diamond and gold jewelry as well as watches. Mentioned as owner of the firm "Jan Reimann" 1908–1912. Shop at the Gostinyi dvor, Zerkal'naia liniia 62.

Butz, Alexander Franz
Active 1840s–57
[Livonia, Pernau] Goldsmith and jeweler. Opened a shop called Butz & Bollien together with the goldsmith Carl Bollien (*v.i.*)

Butz, Friedrich Daniel
Active 1849–90s
[Russia, St. Petersburg] Appraiser of the Cabinet of H.I.M. together with Bolin and Saefftigen. Order of St. Anne 3rd class 1869. Supplied drawings for the 1894 competition for a parure for Empress Alexandra Feodorovna.

Butz, Julius Agathon
Active 1880s–1911
[Estonia, Reval] Schoolmate of Karl Fabergé at the Annenschule. Traveled with him in Europe 1864–66. Appraiser of the Cabinet of H.I.M.

Vaillant, Jean-Baptiste
Active 1840s–93
[France] Court jeweler 1863. Alexander Edvard Tillander sold his first products (wide gold bangles) in 1860 to him. Successor: O. Reihart (*v.i.*). Retail shop at Nevskii 34.

Zajączkowski, Walery
(Valerii Andreevich Zaionchkovskii)
Active 1840s–70s
[Unknown] Goldsmith and jeweler. Managed Gustav Fabergé's company 1860–72. Workshop at Bol'shaia Morskaia 20.

Schubert, Carl Reinhold
Active 1844–80
[Germany, Wesenberg] Master in in St. Petersburg. Goldsmith and jeweler. Journeyman Alexander E. Tillander. Workshop on Gorokhovaia ulitsa.

Olsoni, Johan Ferdinand
Active 1852–81
[Sääminki, Finland] Jeweler. Merchant of the second guild. Apprenticed in St. Petersburg, journeyman in 1842. Retail shop at Nevskii pr. 52. Worked for the Brothers Grachev, St. Petersburg. An example of his his work in the chapter on Alexander II.

Stenberg, Thomas
Active 1863–86
[Artjärvi, Finland] Goldsmith. Learnt the trade in St. Petersburg. Subcontractor to the known

retail shops in St. Petersburg. An example of his work in the chapter on Alexander II.

Bollien, Carl
Active 1849–60s
[Livonia] Goldsmith and jeweler. Member of the foreign guild. Opened a shop called Butz & Bollien with Alexander Franz Butz (*v.s.*)

Hau, Alexander
Active 1849–75
[Estonia, Reval] Apprenticed with Carl Emanuel Saefftigen (*v.s.*) in Reval. Shop at Nevskii 81.

Hau, Georg Aleksandrovich
Active 1890s–1917
[Russia, St. Petersburg] Son of Alexander (*v.s.*) Jeweler. Many pieces in original boxes have survived. Retail shop at Nevskii 12, later 14.

Hau, Nikolai Aleksandrovich
Active 1894-1902?
[Russia, St. Petersburg] Son of Alexander (*v.s.*) Jeweler. Retail shop at Nevskii 12.

Hau, Johann Aleksandrovich
Active 1890s-1917
[Russia, St. Petersburg] Son of Alexander (*v.s.*) Jeweler. Retail shop at Nevskii 12.

Rodhe, F. (Firm)
Active 1849–67(1870s)
Founded by Johann Ferdinand Rodhe. Produced jewelry and objects in gold. His widow, Emilia, continued the business into the 1870s. Workshop in the Frolov House at Karavannaia 18.

Schneegas, Karl Ferdinand
Active 1850-60s
[Reval] Goldsmith. Workshop on the Bol'shaia Morskaia. His brother Johann Konstantin Schneegas was also a goldsmith in St. Petersburg.

Bock, Karl (Karl Ivanovich)
Active 1874–early 1900s
[Unknown] Successor of F. Bühler. Main production was jewelry. Received a gold medal at Nizhnii Novgorod in 1896. Exhibited at the Universal Exposition in Paris in 1900. Supplier to the imperial court from 1901. Workshop had 20–25 journeymen and 3–5 apprentices. See also Eckhardt.

Bock, Alexander (Aleksandr Karlovich)
Active 1890s–1917
[Russia, St. Petersburg] Son of Karl (*v.s.*)
Cataloged the crown jewels together with
Agathon Fabergé in 1922.

ALEXANDER III (1881–1894)

Fabergé (Firm)
Active 1841–1918
See "The Jeweler Karl Faberge" in the chapter
on Nicholas II.
Workmasters and subcontractors:
Aarne, Johan Viktor, *active 1891–1904*
Afanas'ev, Fedor Alekseevich, *active 1915–17*
Armfelt, Hjalmar, *active 1904–17*
Gur'ianov, Andrei, *active 1903–1917*
Hollming, August, *active 1880–1913*
Hollming, Väinö, *active 1913–16*
Holmström, Albert, *active 1903–17*
Holmström, August, *active 1857–1903*
Kollin, Erik, active *1870–86*
Mickelsson, Anders, *active 1867–1913*
Nevalainen, Antti, *active 1885–1917*
Nykänen, Gabriel, *active 1889–1917*
Perkhin, Mikhail, *active 1886–1903*
Pihl, Oscar, *active 1887–97* (Moscow
workshop)
Rappoport, Julius Alexander, *active 1883–
1908* (succeeded by the Third Artel (*v.i.*))
Reimer, Wilhelm, *active 1840s–1894*
Ringe, Theodor, *active 1894–1912*
Ringe, Anna, *active 1894–1912*
Rutsch, Friedrich Konrad, *active 1880s–1917*
Solov'ev, Vasilii Fedorovich, *active 1894–
1917*
Thielemann, Alfred Rudolf, *active 1898–
1909*
Thielemann, Elisabeth, née Körtling, *active
1909–17*
Väkevä, Stefan, *active 1856-1917*
Väkevä, Konstantin, *active c. 1891–1902*
Väkevä, Alexander, *active c. 1891–1917*
Väkevä, Jenny, widow of Konstantin Väkevä,
marked *1902–17*
Wigström, Henrik, *active 1903-17*

Fabergé, Gustav
Active 1841–70
[Livonia, Pernau] Jeweler and goldsmith. See
The Legendary Jeweler – Karl Faberge in the
chapter on Nicholas II.

Fabergé, Peter Carl (Karl Gustavovich)
Active 1870–1918
[Russia, St. Petersburg] Son of Gustav Fabergé
(*v.s.*) Goldsmith and jeweler. One of the
main suppliers to the Cabinet of H.I.M. by
1880. Appraiser of the Cabinet of H.I.M. and
hereditary honorary citizenship 1890. Knight
of the Order of St. Stanislas 2nd and 3rd
classes, the Order of St. Anne 3rd class, and
the Legion of Honor of France. Manufacturing
counselor and court jeweler 1910. See The
Legendary Jeweler – Karl Faberge in the
chapter on Nicholas II.

Schubert, Carl Reinhold
Active 1844–80
[Germany, Wesenberg, Mecklenburg]
Goldsmith. Alexander Tillander (*v.i.*) worked
as a journeyman for him. Workshop on
Gorokhovaia ulitsa in 1849. His widow,
assisted by his son Eduard, continued the
business at Moika 42.

Tillander, A. (Firm)
Active 1860–1918
See The Jeweler A. Tillander in the chapter on
Nicholas II.
Workmaster:
Weibel, Theodor, *active 1880s, independent
1911–18*. Workshop on Gorokhovaia ulitsa at
the Stone Bridge.

Tillander, Alexander Edvard
Active 1860–1918
[Finland, Tali estate, Helsinki] Jeweler and
goldsmith. See The Jeweler A. Tillander in the
chapter on Nicholas II.

Tillander, Alexander Theodor
Active 1910–44
[Russia, St. Petersburg] Son of Alexander
Edvard (*v.s.*) See The Jeweler A. Tillander in
the chapter on Nicholas II.

Johanson, Nikolai Solomonovich
Active 1866–99
[Estonia, Reval?] Merchant since 1866.
Goldsmith and trader in gold. Supplier to the
imperial court. He also owned a wallpaper
shop. Workshop at Nevskii 42.

C. Hahn (Firm)
Active 1873–1911
Founded by Carl Hahn (*v.i.*) Produced jewelry
and objects in gold. When the business closed

in 1911, the premises were taken over by the
jeweler A. Tillander (*v.i.*) Retail shop at Nevskii
26.

Hahn, Carl August Ferdinand
Active 1873–99
[Austria] Goldsmith and jeweler. Founder of
the firm C. Hahn (*v.s.*) Alongside Bolin, and
later Fabergé, the most important jeweler in
St. Petersburg during the latter part of the
nineteenth century. Purveyor of the Imperial
Court during the reign of Alexander III.
Produced an array of imperial presentation
gifts, diamond orders, and decorations in
two large workshops, each headed by master
goldsmiths: Alexander Treyden (*v.i.*) and Carl
Blank (*v.i.*) Appointed appraiser of the Cabinet
of H.I.M. 1896. Order of St. Stanislas 3rd class
and hereditary honorary citizenship 1898.
Exhibited at the World's Columbian Exposition
in Chicago in 1893 and at Nizhnii Novgorod
in 1896. His widow, Adele Marie, continued
the business after his death. An abundance
of objects made by Hahn have survived in
important collections worldwide, and much of
his work is continuously sold on the antique
market.

Hahn, Dmitrii Karlovich
Active 1901–11
[Russia, St. Petersburg] Son and successor
of Carl Hahn (*v.s.*) Title of purveyor of the
Imperial Court renewed in his favor in 1903.
Merchant of the first guild 1907, which at
the time meant the business had the right to
export. Important commissions for the Cabinet
of H.I.M.

Nicholls-Ewing, Nicholas
Active 1880s–*90s*
[Unknown] Supplier to the imperial court.
Merchant of the second guild. Shop at Bol'shaia
Morskaia 47. Supplied drawings for the
1894 competition for a parure for Empress
Alexandra Feodorovna.

Rutsch, Friedrich Konrad
Active 1880s–1917
[Germany, Heidelberg] Maker of chain work.
Subcontractor to many jewelers, including
Fabergé.

Taivainen, Antti
Active 1884–1917
[Finland] Independent master. Specialized in

desk sets in gold and small gold and silver. In particular patronized by the corps of medical doctors. Subcontractor to many retail jewelers. Workshop at Bol'shaia Koniushennaia 6. From 1919 in Viipuri. His son returned to Finland after the revolution and had a shop on the Mannerheimintie, Helsinki, until 1982. (TSGIAL, fond 223, opis' 1, delo 5423, list 42; fond 513, opis' 31, delo 1572; Ves' Peterburg 1898–1917).

Helenius, Edvard
Active 1890s–1917
[Finland] Goldsmith. Worked for Fabergé. Owned a gold and silver workshop at Demidov pereulok 9 in 1910, the same address as Erik Kollin's workshop.

Schramm, Edward Wilhelm
Active late 1890s–1917
[Russia, St. Petersburg] Of German extraction. Jeweler and goldsmith. Worked for many jewelers, including Fabergé and Bolin. Shops at Nevskii 20 and Bol'shaia Koniushennaia 31.

Guériat, Louis François
Active 1892–1918
[Unknown] Goldsmith and jeweler. Retail shop. Collaborated with Vaillant (v.s.)

Reihart, Oscar Petrovich
Active 1893–1917
[Unknown] Took over the business of Jean-Baptiste Vaillant (v.s.) Merchant of the second guild 1893. Workshop making diamond and gold jewelry at Gorokhovaia 36, later at Sadovaia 84. Retail shop at Nevskii 34.

Bostel & F. Olsoni
Active latter part of the 19th century
[Unknown] Goldsmiths.

NICHOLAS II (1894–1917)

E. Kortman (Firm)
Active 1848–1917
Owned by Edvard Johan Kortman, a Finn, who purchased G. Bostel's workshop in 1848 and started to produce silverware, regimental jewelry, jetons, enameled and galvanized objects, as well as guilloché work. Large workshops at Nevskii 34.

I. E. Morozov (Firm)
Active 1849–1917
Founded by Ivan Ekimovich Morozov (v.i.) in 1849. Principally sold silverware, jewelry, and enameled objects made by other masters. Gostinyi dvor 85, 86, 87.
A selection of his subcontractors:
Airaksinen, Petter (for a limited time only before returning to Helsinki, Finland)
A.L. (unknown)
B.K. (unknown)
B.M. (unknown)
Herttuainen, Adam (v.i.)
Н.Б. (unknown)
J.A. (unknown)
Passinen, Johan (Cyrillic I.P.)
Seppänen, Anders Johan
Tiander, Fredrik (v.i.)

Morozov, Ivan Ekimovich
Active 1849–85
[Russia] Goldsmith. Founder of the firm I. E. Morozov (v.s.) Hereditary honorary citizen and merchant of the first guild.

Morozov, Vladimir Ivanovich
Active 1885–1917
[Russia] Son of Ivan Ekimovich (v.s.) Chairman of the society of jewelers, goldsmiths, silversmiths, and merchants of St. Petersburg 1912.

Sumin, Ivan
Active 1849–1894
[Russia] Founder of the firm Sibirskie ural'skie kamni. Specialized in objects made of minerals from Siberia and the Urals. Awarded a prize for his hardstones at the 1882 Pan-Russian Exhibition. Supplier to the imperial court.

Sumin, Avenir Ivanovich
Active 1869–1913
[Russia] Son of Ivan (v.s.) Purveyor of the Court of Empress Aleksandra Feodorovna 1913. The business was taken over by Sergei Georgievich Osmolovskii. Shop at Nevskii 42, from 1911 at Nevskii 60.

A. D. Ivanov (Firm)
Active 1850s–1911
Founded by Aleksandr Dement'evich Ivanov (v.i.) Produced snuffboxes and fine jewelry. Supplier to the imperial court for many years. His widow Ksenia Tarsovna continued the business until 1911. Retail shop at Nevskii 32.

Ivanov, Aleksandr Dement'evich
Active 1850s–1907
[Russia] Jeweler and goldsmith. Founder of the Firm A. D. Ivanov (v.s.) Merchant of the third guild 1856–63, then of the first guild. Hereditary honorary citizen 1888. Produced for the Cabinet of H.I.M. 1894–1907.

Adler & Co (Firm)
Active 1855–1917
Owner Andrei Karlovich Adler. Produced objects in gold. Took over the firm of D. I. Osipov in 1902 and continued their production of orders, badges, and jetons. Workshops at Ekaterininskii kanal 42.

Adler (Firm)
Active 1890s–1917
Owner Alexander Karlovich Adler. Produced objects in gold and silver, including cigarette cases and objets d'art with guilloché enamel in the Fabergé style.

Herttuainen, Adam
Active 1860s–1918
[Finland] Supplied I. E. Morozov (v.s.) with silver cutlery, very large commissions. Workshops at 6-aia Rozhdestvenskaia 31.

F. Koechly (Firm)
Active 1870–1911
Founded by Friedrich Christian Koechly (v.i.) Produced jewelry and objects in gold. Important supplier of presentation objects to the Cabinet of H.I.M. Shop at Gorokhovaia 17.

Koechly, Friedrich Christian
Active 1870–1909
[Switzerland] Jeweler and goldsmith. Founder of the firm F. Koechly. Merchant of the second guild. He won the competition in 1894 for a parure in sapphires and diamonds for Empress Alexandra Feodorovna. A member of the jury at the Paris World Exposition in 1900. Court jeweler 1902. Court jeweler of Empress Maria Feodorovna. Member of the St. Petersburg administration of foreign trade.

Koechly, Friedrich Theodor (Fedor Fedorovich)

Active 1890s–1911

[Switzerland] Son of Friedrich Christian (*v.s.*) Studied sculpting at the Imperial Academy of Arts in St. Petersburg. Graduated in 1890. Assisted his father in the family business.

A. K. Denisov-Ural'skii & Co. (Firm)

Active early 1880s–1918

Founded by Aleksei Koz'mich Denisov-Ural'skii (*v.i.*) Produced objects in gold and silver, as well as jewelry. From 1910 specialists in decorative hardstones. Supplier to the imperial court. Retail shop at Bol'shaia Morskaia 27.

Denisov-Ural'skii, Aleksei Koz'mich

Active early 1880s–1918

[Russia, Ekaterinburg] Son of a lapidary who operated a workshop in the Urals. Founder of the firm A. K. Denisov-Ural'skii & Co. (*v.s.*) Received his master's certificate in sculpture from the Ekaterinburg guild of sculptors in 1884. Studied in St. Petersburg at the school of the Society for the Encouragement of the Arts. Displayed at various exhibitions and awarded numerous medals. See the chapter on Nicholas II.

Polvinen, Tuomas

Active 1880s–1911 (later in Finland)

[Finland, Kuhmonniemi] Goldsmith. Apprenticed in St. Petersburg with Pekka Innanen. Worked with him until 1890. Employed as workmaster for Julius Agathon Butz (*v.s.*). Made contemporary jewelry set with precious stones. His archive of designs remains in the collection of his descendants in Finland. See the chapter on Alexander II.

Beilin & Son (Firm)

Active 1890s–1918

Founded by Abram Solomonovich Beilin-Levkov (*v.i.*) Produced cigarette cases, snuffboxes, and gold and diamond jewelry. Supplied many of the important retail jewelers, among them Fabergé and Tillander, for whom he made cigarette cases. Subcontractors of Paul Buhré making chains for the pocket watches commissioned by the Cabinet of H.I.M. As special orders for the cabinet, Beilin produced diamond set crowns and double-headed eagles (possibly to be used for imperial presentation boxes). Shop at Sadovaia 22.

Beilin-Levkov, Abram Solomonovich

Active 1890s–1918

[Russia] Founder of Beilin & Son (*v.s.*) His son David Abramovich Beilin-Levkov collaborated with him.

Bucknall, Charles Herbert (Karl Fedorovich)

Active 1890s–1917

[Russia, St. Petersburg] Dealer in precious stones. Cofounder of the firm G. Sachs & C. H. Bucknall (*v.i.*) Born St. Petersburg May 5, 1864, died London Sept. 1, 1938, bur. at Brompton Cemetery.

G. Sachs & C. H. Bucknall (Firm)

Active 1890s–1917

Founded by the Frenchman Georges Sachs and Charles Herbert Bucknall (*v.s.*) Dealers in precious stones. Shop at Lakhtinskaia 5, later Italianskaia 3.

Gordon, Vladimir Alekseevich

Active 1890s–1917

[Unknown] Jeweler, gold- and silversmith. Collaborated with Bolin and Fabergé. Purveyor of Grand Duchess Ol'ga Aleksandrovna and Prince Petr Aleksandrovich of Oldenburg 1911. Workshop and retail shop at Gostinyi dvor, Zerkalnaia liniia. See the chapters Alexander III and Nicholas II for examples of his work.

Linden, Nikolai Gustavovich

Active early 1890s–1917?

[Unknown] Jeweler, gold- and silversmith. Retail store at Nevskii 83. Purveyor of the Imperial Court 1912. See the chapter on Nicholas II for an example of his work.

Worbs, Johann Jos.

Active 1892–1917?

[Unknown] Jeweler and goldsmith. Shops at Bol'shaia Morskaia 15 and Nevskii 10.

Treyden, Alexander Adolf (Aleksandr Adol'fovich)

Active 1896–1918

[Unknown] Goldsmith. Former workmaster of Hahn (*v.s.*) Made gold and jeweled objects. Elected treasurer of the Society of Jewelers, Goldsmiths, Silversmiths, and Merchants in 1912. Workshop at Kaznacheiskaia 5 in 1894. Retail shop at the firm of the jeweler Johanson at Nevskii 42.

Britsyn, Ivan Savel'evich

Active 1903–17

[Russia, Moscow] Gold- and silversmith. Peasant from the Moscow region who trained at Fabergé. Established himself as an independent master. Specialized in enameled products, mostly cigarette cases, but also jewelry. He died in 1952. His tools and workbench are preserved at Peterhof. Workshop on Spasskaia ulitsa, then in 1910 at Malaia Koniushennaia 12.

Third Artel (Firm)

Active 1908–11

Headed by Vasilii Nikolaevich Ivanov. Approximately thirty craftsmen. Subcontractors to Fabergé. Succeeded Julius Rappoport. Workshop at Ekaterininskii kanal 48.

Blank, Carl

Active 1911–17

[Russia, St. Petersburg] Jeweler and goldsmith. Head workmaster for Carl Hahn (*v.s.*) 1882–1909, later his partner. Independent master from 1911. Took over Hahn's production of important commissions for the Cabinet of H.I.M. Appraiser to the cabinet and hereditary honorary citizen 1915. Returned at the time of the revolution to his native Finland.

Burchardt, Eduard

Active 1890s–1917

[Unknown] Retail shop at Nevskii pr. 6. Chairman of the Society of Jewelers, Gold- and Silversmiths and Retailers in St. Petersburg. An example of his work in the chapter on Alexander III.

INDEX